NA' ERY

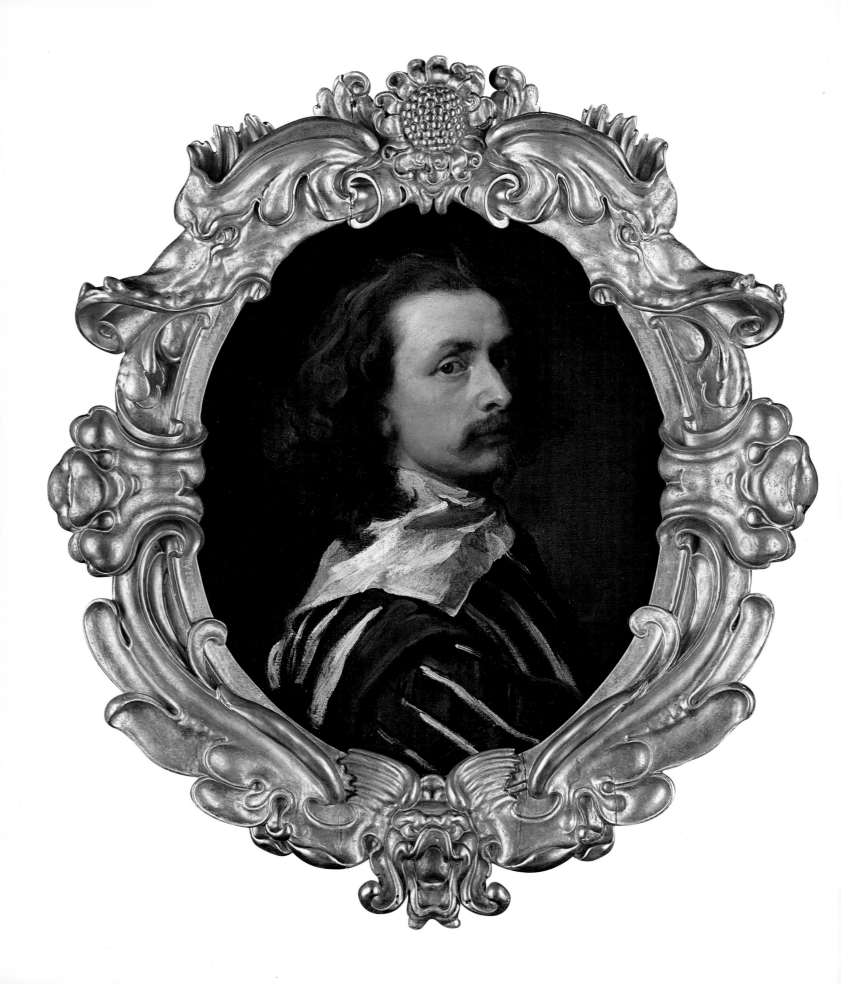

NATIONAL PORTRAIT GALLERY
A PORTRAIT OF BRITAIN

EDITED BY
TARNYA COOPER
CHIEF CURATOR

WITH A FOREWORD BY
SANDY NAIRNE
DIRECTOR

WITH AN INTRODUCTION BY
ROBIN FRANCIS
HEAD OF ARCHIVE & LIBRARY

Published in Great Britain by
National Portrait Gallery Publications
St Martin's Place, London WC2H 0HE

For a complete catalogue of current publications,
please write to the National Portrait Gallery at
the address above, or visit our website at
www.npg.org/publications

ISBN 978 1 85514 485 9

A catalogue record for this book is available from the
British Library.

10 9 8 7 6 5 4 3 2 1
Printed in Italy

Managing Editor: Christopher Tinker
Editor: Andrew Roff
Copy-editor: Denny Hemming
Production Manager: Ruth Müller-Wirth
Designer: Peter Dawson, www.gradedesign.com

MIX
Paper from
responsible sources
FSC® C015829

Acknowledgements

The National Portrait Gallery collections have grown
through the generosity of many institutions, families
and individuals who have donated important works.
Equally important has been the support over many
decades of the Art Fund (formerly known as the
National Art Collections Fund), and in more recent
years of the National Heritage Memorial Fund and
the Heritage Lottery Fund. The Gallery's own Portrait
Fund has become increasingly significant, and the
National Portrait Gallery is very grateful to all those
who have supported the Fund as well as the public
campaigns to acquire particular portraits.

A special thank you is due to Rosie Broadley (Associate
Curator) who has overseen and co-ordinated the
collation of Collection information for this book with
great care and attention. For their help with the
reproductions, the National Portrait Gallery would like
to thank Danny Horner, Peter Norman, Juliet French,
Ruth Slaney, Helen Trompeteler, Matthew Wooller,
and Rob King of Altaimage Ltd.

The National Portrait Gallery would also like to thank
Furthermore: a program of the J.M. Kaplan Fund for
their help with funding the reproduction of a number
of images in this publication.

Furthermore:
a program of the J.M.Kaplan Fund

Page 2: Sir Anthony Van Dyck, self-portrait, *c.*1640
(page 85)

FRONT COVER
Top left to bottom right: Newton
(p.95), *Equanimity* (p.281),
Eliot (p.219), Elizabeth I (p.51),
Darwin (p.166), Woolf (p.188),
The Beatles (p.264), Beharry
(p.271), Shakespeare (p.61),
Byron (p.126), Brontës (p.136),
Wilde (p.168), *Self-portrait with
Charlie* (p.275), *Man's Head
(Self-portrait III)* (p.225)

BACK COVER
Top left to bottom right: Chakrabarti
(p.278), Mowlam (p.260), Wintour
(p.262), *Mike's Brother* (p.226),
Vyner Family (p.91), Bowie
(p.235), Grace (p.176), Seacole
(p.154), Princes William and
Henry (p.277), Shrimpton and
Stamp (p.263), Burnaby (p.156),
Bell (p.195), Drake (p.53),
Jonson (p.76), *Choosing* (p.149).

FRONT FLAP
Top left to bottom right: Thomas
(p.208), Holmes (p.280), Nelson
(p.118), *Portrait of A S Byatt: R
Yellow, Green and Blue: 24
September 1997* (p.253), Morris
(p.155), Churchill (p.194),
Strachey (p.193), Hamilton
(p.111), Miller (p.230),
Gainsborough (p.107),
Self-portrait with Fried Eggs
(p.252), Beckett (p.239).

Contents

Foreword

What fired the great essayist Thomas Carlyle to help found the National Portrait Gallery was a belief in the power of inspiration. He knew that men and women, in many and various ways, could be moved to transform the world in which they lived through their intelligence, skills and endeavour. He wanted to understand how people – from politicians to playwrights, and from explorers to engineers – could make positive change, and collecting portraits of them provided a useful starting point for the assessment of their achievements. This idea of human inspiration remains central to the National Portrait Gallery today.

The Gallery's first portrait – the famous 'Chandos' portrait of William Shakespeare, offered by Lord Ellesmere in 1856 – was the perfect example of this central proposition. Shakespeare was not a high-born aristocrat or a courtier but the son of a glove-maker, and although his life is sparsely documented, he was the perfect example of a self-made man. From modest beginnings Shakespeare created Shakespeare; he became the greatest writer in the English language. And his image has an even greater resonance and poignancy given the lack of surviving letters or diaries, which would otherwise be the trace of him.

The Gallery's Victorian founders had a sense of building on the legacy of earlier collectors: portraits of 'worthies' and pantheons of achievement that could be found in published form and had expression in several country house collections in Britain. Certainly the first Director, Sir George Scharf, was determined to create a visual history of Britain. And, as an artist himself, Scharf was also keen to promote an interest in the art of portraiture.

Over the subsequent decades the collections have grown steadily, and with the development of the building in St Martin's Place and a lively programme of displays and loan exhibitions, together with talks, courses and events for schools, young people and families, the Gallery is now a very different institution. Much, however, remains true to the original concept. Primarily, the idea of 'sitter first', with priority given to the achievements and importance of the subject, still dominates the choice of portraits for acquisition. Secondly, although the ground-floor galleries include loan exhibitions, the collections are still laid out in a chronological fashion, from the second floor down, with a number of changing displays that feature a particular focus or a special point of interest. Thirdly, research still underpins the work of Gallery staff, supported now through the work of the Heinz Archive & Library. Fourthly, there remains a devotion to offering clear and helpful information about the collections (now hugely extended through the online resources) as part of the same ethos of public education. And finally, the Gallery, though able to raise more than sixty per cent of annual operating funding through its own enterprise, still benefits hugely from direct support from government as one of the group of outstanding national museums.

* * *

Much has also changed since those early years. The National Portrait Gallery now operates in a very different, media-saturated world, in which photography and digital portraits have become an integral part of its work. The building in St Martin's Place has seen several phases of expansion, culminating in the Ondaatje Wing, which opened in 2000, and the renovation of the Regency in the Weldon Galleries, which was completed in 2003. Each year two million visitors enjoy the collections, exhibitions and activities; during the day, in the evening, and as part of the Gallery's very extensive learning and participation activities. And, importantly, the Gallery's work extends well beyond the walls of its central London building – through its ever-expanding website, national and digital programmes, and its partnerships with the National Trust, with broadcasters and with many other museums and galleries.

The fact that the Gallery regularly commissions new portraits of contemporary figures, sometimes in digital formats, might have astonished our distinguished Victorian forebears. Equally, they might have found surprising the idea of our international portrait competitions and the broader exploration of portraiture alongside other subjects, such as poetry, or in terms of culture, identity and celebrity (a regular part of our thinking today). And what would they make of the Portrait Restaurant with its stunning views across London as part of its attraction? But if they came along one evening and found visitors drawing intently in the galleries, listening to music, debating animatedly in the Ondaatje Wing Theatre or enjoying a drink while exploring the intimacy of the ground-floor rooms, then perhaps they would recognise that this very special institution has an exciting creative future, as well as a fascinating past.

The collections remain at the centre of the Gallery's ambitions, and a selection of key portraits of sitters who have in so many different ways contributed to the history and culture of Britain is presented here. The works featured have been chosen, and are introduced, by the expert curators devoted both to caring for them and extending the inspiration that flows from them.

Sandy Nairne
Director, National Portrait Gallery, London

Introduction

ROBIN FRANCIS

The National Portrait Gallery was founded on 2 December 1856 when the government, under Lord Palmerston, allocated £2,000 (approximately £150,000 nowadays) to a Board of Trustees 'for the formation of a gallery of the portraits of the most eminent persons in British history'. The Trustees comprised thirteen Victorian grandees, and from their number the politician and sometime historian Philip Henry Stanhope, 5th Earl Stanhope, was elected the Gallery's first chairman. This was a fitting reward for the man who, more than any other, and for over a decade, had campaigned for the creation of such a pantheon.

Stanhope's vision was inspired by the establishment of the National Gallery in 1824, and spurred on by cross-Channel rivalry following the opening of a portrait gallery within the new museum at Versailles in 1837. He first suggested 'the propriety of procuring a collection of portraits of eminent men distinguished in the history of this country' to Parliament in 1845,[1] but it was not until his third attempt in March 1856 that his proposal won favour. The Gallery came into being in an era of emergent nationalism: Britain had seen off the threat of Napoleon Bonaparte in 1815 and by mid-century it commanded the largest manufacturing base in the world and a rapidly expanding colonial empire. Bound up with a growing sense of national identity, hero-worship – the cult of personality and celebration of individual achievement – found expression in a proliferation of popular biographies and histories, and a general enthusiasm for visual images, especially portraits. In the words of eminent historian and biographer Thomas Carlyle:

Often I have found a portrait superior in real instruction to half-a-dozen written biographies ... I have found that a portrait was a small lighted candle by which the biographies could for the first time be read, and some human interpretation be made of them.[2]

Thus the National Portrait Gallery, conceived as a gallery of British history, was also a gallery of famous faces from Britain's glorious past.

The Board of Trustees first met on Monday, 9 February 1857 and within a week they had adopted a set of resolutions that defined the criteria for selecting portraits – criteria that have, more or less (with one significant change in the 1960s), governed the Gallery's acquisition policy ever since. It was agreed that sitters should be considered, impartially and without moral judgement, on the grounds of their historical significance and celebrity, and not on the artistic quality or character of a particular portrait. The first portrait to enter the Collection, and thereafter the centrepiece and greatest work among its early attractions, was the so-called Chandos portrait of Shakespeare, offered to the nation by statesman Francis Egerton, 1st Earl of Ellesmere. The press generally welcomed the new institution but was less willing than its Trustees to ignore the moral shortcomings of potential sitters. In 1859 the *Illustrated London News* opined of Nell Gwyn, the famous actress and mistress of King Charles II, that 'it seems somewhat anomalous, somewhat out of keeping' to see her in the company of poet James Thomson and physician Dr Richard Mead.[3]

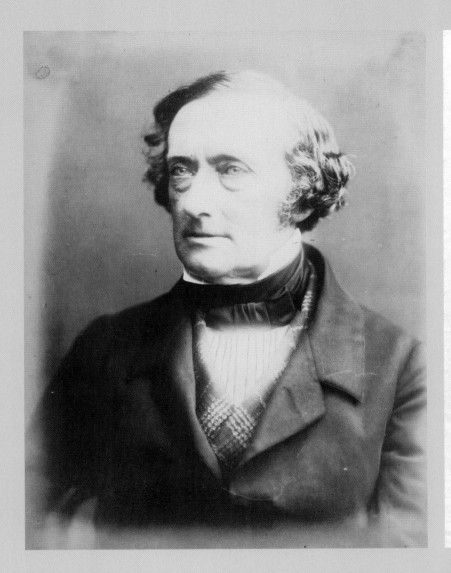

ABOVE

Philip Stanhope, 5th Earl
Stanhope (1805–75), founding
member and first Chairman of
the Trustees of the National
Portrait Gallery. Albumen
print by George Herbert
Watkins, 7 March 1857.
NPG P301(7)

ABOVE

Resolutions concerning the
admittance of portraits into
the Collection of the National
Portrait Gallery approved by
the Board of Trustees at their
second meeting on Monday
16 February 1857.

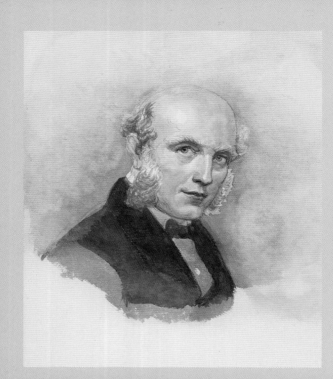

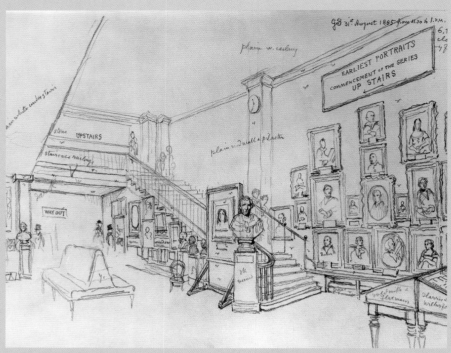

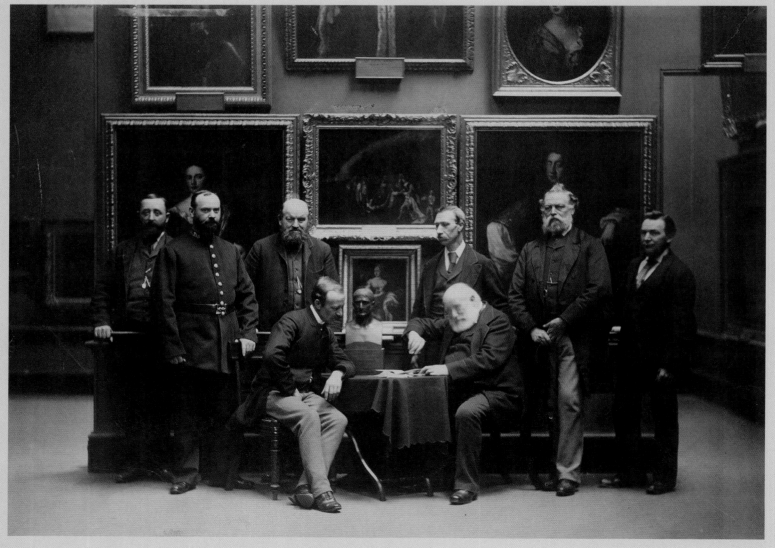

To attend to daily business the Trustees appointed aspiring antiquary and obsessive draughtsman George Scharf as permanent full-time Secretary at a salary of £300 per annum. It fell to Scharf to source potential acquisitions by bringing authentic historical likenesses of significant subjects to the attention of the Trustees. To this end he set about creating a resource specifically for the study of British portraiture and visited country houses and sale rooms around the country to identify, catalogue and sketch portraits. Over the next forty years he would have a profound influence on the fledgling institution, and in 1882, after twenty-five years service, he became, 'without any increase in pay' (as he noted dryly in his diary), Director, Keeper and Secretary.

One of the greatest challenges faced by the Gallery throughout this period was the question of suitable accommodation. Initially it was assigned 'temporary apartments' in an elegant Georgian town house at 29 Great George Street in Westminster. The Collection was allocated two rooms, together with a small back room and the walls of a staircase. As custodian, Scharf lived on the second floor and, from 1860, his mother and aunt occupied rooms above his with their maid, Sarah. However, the house was ill-suited to the purposes of a public gallery. Its cramped conditions meant portraits had to be arranged by size rather than chronologically, and there was nowhere to hang George Hayter's large group painting of the Reformed House of Commons, given by the government in 1859.

This first 'gallery' formally opened to the public two days a week with ticketed entry – tickets obtainable on application from the principal print-sellers of London – in 1859. By this time the Collection numbered seventy portraits and in its first year of opening received 5,305 visitors. In 1860, when quizzed by the Select Committee, Scharf reported that visitors chiefly comprised 'literary people and artists; also a great many ladies'.[4] The Gallery opened specially on the first three days of the Easter week, generally regarded as a holiday among the working classes, and in their annual report of 1863 the Trustees noted that during this period 'many young lads and factory-boys were among the visitors; and … from first to last, every one was quiet and well-behaved'.

By 1869 the Collection comprised 288 portraits and had outgrown its cramped domestic quarters in Westminster. At the end of that year it was moved to wooden buildings in South Kensington, where Scharf was able to arrange it chronologically to provide a continuous narrative of the nation's history. The new rooms opened in March 1870 and the public was admitted six days a week – three free public days (Mondays, Tuesdays and Saturdays) and three private days at a charge of sixpence, the proceeds of which paid for the expense of warming the Gallery and providing police attendance during the night. Visitor figures, in spite of their susceptibility to London weather, leapt from 24,416 in 1869 to 58,913 in 1870 and peaked six years later at 108,252.

Respite, however, was short-lived and to the recurrent problem of space was added the risk of fire, as the Gallery, housed in a wooden building, was overshadowed by the sheds of the India Museum and exposed to the hazards of catering facilities in the adjacent Horticultural Gardens.

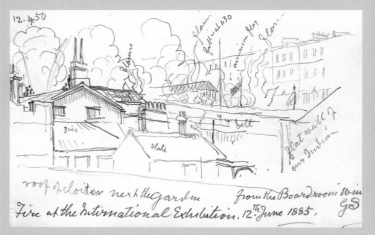

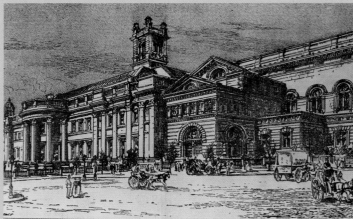

Matters came to a head in June 1885 when an overheated flue ignited the roof of an adjoining building and destroyed a large part of the India Museum next to it. As a matter of urgency, the portraits were removed to the relative safety of Bethnal Green Museum's iron sheds – an unpopular haven, which, in spite of complaints raised in Parliament and the letters pages of the newspapers, remained their home for the next ten years.

In 1889 wealthy philanthropist William Alexander came to the rescue and offered to finance a permanent home for the Gallery. As a condition of his offer, the government was obliged to find a suitable site and earmarked a plot of land wrapped around the back of the National Gallery that was previously occupied by the St Martin's Workhouse. Construction began in 1890 to designs of an eclectic Renaissance nature by ecclesiastical architect Ewan Christian. Scharf remained in post beyond official retirement age to supervise the move from east London, but neither he nor the architect lived to see the completion of the new building.

It was left to Scharf's successor, Lionel Cust, an altogether more worldly and ambitious man, to oversee the final stages of preparation prior to opening in April 1896. Cust planned a predominantly chronological hang on the top floor, with royalty on the landings and other professional classes grouped by room on the lower floors. In total, 1,050 portraits were displayed. The public was admitted free of charge on Mondays, Tuesdays, Wednesdays, Saturdays and, during the summer months, Sunday afternoons. A charge of sixpence was levied on Thursdays and Fridays to deter the general public and allow for free admission by art students and parties of schoolchildren. Opening hours corresponded with seasonal changes in daylight (electric lighting was not introduced until 1935) and were subject to unexpected closures during heavy fogs. In spite of this, almost 169,000 people visited in the first six months – more than the best yearly figure at South Kensington; and by the end of 1896 the Gallery had received nearly 255,000 visitors – an attendance that would not be matched again until 1964.

* * *

The Trustees had achieved one of their primary aims – a purpose-built permanent home in the heart of London – but the Collection was still densely packed. In 1909 Cust was succeeded by the painter Charles Holmes, who recalled in his autobiography that the building was 'singularly ill-adapted to its purposes … the portraits, good, bad and unimportant, were crowded together in monotonous rows, according to size, against a shabby green wall-paper'.[5] He began to respace the paintings, placing the best portraits in the best light, but in 1914 this process was interrupted by the pressing need to protect the Collection 'first against outrage by female agitators for women's suffrage, and later from damage by German aerial attack'.[6] Following a suffragettist assault on the 'Rokeby Venus' by Velazquez next door at the National Gallery, the decision was taken to close temporarily while measures of precaution and defence were considered. In spite of this, in July 1914, the portrait of one of the Gallery's founding fathers, Thomas Carlyle, by John Everett Millais, was attacked by a woman with a butcher's cleaver and, a week after the incident was brought to trial, Austria declared war on Serbia.

With the outbreak of the First World War, the parliamentary grant for purchasing portraits was suspended, as were Holmes's plans for redisplaying the Collection, and, as the threat of enemy attack increased, the Gallery closed. Portraits were removed and the exhibition rooms appropriated by the government's Separation Allowances Department. Male staff were sworn in as special constables – the Director taking duty as Inspector – and the attendants were divided into squads to provide round-the-clock cover. Holmes remained in post until 1916, when he was succeeded by his assistant James Milner. The following year, under his aegis and with the aid of Walter Stoneman of the photographic firm J. Russell & Sons, the

Tuesday. 25 Sepr. 1917.
Returned to duty at the Gallery at 7.30, & twenty minutes later the Constables on the Top Floor reported that they heard Gun-fire. At 8 o'clock the Fire Brigade's notification of enemy's attack was received. Meanwhile the gun-fire in the immediate neighbourhood was considerable, & several attendants thought that they could distinguish the sound of exploding bombs. This attack lasted for about 15 minutes." Normal conditions" 9.20.
 James D. Milner

Friday. 28th Sepr. 1917.
8 pm. Received notice that enemy were attacking. Admitted
from Lion's 122 persons (soldiers, sailors, ladies & civilians), of
Y.M.C.A.) which number 4 soldiers wished to leave a few

National Photographic Record, which ran for more than fifty years, was set up to record the likeness of eminent figures, most of them men, drawn from defined categories and professions. At the end of the war, and as a memorial to it, three paintings, commissioned by Sir Abe Bailey, were presented to the Gallery. These represented Naval Officers by Sir Arthur Cope, General Officers by John Singer Sargent and Statesmen by Sir James Guthrie.

Halted in its tracks by the war, the Gallery in the ensuing peace focused on the refurbishment and phased reopening of the exhibition rooms, which began with the top floor and landings in April 1920. Two years later it inaugurated a modest programme of afternoon lectures. In 1923 a short-lived scheme to introduce extra paying days saw visitor numbers fall by nearly 40,000. Displays of recent acquisitions had become a regular feature by the end of the 1920s, and for the centenary of the death of Sir Walter Scott in 1932 a small exhibition was arranged. However, these small steps were unequal to encroaching external forces: the advance of modernism and the drift away from figurative representation; the emergence of art history as an academic discipline; and the impact of technological advances in photography and film, which provided alternative means of capturing likenesses. In a fast-changing world the Gallery's acquisition and display policies seemed increasingly conservative.

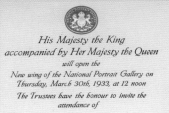

His Majesty the King
accompanied by Her Majesty the Queen
will open the
New wing of the National Portrait Gallery on
Thursday, March 30th, 1933, at 12 noon
The Trustees have the honour to invite the
attendance of

A reply to this invitation is requested by Morning Dress
March 1st in order that cards of admission
may be sent to all who accept.
This invitation will not admit

ABOVE
Invitation to the royal opening on 30 March 1933 of the new wing of the National Portrait Gallery, funded by Sir Joseph Duveen and named after him.

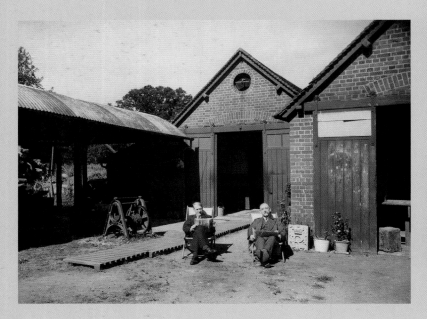

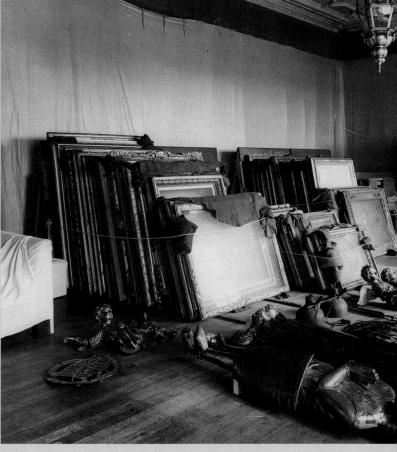

ABOVE AND RIGHT
During the Second World War the majority of the Gallery's Collection was stored at Mentmore for safe-keeping: the portraits were removed from their frames and stored on racks in outbuildings, and the frames were stacked in the billiard room. Living quarters were equipped with bunk beds, electric cooker and a stove for heating so that Gallery staff could stay on site to guard the portraits. The men worked a rota of two weeks at Mentmore and two weeks in London. Unknown photographer, 1943.

In 1927 Henry Mendelssohn Hake, 'Imperial Hake' as he became known, was appointed Director and presided over the Gallery until 1951 with great authority and a sweeping dislike of many classes of people. The Collection had doubled in size since it moved into St Martin's Place thirty years previously and portraits were crowded together wherever space permitted. To relieve the congestion, in 1928 art dealer Sir Joseph Duveen offered to defray the entire cost of an extension on a small plot of land to the west of the main building. Named in his honour, the Duveen Wing was planned by Hake with help from the painter Sir James Guthrie, who previously directed the re-building of the interiors of the Scottish Academy Galleries in Edinburgh, and was duly opened in March 1933.

With the threat of further conflict in Europe looming, official meetings were held as early as 1933 to discuss the protection and removal of valuable objects from London. Thus prepared, when war was declared in September 1939, the Gallery was ready to close immediately and 1,457 pictures were removed to the safety of outbuildings at Lord Rosebery's Buckinghamshire home, Mentmore. They were accompanied by four guards, who soon settled to rural life, preparing a vegetable garden and, later on, keeping chickens. Meanwhile, back in London, the Gallery building at St Martin's Place was twice struck in air raids, but suffered no major structural damage.

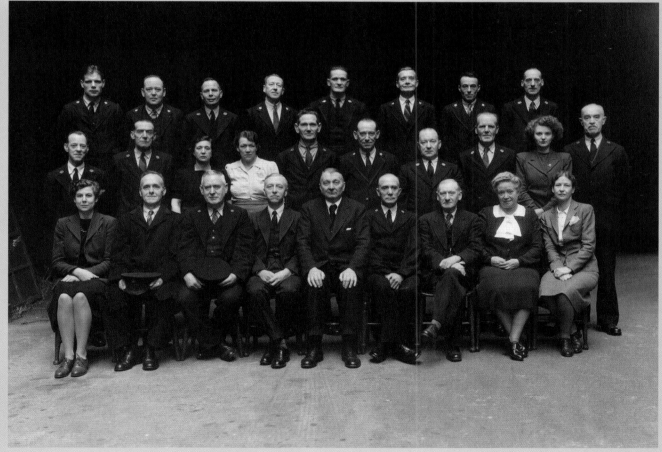

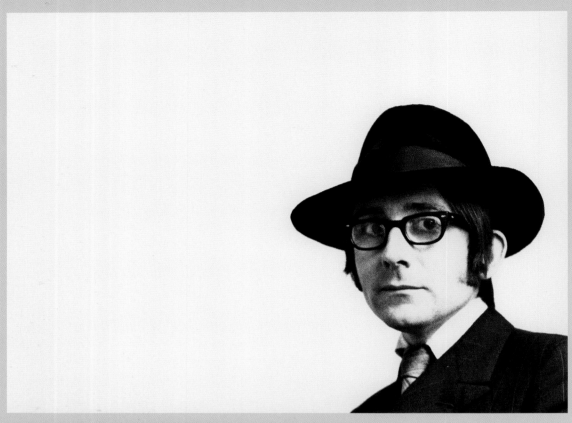

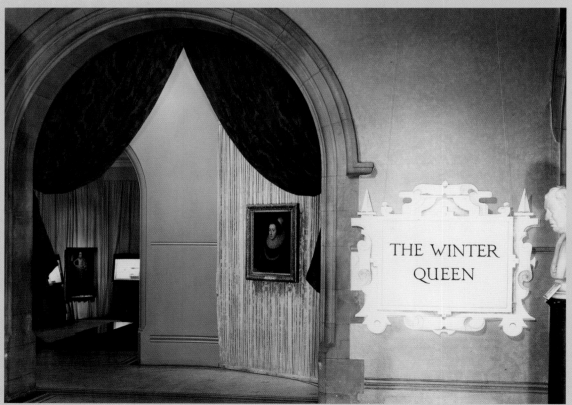

THE WINTER
QUEEN

Sir Roy Strong (b.1935),
Director of the National
Portrait Gallery 1967–73.
Bromide print by Godfrey
Argent, 1969. NPG X32550

Entrance to *The Winter Queen:
Elizabeth of Bohemia and Her
Family* (1963), which was the
first fully designed exhibition
held at the Gallery and
heralded a new approach
to display that transformed
the institution over the next
decade. By an unknown
photographer, 1963.

In July 1945 the Gallery formally reopened with an exhibition of newly acquired portraits of members of the famous Kit-Cat Club, made possible with the help of the National Art Collections Fund. Henry Hake died in post in 1951 and was succeeded by the benign and unassuming Charles Kingsley Adams, who had worked in his shadow for more than thirty years. Post-war refurbishment dominated the next decade and it was not until 1956 that the rebuilding and redecoration was virtually complete – although the underlying ethos remained unchanged and still reflected the fundamentally Victorian function of the Gallery.

* * *

The post-war years at the Gallery have been described as quiet and scholarly[7], or, according to Sir Roy Strong, 'years of lost opportunity'.[8] However, new attitudes to popular history, particularly interest in social and local history, were beginning to influence museum interpretation, and in 1964 the government's seminal white paper *A Policy for the Arts: The First Steps* emphasised the interdependence between the arts and education. David Piper became Director in 1964 and, aided by his dynamic young assistant Roy Strong, introduced a pioneering series of Collection catalogues and undertook 'to reveal this incomparable gallery of British portraits not only as monuments and memorials but as integral in the living, ever continuing texture of the history of Britain'.[9] The exhibition *The Winter Queen: Elizabeth of Bohemia and Her Family*, curated by Strong, was the first fully designed show mounted by the Gallery and an early indication of intent. For the first time since 1896 annual visitor figures exceeded 200,000.

Piper's short directorship marked an important transition before Strong took over in 1967 and propelled the Gallery forward by addressing head-on current and popular themes largely ignored by his predecessors. His appointment was in many respects the most significant since that of Scharf in 1857. He planned an audacious series of professionally designed exhibitions and revolutionised the displays, which became more didactic and evocative with the inclusion of supplementary contextual material to enhance the presentation of themes and periods. In 1968 Thomas Hudson's painting of George Frideric Handel became the first portrait purchased by public appeal. Two years later an Education Department was established and celebrity events were staged, including lunchtime readings by famous actors in the 'People Past and Present' series.

Strong recognised the increasingly important role of photography, hitherto neglected, and in 1968 he mounted the first photographic exhibition to be held at the Gallery, *Beaton Portraits 1928–68*, which attracted unprecedented press interest and drew 76,000 visitors. It demonstrated the popularity of living sitters and prompted the systematic collecting of photographs by the Gallery. The rise of celebrity culture in television and popular music in the 1960s created new icons, and the acquisition policy needed to change to reflect this. In response, the specific rule that 'no portrait of any person still living, or deceased less than ten years, shall be admitted by purchase, donation, or bequest, except only in the case of the reigning Sovereign, and of his or her Consort' was overturned.

NEW 20th CENTURY GALLERIES

Makers of modern Britain: portraits, video and changing exhibitions

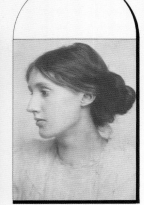

Inaugural Exhibition:

Paul McCartney:
new portrait by Humphrey
Ocean

And pictures made on the
1976 Wings tour

3 February to 29 April 1984
(closed Good Friday)

Paul McCartney by Humphrey Ocean, winner's
commission, Imperial Tobacco Portrait Award 1982

NATIONAL PORTRAIT GALLERY

St Martin's Place WC2 Telephone 01-930 1552
Admission free Open daily

In 1974 John Hayes became Director, and over the next twenty years sought to build on the radical reform introduced during Strong's whirlwind term. At the same time, he gradually moved away from prescriptive display ideas in which historical context was emphasised, and introduced a more formal hang, giving greater prominence to aesthetic considerations. The Gallery began to look beyond St Martin's Place and was one of the first national museums to establish a permanent presence outside London when, in 1975, it entered into partnership with the National Trust at Montacute House in Somerset to display a substantial loan of sixteenth- and seventeenth-century portraits. Collaborations with Beningbrough Hall in Yorkshire, an appropriate setting for late seventeenth- and eighteenth-century portraits, and Bodelwyddan Castle, Denbighshire, where more than 100 portraits from the nineteenth-century collections are displayed, followed in 1979 and 1988.

To stimulate the contemporary collection, in 1980 Hayes launched an innovative programme to commission portraits of living sitters, a policy that over the years has helped transform the Gallery's holdings with numerous high-profile acquisitions. This coincided with the inauguration of an annual portrait award competition for painters (the Imperial Tobacco Award and now the BP Portrait Award), which encouraged young artists to take up the challenge of portraiture and has since become one of the most popular annual events in the Gallery's calendar. The success with which the Gallery has championed contemporary painted portraiture through the annual BP Portrait Award has been matched since 1991 by the John Kobal Photographic Portrait Award, now the Taylor Wessing Photographic Portrait

Prize. New twentieth-century galleries opened in 1984. A solution to the ongoing problem of lack of display space presented itself three years later when the government purchased two properties on Orange Street for the Gallery. An appeal was launched for a development plan to create a research centre, education and conservation studios, and release as much space as possible in the main building for public exhibition. Mrs Drue Heinz generously funded the new Archive & Library, which opened to the public in November 1993, housed in the once-fashionable restaurant and club Ciro's.

John Hayes retired in 1994 and was succeeded by Charles Saumarez Smith, who oversaw the final transformation of the Gallery from traditional to contemporary institution. Since the mid-1990s the ground-floor rooms have been used for a lively programme of changing displays drawn from the contemporary collection. In 1996 the galleries on the first floor were redesigned: the original teak panelling was reclaimed in the Victorian galleries. With more than one million visitors a year by the mid-1990s, an ambitious plan was launched to make use of an unused space between the Gallery and its neighbour, the National Gallery, to radically improve facilities. Architects Jeremy Dixon and Edward Jones designed a new café and bookshop, which opened at an advanced stage of the project in 1998, and a five-storey extension that provided an impressive new entrance hall, lecture theatre, galleries and roof-top restaurant, all linked by a huge escalator. The Ondaatje Wing, named after the major donor Sir Christopher Ondaatje, was opened by Queen Elizabeth II in May 2000. Two years later, a significant exhibition of portraits by photographer Mario Testino marked a further turning point – when an institution devoted to achievement in British culture and history recognised the power and place in the modern world of popular celebrity in all its glamour and ephemerality.

Under the directorship of Sandy Nairne, who was appointed in 2002, the Gallery has continued to steer an outward-facing course – nationally, internationally and digitally – and by broadening its range of acquisitions and exhibitions it has sought to engage with new and more diverse audiences of all ages. In 2003, the renewal of the top-floor Regency Galleries (renamed the Weldon Galleries after benefactors Jane and Anthony Weldon) completed the programme to transform the permanent galleries that was begun by Charles Saumarez Smith. This was followed, as part of its wider remit, by the renewal of the displays at Beningbrough Hall, Montacute House and Bodelwyddan Castle, and the establishment of strategic partnerships with two regional museum networks.

The 150th anniversary of the Gallery in 2006 provided an opportunity to launch an appeal to build a Portrait Fund to support future major acquisitions and, at the same time, £1.6 million was raised by public appeal to buy a portrait of the poet John Donne. In 2007 a major research project, *Making Art in Tudor Britain*, was begun, using the latest scientific techniques to investigate early painting practice and the production of portraits in the Tudor and Jacobean periods. A year later the Gallery received a significant gift from the Lerner Foundation to help build up the Portrait Fund and to enrich research, display, digitisation, educational and outreach programmes.

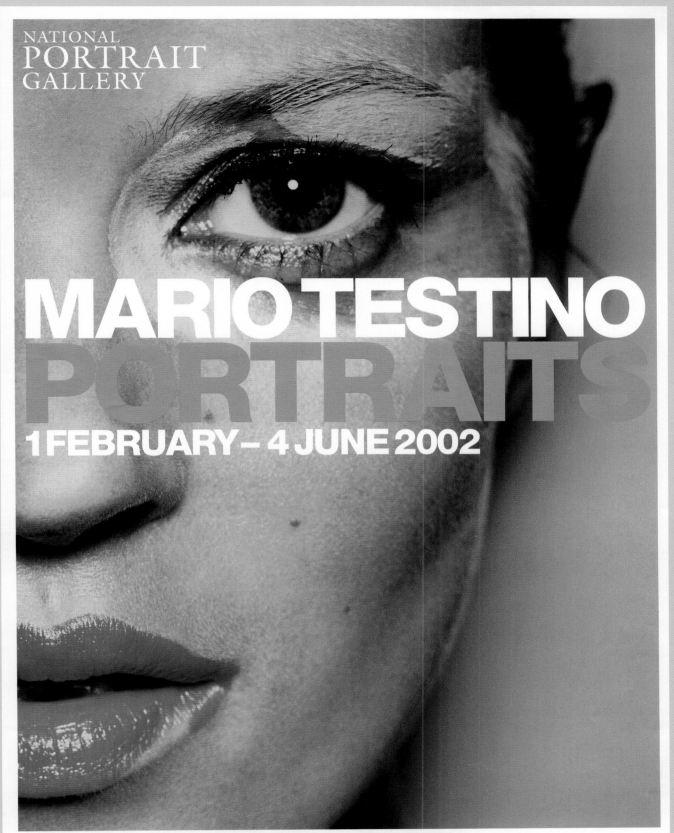

NATIONAL
PORTRAIT
GALLERY

MARIO TESTINO
PORTRAITS
1 FEBRUARY – 4 JUNE 2002

TICKETS £6/£4 ADVANCE BOOKING RECOMMENDED
TICKETMASTER 0870 241 3034 (NO BKG FEE) WWW.NPG.ORG.UK/TESTINO
LATE NIGHT OPENING THURSDAY & FRIDAY UNTIL 9PM ⊖LEICESTER SQUARE
Sponsored by BURBERRY & *Dom Pérignon* in association with VOGUE

Kate Moss, National Portrait Gallery, 2001, London ©Mario Testino

BELOW

The year 2012 was highly significant. Not only did it mark the Queen's Diamond Jubilee and the Olympic and Paralympic Games in London, but it was a landmark in the history of the Gallery. With the outstanding *Lucian Freud Portraits* exhibition, the ever-increasing popularity of the BP Portrait Award, and the success of the *Road to 2012* project with BT, for the first time the Gallery attracted over two million visits.

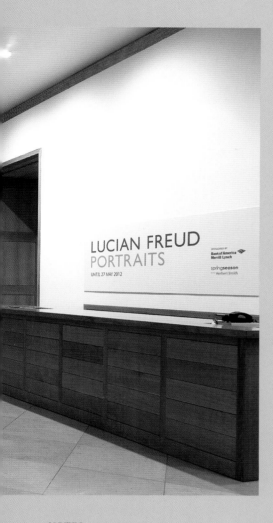

In recognition, the ground-floor galleries displaying contemporary portraits were renamed the Lerner Galleries. The year 2012 was outstanding, being the year in which the BT *Road to 2012* project (part of the Cultural Olympiad) culminated in an extraordinary photographic record of those who had contributed to the success of the London Olympic Games; and, reflecting her personal interest in the arts and the education of young people, the Duchess of Cambridge became Patron of the National Portrait Gallery.

Since 2006 the Gallery has mounted a succession of landmark exhibitions devoted to some of the great names in contemporary British portraiture: *David Hockney Portraits*, which was produced in close collaboration with the artist, in 2006–7; the critically acclaimed *Lucian Freud Portraits*, which attracted 246,801 visitors in 2012; and *Bailey's Stardust* in 2014, a major exhibition of portraits by one of the world's most distinguished photographers, David Bailey.

As the Gallery looks to the future and the challenges ahead, not least the increasing need to support itself through self-generated income and the generosity of external partners, it does so from a position of strength. Through working with a range of supporters, from Members to Patrons, Portrait Circle and major donors, and from corporate sponsors to charitable trusts and foundations, fundraising activity is an established and successful aspect of the Gallery's work. The Primary Collection numbers nearly 12,000 portraits in all media, and strains at the conventions of portraiture. And in 2014, following the success of our largest ever appeal, which raised ten million pounds, the Gallery was able to purchase a portrait of extraordinary importance: a self-portrait of the painter Anthony Van Dyck. This acquisition gained remarkable support from a large number of individuals, trusts and foundations, and the public at large – a sure indicator of the institution's place within Britain's cultural heritage. The Gallery is counted among London's most popular attractions, with annual visitor figures above two million. Through its website, which receives more than 3.5 million virtual visits a year, it provides digital access to more than 200,000 works across its vast holdings. And, through its exhibition, outreach, learning and research programmes, it engages with confidence in debates around celebrity, identity and inclusion. The constraints of space will forever be a challenge to dynamic and ambitious institutions, but the Gallery is already planning the next phase of its development – to release its full potential to engage and excite audiences well into the twenty-first century.

NOTES

1. *Hansard*, Commons, 27 June 1845, col.1338.

2. From a letter written by Thomas Carlyle and quoted by Lord Stanhope during the debate in the House of Lords on 4 March 1856. *Hansard*, Lords, 4 March 1856, col.1772.

3. Gertrude Prescott 'Portraits for the Nation', *History Today*, vol.39, no.6, June 1989, p.34.

4. Reported to the 1860 Select Committee on Public Institutions. Jonathan Conlin, 'Poor relations: the National Portrait Gallery and how the English see themselves', *Times Literary Supplement*, 11 January 2008, p.15.

5. Charles Holmes, *Self and Partners (Mostly Self) being the Reminiscences of C.J. Holmes* (London, 1936) p.267.

6. *Fifty-Eighth Annual Report of the Trustees of the National Portrait Gallery*, 1914–15, p.3.

7. David Piper, unpublished typescript autobiography, ch.8, p.46.

8. Roy Strong, 'The National Portrait Gallery: the missing years', *The British Art Journal*, vol.IV. no.2, Summer 2003, p.79.

9. National Portrait Gallery, *Annual Report of the Trustees*, 1964–5, p.7.

Chronology

1856	National Portrait Gallery founded with a government grant of £2,000; portrait of William Shakespeare is first work to be acquired for the Gallery's Collection.
1857	George Scharf appointed first Secretary (later Director).
1859	Gallery opens in Westminster with ticketed entry and receives more than 5,000 visitors.
1870	Gallery reopens after move to South Kensington and receives more than 50,000 visitors.
1876	Visitor figures exceed 100,000.
1885	Threat of fire leads to emergency removal of portraits to Bethnal Green.
1889	William Henry Alexander offers to fund a new building in St Martin's Place.
1895	Lionel Cust becomes Director.
1896	Gallery opens at St Martin's Place and receives more than 200,000 visitors.
1909	Charles Holmes becomes Director.
1915	Gallery closes as precaution against 'German aerial attack' during First World War.
1916	James Milner becomes Director.
1917	National Photographic Record set up to record distinguished living men and women.
1920	Portraits reinstated after the war and Gallery reopens.
1921	Naval Officers by Sir Arthur Cope is first of three great portrait groups acquired to memorialise the end of the war.
1927	Henry Hake becomes Director.
1932	Portrait of Mrs Beeton is first portrait photograph acquired for the Collection.
1933	Gallery's new wing, funded by Sir Joseph Duveen, opens.
1939	Gallery closes and portraits removed at outbreak of Second World War.
1945	Gallery reopens after the war with display of newly acquired Kit-Cat Club portraits by Sir Godfrey Kneller.
1951	Charles Kingsley Adams becomes Director.
1963	*The Winter Queen: Elizabeth of Bohemia and Her Family* is first major exhibition staged by the Gallery.
1964	David Piper becomes Director.
1966	Visitor figures exceed 250,000.
1967	Roy Strong becomes Director.
1968	*Cecil Beaton Portraits 1928–68* is first photographic exhibition staged by the Gallery; George Frideric Handel by Thomas Hudson is first portrait acquired by public appeal.
1969	Rules governing acquisition of portraits changed to admit living sitters to the Collection.

1970	Portrait of Queen Elizabeth II by Pietro Annigoni unveiled; visitor figures exceed 500,000.
1974	John Hayes becomes Director.
1975	Gallery's first regional partnership opens at Montacute House, Somerset.
1979	Second regional partnership opens at Beningbrough Hall, Yorkshire.
1980	Inauguration of annual Portrait Award competition, sponsored by Imperial Tobacco; commissioning programme launched with new portrait of Prince Charles by Bryan Organ.
1984	Twentieth-century galleries open.
1988	Third regional partnership opens at Bodelwyddan Castle, North Wales.
1990	BP becomes sponsor of annual Portrait Award competition.
1993	Development plan completed with opening of Clore Education Studio and Heinz Archive & Library.
1994	Charles Saumarez Smith becomes Director; annual visitor figures exceed 1 million.
2000	New extension completed, funded by the Heritage Lottery Fund and major donors including Sir Christopher Ondaatje, opened by Her Majesty The Queen.
2001	Marc Quinn's DNA portrait of geneticist Sir John Sulton purchased.
2002	*Mario Testino Portraits* exhibition attracts record visitor numbers; Sandy Nairne becomes Director.
2003	Portrait of Omai by William Parry purchased jointly with Captain Cook Memorial Museum, Whitby, and the National Museums & Galleries of Wales; visitor figures exceed 1.5 million.
2006	Public appeal raises £1.6 million for acquisition of portrait of poet John Donne. As part of its 150th anniversary celebrations, the Gallery stages *David Hockney Portraits: Life Love Art*, hosts the first Portrait Gala and launches the Portrait Fund.
2007	Gallery begins ground-breaking *Making Art in Tudor Britain* research project.
2008	Gallery embarks on major programme to enhance digitisation, education and outreach with funding from the Lerner Foundation; ground-floor galleries renamed Lerner Galleries.
2012	The Duchess of Cambridge becomes the Gallery's Patron; *Lucian Freud Portraits* exhibition achieves record attendance and visitor figures exceed 2 million.
2014	*Bailey's Stardust* presents retrospective of internationally renowned photographer David Bailey; Van Dyck's final self-portrait acquired by public appeal and with support from the Heritage Lottery Fund, the Art Fund, the Portrait Fund, The Monument Trust, the Garfield Weston Foundation and several major individual supporters.

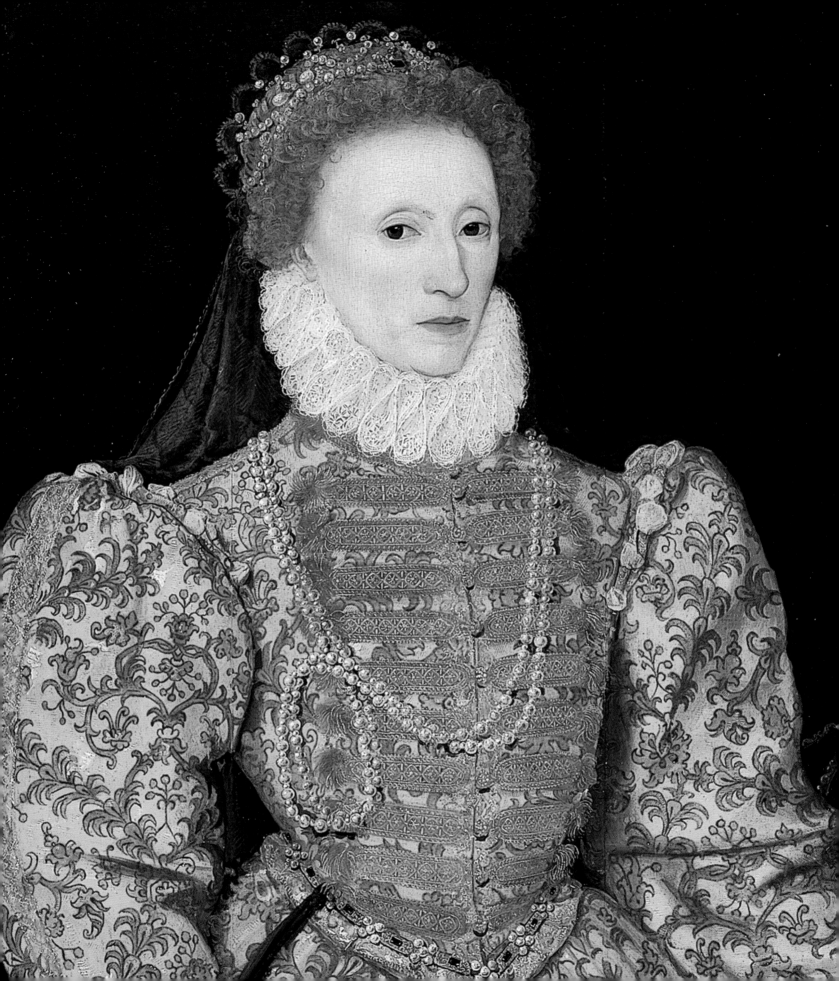

CHAPTER I

Tudor Portraits

1485–1603

OPPOSITE
QUEEN ELIZABETH I
UNKNOWN CONTINENTAL ARTIST,
*c.*1575 (DETAIL OF PAGE 51)

The Tudor period takes its name from the family of five monarchs who reigned in England and Wales from 1485 to 1603. It began when the armies of Henry Tudor (descended from the House of Lancaster) defeated Richard III (descended from the House of York) at the Battle of Bosworth Field in 1485. The two warring factions of Lancaster and York were then united when Henry, by now King Henry VII, married Elizabeth of York. The dynasty they founded was taken forward by their son Henry VIII, whose three surviving children, Edward, Mary and Elizabeth (all from different marriages), ruled successively as monarchs.

This was a period of dramatic change; there was a reformation in religion in England and Wales, the Church of England was established, the Bible was published in English for the first time, and the country became a significant maritime power. This era also saw important social and cultural changes, not least a flowering of literary talent, with playwrights and poets, including William Shakespeare, beginning their careers at this time. The geographic boundaries of the nation were being contested, and the Tudors considered themselves rulers of England, Wales, Ireland and a part of France. Scotland was still a separate country ruled by the Stuarts.

Portraits painted as framed, portable objects became popular in Italy, France, the Netherlands and other parts of Europe in the 1400s, but it was not until the 1500s that the fashion for portraiture took off in Britain. The earliest painting in the National Portrait Gallery's Collection depicts Henry VII (page 31) and was painted as part of a royal marriage negotiation in 1505. Portraits were painted during this period for a variety of reasons, such as the desire to enhance the sitters' status or to document a significant moment in time (for example, a marriage, death or the receipt of a particular honour). They were also produced to provide a memento to loved ones and for posterity, or simply to create a decorative scheme within an architectural setting. Many surviving portraits of Tudor monarchs are versions or copies of the original designs taken from the life, and such copies were produced to meet a lively demand among nobility, gentry and wealthy citizens who wished to demonstrate their loyalty to the Crown. For some, an interest in history led to the desire to document family lineage; for others, a portrait might convey particular sentiments, or tell personal stories, as in the extraordinary narrative painting of Henry Unton (pages 56–7), which features scenes from his life.

The portraits in the sixteenth-century collection depict mainly monarchs and courtiers, but also explorers and poets such as Sir Francis Drake (page 53) and the young writer John Donne (page 58) – and slowly, over the course of the 1500s, many men and women outside the influence of the royal court also began to commission their likeness. Portrait formats also changed over the period, with

full-length images becoming more popular from the 1590s, particularly as the use of canvas (rather than wooden panel) became more common. Representation could also be playful, and an advertisement for an artist's skill, as in the cleverly elongated portrait of Edward VI (page 40) in which the distorted perspective is corrected when seen from the side. Portrait miniatures were popular among the wealthy and first appeared in the 1520s in the courts of England and France. They are one of the most intimate art forms, designed to be seen, as the miniaturist Nicholas Hilliard commented 'in [a] hand near unto the eye', and could also be worn or carried in a pocket, or stored in a cabinet at home.

In the 500 years since these portraits were painted, much information about who painted them, where they were displayed and why they were painted has been lost. Native English painters of the time were considered to be relatively humble artisans and rarely signed their pictures. Sometimes several painters from the same studio would complete one picture, making it difficult to attribute works to particular artists. English painters also faced competition from talented foreign artists who settled in England to work for the court. The German artist Hans Holbein the Younger worked here for over twelve years (from 1532) and his remarkable portrait of Henry VIII (seen in the original drawn design, page 36) helped to characterise this all-powerful (and arguably tyrannical) monarch for posterity. In the later 1500s many of the best artists working in England were from the Netherlands, such as Hans Eworth, who painted Mary I and the double portrait of Lady Dacre with her son (page 44). The style adopted by English artists during Elizabeth I's reign was also distinctive for its bold outlines and emphasis on surface pattern and texture. This was partly due to a lack of training in perspective, as few would have learnt this skill during their apprenticeship.

Recent developments in techniques of examination, such as dendrochronology (a method of dating panel paintings using tree rings), x-radiography and infrared reflectography (a technique used to observe the layers beneath the paint surface), continue to inform – and sometimes transform – our knowledge of how portraits were painted. Occasionally such examination, and conservation treatment, reveals new information, such as an artist's signature, as in the portrait of Mary I (page 43) or an original symbol in the portrait of Sir Walter Ralegh (page 54), elements that had been previously obscured or lost. The National Portrait Gallery holds the largest public collection of Tudor portraits in the world, and this new research continues to inform our understanding of the visual culture in the English Renaissance.

Tarnya Cooper

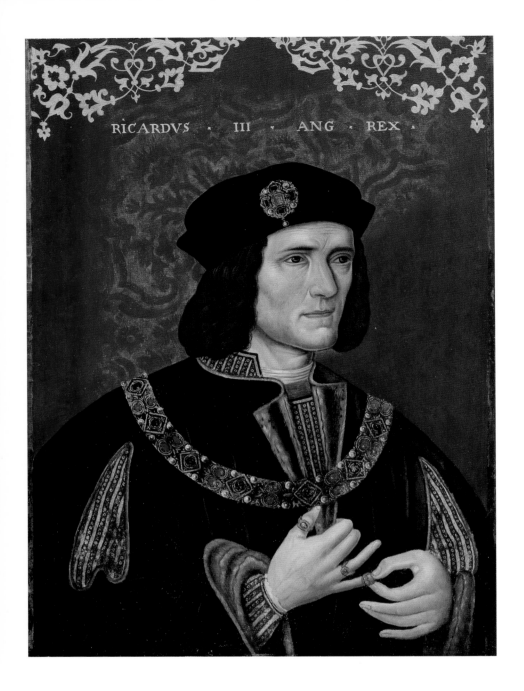

RICARDVS · III · ANG · REX ·

KING RICHARD III
(1452–85)
UNKNOWN ENGLISH ARTIST, LATE 16TH CENTURY,
AFTER A PORTRAIT OF THE 15TH CENTURY
Oil on panel
638 x 470mm

The last king of England from the House of York, Richard III ruled from 1483 until his death two years later, slain by Henry Tudor at the Battle of Bosworth Field. Richard's coronation followed the disappearance of Edward V (then a minor) and his brother Richard of Shrewsbury, Duke of York, from the Tower of London.

This portrait was not painted from life but made in the late sixteenth century, more than 100 years after Richard's death. The likeness was probably copied from an original drawing or painting (now lost). The date of this portrait has recently been confirmed by tree-ring dating of the oak panel.

In 2013 a skeleton recovered from the site of Grey Friars Church, Leicester, was formally identified as that of the King. NPG 148

KING HENRY VII
(1457–1509)
UNKNOWN FLEMISH ARTIST, DATED
1505
Oil on panel
425 x 305mm

This impressive portrait is the earliest painting in the National Portrait Gallery's Collection and the earliest surviving portrait of this king. Henry VII was the son of Edmund Tudor and head of the House of Lancaster (signified by the red rose he holds in this portrait). His victory over the Yorkist king, Richard III, at the battle of Bosworth Field in 1485 saw the start of the Tudor monarchy. His marriage to Elizabeth of York united the previously warring factions of Lancaster and York. His reign was characterised by his desire for political control and the considerable wealth he brought to the Crown.

The inscription on the portrait records that it was commissioned on 29 October 1505 by Herman Rinck, an agent of Emperor Maximillian I, as part of the marriage negotiations between Henry and the Emperor's daughter, Margaret of Austria, Dowager Duchess of Savoy. The marriage did not take place; however, the portrait remained in the Duchess's collection.

The panel and arched frame are made from one single piece of wood. Documentary evidence suggests that this picture once had a red painted cover. NPG 416

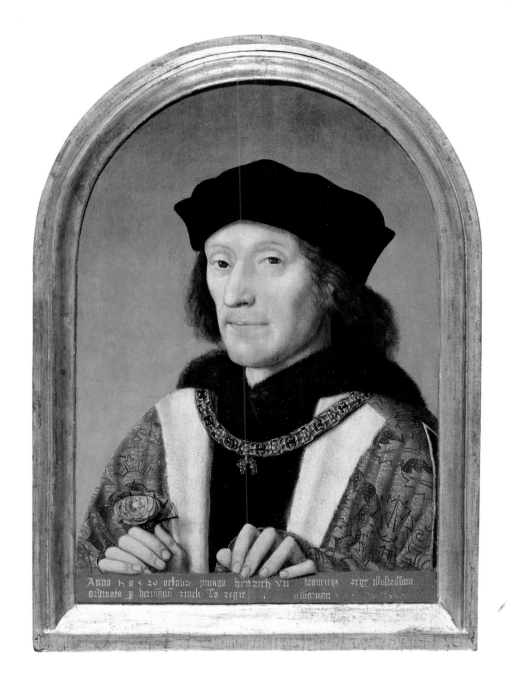

KING HENRY VIII
(1491–1547)

UNKNOWN ANGLO-NETHERLANDISH
ARTIST, *c.*1520
Oil on panel
508 x 381mm

The reign of Henry VIII, who
succeeded his father to the throne
in 1509, aged seventeen, would
dramatically change the course of
English history. Notorious for his
six marriages, Henry rejected the
authority of the Pope in Rome,
dissolved the country's religious
houses, and established himself
as head of the Church in England.
This painting pre-dates the Holbein
portrait type of Henry that is now
so familiar (page 36), and was
produced when the young king was
married to his first wife, Katherine
of Aragon. It suggests something
of the King's noted athleticism and
magnificent dress.

Henry is posed removing a gold
ring from the little finger of his
right hand. Extensive underdrawing,
visible in infrared light, shows
that the shape of Henry's face
was changed during painting and
was originally closer to existing
likenesses of his brother Arthur,
and of his father Henry VII. The
green damask background and
gilded corners suggest that this
work may have had a companion
portrait and it is possible that the
composition was intended to be
displayed alongside a portrait of
Katherine of Aragon (opposite).
The frame shown here is not
original. NPG 4690

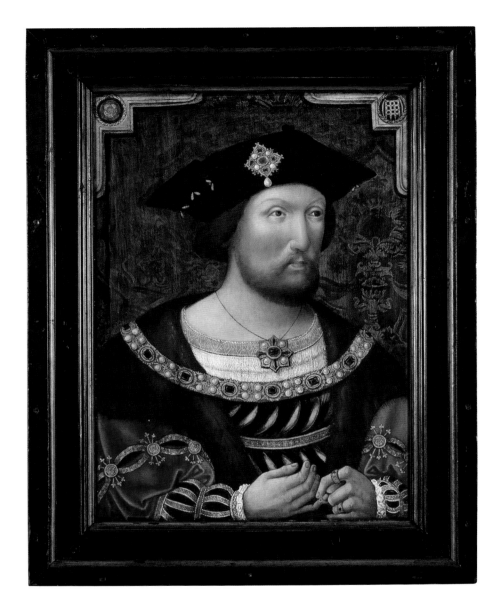

KATHERINE OF ARAGON
(1485–1536)

UNKNOWN ANGLO-NETHERLANDISH
ARTIST, *c.*1520
Oil on panel
520 x 420mm
Lent by Church Commissioners
for England, 2011

Katherine was the youngest
daughter of the Roman Catholic
monarchs Ferdinand of Aragon
and Isabella of Castile. She came
to England in 1501, at the age of
fifteen, to marry Arthur, Prince of
Wales, but only months after the
marriage Arthur died. In 1509 she
married Arthur's younger brother
Henry VIII. They had five children,
of whom only Princess Mary, later
Mary I, survived. Katherine died in
1536, firm in her refusal to give up
her title as Queen, despite Henry
VIII's marriage to Anne Boleyn
in 1533.

This rare early portrait of
Katherine – for many years
misidentified as Katherine Parr –
is on long-term loan to the Gallery
from Lambeth Palace. Recent
conservation treatment uncovered
a bright green background,
patterned to imitate damask silk,
like that in the portrait of Henry
VIII (opposite). Unusually, the
portrait remains in its original
frame, the red frieze section of
which has been recently restored,
providing a sense of how important
early Tudor pictures were
presented. NPG L246

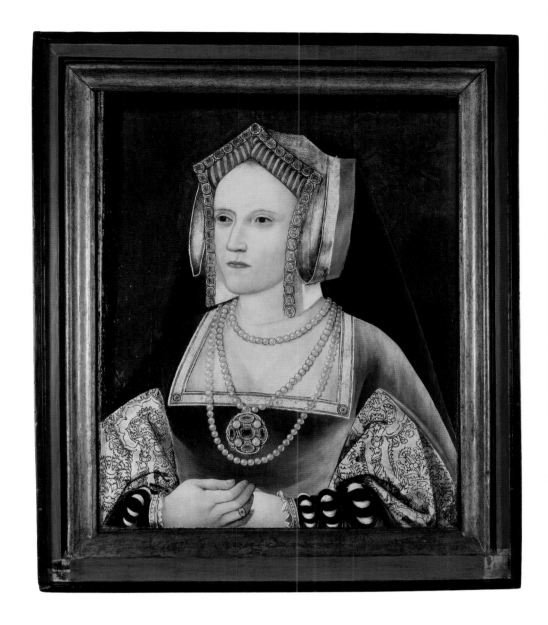

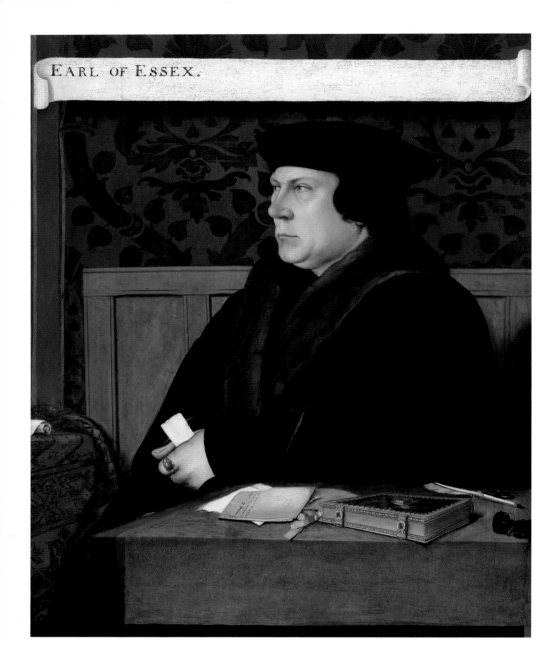

EARL OF ESSEX.

THOMAS CROMWELL, EARL OF ESSEX
(c.1485–1540)
AFTER HANS HOLBEIN THE YOUNGER, EARLY 17TH
CENTURY AFTER A PORTRAIT OF c.1532–3
Oil on panel
781 x 619mm

The principal architect of the annulment of Henry VIII's marriage to Katherine of Aragon and the subsequent break with Rome, Thomas Cromwell was a statesman who rose to power as the right-hand man of Cardinal Wolsey. A brilliant administrator and legal and evangelical reformer, he later negotiated Henry's fourth marriage to Anne of Cleves. The failure of this enterprise, and accusations of treason, led to his execution.

After he had become Master of the Jewels in 1532, Cromwell sat to Holbein the Younger (1497/8–1543). Recent technical analysis confirms that this portrait is an early seventeenth-century version of an original by Holbein in the Frick Collection, New York. This painting belonged to Cromwell's descendants and was probably produced either when the original portrait was sold, or for display in a different family property.
NPG 1727

ANNE BOLEYN
(*c.*1500–36)

UNKNOWN ENGLISH ARTIST, LATE
16TH CENTURY AFTER A PORTRAIT
OF *c.*1533–6
Oil on panel
543 x 416mm

Anne Boleyn became Queen of England as the second consort of Henry VIII in 1533. She spent part of her early life abroad, at the court of Margaret of Austria, and as a member of the household of Queen Claude of France. When she later joined the court of Henry VIII she was distinguished by her Continental education and interest in music and fashion. Her affair with Henry began in 1526 and the couple married in secret in 1533, shortly before the King's marriage to Katherine of Aragon was annulled. Later that year their daughter, the future Elizabeth I, was born. In 1536 Anne was charged with adultery and incest and executed for treason.

This portrait is a late sixteenth-century version based upon a type made of Anne when Queen, and now lost. This portrait may have once belonged to a set of kings and queens that displayed portraits in chronological sequence. Contemporary descriptions suggest Anne was of a dark complexion with a long neck, dark hair and 'black and beautiful' eyes. NPG 668

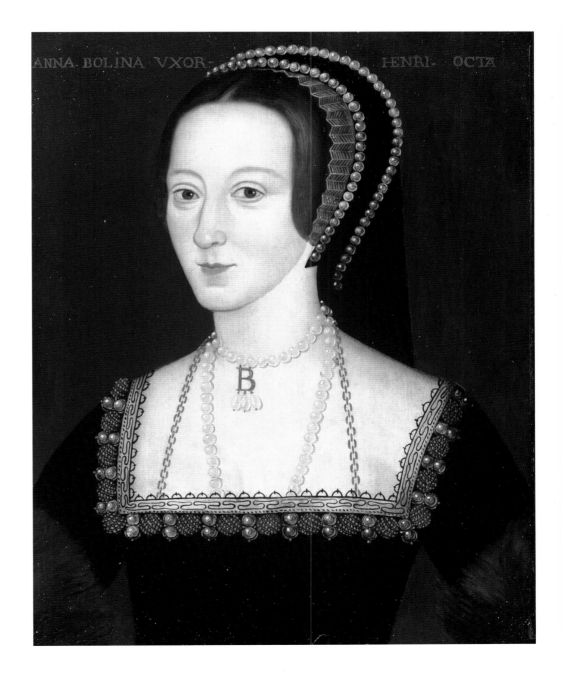

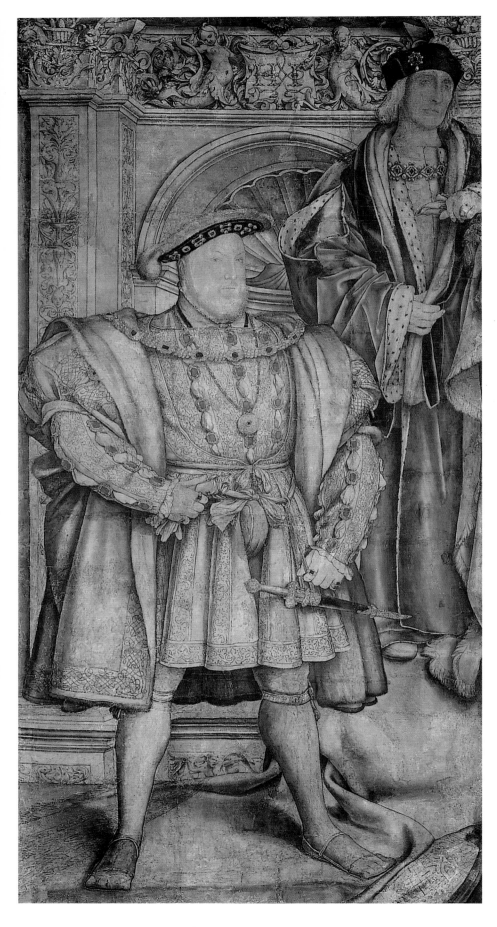

KING HENRY VII (1457–1509) AND KING HENRY VIII (1491–1547)

HANS HOLBEIN THE YOUNGER, *c*.1536–7
Black chalk, ink and watercolour on paper, laid on canvas
2578 x 1372mm

In 1537 Hans Holbein the Younger (1497/8–1543) completed a great wall painting for the Privy Chamber at Whitehall. The painting was a celebration of the Tudor dynasty, and the occasion for the commission may have been the birth – or the expectation of the birth – of Henry's son Edward, later Edward VI, in October 1537. This large work is the preparatory drawing, or cartoon, for the left-hand section, which shows Henry VIII (left) with his father Henry VII, the founder of the dynasty. The right-hand section of the mural depicted Henry VIII's third wife Jane Seymour and his mother Elizabeth of York.

The drawing is executed on many sheets of paper joined together, with the figures of the kings cut and pasted on to the architectural background. Cartoons were pricked for the outlines to be transferred by brushing charcoal dust through the holes. This drawing does not appear to have been used for transfer, suggesting that it was made as a record. Holbein's painting was destroyed in the Whitehall Palace fire of 1698, and the cartoon for the right-hand section is now lost. A mid-seventeenth-century copy by Remigius van Leemput survives in the Royal Collection. NPG 4027

KATHERINE PARR
(1512–48)

ATTRIBUTED TO MASTER JOHN,
*c.*1545
Oil on panel
1803 x 940mm

Katherine Parr was the sixth and last wife of Henry VIII, whom she married in 1543. Kind and affectionate to Henry's children from his previous marriages, she appears to have been influential in restoring both Mary and Elizabeth to the line of succession. She was particularly interested in the medium of portraiture and all Henry's children were painted during Katherine's time as queen.

For a time the sitter in this painting was thought to be Lady Jane Grey. However, following research, the traditional identification as Katherine Parr has been reasserted. This portrait is associated with the artist Master John (active 1544–50). He has paid particular attention to the depiction of the textiles and jewellery, using a complex system of silver and gold leaf, glazes and oil pigment in order to imitate the expensive and luxurious gold and silver cloth of the Queen's dress and gemstones. The distinctive crown-shaped brooch can be identified in an inventory of Katherine's jewels.
NPG 4451

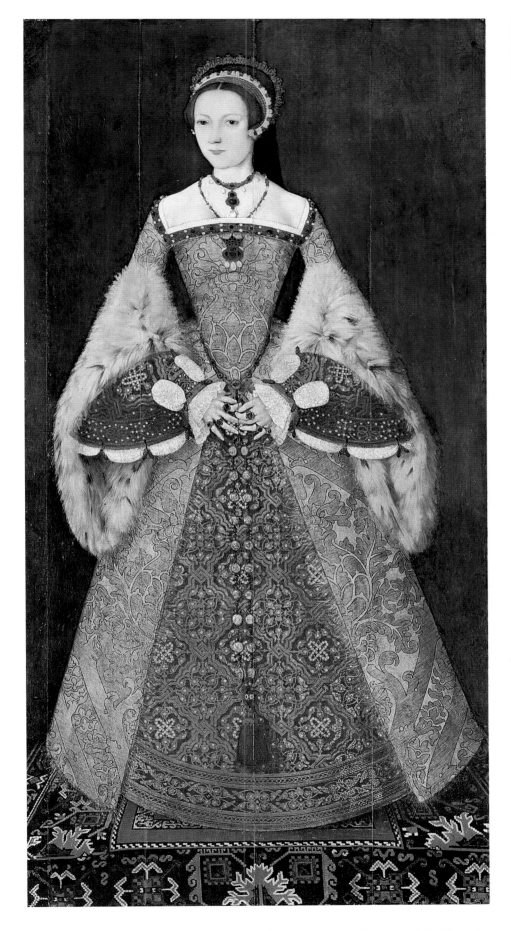

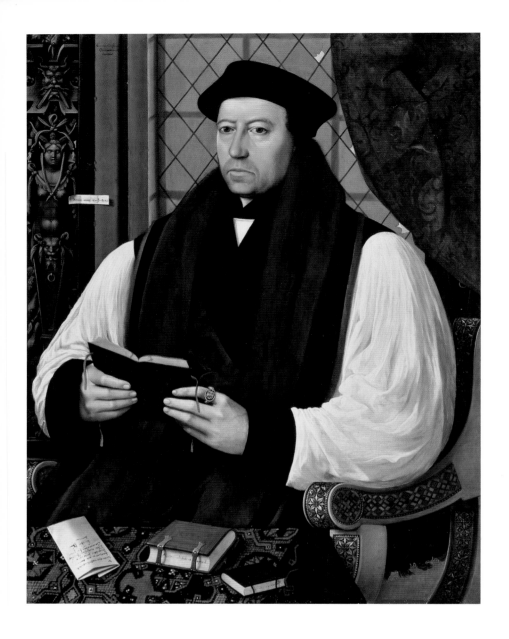

THOMAS CRANMER
(1489–1556)

GERLACH FLICKE, SIGNED *Gerlachŭs Flicci*, 1545–6
Oil on panel
984 x 762mm

Appointed Archbishop of Canterbury by Henry VIII in 1533, it was Thomas Cranmer who secured the King's annulment from Katherine of Aragon later the same year. Deeply committed to religious reform, Cranmer was responsible for the first *Book of Common Prayer*, published in 1549, the 1552 revision of which is still in use today. Deprived of office and imprisoned under the Roman Catholic queen Mary I, Cranmer was tried for treason. He recanted, acknowledging papal supremacy, but reverted to his original position and was executed.

This portrait was commissioned from the German artist Gerlach Flicke (d.1558), whose presence in England is first signalled by this painting. The Archbishop is seated in a fashionable interior, holding the Epistles of St Paul and with St Augustine's treatise *De fide et operibus* (On Faith and Works) on the table before him. Cleaning revealed three areas of broken glass in the window behind Cranmer, which are probably symbolic, although the exact meaning is now unclear. Also revealed was the word 'rot' (German for red) beneath the cushion, as a reminder to the artist or his assistant. NPG 535

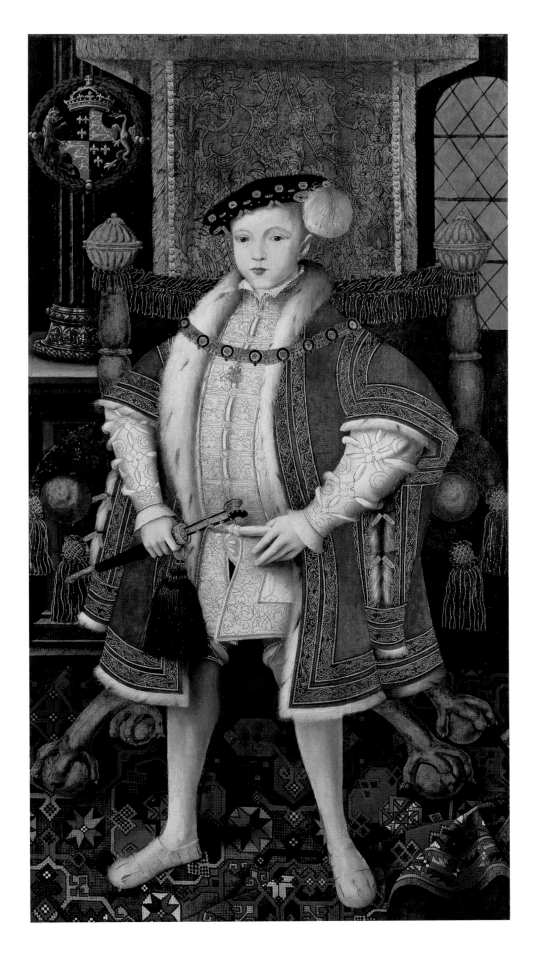

KING EDWARD VI
(1537–53)

UNKNOWN ENGLISH ARTIST, *c.*1547
Oil on panel
1556 x 813mm

Edward VI succeeded his father as king in January 1547, aged nine years, and it is likely that this portrait was painted around the time of his accession. Learned and devoutly Protestant, Edward instigated the removal of images from churches and the introduction of Archbishop Cranmer's first *Book of Common Prayer*, the enforced use of which led to a series of violent uprisings.

Edward is shown richly dressed and wearing the Greater George of the Order of the Garter. His pose is similar to that of his father Henry VIII in the Whitehall cartoon (page 36). Technical analysis has revealed that his feet were originally even further apart and were adjusted by the artist before the portrait was finished, perhaps because it appeared an odd pose for a young boy. A second arched window was initially placed to the left but was superimposed by the pillar with Edward's coat of arms, suggesting that the boy king had inherited the throne before the portrait was completed. At least three different artists appear to have worked on the painting, which would not have been uncommon for a busy workshop. NPG 5511

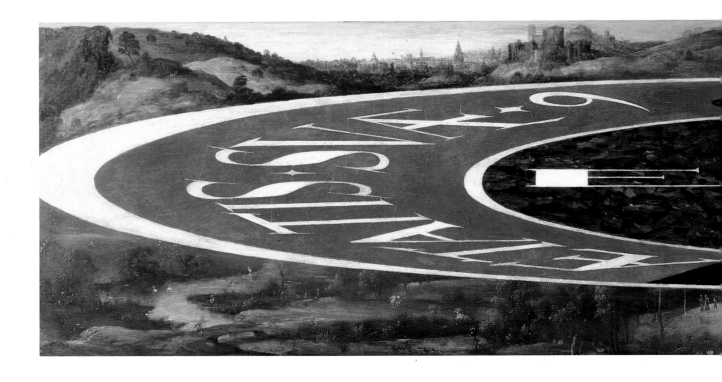

KING EDWARD VI
(1537–53)
ATTRIBUTED TO WILLIAM SCROTS, SIGNED *guilhelmus pingebat*, 1546
Oil on panel, 425 x 1600mm

This extraordinary painting shows Prince Edward aged nine years old in an unusual distorted perspective known as 'anamorphosis', which was designed to display the virtuosity of the painter and amaze the spectator. Edward was the first and only legitimate son of Henry VIII and his third wife Jane Seymour. He came to the throne in 1547 and this image was painted a few months before his succession. Scholarly and firmly Protestant, Edward VI ruled during his minority with the help of a council, dominated first by the Duke of Somerset as Lord Protector and later by the Duke of Northumberland. The latter induced Edward to will the crown to Lady Jane Grey before he died, at the age of fifteen, in order to ensure the Protestant succession.

The picture can be seen in correct perspective when viewed from the right edge of the frame, as seen opposite. The frame is original and is inscribed *guilhelmus pingebat* (William painted this), which may indicate the artist William Scrots (active 1537–53), who succeeded Holbein as court painter in 1545. The beautiful landscape background appears to have been painted by a different artist. NPG 1299

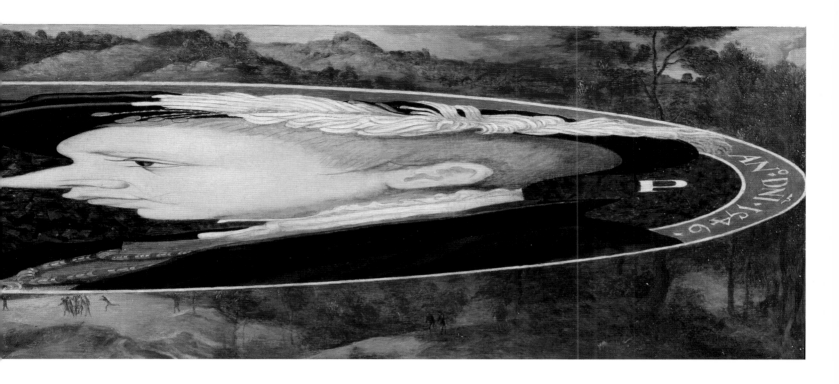

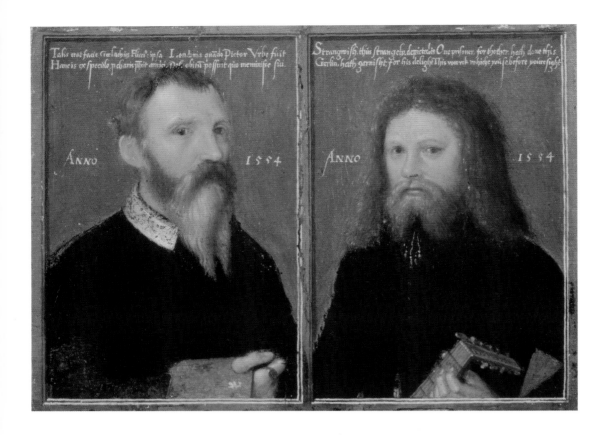

GERLACH FLICKE (d.1558) AND HENRY STRANGWISH (d.1562)

GERLACH FLICKE, SIGNED *Gerlachŭs Flicci* AND DATED 1554
Oil on paper or vellum laid on panel
88 x 119mm

This tiny and highly unusual double portrait incorporates the earliest self-portrait in the Gallery's Collection. Gerlach Flicke was a German portrait painter, resident in England from around 1545. Little is known of his work, and this is one of the few surviving paintings by him. It appears to have been made as a private memento and it shows Flicke with his companion Henry Strangwish (or Strangeways), a pirate from Dorset.

The beautifully painted inscription, in Latin and English, records that the work was painted for Strangwish, who is shown with a lute, while both men were imprisoned in the Tower of London for an unknown crime. Flicke depicts himself with a palette, showing a range of pigments suitable for painting portraits. The inscription also records that he was a painter in the City of London and that he represented himself in this portrait with the aid of a mirror, that his friend might 'have something by which to remember him after his death'.

This double portrait may have originally been presented in a different format, perhaps within a manuscript or a book, or in a frame with a cover.
NPG 6353

QUEEN MARY I
(1516–58)

HANS EWORTH, SIGNED IN
MONOGRAM AND DATED 1554
Oil on panel
216 x 169mm

Mary I, England's last Roman
Catholic monarch, succeeded her
devoutly Protestant half-brother
Edward VI in 1553, following a
brief nine days' reign by Lady Jane
Grey. This portrait was painted in
1554, the year of a rebellion led by
Sir Thomas Wyatt, which sought
to prevent the Queen's marriage
to Philip II of Spain, an alliance
that was linked in the public's
mind with the reinstatement of
Catholicism. The Queen died
childless aged forty-two and
was succeeded by her half-sister
Elizabeth I.

This portrait is signed in
monogram by the artist Hans
Eworth (d.1574), an exceptionally
skilful Netherlandish artist working
in England, and is one of a number
of surviving versions by him of this
composition. The painting shows
a bejewelled Mary shortly before
her marriage to Philip in July 1554,
holding a Tudor rose and wearing
a diamond cross and large diamond
pendant. The large pearl suspended
from her pendant is possibly the
famous pearl of great size known as
'La Peregrina' (The Incomparable),
given to Mary by Philip earlier that
year. NPG 4861

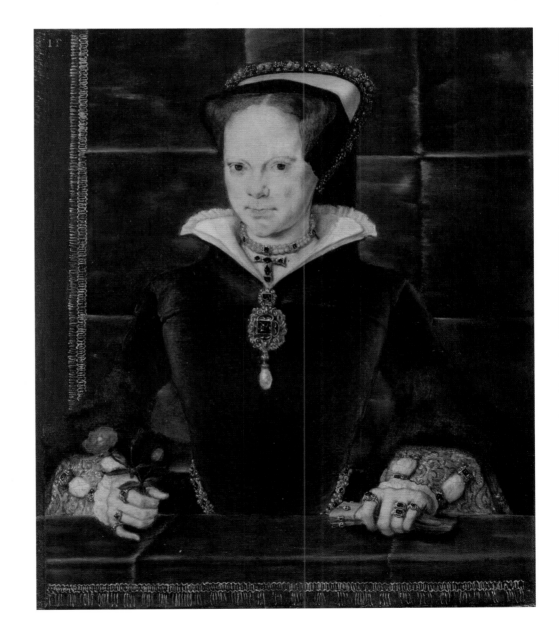

MARY NEVILL, LADY DACRE (died *c*.1576) WITH HER SON GREGORY FIENNES, 10TH BARON DACRE (1539–94)

HANS EWORTH, SIGNED IN MONOGRAM AND DATED 1559
Oil on panel
500 x 714mm

This accomplished double portrait is rare in presenting a mother (Lady Dacre) with her adult son (Gregory Fiennes). Lady Dacre's husband, Thomas, 9th Baron Dacre, had been executed in 1541 and his title and lands forfeited for his part in a poaching incident in which a gamekeeper was killed. She married twice more, all the while campaigning for the restoration of her first husband's honours to her son. This finally took place in 1558, when Elizabeth I came to the throne, and is the likely occasion for this portrait. Fiennes, described by the antiquarian William Camden as 'a little crack-brained', married Anne Sackville, who complained of the degree to which both she and her husband were subject to his mother.

The portrait is signed in monogram by the painter Hans Eworth (d.1574), the artist who painted the portrait of Mary I (page 43). Eworth had painted Lady Dacre a few years previously, and this portrait with her son is considered to be one of the artist's most skilful works. His technique here is particularly sophisticated and conveys a range of textures and materials. Great attention has been paid to the detail of the sumptuous jewellery and costume, particularly the fur, ruffs and cuffs. NPG 6855

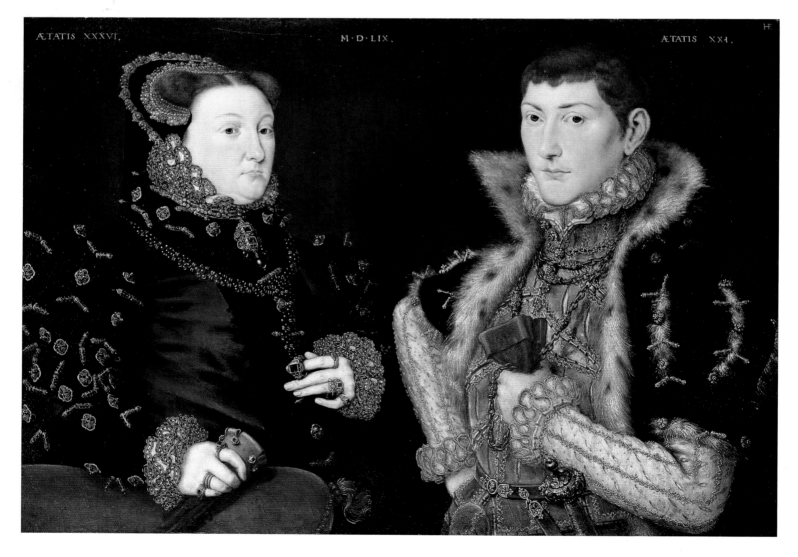

SIR HENRY LEE
(1533–1611)
ANTHONIS MOR, SIGNED *Anthonis Mor pingebat* AND DATED 1568
Oil on panel
641 x 533mm

Henry Lee's epitaph records him as a man who served 'five succeeding princes, and kept himself right and steady in many dangerous shocks and utter turns of state'. A favourite of Elizabeth I, Lee was the Queen's champion and supervised the famous accession day tilts, turning them into spectacular festivals.

This portrait was probably painted in Antwerp in early June 1568 by the sought-after and supremely talented Netherlandish artist Anthonis Mor (1516–1575/6). The exceptionally subtle handling helps to create a powerful sense of presence. Lee was accompanied on this trip by Edward, 3rd Lord Windsor, whose portrait by another artist employs a similar composition (private collection). Both portraits show the sitter with his thumb through a ring suspended from a cord around his neck, a gesture that is now difficult to decipher but may relate to bonds of friendship and honour. The pattern on Lee's sleeves (depicting true-lovers' knots and armillary spheres) had a symbolic meaning as both were personal emblems of the Queen and probably refer to his role as Elizabeth I's champion. NPG 2095

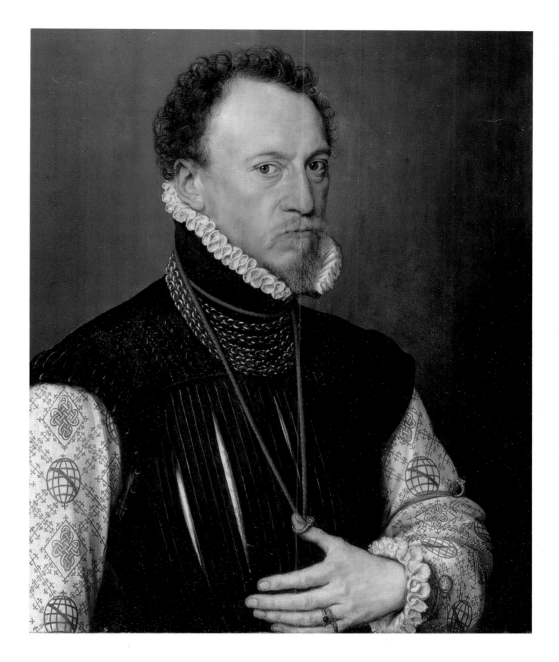

How Early Portraits Were Made

TARNYA COOPER AND CHARLOTTE BOLLAND

The materials used by an artist play an important part in determining the final aesthetic appearance of a portrait. In the early history of portrait production artists painted on to wooden panels, but during the course of the sixteenth century, canvas stretched on to a wooden frame began to be used alongside panels.

The contrasting effect of these different surfaces on which to make pictures can be seen in two sixteenth-century portraits: the crisp details in a portrait of Thomas Howard, 4th Duke of Norfolk (on panel, below), and the imposing grandeur of the large-scale 'Ditchley' portrait showing Queen Elizabeth I in her sixties (on canvas, right).

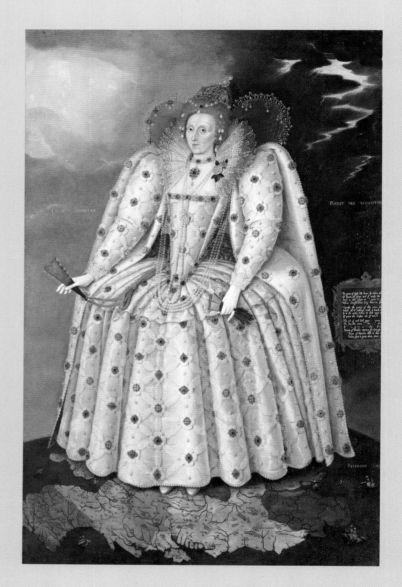

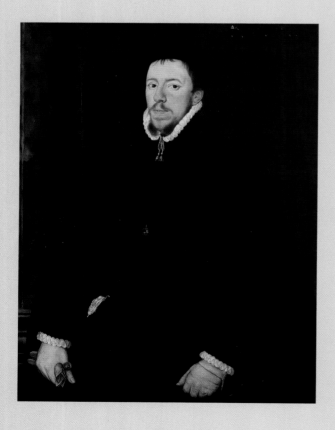

LEFT

Thomas Howard, 4th Duke of Norfolk (1536–72), by an unknown Anglo-Netherlandish artist. Oil on panel, 1565, 1032 x 802mm, NPG 6676 • Thomas Howard was one of the most powerful noblemen in Elizabethan England; he was executed as a result of his role in the plot to place Mary, Queen of Scots on the throne.

ABOVE

Queen Elizabeth I (1533–1603), by Marcus Gheeraerts the Younger. Oil on canvas, c.1592, 2413 x 1524mm, NPG 2561 • This painting is known as the 'Ditchley' portrait because it had been in the collection of the same name from the time of its commission until it was bequeathed to the Gallery in 1932.

A solid wooden panel can be smoothed to a fine finish, and was the most commonly used material for portrait supports until the early seventeenth century. In England panels were typically constructed from oak, which could be local but were more commonly imported from the Baltic; the ideal board had a straight grain that would make it unlikely to warp over time. Panels were constructed by a joiner, who usually took care to ensure that a join between two boards did not run through the centre of the panel where the face would be painted. Paintings on wooden panel are very sensitive to changes in humidity, which causes the wood to expand and contract; this movement can damage the paint surface, particularly along the panel joins.

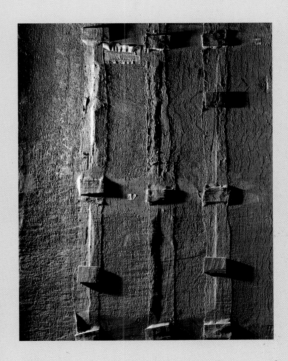

ABOVE

This photograph of Thomas Howard's portrait opposite, taken in raking light, shows the texture of the painted surface and the two vertical panel joins either side of the head. This type of construction is common in early portraits.

ABOVE

The reverse of the portrait of Thomas Howard, showing the wooden blocks and strips of linen canvas that were added at a later date to support the panel joins.

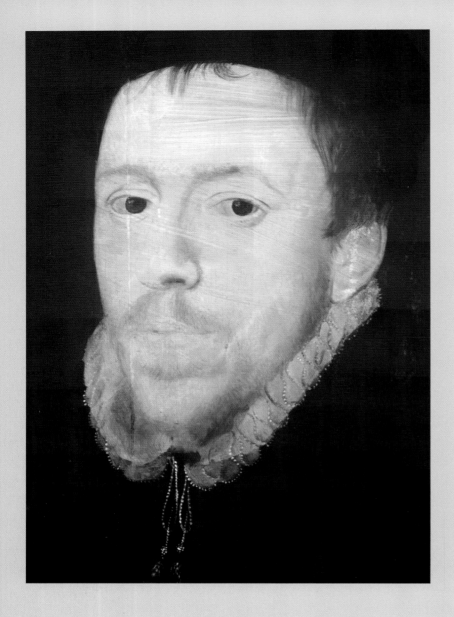

LEFT
Infrared reflectogram mosaic showing faint lines of preparatory underdrawing in the face in the portrait of Thomas Howard (page 46) and the brushstrokes of the priming.

BELOW
The reverse of the 'Ditchley' portrait (page 46), showing the wooden frame that is used to support the canvas.

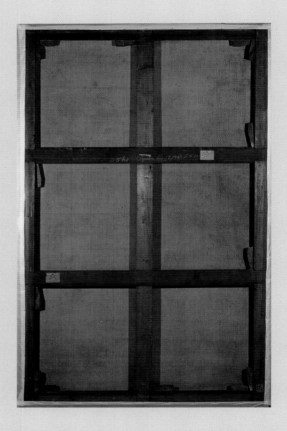

Canvas was also used as a painting surface throughout the sixteenth century, and early surviving examples can be found in the Gallery collections, such as the portraits of Henry Howard, Earl of Surrey (NPG 5291), dated 1546, and John Astley (NPG 6768), dated 1555. By the 1620s it was the standard material for portraits painted in England, and oil paint on canvas continues to be one of the most popular media for artists to work in today, as can be seen in the Gallery's contemporary collection. The main advantage was that large-scale paintings remain lightweight and easily transportable. Not surprisingly, its increased usage coincided with the popularity of large-scale portraits; the sizeable 'Ditchley' portrait (c.1592) is made from a single piece of canvas.

In order to smooth out the last imperfections and to help the paint to adhere to the surface, both panel and canvas supports are covered with a preparatory layer. Artists can then draw or paint directly on to this prepared surface in order to plan the composition, although in the sixteenth century they would more usually transfer a pre-existing drawing. The use of preparatory drawings and patterns meant that portraits did not have to be painted in the presence of the sitter and could also be replicated easily; many existing portraits of Tudor and Stuart monarchs and courtiers were made as versions from patterns as a result of a lively market for their portraits. However, portraits of private individuals would usually have been painted after a sitting from life.

The pigments available in the sixteenth century ranged from expensive imports, such as azurite (an intense blue), to more commonly available earth colours, such as red ochre. Once mixed with an oil medium, the pigments, in the hand of the right artist, could be used to create a colourful and realistic likeness. A transparent varnish layer was applied once the oil paint was dry, which allowed the colour to become fully saturated and helped to preserve the surface finish. This varnish layer can degrade quite quickly, and older paintings have often been revarnished many times. However, as some pigments change colour and fade over time, it is rarely possible to reveal the appearance of a portrait as it was seen by its first audience.

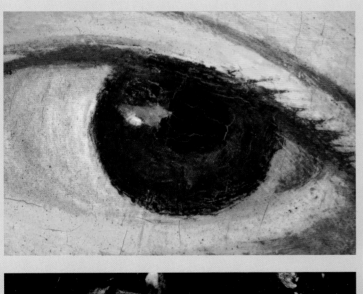

QUEEN ELIZABETH I
(1533–1603)
NICHOLAS HILLIARD, DATED 1572
Watercolour on vellum
51 x 48mm

This is the earliest known miniature of Elizabeth I, the daughter of Henry VIII and Anne Boleyn. Elizabeth came to the throne in 1558 following the death of her half-sister, the Roman Catholic queen Mary I. It was painted by the talented English artist Nicholas Hilliard (c.1547–1619), whom Elizabeth would appoint her official limner, or miniaturist.

This subtle and exceptionally detailed portrait was executed when Elizabeth was thirty-eight years old and the artist about twenty-five. It may be the sitting referred to in Hilliard's treatise *The Arte of Limning* (c.1600), which presumably took place in the garden of one of the royal palaces. Hilliard relates a discussion with the Queen about draughtsmanship and the importance of line and the absence of shadow in painting. The consequence of this, he relates, was that the Queen chose to place herself in the 'open alley of a goodly garden, where no tree was near, or any shadow at all'. The pattern for Elizabeth's face, as created here by Hilliard, was later followed in two large-scale oil paintings that are known today as the 'Phoenix' and 'Pelican' portraits (National Portrait Gallery, London, and Walker Art Gallery, Liverpool, respectively).
NPG 108

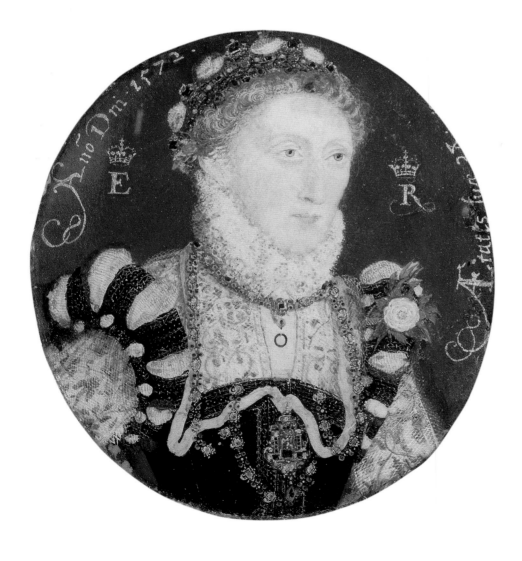

QUEEN ELIZABETH I
(1533–1603)
UNKNOWN CONTINENTAL ARTIST,
*c.*1575
Oil on panel
1130 x 787mm

Elizabeth I, the last Tudor monarch, succeeded to the throne in 1558, her long reign characterised by relative peace and prosperity. This portrait shows a confident ruler and would have been produced following a direct sitting from the life. The resulting pattern was used for the remainder of the Queen's reign, suggesting that she approved of the likeness. The pigments used in this portrait have faded over time. Elizabeth's pale complexion would originally have appeared much rosier and her costume would have been crimson and white.

While the artist is unrecorded, the sophisticated and swiftly rendered paint suggests a talented Continental painter, possibly from the Netherlands. Technical analysis has revealed lively underdrawing that evolved as the artist worked. The crown and the sceptre on the table behind are later additions by another, less competent, artist and may have been included at the request of the patron. Formerly at Cobham Hall, Kent, the portrait may have been painted for William Brooke, 10th Baron Cobham, although it is known today as the 'Darnley' portrait after a subsequent owner. NPG 2082

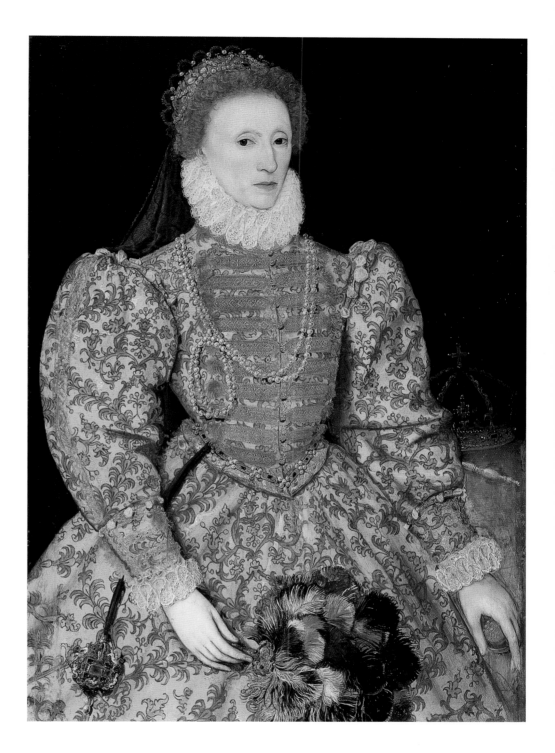

ROBERT DUDLEY, 1ST EARL OF LEICESTER
(1532/3–88)

NICHOLAS HILLIARD, DATED 1576
Watercolour on vellum
45mm diameter

The fifth of thirteen children of John Dudley, Duke of Northumberland, the courtier Robert Dudley was Elizabeth I's only serious English suitor. Their relationship was a defining one in both their lives. Made Master of the Horse at her accession, Dudley joined the Privy Council in 1562 and was created Earl of Leicester and Baron Denbigh in 1564. He was later Governor-General of Elizabeth I's army against the Spanish in the Netherlands.

This miniature, which gives Leicester's age as forty-four, was painted the year after the magnificent festivities he staged for the Queen at his estate in Kenilworth. The care with which Hilliard (c.1547–1619) has delineated the sitter's features and ruff is suggestive of the Earl's noted interest in his appearance. It must have been painted before Hilliard left for France in September 1576, and is one of four miniatures of Leicester attributed to this artist. Leicester's patronage, or perhaps Hilliard's continued desire for it, is reflected in the artist's naming many of his children after members of the Earl's family. NPG 4197

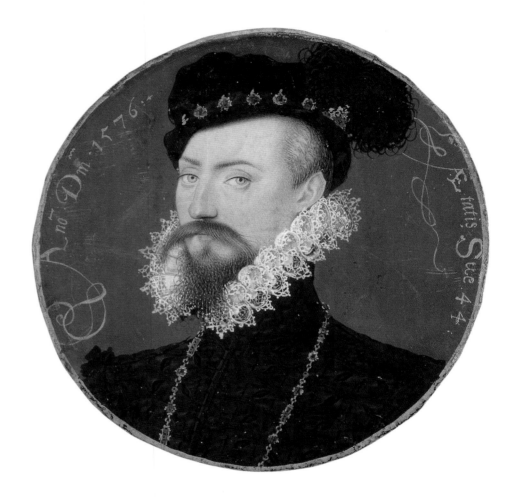

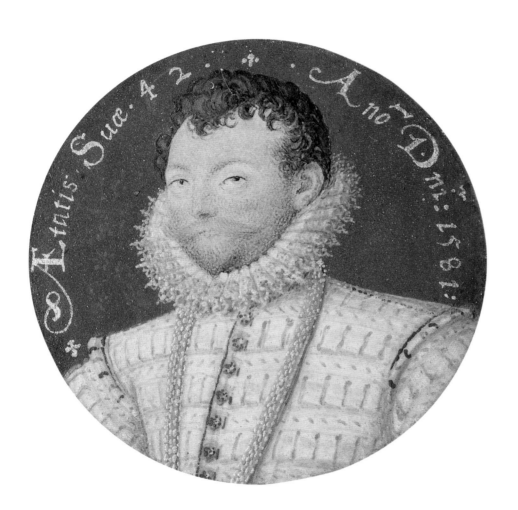

SIR FRANCIS DRAKE
(1540–96)
NICHOLAS HILLIARD, DATED 1581
Watercolour on vellum
28mm diameter

Pirate, sea captain and explorer, Francis Drake is renowned for his three-year circumnavigation of the world, from which he returned in 1580 a rich and feared man. His profitable raids on Spanish ports were a contributing factor in Philip II of Spain's decision to launch an Armada, against which Drake would serve as vice-admiral of the English fleet.

This portrait, by the renowned English miniaturist Nicholas Hilliard (c.1547–1619), was painted in 1581, the year Drake was knighted. Drake is shown as a gentleman and courtier, wearing a splendid gold chain, signifying his new-found wealth. Several contemporary accounts of Drake's appearance survive and record him as being short, stocky and extremely strong. The red pigment Hilliard has used for the nose and cheeks gives Drake's flesh a pronounced ruddy tone. The historian John Stow records that Drake's enemies as well as his friends 'desired his Picture', making it all the more extraordinary that so few authentic portraits made during his lifetime have survived. NPG 4851

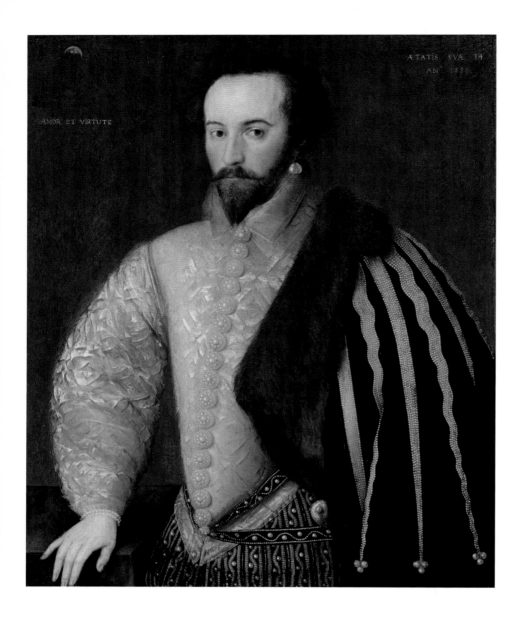

SIR WALTER RALEGH
(1554–1618)

UNKNOWN ENGLISH ARTIST, DATED 1588
Oil on panel
914 x 746mm

A true 'Renaissance man', Walter Ralegh was a poet, explorer and soldier as well as being a favourite of Elizabeth I. Much of his literary work is lost, but about thirty short poems and various prose works survive, including *The History of the World* (1614) and a cycle of poems to 'Cynthia' that were addressed to Elizabeth I. He organised and financed a number of expeditions to North America, and later in life made several unsuccessful attempts to find gold in South America.

Ralegh spent much of the reign of James I in the Tower of London and was executed for treason in 1618.

This portrait is a visual statement of Ralegh's devotion to Elizabeth I. His dramatic costume, in the Queen's colours of black and white, is lavishly embroidered with pearls, jewels much favoured by the Queen. Conservation treatment has revealed a patch of wavy sea beneath the crescent moon in the top left of the painting. Through this metaphor Ralegh likens the moon goddess Cynthia to the Queen and the water to himself (using a pun on his name Walter), signifying his willingness to be controlled by his sovereign as the moon controls the tides. NPG 7

ISAAC OLIVER
*(c.*1565–1617*)*

SELF-PORTRAIT, *c.*1590
Watercolour and bodycolour
on vellum
64 x 51mm

This striking self-portrait was
painted when Isaac Oliver was
around twenty-five years old. He
was born in Rouen and appears to
have trained as an artist before he
arrived in England with his family
as a Huguenot refugee. He joined
the workshop of the renowned
miniaturist Nicholas Hilliard,
later developing the techniques
he learnt there by placing more
emphasis on painted modelling
and blending than on Hilliard's
graphic line, creating a softer, more
illusionistic style. In 1605 he was
appointed limner, or miniaturist,
to Anne of Denmark, the wife of
James I, and thereafter to her son
Henry, Prince of Wales.

 Although Oliver does not
advertise his artistic profession in
this image, it is interesting to note
the lustre of his silk doublet, a
fabric recommended by Nicholas
Hilliard as suitable for painting as
it 'sheddeth least dust or hairs'.
The miniature once belonged to
the eighteenth-century antiquary
Horace Walpole, who said of it:
'The art of the master and the
imitation of nature are so great in
it that the largest magnifying glass
only calls out new beauties.'
NPG 4852

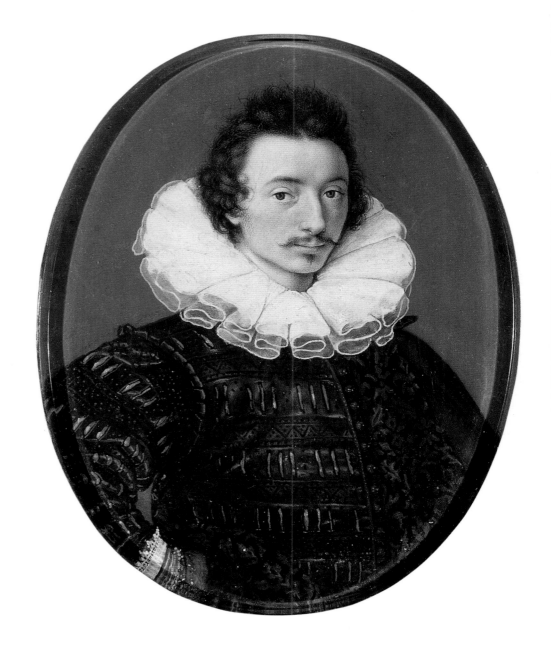

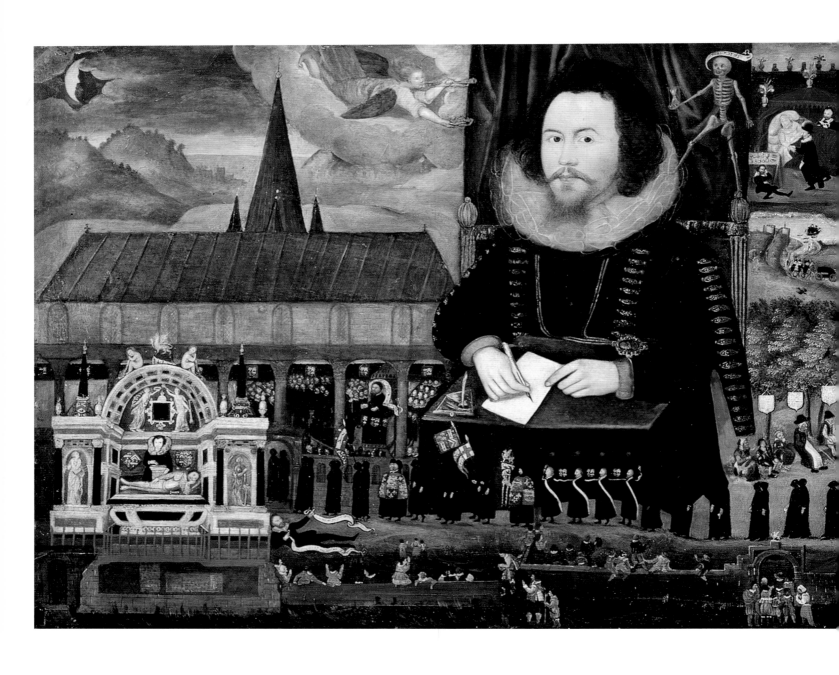

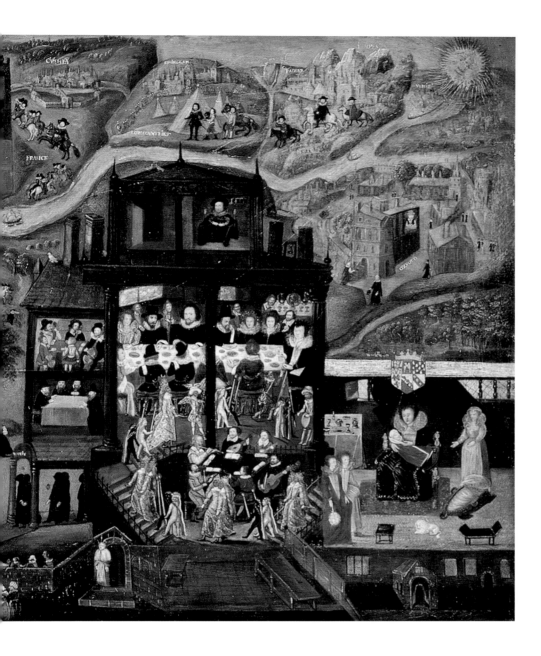

SIR HENRY UNTON
(*c.*1558–96)

UNKNOWN ENGLISH ARTIST, *c.*1596
Oil on panel
740 x 1632mm

This extraordinary narrative portrait is the best-known image of the distinguished soldier and diplomat Henry Unton, and includes numerous scenes from his eventful life. In 1586 he served in the army of the Earl of Leicester in the Netherlands, with Sir Philip Sidney, and in the 1590s he was the resident ambassador to France, twice leading negotiations with its King, Henry IV.

Unton is depicted in several narrative scenes presented in an anti-clockwise direction around his portrait. From bottom right, they show his birth, his study at Oxford, his journey across the Alps to Venice and Padua, his military service in the Netherlands, his death while ambassador in France, and his funerary procession and burial in Oxfordshire. The painting was commissioned after Unton's death by his widow Dorothy, née Wroughton, and may have originally served as a painted funeral monument before a permanent stone memorial was installed at Faringdon Church in 1606. On the table in front of him appears to be a cameo jewel depicting Henry IV of France (previously identified as Elizabeth I). NPG 710

JOHN DONNE
(1572–1631)

UNKNOWN ENGLISH ARTIST, c.1595
Oil on panel
771 x 625mm

The poet John Donne, who trained as a lawyer, is best known for the passionate and witty love poems he wrote in his youth, around the time this portrait was painted. A student at Oxford and at the Inns of Court, Donne was raised a Roman Catholic, converted to the Protestant faith and in 1615 was ordained a priest in the Church of England. He became chaplain to James I and was later Dean of St Paul's Cathedral.

This portrait is one of the earliest of an Elizabethan poet. It presents Donne in the guise of a brooding, handsome melancholic lover, with his wide-brimmed hat and sensuous lips. The artful dishevelment of his triple-layered lace collar, which is left slightly open, enhances the sense of the poet's preoccupation and may be a pun on his name and state of mind (un-done). The Latin inscription around the oval, which translates as 'Lady/or mistress/ Lighten my darkness', is a deliberate misquotation of Psalm 17, and implies that the cause of Donne's misery is a woman. Donne bequeathed this picture, which he described in his will as 'taken in shadowes', to his friend Robert Ker, later 1st Earl of Ancrum. NPG 6790

ROBERT DEVEREUX, 2ND EARL OF ESSEX
(1565–1601)
MARCUS GHEERAERTS
THE YOUNGER, *c.*1597
Oil on canvas
2180 x 1272mm

Essex was the last favourite of
Elizabeth I and organised royal
entertainments in his capacity
as Master of the Horse. He was
confirmed as a popular hero in
1596 after taking the town of Cádiz
in a pre-emptive strike against
the Spanish, and was appointed
Earl Marshal the following year.
Described by his friend Francis
Bacon as having 'a nature not to be
ruled', Essex lost his place at court
as a result of his activities in Ireland
in 1599, when he failed to crush
the uprising of the Earl of Tyrone.
Following an unsuccessful attempt
to raise a rebellion against the
Queen's ministers in 1601 he was
executed for treason.

A Venetian visitor, who described
Essex as 'fair-skinned, tall, but
wiry', recounted how, on the voyage
home after the taking of Cádiz, the
Earl had grown a beard 'which he
used not to wear'. Essex retained
the beard as a mark of his venture,
and this portrait was painted soon
afterwards. This portrait by Marcus
Gheeraerts the Younger (1561/2–
1632) shows him in his robes as a
Knight of the Garter with the collar
of the Order's Greater George
about his neck. NPG 4985

MARY STEWART, QUEEN OF SCOTS
(1542–87)

NObr >AFTER NICHOLAS HILLIARD, LATE-SIXTEENTH CENTURY
Oil on panel, 902 x 791mm

The daughter of James V of Scotland and Mary of Guise, Mary Stewart was raised in France as a Roman Catholic. She married the dauphin, subsequently Francis II of France, in 1558 but, following his early death, returned to Scotland, ruling for seven turbulent years. Her brief marriage to Lord Darnley produced her only child, later James VI of Scotland and I of England, but ended in Darnley's murder in 1567. Forced to abdicate in favour of her son, she fled to England. As heir to the English throne, Mary became the focus for Roman Catholic rebellion. In 1586 she was declared guilty of treason and executed the following year.

This portrait, which was once in the Royal Collection, is probably based on an image from the life. The Latin inscription records that she is shown having been a prisoner for ten years. The cross attached to her rosary bears the letter 'S' on each of its arms (possibly for 'Stewart') and is surrounded by a Latin motto that translates as 'troubles on all sides'. At least one-third of the original panel to the right has been lost and replaced with an addition and repainted. NPG 429

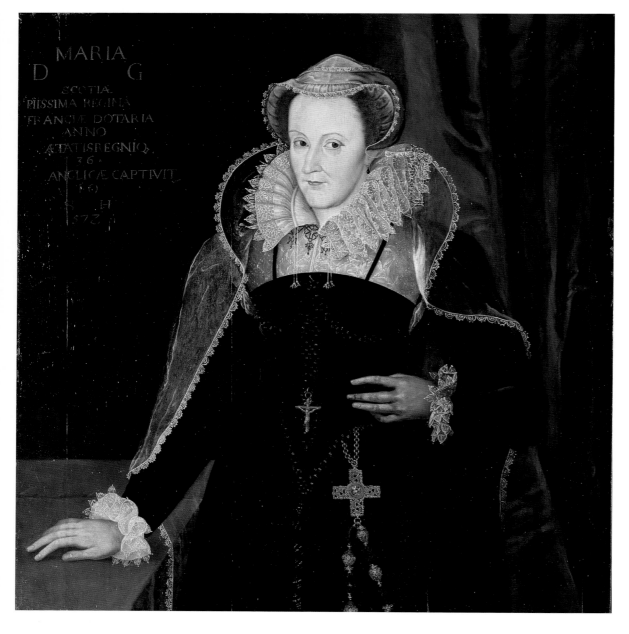

WILLIAM SHAKESPEARE
(1564–1616)
ASSOCIATED WITH AN ARTIST
KNOWN AS JOHN TAYLOR,
c.1600–10
Oil on canvas, feigned oval,
552 x 438mm

The poet, actor and playwright
William Shakespeare is one of
the world's most celebrated
cultural figures, and it is perhaps
appropriate that this painting was
the first to be presented to the
newly founded National Portrait
Gallery in 1856. His prodigious
output included poems, sonnets,
history plays, tragedies and
comedies. Undoubtedly the most
influential playwright in history, his
works include *A Midsummer Night's
Dream, Romeo and Juliet* (both
c.1594–6), *Hamlet* (*c*.1600), *Macbeth*
(1606) and *The Tempest* (1609–11).

This portrait was identified in
the mid-seventeenth century as
a portrait of Shakespeare made
during his lifetime, though the
identity remains highly probable,
rather than proven. It bears a good
similarity to Shakespeare's
memorial bust and to an engraved
likeness included in his published
works in 1623. Documentary
sources suggest that it was painted
by a little-known artist who went
by the name 'Taylor' (possibly John
Taylor [d.1651]). The simple
costume worn by the sitter, of a
black doublet and falling collar,
is similar to that seen in the portrait
of Ben Jonson, Shakespeare's
contemporary (page 76). The work
is known today as the 'Chandos'
portrait after a previous
owner. NPG 1

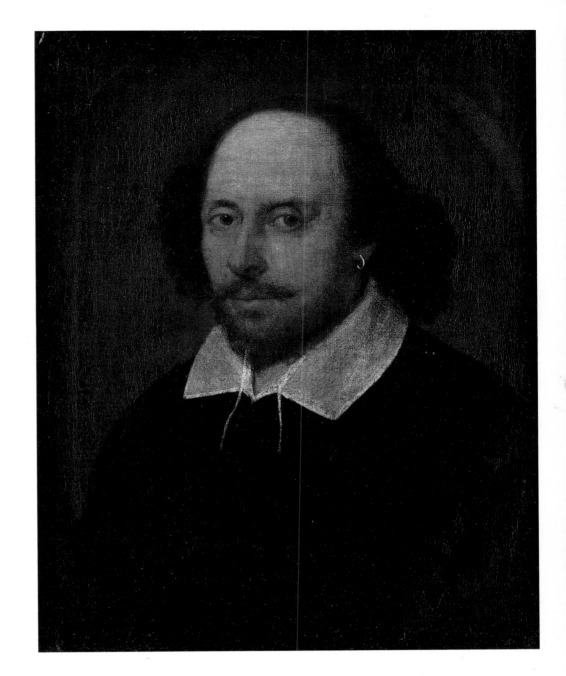

CHAPTER 2

Stuart Portraits

1603–1714

On her deathbed in 1603, Elizabeth I named as her successor her cousin, James VI of Scotland; for the first time, England and Scotland were to be ruled by the same monarch. James's succession to the English throne as James I marked not only the start of a new political dynasty in England, but also the beginning of a century of dramatic political upheaval, as well as of great scientific and artistic achievement. The history of the seventeenth century is in part the story of the Stuarts (as the family name was now generally spelled): their approach to government and to the Church, their ebbing and flowing popularity, and their patronage of literature, art, theatre and science. It is also a century of contrasts, between the extraordinary discoveries in mathematics and the natural world that laid the foundations of modern science, and continuing medieval practices, such as alchemy with its search for the secret of turning base metals into gold; between Puritan restraint and indulgent excess at court; between autocratic monarchical rule and the temporary British republic.

In both Scotland and England a strong literary tradition had been established in the sixteenth century, and under James I, perhaps the most literary of all British monarchs, this tradition flourished. Patronage from the court and the hugely popular public theatres led to the production of some of the most important and influential poetry, prose and drama ever written, including, of course, the works of William Shakespeare. The status of professional writers also underwent a shift; not only were previously ephemeral plays collected together and published, but men such as Shakespeare and Ben Jonson were, like other prosperous professionals, depicted in portraits.

The influx of talented immigrant artists coming to England during the sixteenth century, particularly from the Low Countries, continued in the Jacobean era. But it was not until the advent of Sir Anthony Van Dyck, a Flemish artist with an international reputation, that British painting turned decisively away from the flat, decorative style that had so dominated Tudor portraiture. Van Dyck's greatest patron was Charles I, James's second but only surviving son, who succeeded to the throne on his father's death in 1625. Charles's passion for paintings led to extravagant spending, which, along with his imposition of heavy taxes, restrictions on church worship and long periods of rule without Parliament, contributed to his unpopularity.

Growing dissatisfaction with Charles I as a king was a factor in increasing social and political unrest, which in 1640 erupted into the first of a series of civil wars in Scotland, Ireland, England and Wales. Huge numbers of people died, both in combat and from rapidly spreading disease in the unsanitary conditions of the military camps. The Parliamentarians, led by Oliver Cromwell, eventually won, with the help of their extraordinarily well-organised professional army.

The King was executed in January 1649, and a republican government was established; by 1653 this had failed, so Cromwell took over as Lord Protector until his death in 1658. Power struggles between the army and Parliament followed and, in 1660, Charles's eldest son was invited to return from exile, to be restored to the throne as Charles II.

Despite their differing political and religious beliefs, soldiers on both sides of the wars were depicted in portraiture in very similar ways. They were not, on the whole, shown as the 'Roundheads' and 'Cavaliers' of popular history, and it is usually impossible to guess their political allegiances from the style in which they were painted. Indeed, Cromwell's own portraits suggest that he recognised the propagandist power of Van Dyck's images of Charles I's court, and his favoured painter, Robert Walker, repeated Van Dyck's poses.

The reign of Charles II did, however, see a shift in portrait styles, and the richly coloured, loosely draped women depicted by Charles's Principal Painter, Sir Peter Lely, have come to symbolise the excess and debauchery for which his court was criticised. In spite of such disapproval, and a series of conspiracies and plots as well as major disasters, such as the Great Plague in 1665 and the Great Fire of London in 1666, Charles's reign was relatively stable. But although he had fourteen illegitimate children, he had no legitimate heir and this led to a crisis over the succession, and ultimately to another revolution.

On Charles II's death in 1685 the throne passed to his brother, James II, who was deeply unpopular and mistrusted for his Catholicism. Charles's eldest illegitimate son, the Duke of Monmouth, led an unsuccessful rebellion, which ended with his execution, but James's reign was nonetheless short-lived. After three years as king, he was ousted by the 'Glorious Revolution' of 1688, when his daughter Mary and her husband William of Orange were invited to England from the Netherlands to rule. The political changes effected as part of this revolution were in fact of much greater and more lasting consequence than those brought about by the civil wars, limiting the powers of the monarch and handing greater control to Parliament, thus paving the way for the modern British state.

Catharine MacLeod

THE SOMERSET HOUSE CONFERENCE
(Left to right: Louis Vereyken [dates unknown];
Jean Richardot [1540–1609]; Charles de Ligne,
Count of Aremberg [1550–1616]; Alessandro
Robida [dates unknown], Juan de Tassis, Count
of Villamediana [d.1607]; Juan de Velasco, Duke
of Frias [c.1550–1613]; Thomas Sackville, Earl
of Dorset [1536–1608]; Charles Howard, Earl of
Nottingham [1536–1624]; Charles Blount, Earl
of Devonshire [1563–1606]; Henry Howard,
Earl of Northampton [1540–1614]; Robert
Cecil, 1st Earl of Salisbury [1563–1612])
UNKNOWN ARTIST, 1604
Oil on canvas
2057 x 2680mm

This large group portrait commemorates the peace
treaty signed between England and Spain in August
1604. The two countries had been at war since 1585
but the conflict had reached a stalemate following the
failure of the Spanish Armada in 1588. The deaths
of Philip II of Spain in 1598 and Elizabeth I in 1603
enabled their royal successors, both of whom lacked
the will or funds to prolong the war, to negotiate peace.

The conference took place in Somerset House, the
residence of the queen consort, Anne of Denmark, and
one of the grandest properties in London. The house
was richly decorated for the event, and it is possible
that this picture accurately records the appearance of
the room in which the treaty was signed. The soberly
dressed delegates sit in two rows. To the left are the
Spanish, led by the Constable of Castile, Juan de
Velasco, Duke of Frias (nearest the window). To the
right are the English, the Earls of Dorset, Nottingham,
Devonshire, Northampton and Robert Cecil, the key
negotiator of the English delegation, who sits with the
treaty before him. He was created Earl of Salisbury in
1605. It is unlikely that all the sitters were present at
the same time, and many of the faces are based on
other portraits. Although the identity of the artist is
uncertain, this magnificent painting of a key moment
of diplomacy is unprecedented in British art. NPG 665

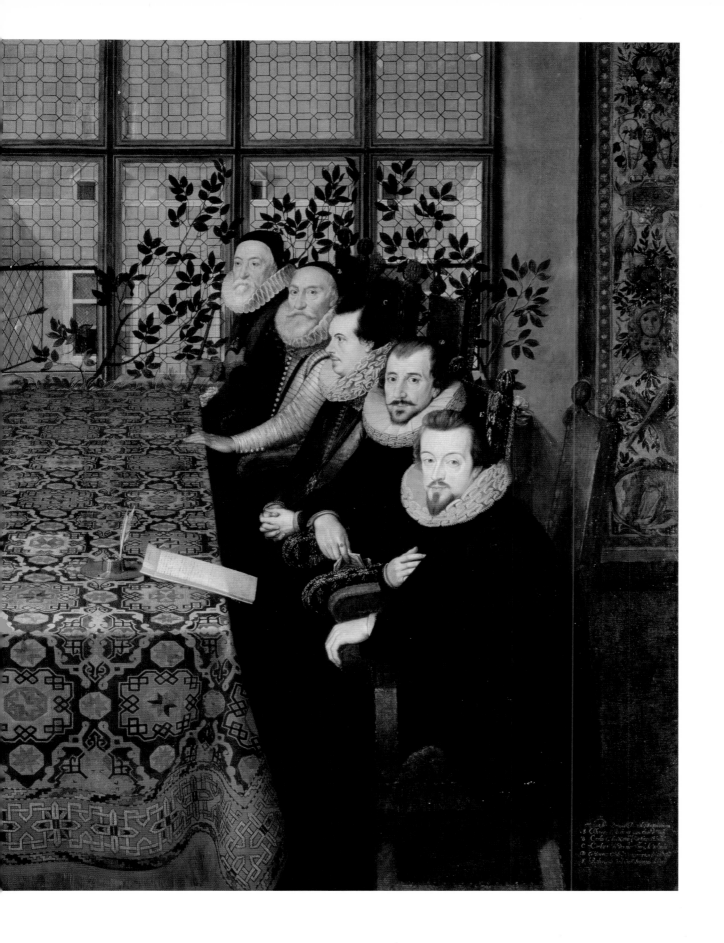

ELIZABETH OF BOHEMIA
(1596–1662)
ROBERT PEAKE THE ELDER, *c*.1610
Oil on canvas
1713 x 968mm

Elizabeth, named after her godmother Elizabeth I, was the daughter of James VI of Scotland and I of England. The first royal princess in England for fifty years, she was the focus of much attention and expectation. As a child, she was briefly in danger of abduction by the Gunpowder Plotters, who planned to place her on the throne as a Catholic puppet queen, after blowing up her father and older brother in the House of Lords.

At the age of sixteen, Elizabeth was married to Frederick, Elector Palatine, a German Protestant prince. Frederick took the disastrous decision to accept the throne of Bohemia in 1619, moving with Elizabeth from their palace in Heidelberg to Prague, where they reigned for less than a year before being ousted by the armies of the Catholic Habsburg emperor, Ferdinand. The rest of Elizabeth's life, much of it as a widow, was lived in exile in The Hague, where she became seen as a symbol of militant Protestantism: the tragic 'Winter Queen'.

The English artist Robert Peake (*c*.1551–1619) depicts the young princess with a fashionable high, wired hairstyle and wearing various expensive jewels, including a long diamond chain worn across her chest. The portrait advertises Elizabeth's wealth, beauty and status, using a pose associated from the early sixteenth century with potential royal brides. NPG 6113

ANNE OF DENMARK
(1574–1619)

ISAAC OLIVER, SIGNED IN MONOGRAM, *c*.1612
Watercolour and bodycolour on vellum
51 x 41mm

The daughter of Frederick II of Denmark, Anne married James VI of Scotland in 1589. Her early life with him appears to have been happy, although she involved herself in various unfortunate political manoeuvres, and suffered miscarriages. The removal of her eldest child, Prince Henry, shortly after his birth into the care of the Earl of Mar, however, created a rift between Anne and James. Six further children were born, although only Henry, Elizabeth and Charles (later King Charles I) lived beyond early childhood. After James's accession to the English throne as King James I in 1603, Anne had much greater funds at her disposal, and she became one of the most important cultural patrons of her day, commissioning artists, writers, composers and choreographers, and collecting paintings.

Anne appointed Isaac Oliver (*c*.1565–1617) as her limner, or miniature painter, in 1605. Oliver's stippled, shadowed style reflected developments in European art, and Anne's patronage of his work suggests that she preferred new, Continental styles to more distinctively English portraiture. She is shown here wearing some of the many expensive pieces of jewellery in her collection, including a crowned 'S', probably for 'Sophia'; Anne's mother was Sophia of Mecklenburg. NPG 4010

PROBABLY MARY, LADY SCUDAMORE
(d.1632)

MARCUS GHEERAERTS THE YOUNGER, DATED
12 MARCH 1614

Oil on panel

1143 x 826mm

When this portrait was acquired by the National Portrait Gallery in 1859, it was thought to represent Mary Sidney, Countess of Pembroke, a poet and translator and the sister of Sir Philip Sidney. However, there is very little evidence to support this identification, and the date inscribed so prominently (given according to the 'Old Style' calendar, in which the year changed on 25 March), as well as the family collection from which it came, suggest that it commemorates the marriage on 12 March 1615 of John, later Viscount Scudamore, to Elizabeth Porter. The most likely sitter seems to be the mother of the groom, Mary, Lady Scudamore; the wreath of flowers and motto 'No Spring Till now' reflect the hope and regeneration that the marriage represented to the family.

The painting is one of the finest works of the important artist Marcus Gheeraerts the Younger (1561/2–1636). Gheeraerts, from an immigrant Netherlandish family, worked in the later years of Elizabeth I's reign and during the reign of James I. NPG 64

GEORGE VILLIERS, 1st DUKE OF BUCKINGHAM
(1592–1628)

ATTRIBUTED TO WILLIAM LARKIN,
*c.*1616
Oil on canvas
2057 x 1194mm

George Villiers was the most notorious of James I's favourites: men admired by the King, with whom he developed what some regarded as unhealthily close and dangerously dependent relationships. Handsome and charming, Villiers was promoted rapidly at court, and as a duke and one of James's leading ministers, he had considerable power. An effective administrator in some areas and a knowledgeable collector of art, he was widely regarded as corrupt and extravagant, and was blamed for various military failures. He was assassinated by a disenchanted soldier at the age of thirty-six.

William Larkin (d.1619) was one of the most accomplished portrait artists of the Jacobean period. He and his studio painted a large number of dramatic full-length portraits, often including spectacular textiles, as well as more intensely focused head-and-shoulders portraits. Buckingham is depicted here in his lavish robes as a Knight of the Garter. NPG 3840

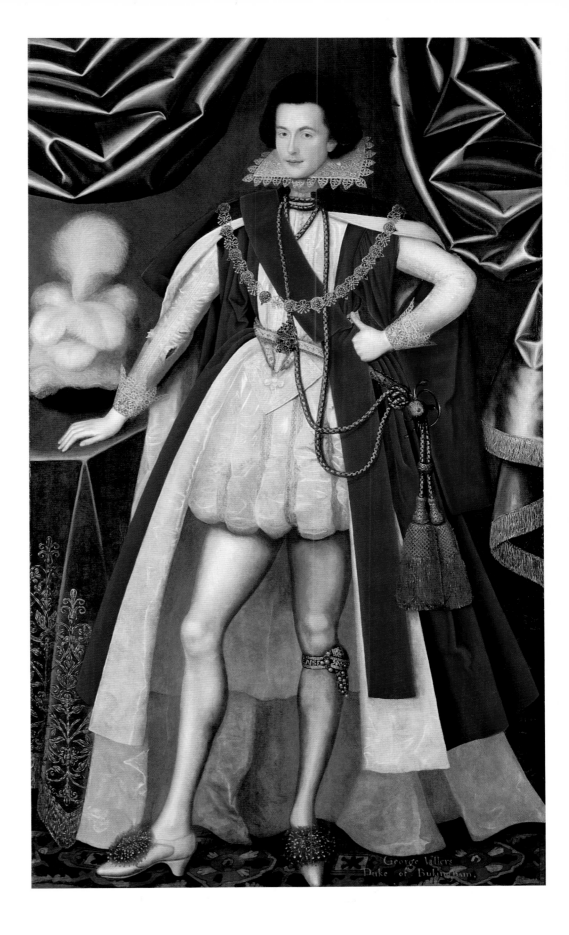

Miniatures

RAB MACGIBBON

Miniatures are small images designed to be held in the hand and looked at closely. The intimacy demanded by this viewing makes miniatures particularly suited to portraits and as tokens of friendship, loyalty and love. They were often mounted within a jewelled case, worn on the body, carried in a pocket or kept for private display within the home. The National Portrait Gallery Collection contains over 250 miniatures. They span a date range of over 400 years from the 1520s to the 1930s and represent the work of the finest miniaturists active in Britain during this time.

Miniature painting developed from the art of illuminated manuscripts and was originally called 'limning', a term that comes from the Latin *luminare*, 'to give light'. The later name 'miniature' did not originally mean 'small', but derives from the Latin word *minium*; the red pigment used in these illustrations. Like illuminated manuscripts, early miniatures were painted in watercolour on vellum (prepared animal skin). The vellum was stuck down on to a piece of playing card for support. In some cases these cards are still visible on the reverse. The colours used by artists were either bought ready-made or ground from raw materials in a painter's studio. These pigments were bound with gum arabic and water and then applied with very fine brushes, usually of squirrel hair.

The first independent miniatures to be made in Britain are believed to have been painted by Lucas Horenbout for the court of Henry VIII. One of the earliest surviving examples may well be the portrait of Henry's eldest child, Princess Mary (later Queen Mary I, above right), which forms part of the National Portrait Gallery Collection. Horenbout belonged to a family of artists from Ghent in the Low Countries, who were famed for their manuscript illuminations. The brilliant blue background to Mary's portrait is a legacy of the manuscript tradition and would become a hallmark of later miniatures. It is present in the work of Hans Holbein (pages 34 and 36), who may have been taught the art of miniature painting by Lucas Horenbout. Perhaps the most famous English miniaturist is

ABOVE

Mary I (1516–58), attributed to Lucas Horenbout. Watercolour on vellum, *c*.1521–5, 35mm diameter, NPG 6453 • The inscription painted on her bodice, meaning 'The Emperor', probably refers to Mary's engagement to the Holy Roman Emperor Charles V between 1521 and 1525.

Nicholas Hilliard, the great recorder of the Elizabethan court. His training as a goldsmith is evident in the technical mastery and clear linear style of portraits such as Mary Herbert, Countess of Pembroke (left). We know much about his practice and character from his *Treatise Concerning the Arte of Limning* (*c.*1600). Hilliard emphasised that the cleanliness and restraint demanded by miniature painting made it a genteel practice elevated above the dirt and clutter associated with other artists' work. Hilliard established it as a separate and highly specialised art form; one that, he asserted in his *Treatise* (*c.*1600), 'excelleth all other painting whatsoever'.

Hilliard's finest pupil, and later his rival, was Isaac Oliver. The French-born Oliver was more influenced by Continental art than his master. He employed perspective and shading to create a more illusionistic sense of a figure occupying space. The bust-length oval favoured by Hilliard remained the most popular format for miniatures, but artists also experimented with full-length and group compositions. Oliver appears to have painted some of the most ambitious examples, such as *Elizabeth I and the Three Goddesses* (below), known as a 'cabinet miniature' as this is how such relatively large miniatures may have been displayed.

ABOVE

Mary Herbert, Countess of Pembroke (1561–1621), by Nicholas Hilliard. Watercolour on vellum, *c.*1590, 54mm diameter, NPG 5994 •
The great literary patron is dressed in the height of fashion, with an elaborate cartwheel ruff and flowers in her hair.

RIGHT

Elizabeth I and the Three Goddesses, attributed to Isaac Oliver. Watercolour on vellum, *c.*1590, 115 x 157mm, NPG 6947 • This ambitious allegorical portrait flatters the Queen by showing her surpassing the combined virtues of Hera, Athena and Aphrodite.

Miniatures could be worn as a mark of royal favour or political loyalty. During the Commonwealth, Samuel Cooper painted numerous portraits of Oliver Cromwell (below), which could be given as diplomatic gifts. Cooper's bold application of paint and the suggestion of the sitter's psychology is far removed from the hard-edged style of Hilliard.

One hundred and fifty years later, the elements within Cooper's miniature are present, but with a very different effect, in Richard Cosway's portrait of George, Prince of Wales (later King George IV, below right). Cosway was a master of flattery, who invested his sitters with remarkable elegance and glamour. The sentimental potency of miniatures such as this could be heightened by setting a lock of the sitter's hair into the mount. Such intimate and private objects were frequently given as love tokens.

Oliver Cromwell (1599–1658), by Samuel Cooper. Watercolour on vellum, 1649, 57 x 48mm, NPG 5589 ● Painted within months of the execution of Charles I, this is the earliest and most flattering of Cooper's many portraits of Oliver Cromwell.

BELOW RIGHT

King George IV (1762–1830), by Richard Cosway. Watercolour on ivory, 1792, 70 x 57mm, NPG 5389 ● This miniature shows George as Prince of Wales in Van Dyck-style masquerade costume and a heavily powdered grey wig.

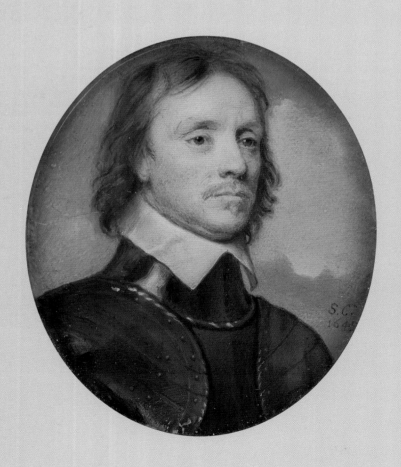

From the beginning of the eighteenth century vellum was replaced by ivory as the surface or support on which miniatures were painted. Oil on metal, plumbago (graphite drawing) and enamel were among the alternative materials employed by artists to produce miniatures. Artists such as George Richmond continued to develop the artistic and expressive qualities of miniature painting into the nineteenth century. However, the period in which he produced his finest works, such as the spiritually charged portrait of Samuel Palmer (right), coincided with the early development of photography. By the mid-nineteenth century miniatures had largely been replaced by photographs, and many miniaturists re-established themselves as photographers.

ABOVE

Samuel Palmer (1805–81), by George Richmond. Watercolour on ivory, 1829, 83 x 70mm, NPG 2223 • Richmond's vivid colouring amplifies the meditative intensity of this portrait of his friend and fellow painter Samuel Palmer.

BEN JONSON
(c.1573–1637)
ABRAHAM VAN BLYENBERCH, c.1617
Oil on canvas
470 x 419mm

One of the most successful playwrights and poets of the seventeenth century, Ben Jonson was probably more famous and celebrated during his lifetime than his contemporary William Shakespeare. He wrote a wide range of poetry and prose but is particularly known for his comedies, including *Every Man in His Humour* (1598), *Volpone* (1605) and *The Alchemist* (1610). He lived a turbulent life and was imprisoned several times for crimes including manslaughter, but found success in court circles as well as the public theatres. He was granted a pension by James I in 1616, and he wrote a series of court masques – elaborate allegorical entertainments involving dance, music, poetry and spectacular stage sets – under the patronage of Anne of Denmark.

Jonson was one of a small group of people painted by the Flemish artist Abraham van Blyenberch (1575/6–1624) during his visit to England between 1617 and 1621. Van Blyenberch's vigorous brushstrokes seem to capture something of Jonson's colourful character. All other known portraits of the playwright appear to derive from this one. NPG 2752

THOMAS HOWARD, 14TH EARL OF ARUNDEL
(1585–1646)

SIR PETER PAUL RUBENS, 1629
Oil on canvas
686 x 533mm

This outstanding portrait represents the most influential connoisseur of his age, Thomas Howard, Earl of Arundel. He was heir to one of the great noble families in England but at the time of his birth it had fallen into disrepute due to his father's involvement in Catholic plots against Elizabeth I. The Arundel title was restored by James I, and Howard rose to become one of Charles I's most trusted courtiers. His impact on English art was considerable; he owned the first major collection of classical antiquities in London and fostered the careers of the architect and theatre designer Inigo Jones, and the artists Wenceslaus Hollar and Anthony Van Dyck.

This portrait was painted in 1629, when the Flemish painter Peter Paul Rubens (1577–1640) was in London on a diplomatic mission. It was also during this visit that Rubens began work on the monumental ceiling paintings for the Banqueting House, Whitehall. Rubens admired Arundel's collections and, according to a letter to Arundel from his secretary, called him 'one of the four evangelists, and a patron of our art'. This portrait focuses on the sitter's imposing and dignified character. He wears the sash of the Order of the Garter and a glimmering suit of armour, befitting his status as Earl Marshal. NPG 2391

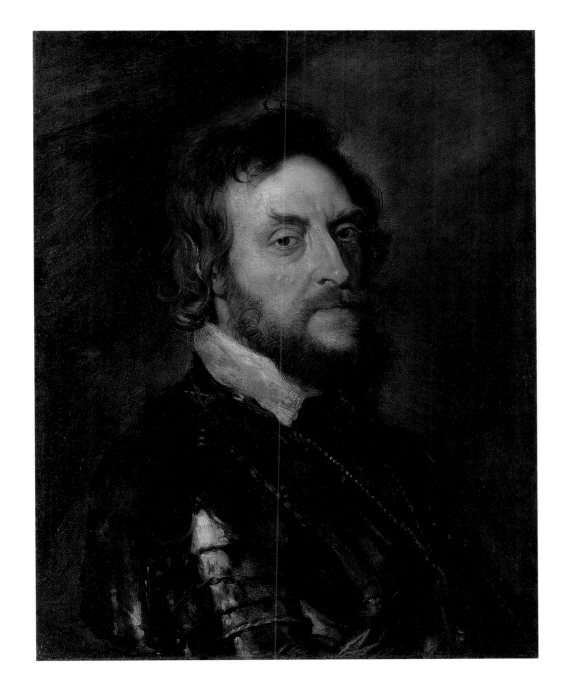

KING CHARLES I
(1600–49)

DANIEL MYTENS, 1631
Oil on canvas
2159 x 1346mm

The younger son of James I and Anne of Denmark, Charles became heir to the throne on the death of his brother Henry in 1612. He was a cultivated man and the greatest of all royal art patrons and collectors. However, Charles's unshakeable belief in the 'Divine Right of Kings' made him an inflexible ruler after he acceded to the throne in 1625. He dismissed Parliament in 1629 and ruled alone for eleven years. His imposition of taxes and attempts to impose religious uniformity led eventually to civil war. He was defeated and tried on the charge of 'traitorously and maliciously' levying war against his people, and was executed outside the Banqueting House, Whitehall, on 30 January 1649.

The Dutch artist Daniel Mytens (c.1590–1647) was appointed Picture Drawer to the King in 1625. This full-length portrait was painted early in Charles's period of personal rule. Mytens imbues the picture with a sense of restrained elegance and self-confidence. Although surrounded by symbols of royal authority – the crown, orb, sceptre and Solomonic column – Charles rests on a stick in an attitude of dignified ease. NPG 1246

PRINCE CHARLES, LATER KING CHARLES II (1630–85)

UNKNOWN ARTIST, DATED 1630
Oil on canvas
1207 x 933mm

The baby is identified as Prince Charles, the future King Charles II, by a contemporary inscription in French at the top of the painting, which gives his age as four months and fifteen days. His mother, Queen Henrietta Maria, described him at this time as 'so fat and tall that he is taken for a year old'. The portrait may have been painted for the baby's grandmother, Marie de' Medici, the French queen mother.

The cool, silvery colour scheme, with touches of scarlet, recalls contemporary descriptions of Charles's christening, at which all the guests were dressed in white satin with scarlet embroidery. The sumptuous cushion on which the baby is propped, the curtains to either side and the strong lighting in the painting are all probably intended to contribute a regal quality appropriate to a depiction of the heir to the throne. Charles holds a heavily jewelled rattle fitted with coral to ward off illness and for teething. An element of informality, and even humour, is contributed by the dog on his lap. The tiny spaniel – a breed that came to be associated with Charles as king – is held by the ear.
NPG 6403

HENRIETTA MARIA
(1609–69)
UNKNOWN ARTIST, WITH
BACKGROUND BY HENDRIK VAN
STEENWYCK THE YOUNGER, *c.*1635
Oil on canvas
2159 x 1352mm

The youngest daughter of Henry IV of France and Marie de' Medici, Henrietta Maria married Charles I in 1625. Small, vivacious and charming, she introduced the latest French fashions to the English court. Charles and Henrietta Maria were a devoted couple and had seven children. However, Henrietta Maria contributed to the unpopularity of the monarchy through her conspicuous Roman Catholicism and promotion of Catholic causes. She was actively involved in the civil wars by personally bringing munitions from France and pawning her jewellery to raise funds. She refused to leave England until the war had decisively turned against the King in 1644 and continued her attempts to muster European support for Charles until his execution in 1649. She briefly returned to England following the restoration of her son Charles II to the throne in 1660, before retiring to her native France.

The figure of Henrietta Maria in this portrait is by an unknown artist, though it is clearly influenced by Anthony Van Dyck (page 85). The architectural background was painted first and is probably by the Dutch painter Hendrik van Steenwyck the Younger (*c.*1580–1649). NPG 1247

VENETIA STANLEY, LADY DIGBY, AS PRUDENCE
(1600–33)

SIR ANTHONY VAN DYCK, *c.*1633–4
Oil on canvas
1011 x 802mm

This elaborate allegorical portrait depicts Venetia Stanley, a famous beauty who married Sir Kenelm Digby (1603–65), a courtier and a great friend and patron of the artist Anthony Van Dyck (1599–1641). Venetia's sudden death, aged thirty-three, prompted her grief-stricken husband to commission a number of memorials, including this portrait of her as Prudence. Kenelm Digby probably devised the symbolic programme himself, and it reflects his anxiety to restore Venetia's tarnished reputation. Before her marriage she was said to have been promiscuous, an accusation Digby passionately repudiated.

The joint themes of the painting are wisdom and innocence. The snake she holds in one hand and the pair of turtle doves by her other hand reflect a passage from the Gospel of St Matthew (10:16), 'Behold, I send you out as sheep in the midst of wolves; so be wise as serpents and innocent as doves'. Venetia places her foot on Cupid, symbolising her defeat of carnal love, and two-faced Deceit is chained to the rock on which she sits. Three heavenly cherubs hold a wreath above her head celebrating her triumph over vice. This unusually small-scale, complex composition, with its rich colouring and exquisite level of finish, is one of Van Dyck's finest English paintings. NPG 5727

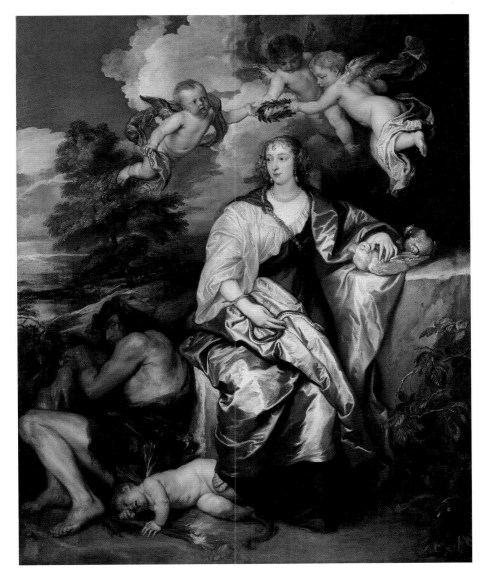

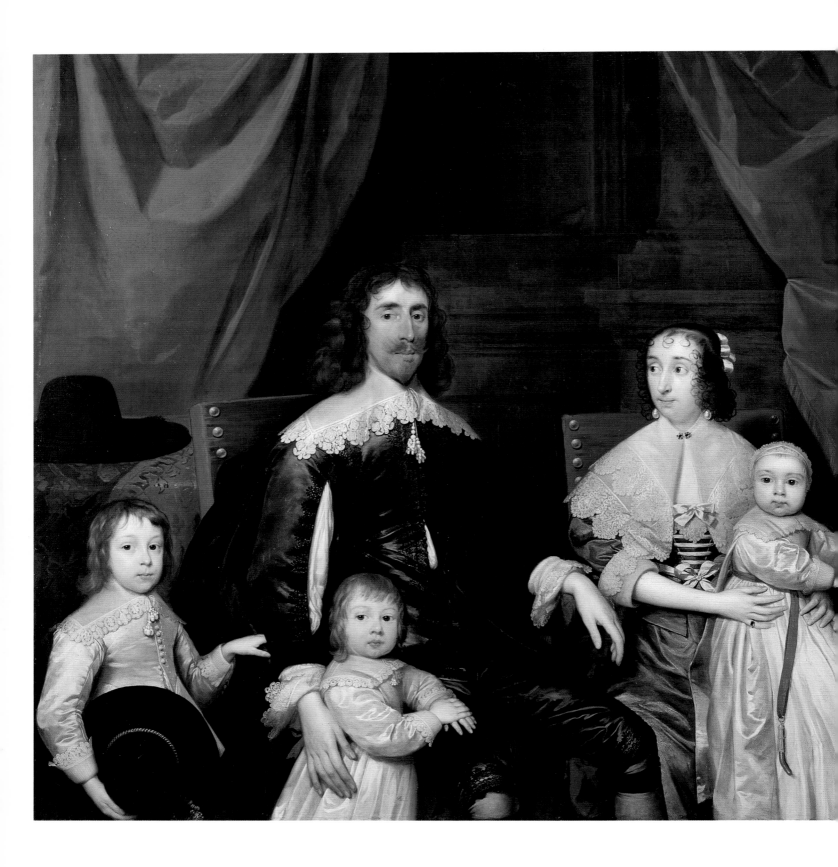

THE CAPEL FAMILY

(Arthur Capel, 1st Baron Capel of Hadham [1604–49], his wife Elizabeth Morrison, Lady Capel [d.1661], and their children: from left, Arthur, later Earl of Essex [1632–78], Charles [d.1657], the baby Henry, later Baron Capel of Tewkesbury [1638–96], Elizabeth, later Countess of Carnarvon [1633–78], and Mary, later Duchess of Beaufort [1630–1715])
CORNELIUS JOHNSON, *c.*1640
Oil on canvas
1600 x 2591mm

This grand family portrait shows Lord and Lady Capel, with five of their nine children, at a time when they were enjoying a comfortable life as one of the richest families in England. The gardens that form the backdrop are perhaps those of Little Hadham, the Capels' home.

The painter, Cornelius Johnson (1593–1661), the English-born son of an émigré Netherlandish family, was a fashionable and accomplished artist. This work shows the influence of Anthony Van Dyck's *Charles I and Henrietta Maria with Their Two Eldest Children* (1632, Royal Collection).

This peaceful scene belies the turbulence that was shortly to overtake the Capels. Initially opposed to Charles I's policies, Lord Capel became a Royalist during the civil wars in reaction to the violence of Parliamentarian views. He was captured and executed shortly after the King himself. His oldest son, Arthur, was later accused of involvement in the Rye House plot of 1683 (a plan to assassinate Charles II and his brother James, Duke of York), and died in suspicious circumstances while imprisoned in the Tower of London. Henry Capel, however, was a successful politician who also created a garden at Kew, the beginnings of the Royal Botanic Gardens; Elizabeth became a talented botanical artist; and Mary was a distinguished horticulturalist. NPG 4759

JOHN EVELYN
(1620–1706)

ROBERT WALKER, 1648
Oil on canvas
879 x 641mm

John Evelyn's wide-ranging interests make him difficult to define; although he held various public positions, his most important contributions were his writings on subjects as diverse as coins and medals, tree cultivation, refrigeration and religion. A founder member of the Royal Society, Evelyn remained true to its ideals, which encompassed what would now be regarded as the arts and sciences. He kept a diary, which, unlike that of his friend Samuel Pepys, was intended to be more about public record than personal revelation.

At the age of twenty-six, Evelyn married the twelve-year-old Mary Browne, then resident with her family in Paris. The couple did not live under the same roof for another three years, and it was during their time apart that Evelyn had this striking portrait painted by the English artist Robert Walker (d.1658), probably to accompany a treatise on marriage that he had written for Mary. Originally he was shown holding a miniature portrait in his left hand, probably of Mary; this was later replaced by the skull, accompanied by the Greek motto, 'Repentance is the beginning of Wisdom', and a Latin quotation from Seneca, which can be translated as: 'He cannot with cheerfulness and joy receive his death, unless he bestowed much time and care in preparations against that sad solemnity.' NPG 6179

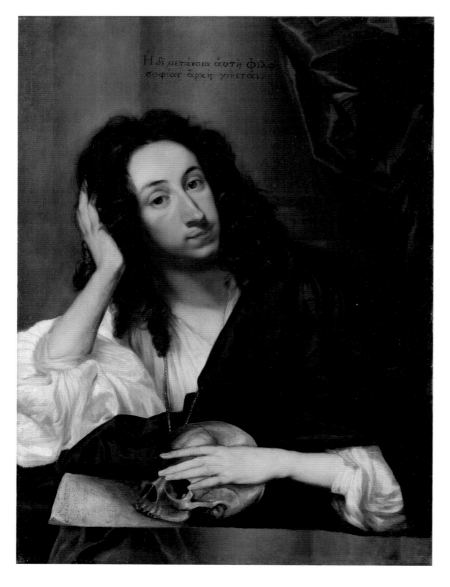

SIR ANTHONY VAN DYCK
(1599–1641)

SELF-PORTRAIT, *c*.1640
Oil on canvas
5970 x 4730mm

Anthony Van Dyck was by far the
most influential painter to have
worked in Britain during the
seventeenth century, and arguably
the most influential portrait painter
ever to work in this country. Flemish
by birth, he found patronage in a
number of European cities, but
his longest stay was in England,
which he made his home from the
beginning of his second visit in
1632 until his death in 1641. Van
Dyck decisively turned British
portraiture away from the stiff,
intricately detailed, formal approach
of Tudor and Jacobean painting,
developing a distinctive fluid,
shimmering style that was to
dominate portraiture in Britain
right up until the early years of the
twentieth century. He was knighted
by Charles I on his arrival in
England and appointed Principal
Painter to the King; he achieved
a status that marked him out as
the first British 'celebrity' painter.

This is one of three known
self-portraits painted by Van Dyck
during his time in Britain. He
shows himself fashionably dressed
but apparently in the act of painting,
the line of his arm suggesting
his hand raised in the process of
applying paint to a canvas. The
marked contrast between the broad,
rapid, confident handling of the
costume and the high level of finish
in the face may suggest that the
costume is unfinished, or it may
be that this self-portrait is simply
more experimental than his grand,
commissioned portraits. NPG 6987

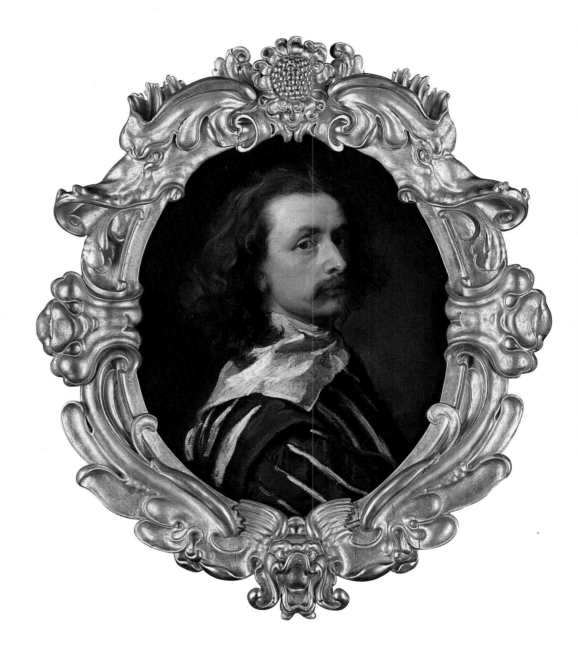

OLIVER CROMWELL
(1599–1658)
ROBERT WALKER, *c.*1649
Oil on canvas
1257 x 1016mm

Oliver Cromwell rose from the position of a country gentleman to become a leading statesman, soldier and finally head of state as Lord Protector (1653–8). His political and military career were shaped by strongly held religious beliefs. As a Puritan, he was distrustful of Charles I and felt that the Church of England was insufficiently Protestant. As the country descended into civil war, Cromwell emerged as a natural leader, and his military skill was a decisive factor in the Parliamentarian victory. Following the execution of the King in 1649, he led the New Model Army in brutal campaigns in Ireland and Scotland. He refused the crown in 1657 and his death left a power vacuum that would only be filled by the restoration of the monarchy in 1660.

This portrait was painted soon after the execution of the King at a time when the new regime was searching for appropriate forms of self-representation. The solution provided by Robert Walker (d.1658) was to base Cromwell's portrait on elements taken from Anthony Van Dyck's portraits of Charles I's court. Cromwell's armour, baton and the sash being tied around his waist by an attendant are all symbols of military command, borrowed from the regime that he has just overthrown. NPG 536

BARBARA VILLIERS, DUCHESS OF CLEVELAND (1640–1709), WITH HER SON, PROBABLY CHARLES FITZROY, LATER DUKE OF SOUTHAMPTON AND DUKE OF CLEVELAND (1662–1730)

SIR PETER LELY, SIGNED *PLely*, *c*.1664
Oil on canvas
1250 x 1020mm

A household name in her day, Barbara Villiers was the mistress of Charles II for the first decade of his reign. Charles acknowledged five of her six children as his own. Famous for her beauty and her 'sleepy' eyes, she was despised by many for her lifestyle and came to symbolise the excess and promiscuity of the Restoration court. As a means of access to the King, she had some political influence and is thought to have both made and broken political careers. Charles created her a duchess in her own right, and her sons were created dukes.

The artist Peter Lely (1618–80) was the leading portrait painter of the day and the King's Principal Painter. Barbara Villiers was his muse and, according to the diaries of the antiquarian Thomas Hearne, Lely is said to have stated 'that it was beyond the compass of art to give this lady her due, as to her sweetness and exquisite beauty'. Lely painted her in a wide range of roles, as Minerva, St Catherine, St Barbara, a shepherdess, and here, most audaciously, as the Virgin Mary, with her child – probably her eldest son by the King – as the Christ Child. NPG 6725

MARY BEALE
(1633–99)
SELF-PORTRAIT, c.1665
Oil on canvas
1092 x 876mm

Mary Beale is a very rare example of a seventeenth-century woman who became a professional artist. Her husband Charles's job was insecure, so, after a period of time in which she supplemented the family income by painting mainly for friends, she and Charles decided that she should set up in professional practice with Charles as her studio manager and assistant. He kept a series of notebooks recording commissions, sittings, payments and much else; the two surviving volumes are an important source of information about seventeenth-century studio practice. Mary also wrote a manuscript, 'Essay on Friendship', in which she argued for equality between men and women, both in friendship and in marriage.

Mary depicts herself in this painting in what she would have regarded as her two primary roles: as a painter and a mother. The unfinished canvas she holds shows the heads of her two young sons, Bartholomew and Charles. Although her palette hangs on the wall beside her, she is dressed not as a working painter but in the kind of deconstructed gown made fashionable in court portraiture by her friend Sir Peter Lely, Principal Painter to the King (page 87). NPG 1687

SAMUEL PEPYS
(1633–1703)
JOHN HAYLS, 1666
Oil on canvas
756 x 629mm

Samuel Pepys was an important
naval administrator, but he is
best known for his *Diary*, an
extraordinary record of his life
in Restoration London. Lively,
intimate and full of fascinating
detail, it begins in 1660 and it ends
nine years later when the author
believed (mistakenly) that he was
going blind. As well as chronicling
the minutiae of his everyday life,
it includes eye-witness accounts of
important historical events, such
as the Great Plague of 1665 and
the Great Fire of London in 1666.
Pepys records not only his visit to
inform Charles II about the fire,
but also the burial of his precious
cheese in his garden to save it from
burning.

Pepys described in his *Diary* the
process of sitting for this portrait by
John Hayls (*c.*1600–79), writing on
17 March 1666: 'I sit to have it full
of shadows and do almost break my
neck looking over my shoulders to
make the posture for him to work
by.' His gown was hired especially
for this portrait, and the music he
holds is his own composition, a
setting of a poem by William
Davenant, 'Beauty, Retire'.
NPG 211

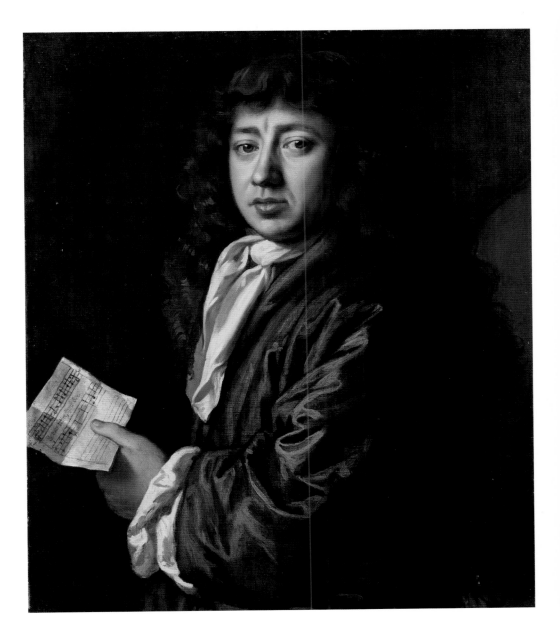

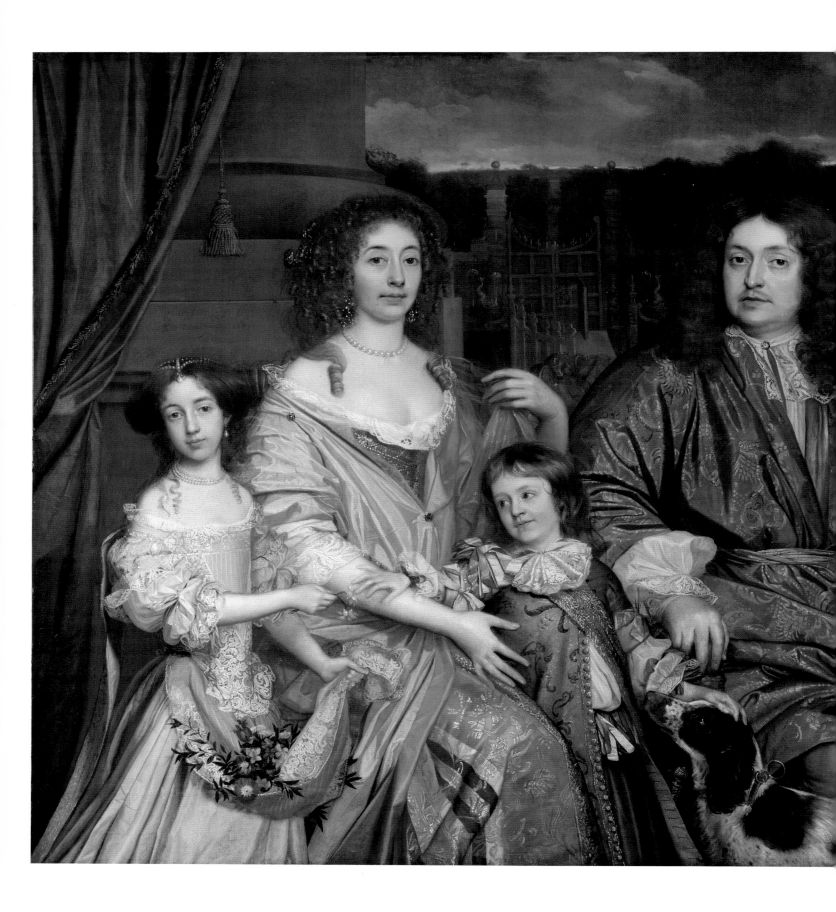

THE VYNER FAMILY

(Sir Robert Vyner [1631–88], his wife Mary [d.1674], their son Charles [*c.*1666–88], and Mary's daughter by her first marriage, Bridget Hyde, later Duchess of Leeds [1662–1734])

JOHN MICHAEL WRIGHT, 1673

Oil on canvas

1448 x 1956mm

This sympathetic group portrait depicts a leading goldsmith and banker of the late seventeenth century, Sir Robert Vyner, and his family. The artist's positioning of the children illustrates the family relationships; the setting is probably Swakeley's, the Vyners' house in Middlesex. The family fortunes were to fall dramatically in the years after this portrait was painted. Lady Vyner died on New Year's Day, 1675; her daughter Bridget was kidnapped in that year as part of a tussle between two rival suitors; Sir Robert's enormous loans to Charles II led to his bankruptcy in 1684; and finally his son Charles died as a young man in 1688. Sir Robert himself died shortly afterwards, allegedly of a broken heart.

John Michael Wright (1617–94) was one of the most talented and original portrait painters working in England in the second half of the seventeenth century. Much of the portraiture of this period tends to make both male and female sitters conform to a fashionable type, with idealised features and simplified, classically influenced costumes. Wright resisted this tendency; his sitters look like distinctive individuals and their elaborate, embroidered clothing represents actual court dress. NPG 5568

NELL GYWN
(*c.*1651–87)
SIMON VERELST, *c.*1680
Oil on canvas
737 x 632mm

Perhaps the most famous name of the Restoration court, Nell Gwyn was also one of the first women to act on the public stage. Apparently working first as an orange-seller outside the theatre, she began acting in the mid-1660s and was much admired for her comic roles. She caught the attention of the diarist Samuel Pepys, who described her as 'pretty witty Nell', but, more importantly, she was introduced to Charles II and became his mistress. She had two sons by him: Charles, later Duke of St Albans, and James. The King bought her a house in Pall Mall, paid her a pension and is said to have remembered her on his deathbed with the words 'Let not poor Nelly starve'.

Simon Verelst (*c.*1644–*c.*1710) was a Dutch artist who arrived in England as a specialist flower painter but appears to have soon turned to portraiture. He painted most of the prominent figures at court at least once, using distinctive strong lighting contrasts, rather simplified modelling and bold colours. His theatrical style perhaps particularly suited Nell Gwyn, whose portrait he painted on a number of occasions and in different poses. NPG 2496

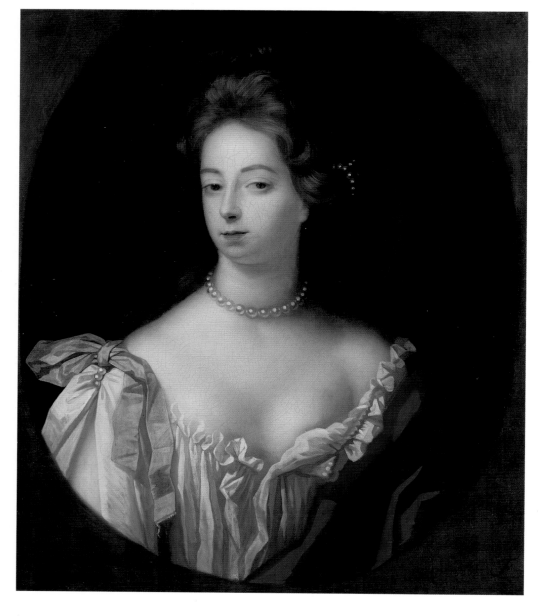

KING CHARLES II
(1630–85)

ATTRIBUTED TO THOMAS HAWKER,
*c.*1680
Oil on canvas
2267 x 1356mm

Cynical and lazy, but also clever
and charming, Charles II has always
divided opinion. He is remembered
for his numerous mistresses and
illegitimate children and his secret
treaty with France, but also for
his interest in and support for
the development of science and
technology, and his popularity
and ease with ordinary people.
He was shaped by experience: his
childhood was hugely disrupted by
civil war, and he spent most of his
youth in exile on the Continent,
returning to ascend to the throne at
the age of thirty in 1660, after the
failure of the Commonwealth.

 Very little is known about the
artist Thomas Hawker (died
*c.*1722), who worked in the style
of Sir Peter Lely, probably mostly
after the Principal Painter's death
in 1680. Hawker's depiction of the
King seems to reveal something
of the effects of Charles's rather
dissolute and unsettled life; he
looks magnificent but also rather
jaded and tired. NPG 4691

HENRY PURCELL
(1659–95)

JOHN CLOSTERMAN, *c.*1695
Black chalk heightened with white
381 x 286mm

Henry Purcell was the pre-eminent composer of the Restoration period and is celebrated as the father of modern music in England. As a child, he showed prodigious talent, writing an ode for the birthday of Charles II in 1670. He was appointed Composer in Ordinary to the King aged eighteen, organist of Westminster Abbey at twenty and of the Chapel Royal three years later. He composed music for the coronations of James II in 1685 and William III and Mary II in 1689, and collaborated with the poet John Dryden on music for the theatre. His greatest works are the operas *Dido and Aeneas* (1689) and *The Fairy Queen* (1692). He died aged thirty-seven and is buried near the organ at Westminster Abbey.

This chalk drawing by the German artist John Closterman (1660–1711) was probably made in the final year of Purcell's life. It is Closterman's only known portrait sketch and the earliest surviving drawing of an English composer. An oil painting relating to this study is also in the Gallery's Collection (NPG 1352). The drawing once belonged to the music historian Dr Charles Burney. NPG 4994

SIR ISAAC NEWTON
(1642–1727)

SIR GODFREY KNELLER, 1702
Oil on canvas
756 x 622mm

One of the greatest of all scientists
and thinkers, Isaac Newton was
the most important influence on
theoretical physics and astronomy
before Albert Einstein. His wide-
ranging achievements include
theories concerning light, colour
and calculus. His most significant
contribution to scientific thought is
the theory of universal gravitation,
an idea that supposedly first came
to him when he saw an apple
falling from a tree. His most
important theories were published
in two seminal works: *Mathematica
Principia* (1687) and *Opticks* (1704).
He was knighted by Queen Anne
in 1705 and presided over the Royal
Society from 1703 until his death.

This portrait was painted when
Newton, aged sixty, and Godfrey
Kneller (1646–1723), aged fifty-six,
were at the indisputable pinnacle
of their respective professions.
The picture is conventional in
almost every sense – the head-and-
shoulders composition, the wig
and the arbitrary swathe of drapery.
However, Kneller's vigorous,
swift handling gives the picture an
exceptional vividness and expressive
quality, while the piercing intensity
of Newton's gaze provides a sense
of the sitter's genius. NPG 2881

JOHN CHURCHILL, 1ST DUKE OF MARLBOROUGH
(1650–1722)

SIR GODFREY KNELLER, *c.*1706
Oil on canvas
927 x 737mm

The soldier and statesman John Churchill played a decisive role in shifting the balance of European power towards Britain in the early eighteenth century. Handsome and charming, his early career was advanced under the patronage of James, Duke of York. When the Duke acceded to the throne as James II in 1685, Churchill helped crush the Duke of Monmouth's rebellion. Three years later, his desertion of the King helped to ensure a smooth transition of power to William III and Mary II. His influence reached its height under Queen Anne. He was undefeated as Commander-in-Chief of the allied forces in the War of the Spanish Succession, during which his remarkable series of victories against the French included the battles of Blenheim (1704) and Ramillies (1706). He was dismissed by a war-weary government in 1711.

This brilliant oil sketch by the German artist Godfrey Kneller (1646–1723) is presumably the study for a large-scale allegorical painting that was never completed. An imperious Marlborough is shown trampling a wretched figure of Discord and the sunburst shield of Louis XIV of France. To his right, no less a figure than Hercules looks up admiringly, while above, Victory crowns him with a laurel wreath.
NPG 902

SIR CHRISTOPHER WREN
(1632–1723)

SIR GODFREY KNELLER, 1711
Oil on canvas
1245 x 1003mm

The great architect Christopher Wren first came to prominence as an astronomer and mathematician. He pioneered optics, making telescopic observations of the moon, and was the first Englishman to draw creatures with the aid of a microscope. His career changed dramatically with the Great Fire of London in 1666, after which he devoted himself to architecture. He was commissioned to rebuild St Paul's Cathedral and dozens of the City churches destroyed by the fire. This vast project occupied Wren's office for decades and enabled him to define his era to a degree unique in English architecture. A man of astounding talent and productivity, other major works include the Sheldonian Theatre, Oxford (1669), Chelsea Hospital (1692), Trinity College Library, Cambridge (1695) and the Royal Naval Hospital, Greenwich (1712).

This portrait of Wren celebrates the completion of his masterpiece, St Paul's Cathedral, in 1711. Godfrey Kneller (1646–1723) presents the seventy-nine-year-old Wren in a flattering manner. He looks suitably proud of his achievement, which is alluded to by the pair of dividers in his hand, the copy of *Euclid* and a plan of the new cathedral. NPG 113

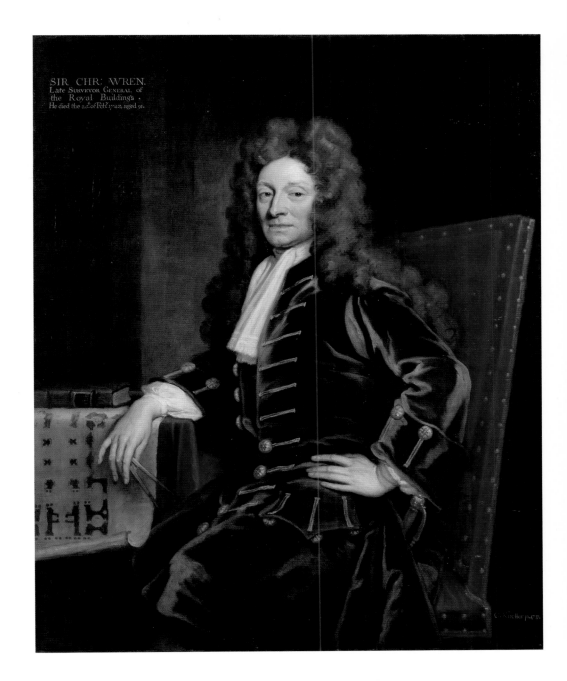

SIR CHR: WREN.
Late SURVEYOR GENERAL of the Royal Buildings .
He died the 25 of Feb 1723, aged 91.

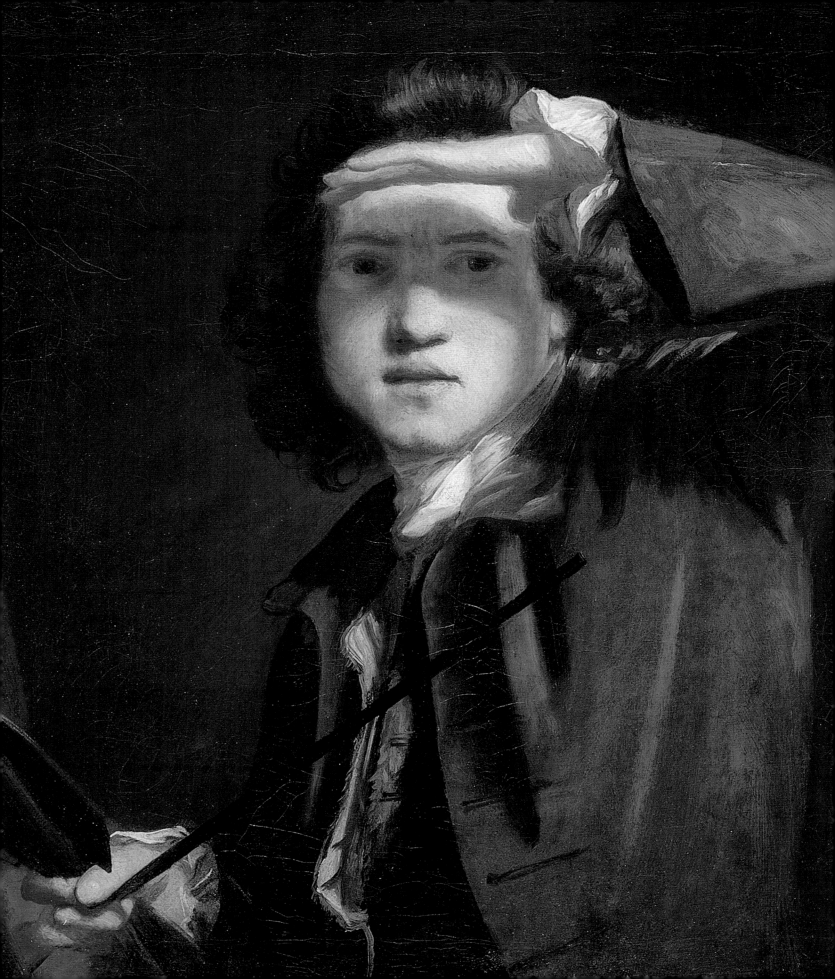

CHAPTER 3

Georgian Portraits

1714–1837

Portraits of some of the leading men and women from the 'long eighteenth century' (1700–1837) reveal much about Britain as it became a world power, an industrial giant and a dynamic commercial society. The crowning of George I in 1714 marked the start of the Georgian era and secured a Protestant succession. However, this triggered unrest among Jacobites, the supporters of the Catholic Stuart dynasty. Portraits served as rallying points and diplomatic gifts for the Stuart court in exile – for example, the flamboyant picture of 'Bonnie Prince Charlie', James II's grandson, painted in Rome (page 102). Following an uprising led by Prince Charles Edward Stuart, the Jacobites were defeated at the Battle of Culloden in 1745, ending all Jacobite claims.

As Britain dealt with the constitutional threat, it entered a period of rapid financial growth and increasing political stability. New-found prosperity prompted social mobility and the emergence of a 'middling sort' composed of successful merchants, entrepreneurs and professionals. With the aristocracy, they formed a hungry market for portraiture – the most popular art form in the eighteenth century. In 1755, Jean André Rouquet, a French miniaturist working in London, wrote in his book *The Present State of the Arts in England*, 'how fond the English are at having their pictures drawn'. His friend, William Hogarth, was frustrated nevertheless by the way British patrons favoured the work of foreign artists. To counter this, he helped establish the Saint Martin's Lane Academy and the Engraver's Copyright Act in 1735. This went some way towards protecting and promoting the interests of British artists. Sharing his fellow artists' ambition for professional status, Hogarth depicted himself in genteel dress drawing the classical muse of comedy to assert the intellectual and moral value of the comic history painting in which he specialised (page 106).

The interests of Britain's artists were advanced further by the foundation of the Royal Academy in 1768 under the presidency of the portraitist Joshua Reynolds. His ambition and originality can be seen in the youthful self-portrait painted just before he travelled to Italy in 1748 (page 103). Influencing the art world through his *Discourses*, and with his painting, he set out to elevate the status of portraiture in relation to the more highly regarded genre of history painting. He did this by promoting the ideal over individual likeness and by creating 'Grand Manner' portraiture that incorporated references to historical or classical sources, or Old Master paintings. This approach was influential and enduring and can be seen, for example, in William Beechey's portrait of the actress Sarah Siddons with the emblems of Tragedy (page 115).

Portraiture was a competitive business and the most successful artists understood the need to run a fashionable studio and paint works that dominated the crowded hang at the Royal Academy exhibition. Unusual compositions, bold

colouring, large canvases and notable sitters all helped win attention for leading artists such as Reynolds, Thomas Gainsborough and, in the next generation, Thomas Lawrence. There was also money to be made from painting the leading celebrities of the day. Reynolds's portrait of Joseph Banks (page 110) was executed without commission, suggesting that the artist expected to profit from the sale of its engraving. The portrait brilliantly captures the restless spirit and enquiring mind of this wealthy explorer and natural historian who had just returned from Captain Cook's voyage of discovery to the South Pacific.

While Australia became part of Britain's expansion overseas, America was lost after the War of Independence (1775–83). George III was devastated and, in 1785, he experienced his first bout of the hereditary disease porphyria, the symptoms of which were interpreted as insanity. It was then that the King's eldest son George, Prince of Wales, first asserted his right to be Regent.

As a period in Britain's constitutional history, the Regency lasted less than ten years, beginning in 1811 when George III finally withdrew from public life. As a distinctive and dynamic period in Britain's social and cultural life, the Regency lasted from the start of the French Revolution in 1789 to the death of William IV in 1837. As a result of the long wars fought against Revolutionary and Napoleonic France (1792–1815), a cult of patriotic heroism spread through Regency society and painting and sculpture became central to the creation and commemoration of war heroes such as Lord Nelson and the Duke of Wellington (pages 118–19).

The Regency fascination for individual lives did not stop with these heroes. Authors such as Jane Austen (page 125) wrote about private life and the situation of women. In a letter dated 16–17 December 1817, Austen modestly compared her work to painting literary miniatures on 'a little bit of ivory'. The Romantics also proposed new ideas about individuality, genius and humanity. Mary Wollstonecraft and William Wordsworth (pages 116 and 129) imagined the dawning of a new age of equality with the outbreak of the French Revolution in 1789. As a conservative backlash against the Revolution strengthened, younger Romantic poets such as Keats, Shelley and Byron (pages 126–8) adopted radical positions against oppressive legislation at home and abroad. While the first two were depicted only by friends, Byron was painted often and constructed his exotic image carefully, conscious of what Samuel Taylor Coleridge called, in his *Biographia Literaria* of 1817, 'this Age of Personality'.

Each of these idealistic poets died early, but would have been pleased when the Whigs swept to power on a platform of social and electoral reform, initiated in 1832 by the Great Reform Act and, in 1833, by the ending of slavery at home and in the colonies.

Lucy Peltz

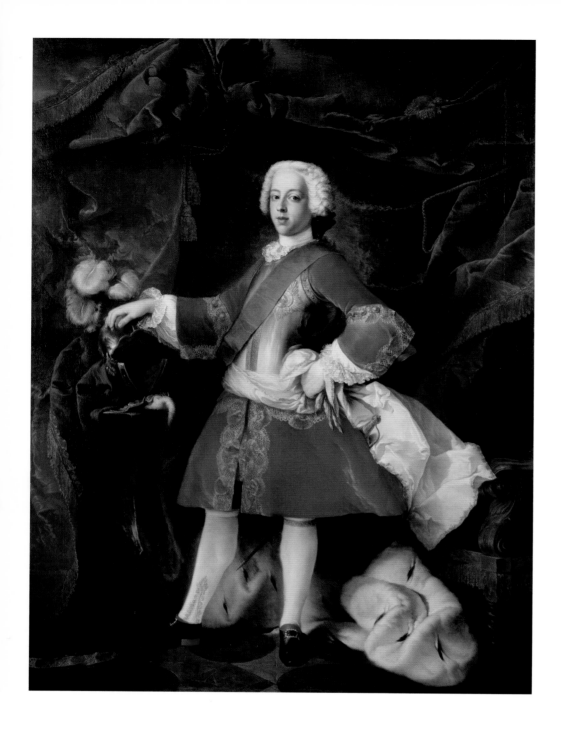

PRINCE CHARLES EDWARD STUART
(1720–88)

LOUIS GABRIEL BLANCHET, SIGNED
AND DATED 1738
Oil on canvas
1905 x 1410mm

Born in Rome, Prince Charles
Edward Stuart – also known as
'Bonnie Prince Charlie' and the
'Young Pretender' – was the
grandson of James II, who had
been deposed from the British
throne in 1688, largely because
of his Catholicism. The Stuart
royal family lived in exile, moving
around the courts of Europe and
attempting to assert their claims
to the British throne. Portraiture
in a variety of media played an
important role by serving as a
rallying point for their so-called
'Jacobite' supporters in Britain
and elsewhere.

In this flamboyant portrait,
painted in Rome by the French
artist Louis Gabriel Blanchet
(1705–72), Prince Charles is shown
aged seventeen wearing royal
regalia and armour as a projection
of Jacobite ambition, identity
and military intentions. In 1745,
seeking to reclaim the British
throne, Charles landed in Scotland
and led a rising of Highland
clansmen as far south as Derbyshire
but, forced to turn back, many of
his men were massacred by the
better-equipped British troops at
the Battle of Culloden. Charles
fled, disguised as a maidservant and
assisted by his loyal supporter Flora
Macdonald. He evaded capture and
eventually escaped to France but
his hopes of regaining the throne
were crushed. He died in exile in
1788. NPG 5517

SIR JOSHUA REYNOLDS
(1723–92)

SELF-PORTRAIT, c.1747–9
Oil on canvas
635 x 743mm

The artist Joshua Reynolds was the leading portrait painter in eighteenth-century Britain and the first President of the Royal Academy of Arts. In his attempt to elevate the status of portraiture, he invented a style known as the 'Grand Manner' by borrowing from classical antiquity and the Old Masters to invest his portraits with moral and heroic symbolism. Although a prolific self-portraitist, he was determined to raise the social status of the arts and usually presented himself as a gentleman, or 'man of letters'. This early painting is unique, however, in depicting him at work, clothes loosened and displaying the tools of his trade: a canvas, palette and brushes. Painted just before he left for a formative trip to Italy, this portrait conveys Reynolds's confidence in his talents and ambitions for the future. The use of chiaroscuro – strong contrast of light and dark – indicate his life-long appreciation of Rembrandt, the most revered master of self-portraiture. The landscape format and pose are also unusual, no doubt a bid by the artist to showcase his versatility and inventiveness: his contemporary and chief rival Thomas Gainsborough allegedly once exclaimed: 'Damn him, how various he is!' NPG 41

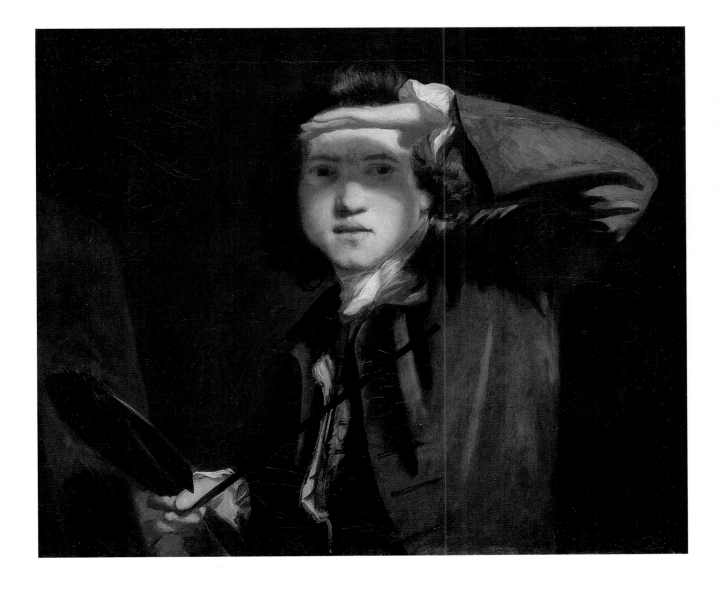

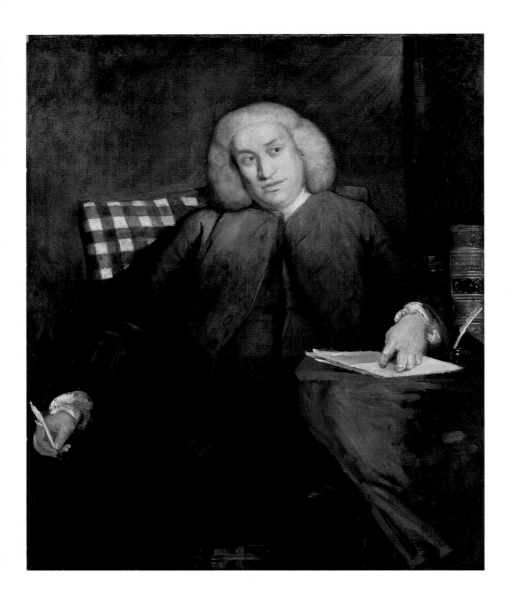

SAMUEL JOHNSON
(1709–84)
SIR JOSHUA REYNOLDS, 1756–7
Oil on canvas
1276 x 1016mm

This portrait of the poet Samuel Johnson, by his close friend Joshua Reynolds (1723–92), was painted shortly after the publication of Johnson's *Dictionary of the English Language* (1755). While not the first dictionary of English to appear, Johnson's work was by far the most ambitious, and his infamous wit and intellect shone through the definitions, making it his most celebrated work. The success of this project was hard won. In 1737, when Johnson first came to London from Lichfield, he was so poor that, for the journey, he had to share a horse with his friend, the actor David Garrick. Johnson would become acclaimed as an essayist, critic, biographer and editor, despite suffering greatly from nervous tics and recurrent bouts of depression. A man who also could not bear solitude, he was a most entertaining conversationalist and intellectual with a wide circle of friends. Reynolds founded the Literary Club in 1764 to give Johnson unlimited opportunities for talking.

This portrait remained unfinished in Reynolds's studio until after Johnson's death. In 1789 it was given to Johnson's close friend and biographer James Boswell, who was looking for the most incisive likeness of the writer to engrave for the frontispiece of his *Life of Samuel Johnson* (1791), the book that secured Johnson's enduring reputation. NPG 1597

GEORGE FRIDERIC HANDEL
(1685–1759)

THOMAS HUDSON, SIGNED
T. Hudson Pinxt AND DATED 1756
Oil on canvas
2388 x 1461mm

Born in Saxony, the composer
George Frideric Handel worked in
Halle, Hamburg, Italy and Hanover
before settling in London, finally
becoming a British citizen in 1727.
He quickly became established in
Britain, composing a succession
of operas beginning with *Rinaldo*
(1711) and writing church music for
the Chapel Royal. His orchestral
scores include *Water Music*,
performed from barges on the
Thames for George I in 1717, and
Music for the Royal Fireworks (1749).
One of his greatest achievements,
however, was popularising the
oratorio, a sort of religious musical
drama. Handel's most famous
oratorio is *Messiah*, which was
composed in twenty-four days. First
performed in Dublin in 1742, it
became a national institution within
Handel's lifetime.

The lasting fame of *Messiah*
is represented in this portrait
by Thomas Hudson (1701–79),
painted in 1756 for Charles
Jennens, the librettist of many
of Handel's works, including this
oratorio. The score is depicted on
the table in front of the composer,
despite the fact that by the time
of this painting Handel had gone
blind. In 1967, this important
portrait was the subject of the
National Portrait Gallery's first
public appeal. NPG 3970

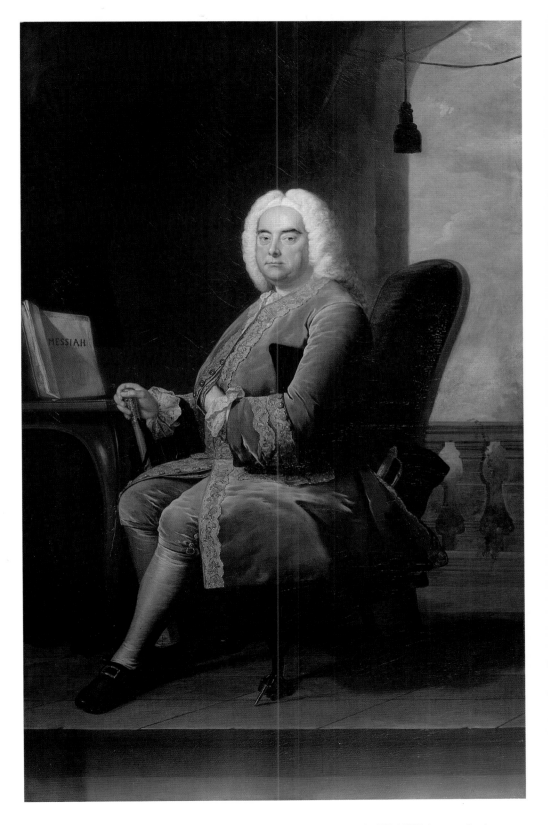

WILLIAM HOGARTH
(1697–1764)
SELF-PORTRAIT, 1758
Oil on canvas
451 x 425mm

William Hogarth was one of the most important
artists in eighteenth-century Britain. Renowned for
his satirical paintings and engravings, he was also a
talented and sensitive portraitist, painting mostly small-
scale conversation pieces depicting family groups in
domestic environments. His 'modern moral subjects',
such as *The Harlot's Progress* (1731) or the 'Election'
series (1755–8), demonstrate his personal mission
to establish modern life, including low subjects,
as an appropriate matter for high art. He was also

determined to improve the status of British art against
the prevailing taste for Old Master paintings and the work
of Continental artists. To do this he helped establish the
Saint Martin's Lane Academy (1735) and instituted the
Engraver's Copyright Act (1735) to protect artists' work
from piracy. His theoretical art treatise *The Analysis of
Beauty* (1753) challenged established academic theory
by promoting 'variety' and nature over the ideal.

This informal self-portrait shows him painting Thalia,
the classical Muse of Comedy, in a composition that
asserts the intellectual and moral value of the comic
history painting in which Hogarth specialised. X-rays
reveal that the picture originally contained a nude
model instead of his easel, and the painter's dog
urinating on a pile of Old Master paintings to signify
his commitment to working from nature. NPG 289

THOMAS GAINSBOROUGH
(1727–88)

SELF-PORTRAIT, *c*.1758–9
Oil on canvas
762 x 635mm

Thomas Gainsborough was, with Joshua Reynolds, the leading portrait painter in eighteenth-century Britain. Nevertheless, he felt trapped by his profession and preferred to paint landscapes: 'If the People with their damn'd Faces could but let me alone a little,' he recorded in a letter of 25 May 1768 to his friend James Unwin. Often Gainsborough managed to combine the two, as seen here, by introducing hints of landscape into the backgrounds of his portraits. In a period when idealisation was highly prized in portraiture, Gainsborough eschewed references to classical and Renaissance art and chose to paint his sitters in contemporary fashions. He also regarded likeness to be 'the principal beauty and intention of a portrait', as he stated in a letter of 13 April 1771 to William, 2nd Earl of Dartmouth. Unusually among his peers, he painted the costumes and backgrounds of his portraits without the use of assistants, employing the distinctive six-foot-long paintbrushes with which he achieved his feathery style of painting.

In contrast to Reynolds, his main rival in portraiture, Gainsborough was modest, informal and amiable. This early self-portrait, which depicts him with an unpretentious and direct gaze, was painted shortly before he moved to Bath, where he established a fashionable studio in 1759. NPG 4446

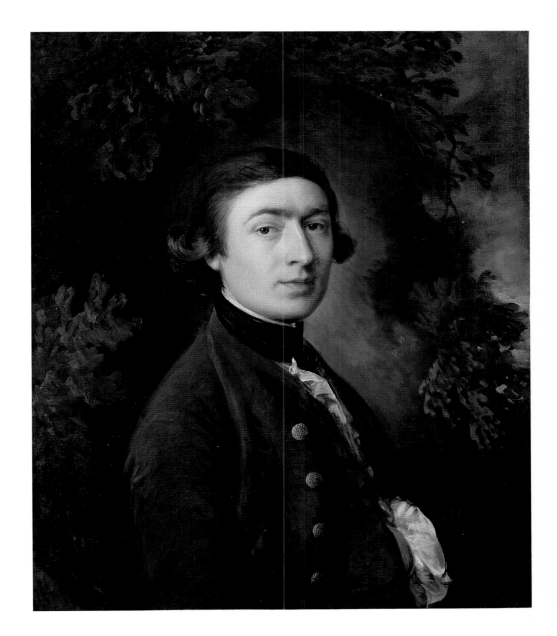

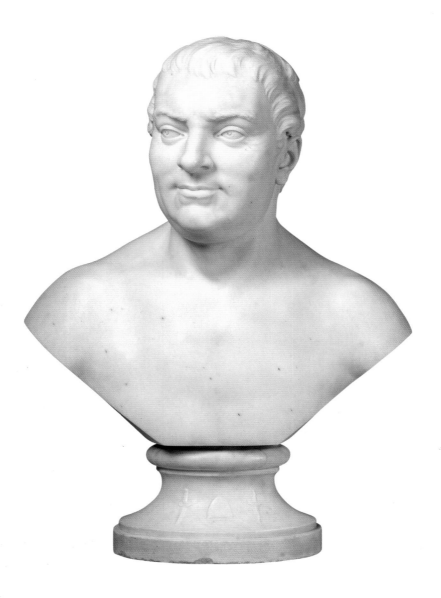

THOMAS HOLLIS
(1720–74)
JOSEPH WILTON, 1762
Marble
660mm high

The writer, publisher and free-thinker Thomas Hollis promoted civil rights in Britain and America. Inspired by the republican heroes of ancient Rome, Hollis stood against corruption, defended the freedom of the press and tried to encourage wider participation in politics. Usually acting anonymously, he published and distributed books and pamphlets that promoted liberty and was an important British supporter of the American colonists, corresponding with the 'Founding Fathers'.

This bust, by his friend Joseph Wilton (1722–1803), captures Hollis's democratic principles and devotion to the classical past as the foundation of his ideology. In a style of representation that evokes the busts of ancient Rome, Hollis is depicted bare-chested, and without a wig. This austere simplicity shows off the beauty of Wilton's carving, and the delicately moulded features and wry half-smile give this marble portrait an unusual intimacy. The only embellishments are the emblems on the plinth: the 'liberty' cap and the 'Brutus' daggers that represent resistance to tyranny. These were two of Hollis's favourite motifs and he embossed them on the lavish bindings of many of the political texts that he circulated to libraries and individuals in England and America. NPG 6946

ANGELICA KAUFFMANN
(1741–1807)

SELF-PORTRAIT, *c.*1770–5
Oil on canvas
737 x 610mm

Angelica Kauffmann was one of
the few women in the eighteenth
century to achieve an international
reputation as an artist. Born in
Switzerland, she was raised in
Italy and showed precocious talent
for both art and music but made
the difficult decision to focus on
becoming a professional painter.
Women were not allowed to draw
naked life models, so Kauffmann
learned anatomy by studying
classical statues. In Rome her
work gained favour with British
travellers visiting the city on their
Grand Tour, which persuaded her
to come to England in 1766. Here
she developed a following for her
portraits and historical scenes. Her
status as an artist was such that in
1768 she became one of the thirty-
six founding members of the Royal
Academy of Arts. She returned
to Italy thirteen years later.

Kauffmann painted a number
of self-portraits that celebrated
her identity as an artist. She shows
herself here with the tools of her
trade. The positioning of her
crossed arms appears to modestly
shield her body but her gaze is
confidently directed towards the
viewer. Kauffmann thus addressed
any potential criticism by asserting
that her professional achievements
were completely compatible with
the beauty and virtue expected of
a lady. NPG 430

SIR JOSEPH BANKS
(1743–1820)

SIR JOSHUA REYNOLDS, 1771–3
Oil on canvas
1270 x 1015mm

This portrait of Joseph Banks
by Joshua Reynolds (1723–92)
was painted on Banks's return to
England, to a rapturous welcome,
having participated in Captain
James Cook's successful Pacific
voyage on the *Endeavour* (1768–71).
The globe on the table alludes to
his travels, while the inscription on
the letter, a quotation from Horace,
translates as 'tomorrow we will
set out again upon the vast sea'.
Banks had developed his scientific
expertise on an earlier expedition
to Labrador and Newfoundland in
1766. The *Endeavour* voyage to the
comparatively unknown territories
of Tahiti, New Zealand and
Australia gave him an unparalleled
opportunity to study local plants,
wildlife and people. He made a
unique natural history collection,
learned Tahitian and participated
in local traditions, including being
tattooed. On his return to England
in 1771 he was introduced to
George III, who became a close
friend and supporter. Cook's second
expedition of 1772–5 could not
accommodate Banks's entourage;
instead Banks organised a voyage
to explore the natural history of
Iceland. In Britain he held positions
of great scientific influence and
advised the government on the
establishment of the Royal Botanic
Gardens at Kew and the first British
colonies in Australia. He was
elected president of the Royal
Society in 1778. NPG 5868

EMMA, LADY HAMILTON
(*c*.1765–1815)
GEORGE ROMNEY, *c*.1785
Oil on canvas
737 x 597mm

Emma, Lady Hamilton, is most
famous as the artist George
Romney's 'muse' and as Lord
Nelson's lover. Born Emma Lyon,
she became a celebrity as a result
of her beguiling beauty and skill
as a theatrical performer. From
humble beginnings, she rose
through society as the mistress to
a string of older men, eventually
becoming Lady Emma on marrying
Sir William Hamilton, British
Ambassador to Naples. To please
him she developed her notorious
'attitudes' – candlelit performances
emulating antique sculptures.
It was in Naples that she also
became Lord Nelson's lover after
the Battle of the Nile (1798),
when she and Hamilton cared for
the wounded admiral. The affair
was an international scandal, but
enhanced Nelson's reputation as
a romantic hero. On his death,
Nelson entrusted Emma's care to
the nation but his wish was ignored
and she eventually died penniless
in France.

The English artist George Romney
(1734–1802) painted Emma over
twenty times. In December 1791
she confessed to him, 'you [were]
the first dear friend I open'd my
heart to … you have known me
in my poverty and prosperity'.
NPG 294

FRANCES D'ARBLAY (FANNY BURNEY)
(1752–1840)

EDWARD FRANCISCO BURNEY, *c.*1784–5
Oil on canvas
762 x 635mm

Fanny Burney's first novel, the best-seller *Evelina, or A Young Lady's Entrance into the World* (1778), was written in extreme secrecy and delivered to the publisher by her brother. Gradually, the news of Burney's identity spread to the literary friends of the family, including Samuel Johnson, Hester Thrale and Edmund Burke. To everyone's astonishment, Burney became a celebrity. In 1786 she was appointed Keeper of Robes to Queen Charlotte but was unhappy at court and was permitted to retire in 1791. In 1793 she resumed writing after marrying a Frenchman, General d'Arblay, who had fled the Revolution. The profits from *Camilla, or A Picture of Youth* (1796) allowed them to build their own house. Her *Journals and Letters* were published after her death and are a rich source for eighteenth-century historians.

This portrait is by the novelist's cousin, Edward Francisco Burney (1760–1848). Her account of the sitting suggests her abiding shyness: 'to my utter surprise and consternation, I was called into the room appropriated for Edward and his pictures, and informed that I was to sit to him … Remonstrances were unavailing and declarations of aversion to the design were only ridiculed.' NPG 2634

THOMAS PAINE (1737–1809)

LAURENT DABOS, c.1791
Oil on canvas
743 x 591mm

Thomas Paine was a supporter
of the American and French
Revolutions and is hailed as one of
the fathers of modern democracy.
In 1774 he emigrated to America,
where his pro-revolutionary
pamphlet *Common Sense* (1776)
was so influential that John Adams,
one of the 'Founding Fathers',
wrote that 'Without the pen of the
author of *Common Sense*, the sword
of Washington would have been
raised in vain.' Paine is, however,
most famous for his controversial
The Rights of Man (1791), published
in response to Edmund Burke's
conservative reaction to the start of
the French Revolution. It promoted
the right to representative
government, freedom of speech and
freedom of religious belief. This
has had a profound and enduring
influence on generations of political
thinkers. At the time, however,
the British government and press
were scandalised, and Paine fled to
France in 1792, only to be tried and
convicted for seditious libel in his
absence.

This portrait was painted in
France by Laurent Dabos (1761–
1835) and was probably intended
to be one of a series of images of
leading revolutionaries. In 1792
Paine was appointed to the newly
formed National Convention but
was imprisoned the following year
for opposing the execution of Louis
XVI. In 1802, he returned to
America. NPG 6805

CHARLES GENEVIÈVE LOUIS AUGUSTE ANDRÉ TIMOTHÉE D'EON DE BEAUMONT (CHEVALIER D'EON)
(1728–1810)

THOMAS STEWART, AFTER JEAN-LAURENT MOSNIER, SIGNED AND DATED 1792
Oil on canvas
765 x 640mm

The Chevalier d'Eon, a minor French aristocrat, had a triumphant career as a French diplomat, soldier and spy before publicly assuming a female gender. D'Eon first came to London in 1763 to negotiate peace at the end of the Seven Years' War, after which he was ordered to return to France but refused to go. Instead, he blackmailed the French court with his knowledge of secret invasion plans against England and published secret diplomatic correspondence that implicated prominent French ministers in corruption. Rumours that d'Eon was a woman in disguise, encouraged by d'Eon himself, spread from 1771 onwards and were widely accepted. In 1777, after a period of exile from France, Louis XVI offered d'Eon a royal pension if he henceforth exclusively wore women's clothing.

In 1785 d'Eon returned to England, where he mixed in high society and became a celebrated female fencer, a career cut short by injury in 1796. After his death, an autopsy revealed him to be anatomically male.

This work by Thomas Stewart (1766–c.1801) is a contemporary copy of a portrait by the French artist Jean-Laurent Mosnier (1743–1808) and exhibited at the Royal Academy exhibition in 1791. NPG 6937

SARAH SIDDONS
(1755–1831)

SIR WILLIAM BEECHEY, 1793
Oil on canvas
2456 x 1537mm

Sarah Siddons is acknowledged as
one of the greatest actresses in the
history of English theatre. Born
into the Kemble family, a powerful
dynasty of actors, Siddons showed
talent early and began to act
alongside members of her family.
After establishing her reputation
around the country, she made her
London debut in 1782, playing
Isabella in David Garrick's *Isabella,
or the Fatal Marriage* (1808) at Drury
Lane. A critic at the time mused,
'There never, perhaps, was a
better stage figure than that of Mrs
Siddons.' She went on to dominate
the London stage for three decades,
specialising in tragic roles from
contemporary and classical theatre.
 This 'Grand Manner' portrait
by William Beechey (1753–1839)
conveys Siddons's statuesque
presence and eminence as a
Shakespearean actress. Her
association with tragedy is
symbolised by the tragic mask,
dagger and weeping putto, and
her talent at comedy by the comic
mask resting on the monument
(far right). When the portrait was
displayed at the Royal Academy
exhibition in 1794, it was criticised
by A. Pasquin (John Williams) for
conveying 'the semblance of a
gipsey [*sic*] … at a masquerade,
rather than the murder-loving
Melpomene [Muse of
Tragedy]'. NPG 5159

MARY WOLLSTONECRAFT
(1759–97)

JOHN OPIE, *c*.1797
Oil on canvas
768 x 641mm

A political radical, Mary
Wollstonecraft is one of the
founders of modern feminism. Her
most famous work, *A Vindication of
the Rights of Woman* (1792), made a
powerful case for the liberation and
education of women. Wollstonecraft
ran a small school and worked as a
governess before settling in London
in 1787. There she joined a radical
circle around the publisher Joseph
Johnson and regularly published
literary criticism and educational
works. She welcomed the French
Revolution and travelled to Paris,
where she fell in love with the
American Gilbert Imlay and defied
convention by having her first child
outside wedlock. However, the
relationship did not last. Distraught,
Wollstonecraft returned to England.
She later fell in love with the
philosopher William Godwin and
lived with him, marrying only when
she became pregnant with her
daughter, the author Mary Shelley.

This portrait by John Opie
(1761–1807) was probably painted
around this time. The simplicity
of her gown and cap reflects her
belief, as expressed in her *Thoughts
on the Education of Daughters*
(1787), that clothes should
'adorn the person and not rival it'.
Wollstonecraft died in childbirth.
Grief-stricken, Godwin wrote the
startlingly frank *Memoirs of Mary
Wollstonecraft* (1798), dominating
public perception of her for
decades. NPG 1237

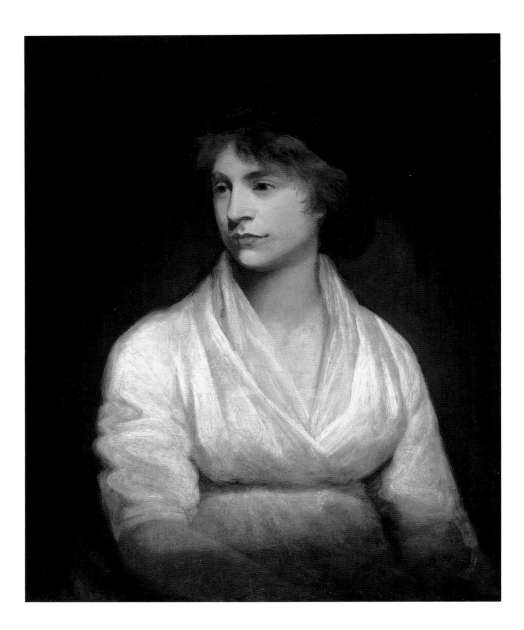

JOHN CONSTABLE
(1776–1837)

RAMSAY RICHARD REINAGLE,
*c.*1799
Oil on canvas
762 x 638mm

Although not recognised as such in his lifetime, John Constable is one of England's greatest and most original landscape painters. At a time when domestic landscape was valued less than classical views, he focused on the English countryside and particularly his native Suffolk. He made hundreds of outdoor oil sketches, capturing the changing skies with near scientific precision. These helped to bring immediacy and realism to the large-scale landscapes that he developed in his studio for exhibition. In 1802, when he began to exhibit at the Royal Academy, he declared that 'natural painture' – or landscape – could rival history painting.

Constable's greatest lifetime success, however, was in France. *The Hay Wain* (1821) was so admired by French visitors to the Academy, including Théodore Géricault, that it was borrowed for the Paris Salon of 1824 and awarded a gold medal. At his death, Constable's artist friends presented *The Cornfield* (1826) to the National Gallery, thus acknowledging his achievement and ensuring his ongoing influence on later artists such as the Impressionists.

This portrait was probably painted when Ramsay Richard Reinagle (1775–1862), who had been a fellow student at the Academy, stayed with Constable in Suffolk during 1799. The likeness does justice to Constable's local reputation as 'the handsome miller'. NPG 1786

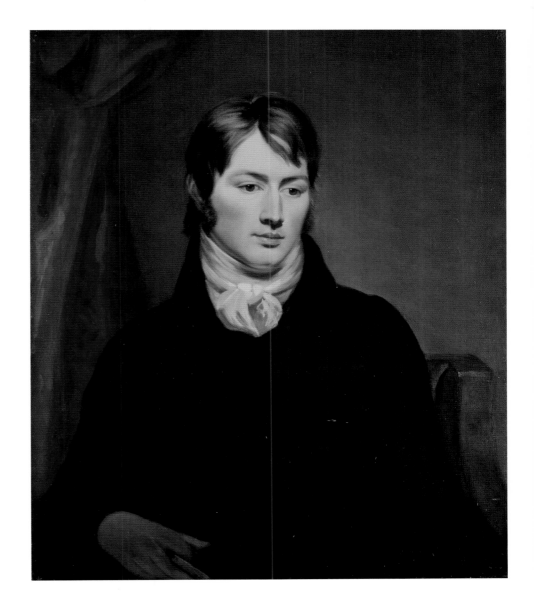

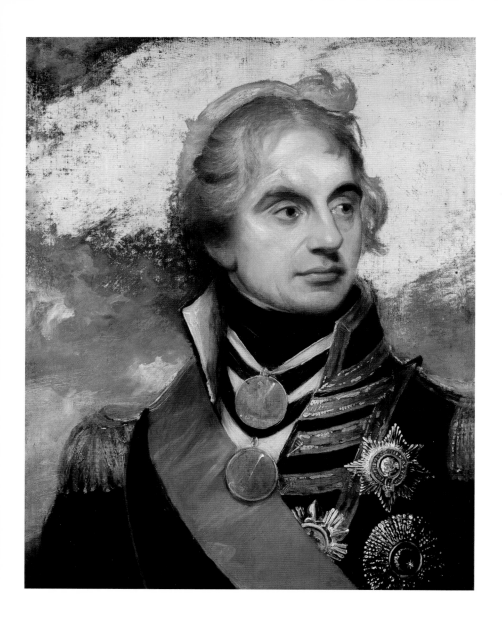

HORATIO NELSON, VISCOUNT NELSON
(1758–1805)
SIR WILLIAM BEECHEY, 1800
Oil on canvas
623 x 483mm

Admiral Lord Nelson remains one of Britain's most illustrious war heroes, and his memorial has pride of place in London's Trafalgar Square. Charismatic, self-confident and vain, he was ever conscious of his public profile. He was also a notorious maverick in battle and prone to insubordination, traits he dubbed 'the Nelson Touch'. In 1793, following the outbreak of war with France, he lost an eye in a successful attack on Corsica, and his right arm in a battle of 1797. Despite these injuries, Nelson was a masterful tactician, leading the British fleet to victory at the Battle of Cape St Vincent (1797) and the Battle of the Nile (1798). While convalescing in Naples, Nelson famously began an affair with Emma, Lady Hamilton. He subsequently destroyed Napoleon's sea power at the Battle of Trafalgar (1805), where he was mortally wounded.

This vivid sketch by William Beechey (1753–1839) is a study for a full-length portrait commissioned by the City of Norwich in Norfolk, where Nelson was born. The artist's alteration to the shape of the head is clearly visible, yet the eye colour, which is depicted as brown instead of grey, was not corrected. Nevertheless, it is considered the most faithful likeness of the admiral.
NPG 5798

ARTHUR WELLESLEY, 1ST DUKE OF WELLINGTON (1769–1852)

ROBERT HOME, 1804
Oil on canvas
749 x 622mm

One of Britain's most iconic military leaders, the Duke of Wellington was hailed as the man who finally achieved the 'peace of nations' after leading the defeat of Napoleon at the Battle of Waterloo in 1815. This portrait by Robert Home (1752–1834) shows Wellington early in his career, when he was a major-general in India. After his return to Britain in 1805, he rose to prominence as a general during the Peninsular Campaign of the Napoleonic Wars (1809–14), leading the allied forces to victory at the Battle of Vitoria (1813) and finally at Waterloo. He was celebrated for his defensive style of warfare and as a battle strategist; and, although a stern disciplinarian, he was dedicated to the well-being of his troops.

Wellington entered Parliament in 1818 and served twice as prime minister, between 1828 and 1830 and again in 1834. A staunch Tory, he was nicknamed 'the Iron Duke' for his firm opposition to the Great Reform Act (1832), which was the first step toward full enfranchisement. He was a trusted adviser to Queen Victoria and was adopted as the nation's 'elder statesman'. Wellington was one of only a handful of British subjects to receive a state funeral during this period. NPG 1471

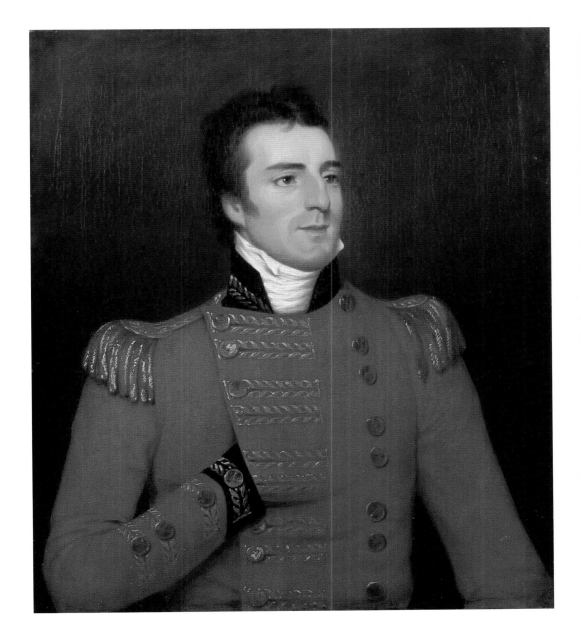

Sculpture

ROSIE BROADLEY

The National Portrait Gallery's Collection includes over 900 remarkable examples of sculpture produced across four centuries. These sculpted portraits are made in a range of different materials, including marble, bronze, plaster, wax, wood, terracotta and ceramics, and in modern and unusual media such as plastic and taxidermy. The portrait bust was particularly popular in the eighteenth and nineteenth centuries, when artists looked back to ancient Greek and Roman sculpture for inspiration, and sitters and patrons valued its inherent commemorative properties. Other types of sculpted portrait within the Collection include tomb monuments, coins, life masks and death masks, reflecting the various ways in which portrait sculpture is made, displayed and used.

One of the most remarkable portraits is an exquisite clay figure by the Chinese artist Amoy Chinqua (right). It represents the merchant Joseph Collet and stands at just under a metre tall. Commissioned in Madras, India, in 1716, the portrait was sent to England as a gift for Collet's daughter. In a letter that accompanied the work, Collet notes, 'the proportion of my body and my habit is very exact'. This emphasis on the mimetic capacity of a three-dimensional portrait reveals that Collet's gift was not only intended as a sentimental memento of an absent father, but as a precise record of his appearance at that time.

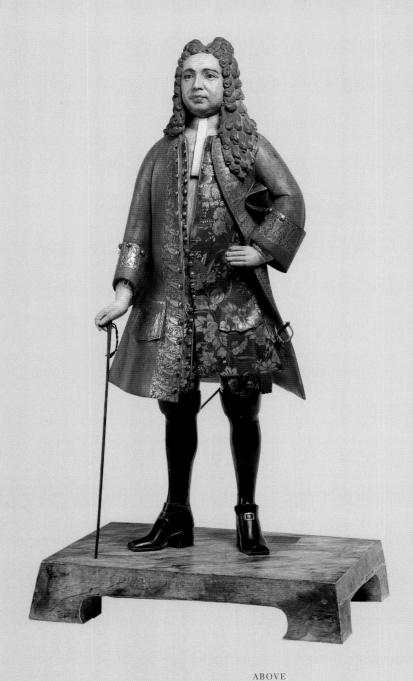

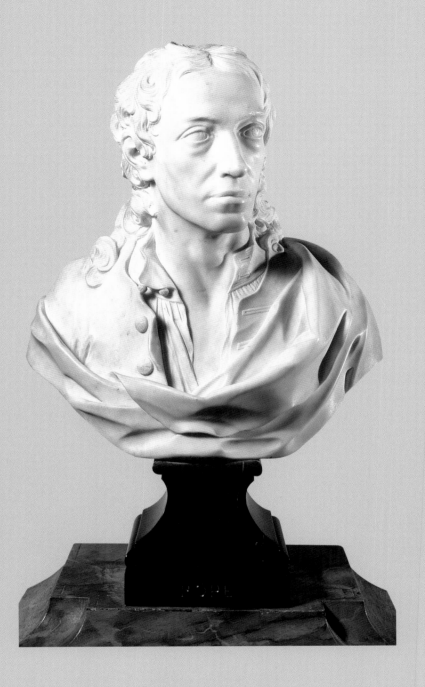

By the mid-eighteenth century, the bust had become the dominant format for portrait sculpture in Britain, and the Dutch sculptor John Michael Rysbrack was a leading exponent. In common with classical prototypes, which often represented poets and philosophers, Rysbrack's dignified bust of the eminent poet Alexander Pope (left) evokes the sitter's intellectual virtue. By rendering details of Pope's shirt and coat, Rysbrack presents him as a contemporary figure. Later in the century, the author and sculptor Anne Seymour Damer adopted a more strictly classical style in her portrait of the actress Elizabeth Farren (below). This approach extended to depicting her friend in the guise of Thalia, the Greek muse of comedy and idyllic poetry, an allusion that also signalled the sculptor's Latin and Greek scholarship.

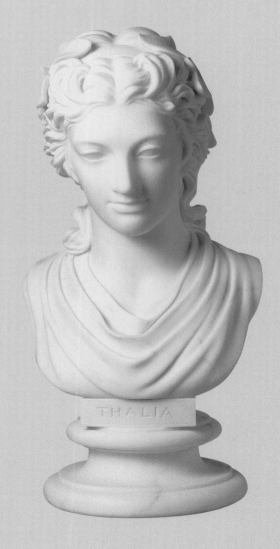

ABOVE

Alexander Pope (1688–1744), by John Michael Rysbrack. Marble, 1730, 524mm high, NPG 5854 • This bust was carved for James Gibbs, the architect of Pope's Thames-side villa, and was described by Horace Walpole in *Anecdotes of Painting*, Vol.III (1764) as 'very like'.

RIGHT

Elizabeth Farren (*c.*1759–1829) as Thalia, by Anne Seymour Damer. Marble, *c.*1788, 597mm high, NPG 4469 • After twenty years as an actress, Elizabeth Farren retired from the stage in 1797 to marry the 12th Earl of Derby.

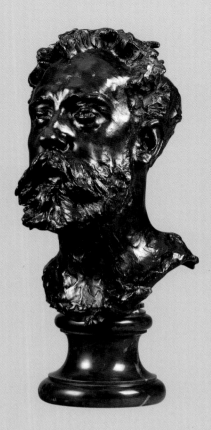

The portrait bust continued to dominate throughout the nineteenth century. Considered particularly suitable for statesmen, these busts were often commissioned to dignify public spaces and architecture, and are included in roundels on the exterior of the National Portrait Gallery building itself. The format was reinvigorated at the end of the century by the pre-eminent French sculptor Auguste Rodin. His bust of the British writer and poet William Henley (above) was made as a token of friendship. During his editorship of the *Magazine of Art*, Henley championed Rodin's work in Britain. The dynamic modelling of the original clay is evident in the richly textured bronze cast, resulting in an expressive rather than an idealised portrait.

Rodin's influence is evident in portrait sculpture produced in Britain in the twentieth century, including the work of the leading modernist Jacob Epstein. His bust of the writer Joseph Conrad (right) shows vigorous handling of the clay, and the varied bronze patina invests the bronze head with latent energy. Although formal conventions were being challenged by artists such as Epstein, the commemorative nature of the bust was still prized. This portrait prompted Conrad to comment, 'It is wonderful to go down to posterity like that.'

LEFT

Isabella Blow (1958–2007),
by Tim Noble and Sue
Webster. Taxidermy, wood,
fake moss, light projector and
installation template, 2002,
1550 x 500 x 500mm, NPG 6872
• The assemblage includes
objects that belonged to the
sitter, including a lipstick and
one of her shoes.

Throughout history sculpted portraits have been used as tomb sculpture, and the Collection includes a significant group of electrotype copies of medieval tomb monuments, mainly representing early kings and queens. This association with death continues to fascinate contemporary artists working in three dimensions. Tim Noble and Sue Webster's taxidermy portrait of the fashion journalist and stylist Isabella Blow (above) was inspired by their friend's 'gothic' qualities. A spotlight applied to an assemblage of objects, including a stuffed raven, rat and snake, casts a perfect silhouette on the wall showing the sitter's head as though on a stake, for which the sitter posed. Following Blow's death, five years after the portrait was completed, the work has become a poignant memorial.

WILLIAM BLAKE
(1757–1827)

THOMAS PHILLIPS, 1807
Oil on canvas
921 x 720mm

William Blake, visionary poet, painter and engraver, now frequently thought of as a Romantic, was a man who claimed to have grown up 'conversing with angels' and lived according to his own mystical and moral beliefs. Unable to conform to contemporary social expectations, he was fortunate to be supported in his radical exploits by a close group of friends, including the artists Henry Fuseli and John Flaxman. Unlike many of his contemporaries, Blake could not afford to travel to Rome. Instead he derived his inspiration from the extremes of poverty and glory he witnessed around him in London. The outcome was not only simple, spiritual and enigmatic, but also unique in its design. In his illuminated 'prophetic book' *Songs of Innocence and of Experience* (1794), he developed the technique of relief etching, uniting both word and image on a single plate.

 This portrait by Thomas Phillips (1770–1845) depicts Blake in a moment of visionary reverie. The artist recalled that he managed to capture Blake's rapt expression by inviting him to talk of his friendship with the Archangel Gabriel, whom Blake described as descending through the ceiling. NPG 212

JANE AUSTEN
(1775–1817)

CASSANDRA AUSTEN, c.1810
Pencil and watercolour
114 x 80mm

This frank sketch depicts Jane Austen, one of Britain's greatest and best-loved novelists. It is the only certain portrait from life and was made by her sister Cassandra (1773–1845), her closest confidante.

The daughter of a rector, Austen was brought up in a close-knit family and began to write when young. Some of her earliest works were plays that were performed by members of the family. In 1796 she started work on what would become her most famous novel, *Pride and Prejudice*. Originally written under the title 'First Impressions', it was the first of her novels to be completed. Austen wrote with wit and irony, drawing on her own observations of genteel social relations, courtship and the position of women during the Regency. Austen's father tried to submit the manuscript to a publisher but without success. It was not until 1812 that Austen's brother Henry finally helped to negotiate the publication of *Sense and Sensibility*. It was swiftly followed by *Pride and Prejudice* (1813), which was an immediate success. These works marked the most fruitful period of Austen's career but her success was short-lived. In 1816 she became sick with a progressive illness and died in 1817. NPG 3630

GEORGE GORDON BYRON, 6TH BARON BYRON
(1788–1824)

THOMAS PHILLIPS, 1835
Oil on canvas
765 x 639mm

Famously deemed 'mad, bad and dangerous to know' by Lady Caroline Lamb, the flamboyant Lord Byron was the most painted poet of his generation. With his brooding good looks, charisma and notoriously wild lifestyle, he constructed himself as the ultimate English Romantic hero.

Byron made his poetic debut with the satirical *English Bards and Scotch Reviewers* (1809). But it was not until he published the first two cantos of *Childe Harold's Pilgrimage* (1812) that he achieved critical acclaim and was reported to have remarked, 'I awoke one morning to find myself famous'. This success was followed by a series of tales inspired by his travels, including *The Giaour* (1813), and his semi-autobiographical epic satire *Don Juan* (1819–23).

This theatrical portrait by Thomas Phillips (1770–1845), a copy from the artist's full-length of 1813, shows the 'popular poet of the East' depicted in luxurious Albanian costume. The portrait met with a mixed reception when it was exhibited the following year at the Royal Academy. The portrait likeness was, however, not without its supporters. In 1823, Byron's play-acting became a reality when he joined the Greek revolutionaries who were fighting the Turks, later dying of fever in Missolonghi. NPG 142

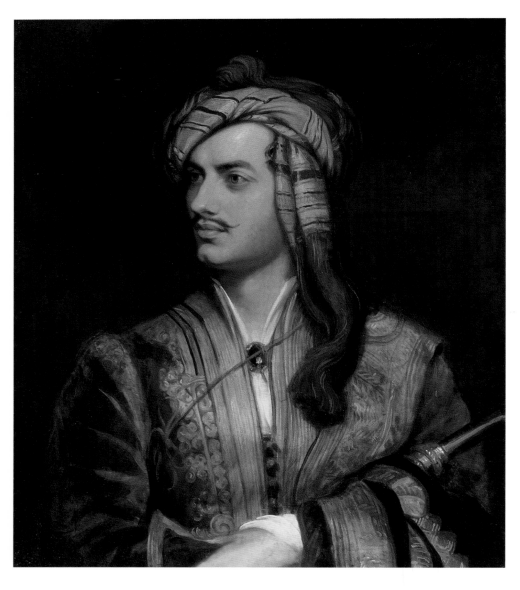

PERCY BYSSHE SHELLEY
(1792–1822)

AMELIA CURRAN, 1819
Oil on canvas
597 x 476mm

The poet Percy Bysshe Shelley
was among the most radical of the
English Romantics. At nineteen,
he was expelled from Oxford
University for professing his
atheism and was duly cut off by
his father. His first major poem,
Queen Mab (1813), promoted radical
social change and denounced meat-
eating and marriage. Yet Shelley
married twice, the second time
to Mary Wollstonecraft Godwin,
daughter of Mary Wollstonecraft
(page 116) and William Godwin,
and later the author of *Frankenstein*
(1818).

Perpetually on the run from
their creditors, the Shelleys spent
a brief spell on the Continent in
1816, staying with Lord Byron.
It was there that Shelley signed
himself (in Greek) as: 'democrat,
great lover of mankind, and atheist',
revealing his profound passion and
ideology. In 1818, the couple
travelled to Italy, where Shelley
produced some of his best work,
including 'Ode to the West Wind'
(1819) and *Adonais* (1821), a
meditation on Keats's death.

Shelley drowned in a storm at
sea off the Italian coast on his
return from setting up the anti-
establishment journal *The Liberal*
with Byron and Leigh Hunt.
Painted in Rome a few years earlier,
this portrait by the art student
Amelia Curran (1775–1847) is the
only authentic likeness of the poet.
NPG 1234

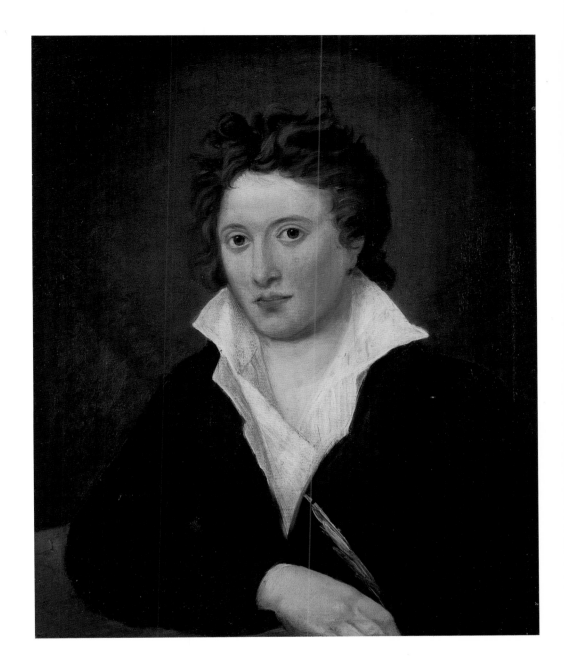

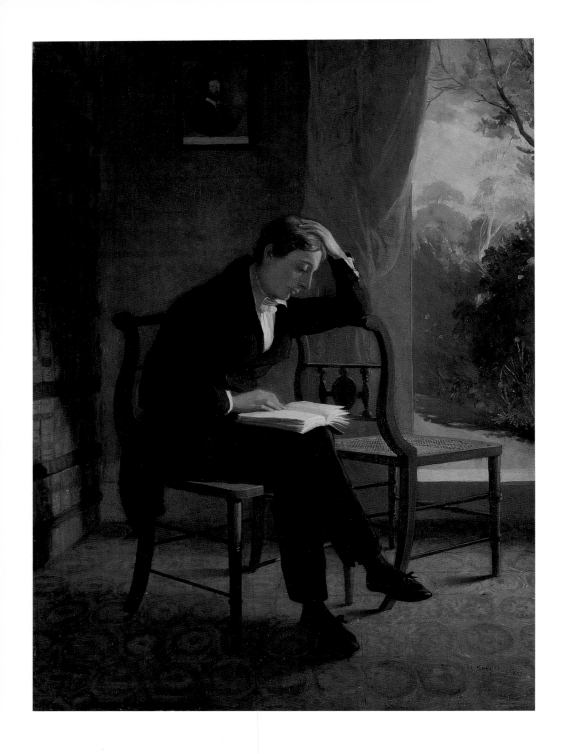

JOHN KEATS
(1795–1821)
JOSEPH SEVERN, DATED 1821–3
Oil on canvas
565 x 419mm

John Keats was one of the greatest Romantic poets, although, in his short career, he had little impact beyond his circle of friends. His first volume of poetry, published in 1816, was followed by *Endymion* (1818), which was mercilessly attacked by reviewers. Inspired by a walking tour of the Lake District and Scotland in 1818, Keats composed the poems for which he is best known, including 'To Autumn' and 'La Belle Dame sans Merci', which were published a year before his untimely death.

This posthumous portrait is one of several painted by Keats's close friend Joseph Severn (1793–1879). He has imagined the poet at home in Hampstead on the morning he wrote his famous meditation on mortality, 'Ode to the Nightingale' (1819). Severn had told George Scharf (22 December 1859) that he 'found him sitting with the two chairs as I have painted him & was struck with the first real symptom of sadness in Keats so finely expressed in that Poem … After this time he lost his cheerfulness & I never saw him like himself again.' Tragically, the poet's health worsened and he died of consumption in Severn's arms in Rome, aged only twenty-five.
NPG 58

WILLIAM WORDSWORTH
(1770–1850)

BENJAMIN ROBERT HAYDON, SIGNED AND DATED 1842
Oil on canvas
1245 x 991mm

William Wordsworth dedicated his life to poetry, becoming the leading British writer of his age. His *Lyrical Ballads* (1798), published with Samuel Taylor Coleridge, is a landmark in British Romanticism and heralded a new type of poetry that dealt with feeling and imagination, and which in Wordsworth's hands was characterised by an exploration of humanity's relationship with nature. In 1799 Wordsworth settled in Grasmere in the Lake District. Here he composed the 'Lucy' poems, about an idealised and tragic English girl who died young. He also wrote two other major works, his autobiographical poem *The Prelude* (1850) and *The Excursion* (1814), a philosophical epic. His contribution to poetry was recognised in 1843, when he was made Poet Laureate.

Wordsworth had a long association with the artist Benjamin Robert Haydon (1786–1846), who made a life mask of the poet in 1815 and subsequently produced many sketches of him. This portrait was probably inspired by a sonnet that Wordsworth sent to Haydon in 1840, which he said was actually composed while he was climbing Helvellyn mountain. This followed Wordsworth's usual practice of composing while he walked; thus Haydon depicts him as the archetypal brooding Romantic hero, lost in thought and overtaken by the cataclysmic power of nature. NPG 1857

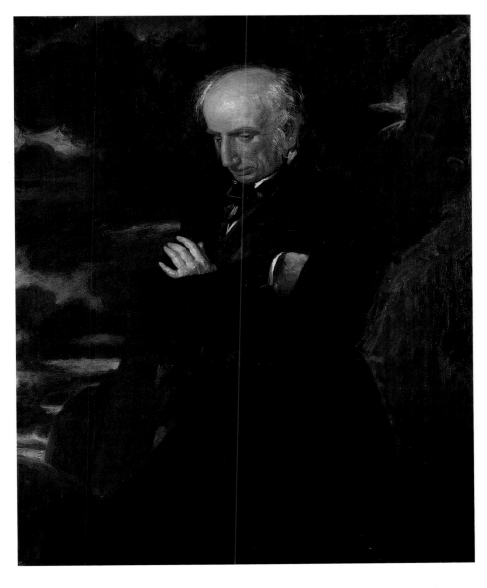

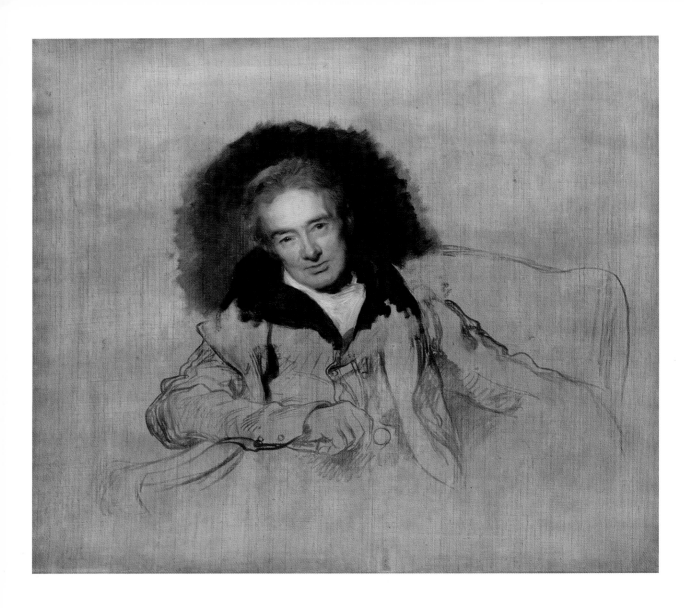

WILLIAM WILBERFORCE
(1759–1833)
SIR THOMAS LAWRENCE, 1828
Oil on canvas
965 x 1092mm

The Tory Member of Parliament William Wilberforce
was renowned for his high principles and great personal
charm. A leading member of the Clapham Sect, an
influential group of Evangelicals, Wilberforce devoted
his career to social reform. His life's work was as
parliamentary leader of the abolitionist movement.
Having campaigned tirelessly for twenty years to end
the slave trade, declaring to Parliament in 1791 that
'never, never will we desist till we … extinguish every
trace of this bloody traffic', Wilberforce's Bill was

eventually passed with a standing ovation in 1807.
He then campaigned for the total abolition of slavery,
dying one month before the Slavery Abolition Act was
passed in 1833.

This portrait was begun in 1825, when Wilberforce
retired from Parliament on account of ill health,
suffering from extreme skeletal degeneration.
His constant discomfort helps explain the awkward
pose and unfinished state of this painting. With only
one sitting, Thomas Lawrence (1769–1830) captured
Wilberforce's 'winning sweetness', as John Harford,
his friend, described it. By adding a summary outline
of the figure, the artist achieved a memorable image
of one of the most important men of his age. It was
accordingly the third portrait to be acquired by the
newly founded National Portrait Gallery. NPG 3

IRA ALDRIDGE
(1807–67)

AFTER JAMES NORTHCOTE, *c*.1826
Oil on canvas
763 x 632mm
Lent by a private collection, 2012

Ira Aldridge was the first major
black actor on the British stage.
He arrived from America in 1824
and first appeared in London
in 1825, playing the part of
Orinokoo in *The Revolt of Surinam,
or, a Slave's Revenge* at the Royal
Coburg Theatre (now the Old
Vic). Reviewers were surprised
by his American accent and light
complexion. Yet even though
audiences were enthusiastic about
his acting, Aldridge was relegated
to playing in regional theatres.
This portrait depicts him as Othello
in Manchester.

Aldridge was finally able to make
his West End debut, in the same
role, in 1833, two weeks after the
actor Edmund Kean had died.
But Kean had dominated such
tragic roles, and there was much
hostility to a real black man acting
as Othello alongside a white
Desdemona, with the result that
the production quickly closed.

After this false start, Aldridge
cultivated roles beyond the
standard repertoire and revived
Shakespeare's rarely performed
Titus Andronicus, turning the Moor
Aaron into an unlikely tragic hero.
After several Continental tours in
the 1850s and 1860s, he developed
a significant following in Europe
and died in Poland in 1867.
NPG L251

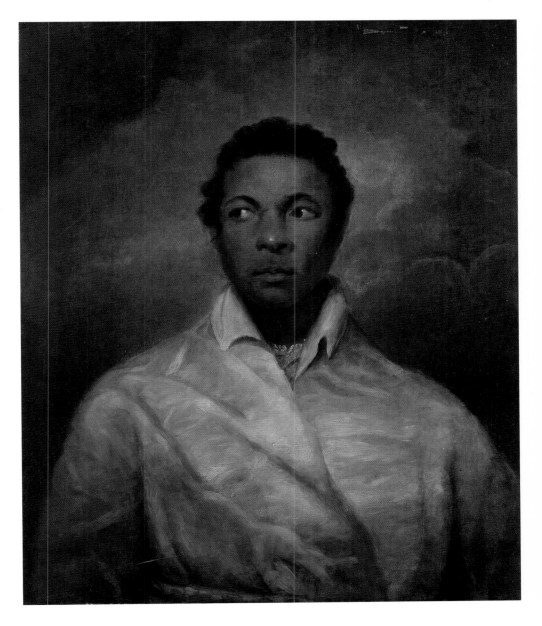

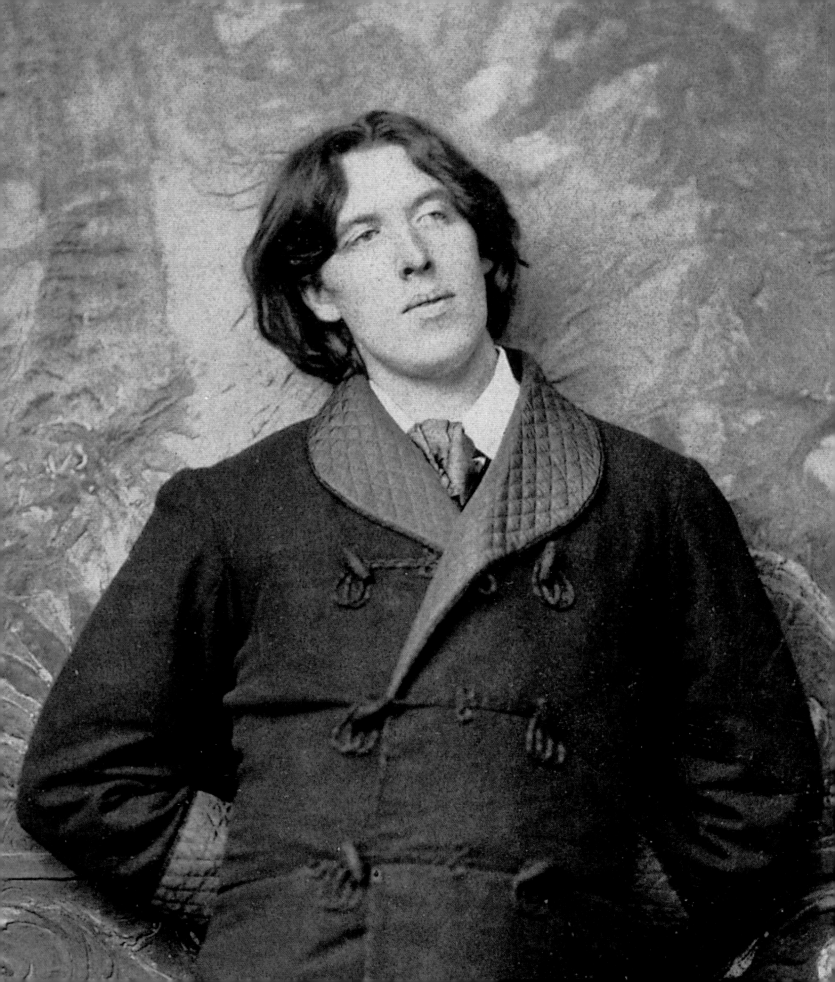

Victorian and Edwardian Portraits

1837–1913

OPPOSITE
OSCAR WILDE
NAPOLEON SARONY, 1882
(DETAIL OF PAGE 168)

The decades between the accession of Queen Victoria in 1837 and the death of her son, Edward VII, in 1910 saw Britain become the world's leading industrialised commercial power. By the end of the period, changes in politics, science and technology had begun to influence aspects of daily life in ways that we would recognise today; portraiture, in both approach and execution, was no exception.

Victoria's long reign witnessed the transformation of British interests abroad into a full-scale empire. Many portraits – such as those of Captain Frederick Burnaby, an officer in the Household Cavalry (page 156), and Sir Frank Swettenham, colonial administrator in South-East Asia (page 180) – display an ideal of manly heroism that was central to the imperial consciousness. Another work, entitled *The Secret of England's Greatness* (page 148), epitomises the evangelical convictions that underpinned Britain's colonisation of foreign lands and peoples. As well as leaders of empire, there were many who were its subjects, and whose lives were shaped by it. For example, the much-travelled Mary Seacole (page 154) came from Jamaica but won fame by caring for the troops during the Crimean War (1853–6), an administrative and military fiasco that shocked the nation, yet produced conspicuous acts of mercy.

Events at home and abroad were celebrated in major group portraits, paintings that toured Britain and were made into widely circulated engravings. Artist Jerry Barrett was commissioned by the dealer and printseller Thos. Agnew & Sons to travel to Constantinople during the Crimean War to record Florence Nightingale's famous mission to relieve the suffering of the British soldiers in Scutari (pages 140–1). The burgeoning art and print trade served a new class of consumer, and bestowed wealth and social status upon many portrait painters. Agnews, for example, paid John Everett Millais no less than £1,000, including copyright, for his celebrated portrait of the great statesman William Ewart Gladstone (page 160).

Another aspect of Victorian and Edwardian portraiture revealed in the Gallery's Collection is the importance of what contemporaries would have called 'character'. In Millais's portraits of Gladstone and his great political rival Benjamin Disraeli (page 161) there are none of the trappings of office. Instead the focus is on their faces; indexes, the Victorians thought, of the mind and spirit within. The same applies to George Frederic Watts's series of portraits commemorating his age and nation. These included many of the period's intellectual leaders, whose names still resonate today, such as William Morris (page 155), who rejected the mass-production and industrialisation of the age and proclaimed the virtues of the artisan and craftsman. His belief in art for the people had a long-lasting influence, while the Arts and Crafts movement produced designs for textiles and wallpapers that are still made today.

Science and technology changed the world beyond recognition during the period. The chemist and physicist Michael Faraday (page 138) made experimental discoveries that led to the foundation of modern chemical and electrical technologies; engineers, such as Isambard Kingdom Brunel, recorded standing before the massive restraining chains of the SS *Great Eastern* in Robert Howlett's famous photograph (page 143), built and designed the docks, bridges, railways and ocean-going ships that revolutionised commercial trade. In the natural sciences, Darwin's theory of natural selection, published as *On the Origin of Species* in 1859, crystallised doubts in the biblical account of creation and challenged traditional notions of man's place in the world. In the public mind, at least, science and religion were in conflict, and certainties that had held for centuries were open to question.

In literature, the mass publication of novels and periodicals made the writings of the Brontë sisters (page 136) and Charles Dickens (page 137), for example, widely available to an increasingly literate population. New genres, such as the detective stories of Wilkie Collins (page 139), captivated readers and made their authors national celebrities. In the theatre, 'star' actors, such as Ellen Terry (page 149) and Henry Irving (page 159), emerged as major public figures, Irving becoming an impresario and theatre manager as well as an actor, and the first in his profession to be given a knighthood.

The greatest change in portraiture itself was the invention of photography and its commercial exploitation (pages 162–5). The earliest form of portrait photography was the daguerreotype, while, from about 1860, small photographic images known as *cartes-de-visite*, taken in professional photographic studios, rapidly made portraiture available to many. Yet, in the hands of photographers such as Julia Margaret Cameron, Frederick Evans and Frederick Hollyer, photographic portraiture could aspire to the status of an art form (pages 152, 165 and 172).

The end of the era also saw changes in the painted portrait under the influence of French naturalist and Impressionist painting. The informality of this type of portrait painting seems appropriate for figures such as the radical campaigner Edward Carpenter, painted by the leader of the avant-garde, Roger Fry (page 173), or artist Augustus John, portrayed in defiant mode by his friend and fellow student William Orpen (page 177). Both Carpenter and John, in their very different ways, dissented from many of the orthodoxies of the Victorian period and prefigured ideas and lifestyles that would prevail during the twentieth century.

Peter Funnell

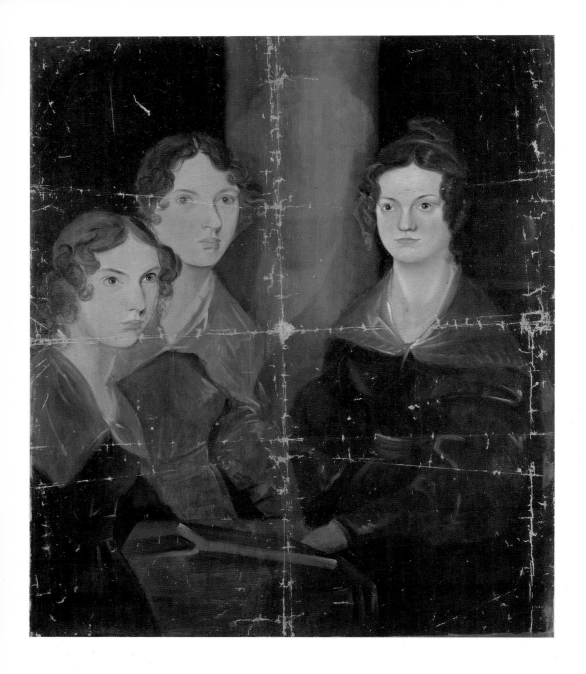

THE BRONTË SISTERS (ANNE [1820–49],
EMILY [1818–48], CHARLOTTE [1816–55])
BRANWELL BRONTË, *c.*1834
Oil on canvas
902 x 746mm

The novels and poetry of Charlotte, Emily and Anne
Brontë defied nineteenth-century literary taste.
The passionate, destructive Romanticism of Emily's
Wuthering Heights (1847) confounded and disgusted
critics, while the *Spectator* accused Anne of a 'morbid
love for the coarse' in its review of *The Tenant of Wildfell*
Hall (1848). Charlotte was more successful, forging her
enduring literary reputation with *Jane Eyre* (1847) and
Villette (1853).

This is the only surviving group portrait to depict
the sisters (left to right: Anne, Emily and Charlotte)
and it was discovered folded up on top of a cupboard
by Charlotte's husband, the Reverend A.B. Nicholls,
in 1914. It is just possible to discern a male figure
in the middle of the group, which is almost certainly
a self-portrait of the artist, their dissolute brother
Branwell (1817–48). His figure has been painted
over with a pillar in the final composition. NPG 1725

CHARLES DICKENS
(1812–70)

DANIEL MACLISE, SIGNED AND
DATED 1839
Oil on canvas
914 x 714mm

Charles Dickens was one of the
greatest novelists of his age, with an
international reputation. A prolific
writer, he established his name
with *The Pickwick Papers* (1836–7)
and went on to write a total of
fifteen novels. These include some
of the best-known works in the
English language, such as *Oliver
Twist* (1837–9), *A Christmas Carol*
(1843), *Bleak House* (1852–3) and
Great Expectations (1860–1). Most
were initially published as serials in
literary journals, such as *Household
Words*, which Dickens co-founded
and edited. In addition to his
novels, he worked extensively as
a journalist.

This portrait was painted in 1839,
when Dickens had just published
Nicholas Nickleby. He had met the
artist Daniel Maclise (1806–70) the
previous summer and they had
become close friends. Maclise
painted him on several occasions
and also made portraits of Dickens's
wife and children. In a letter dated
28 June 1839, Dickens wrote that
'Maclise has made another face
of me, which all people say is
astonishing'. NPG 1172

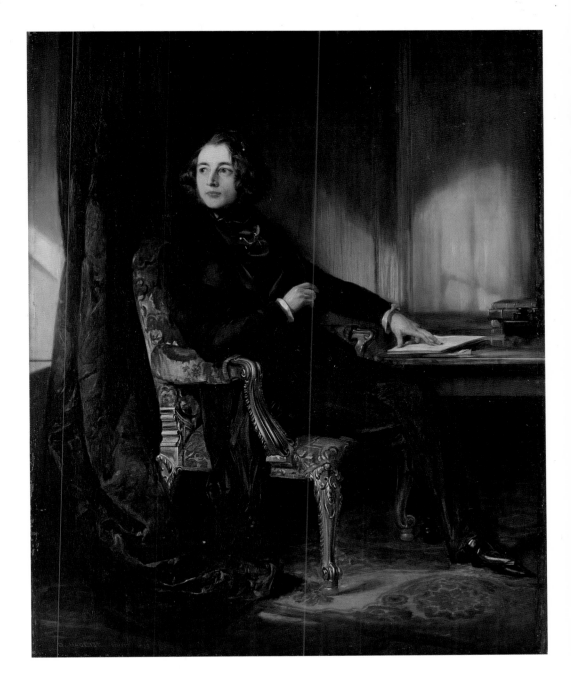

MICHAEL FARADAY
(1791–1867)

THOMAS PHILLIPS, 1841–2
Oil on canvas
908 x 711mm

Michael Faraday was born the son of a blacksmith in what is now the Elephant and Castle district of London. He became, arguably, the greatest of all experimental scientists. Apprenticed to a bookbinder and bookseller, Faraday formed an early interest in science, and in March 1813 became assistant to Sir Humphry Davy, one of the most famous scientists in Europe and Professor of Chemistry at the Royal Institution. Davy's influence was crucial, as was the

Institution, where Faraday became Superintendent in 1821 and where he spent his entire working life. He introduced popular lecture series there for children, and it was in its laboratory in August 1831 that he made his most important discovery: electromagnetic induction. It was a discovery that became the basis of modern electrical technologies. Likewise, in chemistry his establishment of the chemical formula of benzene and its derivatives formed the building blocks of the modern pharmaceutical industry.

This portrait by Thomas Phillips (1770–1845) shows Faraday with two essential pieces of laboratory equipment of the period. On the left is a Cruikshank battery of the sort he used in his electrical experiments, while the flames on the right indicate a furnace. NPG 269

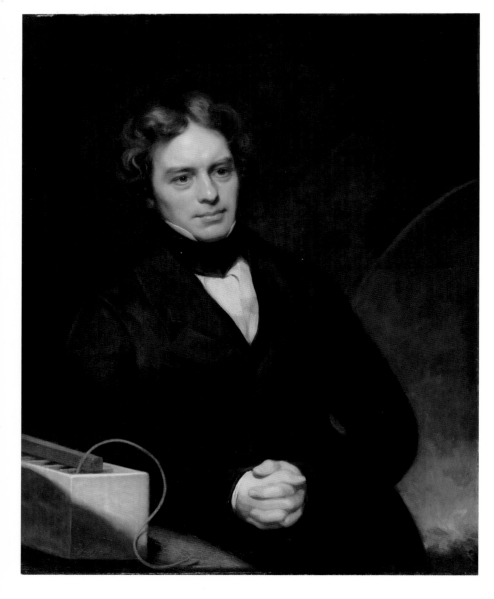

WILKIE COLLINS
(1824–89)

SIR JOHN EVERETT MILLAIS,
SIGNED IN MONOGRAM AND
DATED 1850
Oil on panel
267 x 178mm

At the time this portrait was painted, Wilkie Collins was about to begin the 'novels of sensation' that would make his name. This series of tales of mystery, crime and suspense opened with *Basil* (1852). It would eventually include Collins's most famous novels, *The Woman in White* (1860) and *The Moonstone* (1868), which breathed life into the new genre of the detective story.

The artist John Everett Millais (1829–96) was one of the leading members of the Pre-Raphaelite Brotherhood, who held their first exhibition in 1849. This group took the name 'Pre-Raphaelite' in protest at the academic principles that, they believed, had constricted Western art since the Renaissance. Collins's brother Charles was one of Millais's closest friends, and Millais was a frequent visitor at 17 Hanover Terrace, London, where both brothers lived. Millais's fellow Pre-Raphaelite Holman Hunt later wrote in his memoir *Pre-Raphaelitism and the Pre-Raphaelite Brotherhood* (1914) that this portrait of Collins 'remained to the end of his days the best likeness of him … It will be seen that he had a prominent forehead, and in full face the portrait would have revealed the right side of his cranium outbalanced in prominence that of the left.' NPG 967

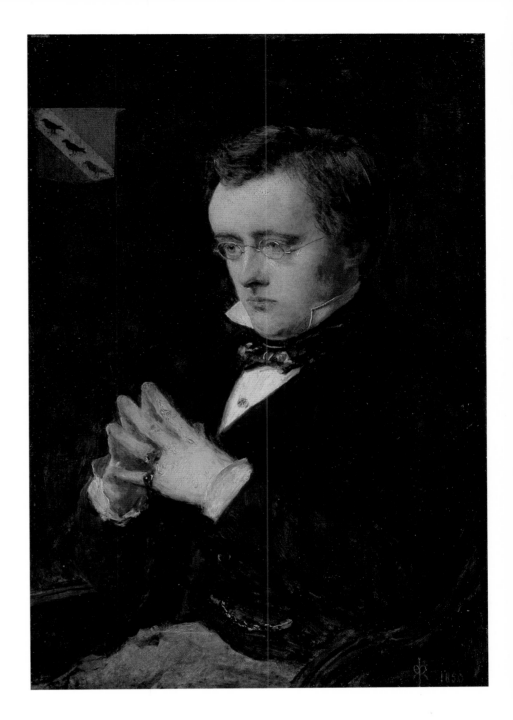

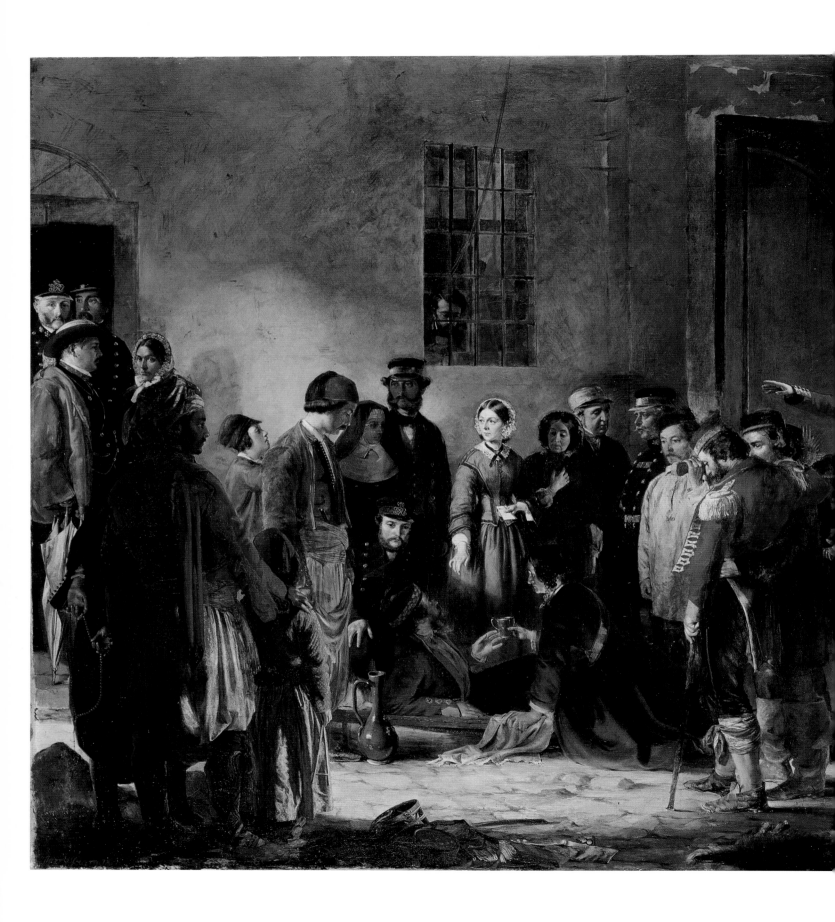

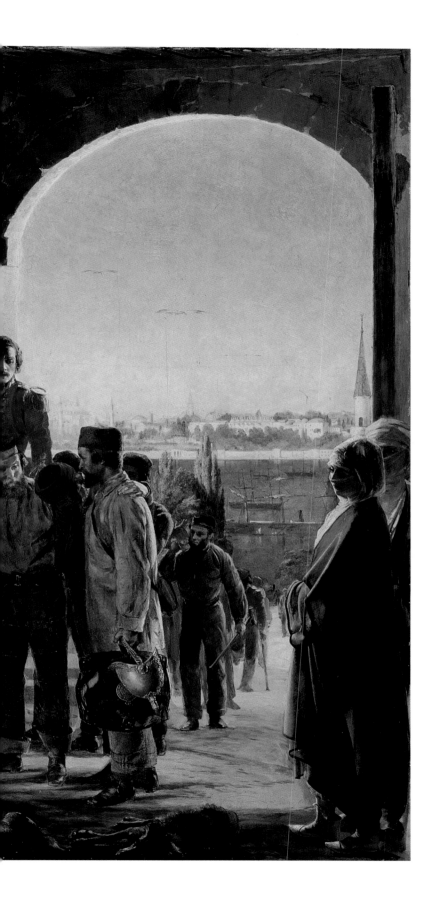

THE MISSION OF MERCY: FLORENCE NIGHTINGALE RECEIVING THE WOUNDED AT SCUTARI

JERRY BARRETT, 1857
Oil on canvas
1410 x 2127mm

Florence Nightingale (1820–1910) pioneered major reforms in nursing care and organisation. This painting by Jerry Barrett (1824–1906) records her receiving the wounded at the Barrack Hospital in Scutari, Constantinople (Istanbul) in 1854. It was here that she intervened at a crucial point in the Crimean War (1853–6), improving the atrocious conditions endured by the wounded soldiers. The painting was commissioned by the publisher and dealer Thos. Agnew & Sons, who also paid for Barrett to visit Scutari. To prove his presence on site, Barrett includes himself looking through the window above Nightingale. The painting also features portraits of thirteen others associated with Nightingale's work at Scutari, including Alexis Soyer (far left, with grey jacket), who revolutionised dietary regimes at the hospital.

Nightingale showed immense determination in the face of military red tape to realise her clear-sighted vision of improvements to be made to the nursing system. *The Times* created her now familiar nickname, 'The Lady of the Lamp', describing her legendary midnight vigils when 'she may be observed alone, with a little lamp in her hand, making her solitary rounds' and 'every poor fellow's face softens with gratitude at the sight of her'. On her return to England in 1856, she was greeted as a national hero. NPG 6202

ISABELLA BEETON
(1836–65)
MAULL & POLYBLANK, 1857
Hand-tinted albumen print
184 x 149mm

Aimed at the aspiring middle classes, *Beeton's Book of Household Management* (1861) was an essential guide to running a Victorian household. Best known today for its recipes, Mrs Beeton's book covered every aspect of life, from setting servants' wages to caring for children. Her pursuit of an authorial career was encouraged by her husband, a successful publisher. *Beeton's Book of Household Management* first appeared as a series of supplements to the *English Woman's Domestic Magazine*, which she helped to edit, before being collected into book form. Her introduction frankly admitted that 'if I had known, beforehand, that this book would have cost me the labour which it has, I should never have been courageous enough to commence it'. Her efforts paid off and the book became an immediate hit, selling 60,000 copies in its first year of publication. It has never been out of print. The London-based commercial photographers Maull & Polyblank (active 1854–65) had studios on Gracechurch Street and on Piccadilly. The touches of colour seen here have been applied to the image by hand to enliven the portrait. NPG P3

ISAMBARD KINGDOM BRUNEL
(1806–59)

ROBERT HOWLETT, 1857
Albumen print
286 x 225mm

This photograph of Isambard
Kingdom Brunel by Robert
Howlett (d.1858) has become
an enduring image of Victorian
engineering might. It is among a
series that shows Brunel at one
of the attempted launches of the
'Leviathan', the SS *Great Eastern*,
in November and December 1857
at the shipyard where it was built
on London's Isle of Dogs. This
was the last of the great ocean-
going ships that Brunel designed,
and the most ambitious: at 32,000
tons displacement, she was by far
the largest ship of her time. She
came towards the culmination of
a career that had made Brunel
the most famous civil engineer
of his generation, and had seen
him design, among many other
enterprises, the Clifton suspension
bridge in Bristol and create the
Great Western Railway.

Six photographs are recorded:
three single portraits of Brunel and
three showing him with other men.
This image is the most successful
and shows how, in adjusting the
angle to show Brunel four-square
in front of the massive chains used
to control the launch of the ship,
Howlett was able to make such a
powerful portrait. The photographs
formed the basis of engravings
published in the *Illustrated Times*
the following year, in a feature on
the SS *Great Eastern*. NPG P112

ROBERT BROWNING
(1812–89)
MICHELE GORDIGIANI, 1858
Oil on canvas
724 x 587mm

ELIZABETH BARRETT BROWNING
(1806–61)
MICHELE GORDIGIANI, 1858
Oil on canvas
737 x 584mm

Robert Browning and Elizabeth Barrett Browning were two of the foremost Victorian poets. After eloping together, they lived mainly in Italy. Robert is remembered for his dramatic psychological monologues, such as *My Last Duchess* (1842), and Elizabeth's reputation now rests chiefly on *Sonnets from the Portuguese* (1850).

The portrait painter Michele Gordigiani (1830–1909), whose studio was in Florence, was commissioned to paint these companion works by the American writer, Sophia May Eckley. Eckley's inscriptions on the reverse of the works indicate her determination that the portraits would be the best available likenesses of the poets, noting that Robert described his own as an 'Incomparable Portrait by far the best ever taken', while that of Elizabeth was 'pronounced by Robert

Browning to be the best Portrait ever taken of the
Poetess'. At the time, however, Robert had reservations
about the portrait of his wife, writing to Eckley: 'The
portrait is not perfect certainly; the nose seems over
long and there are some other errors in the face; also,
the whole figure gives the idea of a larger woman.'
Similarly, William Michael Rossetti wrote of Robert's
portrait, 'The face in this portrait is certainly a highly
intellectual one; but I think it is treated with too
much *morbidezza* [softness], so as to lack some of that
extreme keenness, which characterised Browning.'
Nevertheless, these companion portraits certainly
convey the intense and cerebral characters of the
sitters. NPG 1898 and NPG 1899

PRINCE ALBERT OF SAXE-COBURG-GOTHA (1819–61)

FRANZ XAVER WINTERHALTER,
1867
Oil on canvas
2413 x 1568mm

The second son of Ernest, Duke of Saxe-Coburg-Gotha, Albert married his cousin, Queen Victoria, in 1840, shortly after her accession to the throne. He came to play an influential role in British public life, was a notable patron of the arts, and an enthusiastic supporter of technological developments and agricultural reform. He was largely responsible for the Great Exhibition of 1851. Victoria and Albert enjoyed a close relationship and she was devastated by his early death in 1861.

The German artist Franz Xaver Winterhalter (1805–73) first came to the British court in 1842, thereafter making trips to England every summer or autumn for six or seven weeks, painting portraits at Buckingham Palace or Windsor Castle. Between then and 1871 he painted more than 100 works in oil for Victoria and Albert, of them and their growing family. His elegant and cosmopolitan style, which could also convey the affectionate informality of the royal family, was admired by them to the exclusion of native artists. This work is a replica by Winterhalter himself of the fourth and last portrait that he painted of Albert in 1859. It was commissioned by Queen Victoria after discreet enquiries from the Gallery, and was presented by her in 1867. NPG 237

THE ROSSETTI FAMILY

LEWIS CARROLL (CHARLES LUTWIDGE DODGSON),
1863
Albumen print
175 x 222mm

This portrait of the Rossetti family was one of a series taken in the garden of Dante Gabriel Rossetti's house, 16 Cheyne Walk, Chelsea, during a four-day session in October 1863. The photographer was Charles Lutwidge Dodgson (1832–98), better known under his pseudonym Lewis Carroll as the author of *Alice's Adventures in Wonderland* (1865). Dante Gabriel (1828–82), poet and founding artist of the Pre-Raphaelite Brotherhood, stands prominently to the left beside his seated sister Christina (1830–94), the celebrated poet

of 'Remember' (1850) and 'Goblin Market' (1862), their mother Frances (1800–86) and brother William Michael (1829–1919), an art critic and literary editor. Significantly, this is the only portrait grouping to feature both Dante Gabriel and Christina. On receipt of the set of photographs, Dante Gabriel wrote to Dodgson (13 March 1864): 'the three groups are all very good, I think – the best being that with 4 figures only'. William Michael described the portrait of his brother as 'an excellent likeness, in an easy and simple attitude. One here sees Rossetti's stature and figure better than in any other portrait; the figure now rather fleshy and bulky ... "*nel mezzo del cammin di nostra vita*" ['in the middle of the journey of our life', from Dante's *The Inferno*] for he was now thirty-five years of age.'
NPG P56

THE SECRET OF ENGLAND'S GREATNESS (QUEEN VICTORIA PRESENTING A BIBLE IN THE AUDIENCE CHAMBER AT WINDSOR)

THOMAS JONES BARKER, *c*.1863

Oil on canvas

1676 x 2138mm

This is an imagined scene, with real historical figures. Queen Victoria (1819–1901) is shown at Windsor Castle receiving an ambassador from East Africa, to whom she is presenting a fine copy of the Bible. She is attended by Prince Albert (1819–61) and two politicians, Lord John Russell (1792–1878) and Lord Palmerston (1784–1865), respectively Foreign Secretary and Prime Minister. The painting, by Thomas Jones Barker (1815–82), is based upon a popular, but unfounded, anecdote current in the 1850s. This stated that Queen Victoria, when asked by a foreign delegation how Britain had become so powerful in the world, replied that it was not because of its military or economic might. Handing him a copy of the Bible, she said, 'Tell the Prince that this is the Secret of England's Greatness.' The painting therefore evokes the evangelical underpinnings of the British Empire rather than showing an actual event. But recent research has suggested that the envoy depicted is probably based on Ali bin Nasr, governor of Mombasa, who attended Victoria's coronation in 1838 and returned again in 1842, together with his young interpreter Mohammed bin Khamis. Although not a portrait, the envoy's costume is based on that of the Omani rulers of East Africa. Paintings such as this toured widely in Victorian Britain in order to promote sales of the engraving made from it. NPG 4969

CHOOSING (ELLEN TERRY [1847–1928])

GEORGE FREDERIC ('G.F.') WATTS,
1864
Oil on panel
480 x 352mm

Regarded as the greatest English actress of the period, Ellen Terry played many leading roles in Henry Irving's productions, such as Portia in Shakespeare's *The Merchant of Venice*. This portrait was painted by George Frederic Watts (1817–1904) at the time of his marriage to Terry, when he was forty-five and she was not quite seventeen. She wears her Renaissance-style wedding dress of brown silk (which now appears closer to green) and, according to Terry, it was designed by Pre-Raphaelite artist William Holman Hunt. The sensuous depiction of pale flesh against abundant foliage celebrates her youthful beauty. This work is at once a portrait and an allegory: Terry must choose between the spectacular yet scentless camellias to which she inclines, and the small bunch of sweet-smelling violets cradled in her left hand. Whilst the latter symbolises innocence and simplicity, the former signifies worldly vanities, in this instance the stage.

The couple separated a year later and divorced in 1877. The actress's lifelong friend, the painter Walford Graham Robertson, maintained that 'to marry Ellen was an absurd thing for any man to do. He might as well marry the dawn or the twilight or any other evanescent and elusive loveliness of nature.' NPG 5048

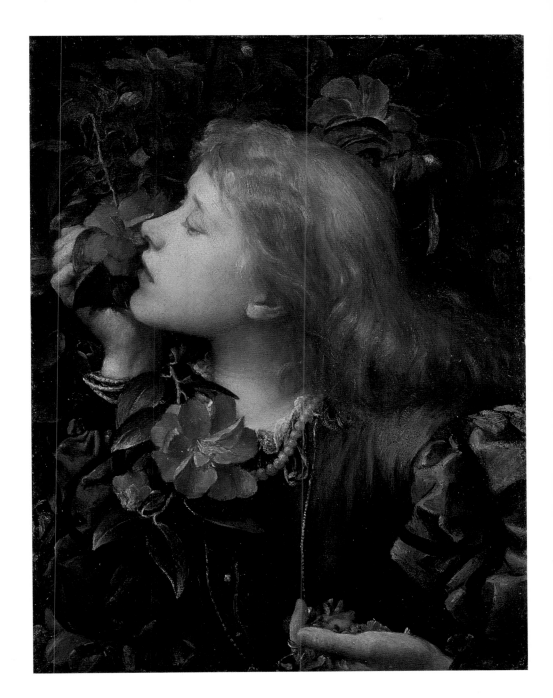

SIR EDWIN LANDSEER
(1802–73)

JOHN BALLANTYNE, *c.*1865
Oil on canvas
800 x 1130mm

Edwin Landseer was a favourite of Queen Victoria and
one of the most popular painters of the nineteenth
century. He specialised in animal painting, chiefly pet
portraits and hunting scenes, and also anthropomorphic
works parodying human behaviour, such as *Laying
Down the Law* (1840), which satirises the legal
profession. A child prodigy, Landseer entered the
Royal Academy Schools at the age of fourteen, and
was affectionately nicknamed by the Keeper, Henry
Fuseli, as 'my little *dog boy*'. In addition to his animal
subjects, he painted historical works and portraits, and
made sculptures and prints. Much of his fame and
income was generated by engravings of his work, many
executed by his brother, Thomas, with whom he also
gave art lessons to Queen Victoria and Prince Albert.

 This is one of a series of portraits of artists at work by
John Ballantyne (1815–97), and shows Landseer in the
studio of Baron Marochetti, modelling one of the lions
for the base of Nelson's Column in Trafalgar Square,
London – now his most universally recognised work.
The commission occupied him for over eight years,
and the pressures of the ambitious project greatly
affected his health. The ageing artist is here shown,
appropriately, accompanied by his pet collie, Lassie.
NPG 835

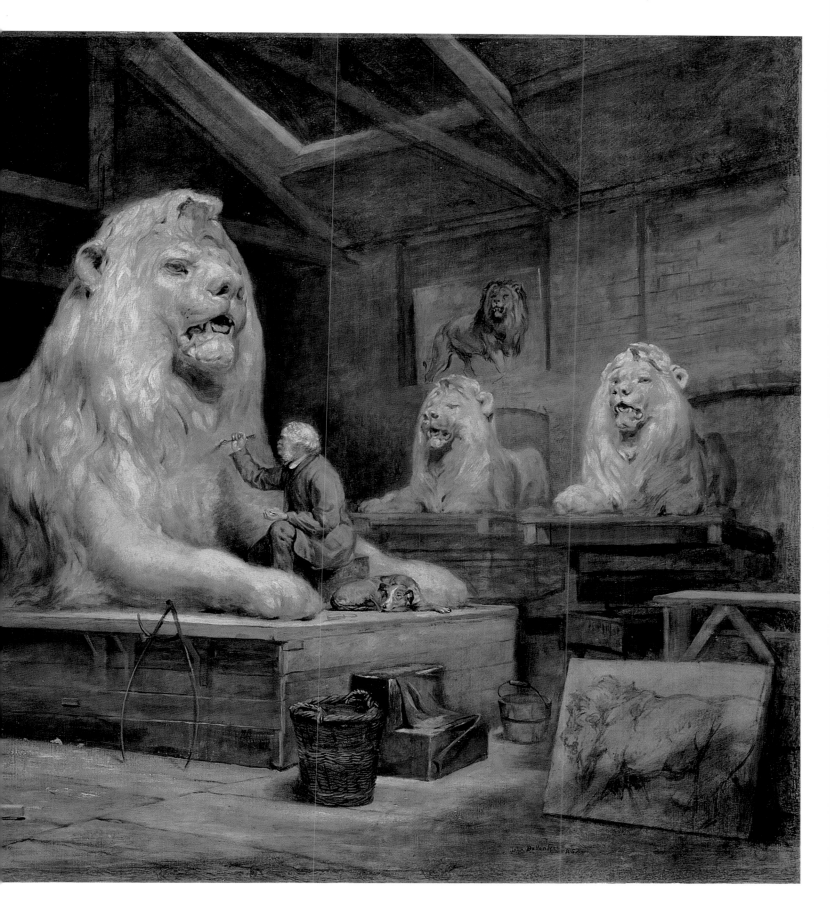

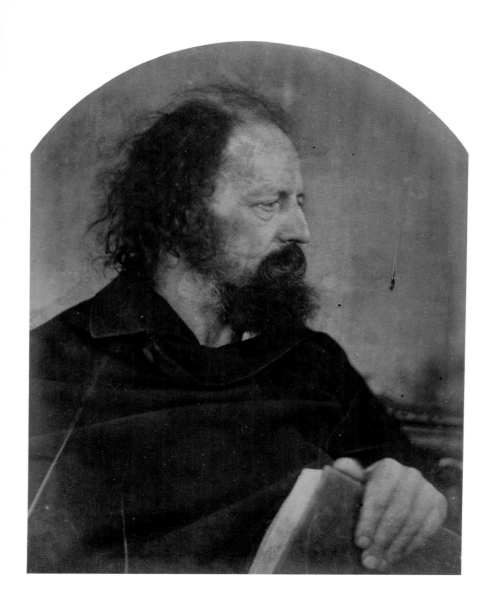

ALFRED TENNYSON,
1ST BARON TENNYSON
(1809–92)
JULIA MARGARET CAMERON, 1865
Albumen print
249 x 201mm

Alfred Tennyson was the most popular poet of
the Victorian age, renowned for his expressions of
deep sentiment, as in *In Memoriam A.H.H.* (1850) in
remembrance of his best friend, Arthur Hallam. He was
also acclaimed for his classical and Arthurian narratives,
such as 'Ulysses' and 'Morte d'Arthur' (both 1842).
The longest-serving Poet Laureate ever, he was held
in such esteem by Queen Victoria that the post itself
was considered for abolition upon his death. Despite
his great fame and ambition, Tennyson was a socially
awkward, private man who was prone to depression,
acutely sensitive to critics and hostile to the imposition
of celebrity.

Julia Margaret Cameron (1815–79) took up
photography in her late forties and was one of the
first, and remains one of the greatest, portrait
photographers. As a close friend and neighbour of
Tennyson on the Isle of Wight, Cameron photographed
him often. This profile portrait of the poet, clothed
in dark robes and in pensive reverie, his attribute of
a book in hand, illustrates Cameron's mid-Victorian
fascination for High Renaissance art and the Romantic
medievalism of the Pre-Raphaelites. Tennyson wrote
under the portrait, 'I prefer the Dirty Monk to the
others of me.' NPG x18023

WILLIAM GIFFORD PALGRAVE
(1826–88)

THOMAS WOOLNER, 1864
Plaster cast of medallion
248mm diameter

William Palgrave was an explorer
and scholar of the Middle East.
After serving in the Indian army,
he converted to Roman Catholicism
and worked as a missionary in
southern India until 1853.
He began his long engagement
with the Arab world in 1855 as
a missionary in Syria, where he
witnessed the persecution of Syrian
Christians. Palgrave's most notable
achievement lay in exploring
Arabia, which had for years been
closed to Europeans. In 1862 and
1863 he became the first Westerner
to cross Arabia by a diagonal route,
from north-west to south-east,
travelling in disguise and at great
risk as a European. He recorded his
adventures and observations in his
*Personal Narrative of a Year's Journey
through Central and Eastern Arabia*
(1865). A series of consular posts, as
far afield as Bangkok and Uruguay,
followed.

Thomas Woolner (1825–92)
was the only sculptor in the
Pre-Raphaelite Brotherhood and
knew the Palgrave family through
his intimate friendship with
William's older brother, Francis
Turner Palgrave, the compiler
of the famous poetry anthology,
The Golden Treasury. Woolner
wrote to Francis in September
1865 that he had read William's
Personal Narrative and had 'for the
last fortnight scarcely thought of
anything else, I found it so
absorbing'. NPG 2071

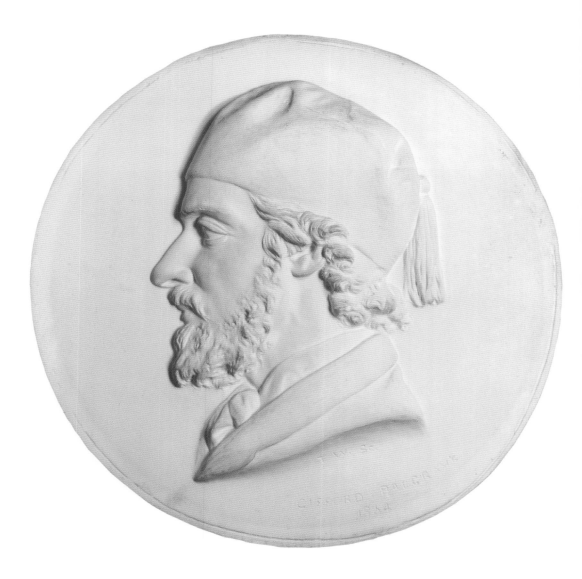

MARY SEACOLE
(1805–81)

ALBERT CHARLES CHALLEN, 1869
Oil on panel
240 x 180mm

Born in Kingston, Jamaica, in 1805, Mary Seacole learnt her nursing skills from her mother, who ran a boarding house for invalid soldiers. After the outbreak of the Crimean War (1853–6), she sailed for England in 1854 and volunteered for Florence Nightingale's nursing contingent. She was refused interviews with the War Office, probably due to her ethnicity and lack of formal training. Undeterred, Seacole travelled to the region at her own expense, opening 'The British Hotel' outside Balaklava. Here she fed and cared for the sick and wounded troops on the battlefield, becoming affectionately known as 'Mother Seacole' throughout the Crimea.

This small portrait by the London artist Albert Charles Challen (1847–81) is the only known painting in oil of the sitter. It only came to light in 2002, and was acquired by the National Portrait Gallery six years later. Since the 1970s, the development of a black and Asian historiography has given Seacole a central place in black British history. NPG 6856

WILLIAM MORRIS
(1834–96)

GEORGE FREDERIC ('G.F.') WATTS,
1870
Oil on canvas
648 x 521mm

This is a rare painted portrait of
William Morris, one of the most
influential artistic figures of the
Victorian period, whose name has
become synonymous with the
Arts and Crafts movement, which
embraced standards of medieval
craftsmanship in order to oppose
factory mass-production. His
industriousness and apparent
dislike of portraiture made him
an elusive subject. According to
Mary Seton Watts, wife of the
artist George Frederic Watts
(1817–1904), there may have been
just one sitting for the picture, on
15 April 1870. In 1880 the work
was submitted to the Summer
Exhibition at the Grosvenor
Gallery, for which it was possibly
reworked. Ultimately it made a
worthy addition to Watts's 'Hall
of Fame', a series of eminent
Victorians that numbers over fifty
portraits and is now in the Gallery's
Collection. Although selected for
presentation in September 1895,
it was not officially acquired until
February 1897, owing to Gallery
regulations that then precluded the
display of a portrait during a sitter's
lifetime. The fact that it eschewed
the usual ten-year rule regarding
the acceptance of deceased sitters
into the Collection is testament to
Morris's celebrity at the time of
his death. NPG 1078

CAPTAIN FREDERICK BURNABY
(1842–85)

JAMES JACQUES TISSOT, SIGNED AND DATED 1870
Oil on panel
495 x 597mm

Captain Burnaby is here portrayed as a dashing young officer of the Household Cavalry, with waxed moustache and nonchalantly posed with cigarette. He lounges on a sofa in undress uniform, the scarlet stripe of his trouser leg emphasising his physical height, for which he was renowned. In his late twenties, at the time this portrait was painted, the sitter's achievements as an adventurer and balloonist largely lay ahead of him, and this picture presents a more generalised depiction of the easy confidence of an army officer of the period. The informal presentation contrasts with the conventional full-length standing or mounted military portrait; the seemingly domestic interior in which he sits resists identification.

The picture was commissioned by Thomas Gibson Bowles, a friend and associate of Burnaby with whom he founded *Vanity Fair* in 1868. It is likely that the idea for the portrait was conceived in 1869, the year that Bowles met James Jacques Tissot (1836–1902) in Paris and when the French artist's first caricatures of European monarchs were published in the magazine under the pseudonym 'Coïdé'. NPG 2642

HENRY FAWCETT
(1833–84) AND DAME
MILLICENT GARRETT
FAWCETT (1847–1929)
FORD MADOX BROWN, 1872
Oil on canvas
1086 x 838mm

This portrait by Ford Madox Brown
(1821–93) shows two of the period's
leading liberal intellectuals. Henry
Fawcett was Professor of Political
Economy at the University of
Cambridge from 1863 to 1884 and
a Member of Parliament from 1865
until his death. He was an advocate
of radical causes and a keen
supporter of feminism. Blinded
by a shooting accident in 1858, he
resolved that this would not affect
how he spent his life and career.
He is shown with his wife, Millicent
Garrett Fawcett, and appears to be
dictating to her: the paper he holds
is inscribed with both their names.
A leading feminist, Millicent
joined the first women's suffrage
committee in 1867, the year of
their marriage, and in 1897 became
president of the influential National
Union of Women's Suffrage Societies.

The portrait was commissioned
from the Pre-Raphaelite painter
Ford Madox Brown by Henry
Fawcett's friend and political ally
Sir Charles Dilke. Its conception
as a double portrait appears to have
come from Madox Brown, who
wrote to Dilke on 21 January 1872
that 'My idea of painting Fawcett
and his wife seems to me the most
interesting' and that 'a group might
be made of them full of character &
pathos'. NPG 1603

LOUISE JOPLING
(1843–1933)
SIR JOHN EVERETT MILLAIS, 1879
Oil on canvas
1240 x 765mm

Louise Jopling was a portrait painter and personal friend of John Everett Millais (1829–96) and his family. This picture was painted for her husband Joseph Jopling in Millais's London studio at Palace Gate, Kensington. In the late 1870s Millais's portrait practice was thriving; his recent subjects included Thomas Carlyle, Lillie Langtry and William Ewart Gladstone. The portrait was painted quickly, requiring just five short sittings, and, as Jopling noted in her autobiography, *Twenty Years of My Life, 1867 to 1887* (1925): 'We had great discussions as to what I should wear. I had at that time a dress that was universally admired. It was black, with coloured flowers embroidered on it. It was made in Paris.' The portrait exemplifies the fluency of Millais's later style and displays a strong sense of design. It was exhibited at the Grosvenor Gallery in 1880, where James McNeill Whistler declared it 'superb'. NPG 6612

SIR HENRY IRVING
(1838–1905)
JULES BASTIEN-LEPAGE, 1880
Oil on canvas
432 x 457mm

The actor Henry Irving apparently disliked this unfinished portrait by French artist Jules Bastien-Lepage (1848–84) and nearly destroyed it. It was rescued by Ellen Terry (page 149), Irving's stage partner and close friend, who hung it on the walls of her Chelsea home. The idea came from the artist, who met Irving in the spring of 1880, whilst on a visit to London. At this time he was in his forties and at the height of his career, earning critical acclaim for his productions at the Lyceum Theatre and performances on stage. Initial sittings took place in Irving's study at 15A Grafton Street in London's Mayfair. Yet Irving soon tired of the process and this sensitive likeness, showing the actor in private dress, remained unfinished except for the head. When Terry presented it to the National Portrait Gallery in 1909, she asked to keep the fragment of a note from Irving pasted on the reverse, which read: 'I'm expecting Bastien-Lepage every moment. I'd cut up the nasty thing, but think you like it.' NPG 1560

WILLIAM EWART GLADSTONE
(1809–98)

SIR JOHN EVERETT MILLAIS, 1879
Oil on canvas
1257 x 914mm

Four times prime minister, William Ewart Gladstone, who had first held office in 1834 and left it for the last time in 1894, was one of the commanding political, intellectual and moral presences of the Victorian period. This is the first of four portraits of Gladstone painted by John Everett Millais (1829–96), made at the artist's request and painted when Gladstone was out of government: he was to defeat Disraeli and become prime minister for the second time in April 1880. There were six sittings for the portrait between 26 June and 6 August 1878, Gladstone noting in his diary that it took a total of eight hours. He was impressed by the way Millais tackled the portrait, writing to the artist's son and biographer of 'the intensity with which he worked' and 'the extraordinary concentration with which he laboured'. The contemporary critic Claude Phillips wrote in a review of Millais's 1898 memorial exhibition of the portrait that it gave 'the whole man with mind and body in perfect balance, with breath in his nostrils as well as speculation in his eyes'. It was a painting, Phillips thought, that was 'perfect as a portrait', masterly in 'its concentrated force and simplicity'. NPG 3637

BENJAMIN DISRAELI, EARL OF BEACONSFIELD
(1804–81)

SIR JOHN EVERETT MILLAIS, 1881
Oil on canvas
1276 x 931mm

In a remarkable career, Benjamin Disraeli transformed himself from romantic literary prodigy to one of the greatest statesmen of the age. By gradually asserting his influence on the Tory party, he became Prime Minister in 1868. He guided through the Second Reform Bill, while his diplomatic triumphs included the purchase of the Suez Canal and the Congress of Berlin.

 This portrait by John Everett Millais (1829–96) appears to have been conceived as a pendant to that of Disraeli's adversary, William Ewart Gladstone (opposite). Lord Ronald Gower had lobbied Disraeli to sit for Millais at a meeting of the Trustees of the National Portrait Gallery in May 1879, while the Gladstone portrait was on display at the Royal Academy. In the end, sittings did not take place until March 1881, after Disraeli's crushing defeat by Gladstone in the 1880 general election and when Disraeli was fatally ill. The portrait was left unfinished at his death on 19 April 1881. Queen Victoria commanded that it be shown at the forthcoming Royal Academy exhibition. Millais apparently left the face as it was but worked on the background and frock coat. It was exhibited on a special screen draped with black crêpe. NPG 3241

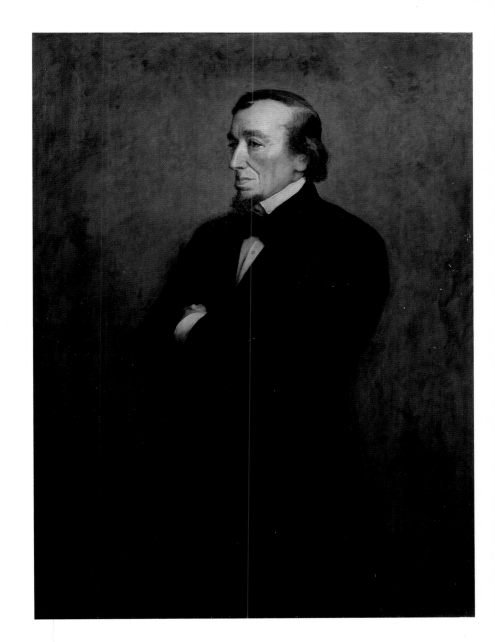

Early Photography

CLARE FREESTONE

The origins of photography stem from imaging devices such as the camera obscura, but it was Louis Daguerre who, in 1839, patented the first practical photographic process after building on the experiments of Joseph Nicéphore Niépce. The daguerreotype technique, involving the exposure of a sensitised silvered copper plate, resulted in a unique, lustrous image. It was the first process to become widely used, and the high level of detail was particularly suitable for portraiture.

In England, William Henry Fox Talbot had concurrently been conducting experiments in exposing sensitised paper to light. In 1840 he discovered the calotype (patented 1841) whereby sensitised paper is exposed, developed, waxed and printed on to salted paper. The Scottish chemist and pioneer photographer Robert Adamson and the painter David Octavius Hill combined their technical knowledge and aesthetic sensibility to make portraits and topographical scenes using this method. The benefit of a positive image that could be printed from a negative and could therefore be reproduced countless times was not widely appreciated until the 1850s.

It was perhaps no coincidence that the first golden age of photography coincided with the increasing interest in personal celebrity in the Victorian age. This was reflected by publications of collections such as Herbert Fry's *National Gallery of Photographic Portraits* (1857–8) and Maull & Polyblanks's *Living Celebrities* (1856–9). The Gallery began to accept photographs for its reference collection in the 1870s, and has an important and diverse collection of early portrait photographs by some of the first exponents of the medium. The Gallery's first Director, Sir George Scharf, was himself a keen collector of photographs, and bequeathed his own personal collection to the Gallery.

The advancement of photography, especially out of the studio, was technically challenging. Between 1856 and 1859 travel photographer Francis Frith embarked on three pioneering trips to the Middle East, photographing landscapes and monuments. Frith preferred the clarity of wet-collodion glass plate negatives (introduced by Frederick Scott Archer in

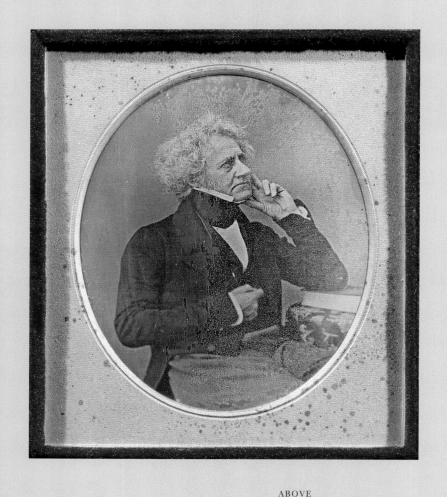

ABOVE

Sir John Herschel (1792–1871), by J.J.E. Mayall. Daguerreotype, *c.*1848, 86 x 70mm, NPG P660 •
This portrait of John Herschel, pictured adopting a 'thinking man's pose', is especially relevant in that the scientific sitter himself made contributions to early photography and originated the terms 'photograph', 'negative' and 'positive'.

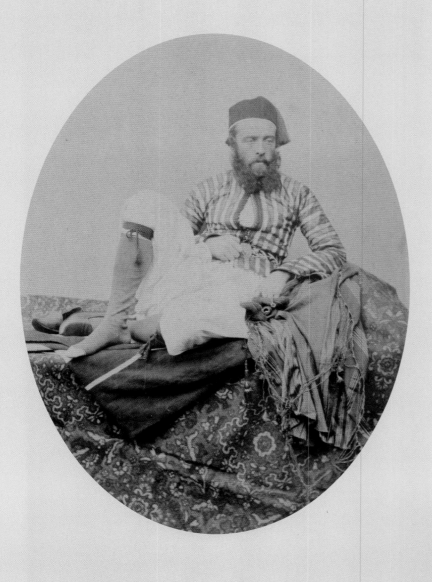

1851) and the ability to make from them multiple albumen prints, which retained detail well.

The aim of raising photography above the 'mere attempt at producing a likeness' was championed by Julia Margaret Cameron. The wet-collodion process was the means adopted for artistic portraiture of this kind, such as Lewis Carroll's images of Alice Liddell (overleaf). However, its commercial use was also widespread as, during the 1850s, the number of photographers registered in England rose from around 50 to over 3,000. In addition, photography was disseminated by the press: Roger Fenton's pioneering salt prints of the Crimean War appeared as line engravings in the *Illustrated London News* in 1855, and in 1857 the *Illustrated Times* commissioned Robert Howlett to photograph Isambard Kingdom Brunel (page 143), engineer of the 'Leviathan' steamship, also known as the SS *Great Eastern* (published 16 January 1858).

ABOVE

Francis Frith (1822–98), self-portrait in Turkish summer costume. Albumen print, 1857, 186 x 142mm, NPG X13682 • This self-portrait appeared as the frontispiece to Francis Frith's two-volume publication *Egypt and Palestine*, in which both the photographs and descriptions are by the author (1858–60).

RIGHT

Lady Eastlake (1809–93), by Hill & Adamson. Calotype, 1843–5, 206 x 156mm, NPG P6(124) • The art historian Elizabeth Eastlake's 1857 essay on photography was an early defence of the new art form. Her husband Sir Charles Eastlake, the first Director of the National Gallery, was also the first president of the Royal Photographic Society, which was founded in 1853 following an increased awareness of photography that was enhanced by the Great Exhibition (1851).

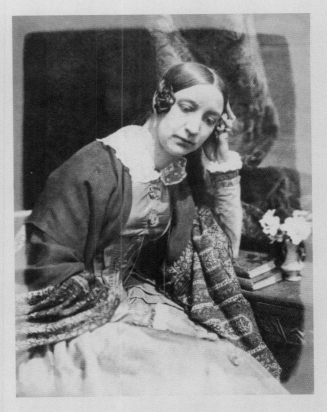

In 1859 the French photographer Camille Silvy opened a portrait studio in Bayswater, producing photographic visiting card-sized prints known as 'cartes-de-visite' (patented 1854, by André Disdéri), one of the first to do so in London. Working under the patronage of Queen Victoria, Silvy photographed royalty, leading members of society, visitors to London and other celebrities. By 1864, aged twenty-six, Silvy had forty employees. His personal archive (or 'daybooks'), containing 12,000 file prints recording the names of his subjects and the date of their sittings, was purchased by the Gallery in 1904.

The mass-production of cartes-de-visite placed photography within the grasp of the growing upper-middle class, and celebrity culture was fostered. The collecting of these 'cartes' increased significantly when a series of portraits of Queen Victoria and Prince Albert, taken by J.J.E. Mayall in 1860, became the first photographs of the royal family to be made widely available.

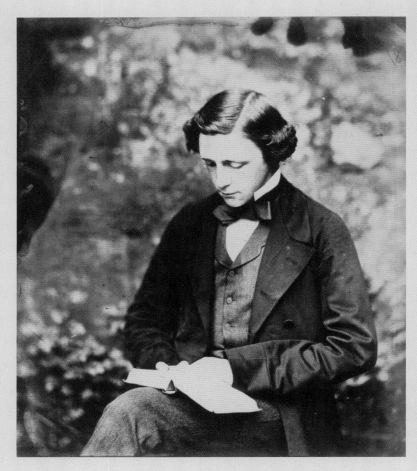

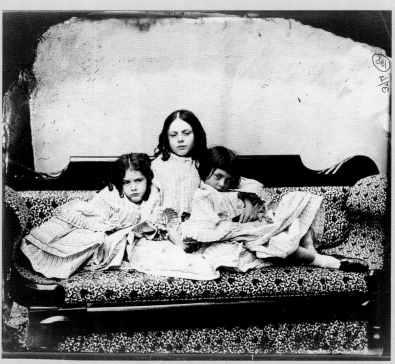

TOP

Lewis Carroll (Charles Dodgson, 1832–98), by Lewis Carroll. Albumen print, *c.*1857, 140 x 117mm, NPG P7(26) • In this self-portrait Carroll looks down at a book, a similar pose to those he established for many of his Oxford contemporaries in his album. It is possible that this image was taken by Reginald Southey, a fellow student of Carroll's, who encouraged his interest in photography.

RIGHT

Alice Liddell (1852–1934) and her sisters, by Lewis Carroll (Charles Dodgson). Albumen print from wet-collodion glass plate negative, 1858, 154 x 181mm, NPG P991(4) • Alice Liddell (right), pictured with her sisters Ina and Edith, was the inspiration for Lewis Carroll's *Alice's Adventures in Wonderland* (1865), her beguiling gaze is captured in this portrait by the author.

Sarah Forbes Bonetta (Sarah Davies, d.1880), by Camille Silvy. Albumen print, 1862, 83 x 56mm, NPG AX61380 • West African-born Sarah Forbes Bonetta is wearing her wedding dress following her marriage to the Sierra Leonean merchant Captain James Davies in Brighton in August 1862. The marriage was sanctioned by Queen Victoria to whom she had been presented by Commander Forbes, captain of HMS *Bonetta*. The Queen was instrumental in Sarah's middle-class education, and gave permission for her first child to be named Victoria.

Aubrey Beardsley (1872–98), by Frederick H. Evans. Platinum print, 1894, 136 x 97mm, NPG P114 • A recommendation by Frederick H. Evans facilitated Aubrey Beardsley's career as a full-time illustrator, and their friendship allowed for this defining portrait. Beardsley adopted the pose when his friend jested that his face was like a 'gargoyle'. Beardsley wrote to Evans on 20 August 1894: 'I think the photos are splendid; couldn't be better.' Evans experimented with the platinum process; matt and dense, it was favoured by members of the leading art photographers' group, the Linked Ring.

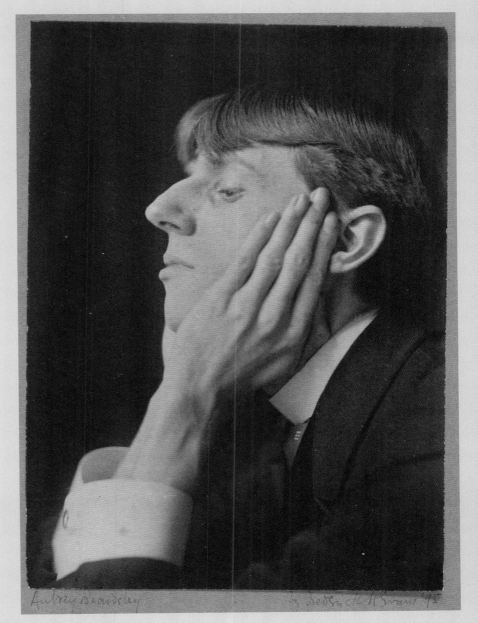

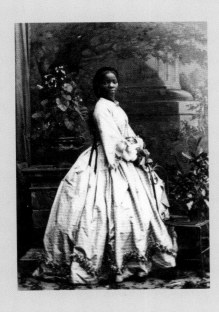

Towards the latter part of the nineteenth century photographers such as James Craig Annan, Frederick Hollyer, Eveleen Myers and Frederick H. Evans became concerned with individual expression and the integrity of the medium. Evans's pictorial sensitivity led to his reputation as one of the most important members of the art photographers' group known as the Linked Ring (founded 1892).

His portrait of Aubrey Beardsley (above) was exhibited at the group's second Photographic Salon (October 1894), mounted on one of Beardsley's designs.

By the end of the century the many technical improvements made since its inception ensured photography was a critical tool for accurate recording and mass distribution, as well as an emerging art form.

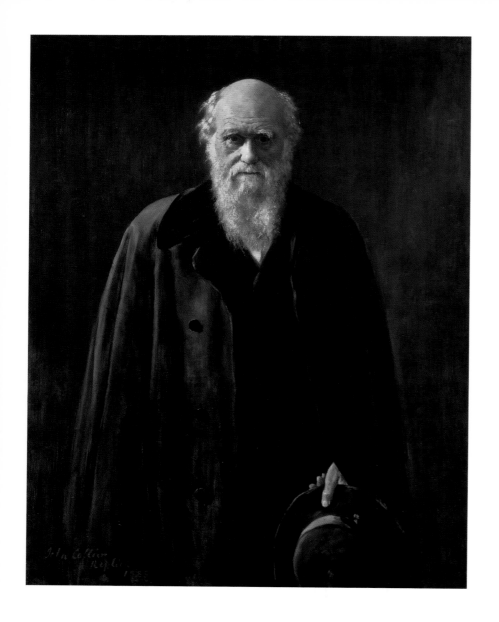

CHARLES DARWIN
(1809–82)
JOHN COLLIER, 1883
Oil on canvas
1257 x 965mm

This portrait of the naturalist Charles Darwin is a copy by the artist of a painting made for the Linnaean Society in 1881. It was given to the National Portrait Gallery by Darwin's eldest son, William Erasmus Darwin, who in 1896 wrote to the Director Lionel Cust that 'as a likeness, it is an improvement on the original'. Darwin's career as a scientist began properly in 1831, when his university tutor secured him a place on the *Beagle* voyage around the world. The expedition lasted five years, visiting some of the most remote places in the world, including South America, the Galápagos Islands, Australia and South Africa. Darwin's experiences and the samples that he collected provided the foundations of his controversial work on evolution, *On the Origin of Species by Means of Natural Selection* (1859).

John Collier (1850–1934) was the son-in-law of Thomas Huxley, Darwin's defender in the furore surrounding the publication of his work. Collier's portrait, which depicts Darwin as an old man, was much admired. Darwin's son Francis wrote in his *Life and Letters of Charles Darwin* (1887), 'Many of those who knew his face most intimately, think that Mr Collier's picture is the best of the portraits and in this judgement the sitter himself was inclined to agree.' NPG 1024

SAMUEL COLERIDGE-TAYLOR
(1875–1912)
WALTER WALLIS, 1881
Oil on canvas
256 x 205mm

Samuel Coleridge-Taylor was the son of a doctor from Sierra Leone and an English mother. Raised in Croydon, he posed for painters associated with the Croydon Art Club when he was about seven years old. One of the resulting portraits, by Walter Wallis, who was principal of Croydon Art School in the 1880s and 1890s, shows the sitter wearing a plain cap and tunic and is a rare example of a child's portrait in the Gallery's Collection.

As a boy, Coleridge-Taylor learnt to play the violin and sang in the church choir, and in 1890 entered the Royal College of Music to study violin and composition. He was still a student when the first part of his best-known work, the cantata trilogy 'The Song of Hiawatha', was played in public. This remained a favourite with choirs until the 1940s. A composer of opera, orchestral, church and chamber music, he also wrote incidental music for the romantic plays at His Majesty's Theatre, London. Coleridge-Taylor was appointed conductor of the Handel Society in 1904, and made three trips to the United States as visiting conductor in the first decade of the century. He died of pneumonia at his home in Croydon, aged just thirty-seven. NPG 5724

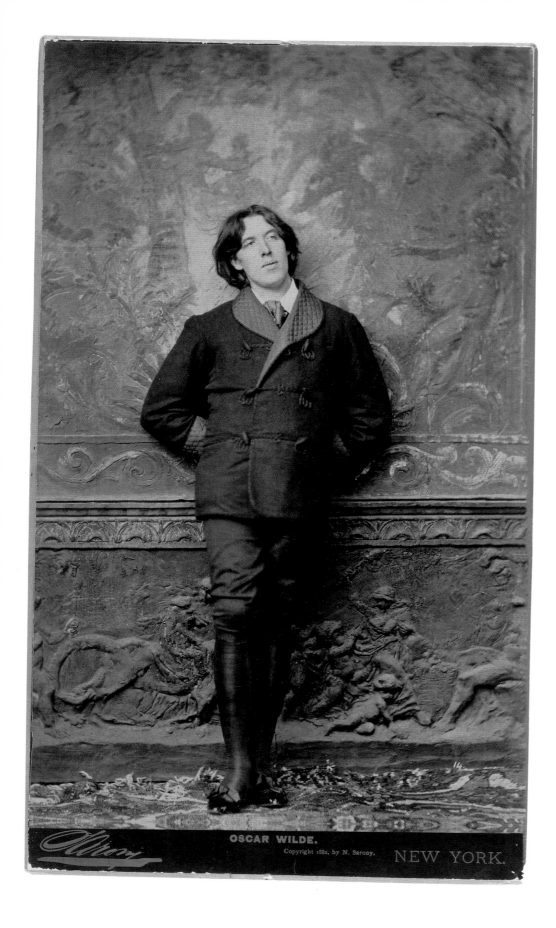

OSCAR WILDE.
Copyright 1882, by N. Sarony.
NEW YORK.

OSCAR WILDE
(1854–1900)
NAPOLEON SARONY, 1882
Albumen panel card
305 x 184mm

Poet, playwright, legendary wit and gay icon, Oscar Wilde is one of the best-known figures of the late nineteenth century. A brilliant conversationalist, he quickly became established in fashionable London society and was an important spokesman for the Aesthetic movement, which proclaimed 'Art for Art's sake'. Wilde's only novel, *The Picture of Dorian Gray* (1891), was greatly influenced by Aesthetic thought. His play *The Importance of Being Earnest* (1895) has been hailed as one of the greatest of British comedies, but Wilde's success was cut short by his trial and imprisonment for gross indecency. His reputation was destroyed and he died in poverty in France.

This photograph, taken in New York, captures Wilde before his literary triumphs. While on a lecture tour to promote Aestheticism in America, he went to the studio of Napoleon Sarony (1821–96) for a publicity photograph. Sarony took a number of images depicting Wilde in different poses and in various outfits. In this image Wilde wears the quilted smoking-jacket, silk knee-breeches and patent leather slippers in which he delivered his lectures: clothes that mark him out as the quintessential dandy. As Sarony reputedly declared, Wilde was 'A picturesque subject indeed!' NPG P24

SIR WILLIAM SCHWENCK ('W.S.') GILBERT
(1836–1911)
FRANCIS MONTAGUE ('FRANK') HOLL, SIGNED AND
DATED 1886
Oil on canvas
1003 x 1257mm

From the late 1850s, W.S. Gilbert established himself as a prolific author in periodicals, in particular *Fun*, the rival to *Punch*, and had written a number of pieces for the stage. But it was his collaboration with Arthur Sullivan and the 'Savoy' operas for which he wrote the librettos that were Gilbert's greatest success, and he was at the height of his fame when he was painted by Frank Holl (1845–88). Holl and Gilbert were well acquainted, the artist's daughter recalling children's parties at the Gilberts' home in London's South Kensington, so it was natural that Gilbert should turn to Holl when his wife wanted his portrait painted. Gilbert wrote to Holl on 22 November 1886 to arrange the first sittings and asked what he should wear. 'My usual writing dress would hardly do for exhibition', he wrote, 'consisting, as it does of nightshirt and dressing gown.' Since he would usually ride to Holl's studio, he continued, 'would an easy-going riding dress do? Say broad cords – with a velveteen jacket?' And so he is shown, holding a riding crop in his right hand. NPG 2911

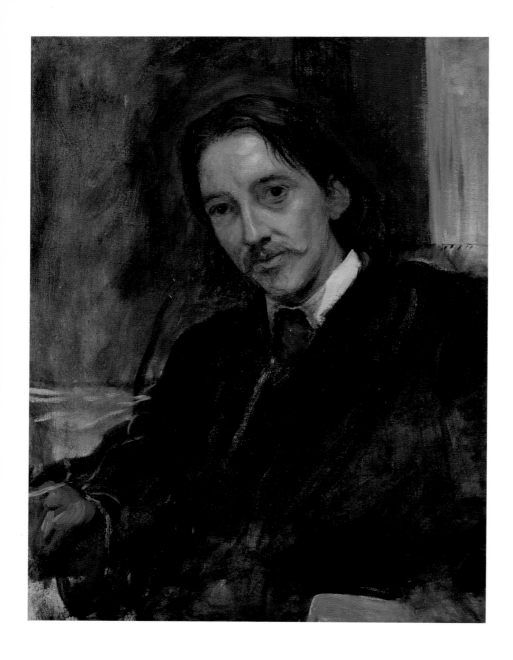

ROBERT LOUIS
STEVENSON
(1850–94)
SIR WILLIAM BLAKE RICHMOND,
1886
Oil on canvas
737 x 559mm

Robert Louis Stevenson abandoned the studies of engineering and the law early in life and turned to writing stories and novels of great charm and humour. His name will forever be associated with *Treasure Island* (1883), but he also wrote other classics of the language, such as *The Strange Case of Dr Jekyll and Mr Hyde* and *Kidnapped* (both 1886), produced around the time this portrait by William Blake Richmond (1842–1921) was painted. Much travelled, partly in response to enduring ill health, Stevenson spent the last four years of his life on his plantation, Vailima, in Samoa. Although the painting is unfinished, the circumstances in which it was painted are highly evocative of artistic friendships of the period and record a memorable late Victorian occasion. It was executed in one sitting, at Richmond's house in Hammersmith, on a hot August afternoon amid a jovial company, including Stevenson's mentor and closest friend, the art historian Sidney Colvin, the Pre-Raphaelite artist Edward Burne-Jones and Burne-Jones's daughter, Margaret. Margaret recalled their conversation in her diary for 10 August 1886: 'They discussed suicide; compared notes as to their feelings towards policemen; told ghost stories; and most of the time Mr. Richmond painted, and Mr. Stevenson sat easily talking, smoking, and drinking coffee.' NPG 1028

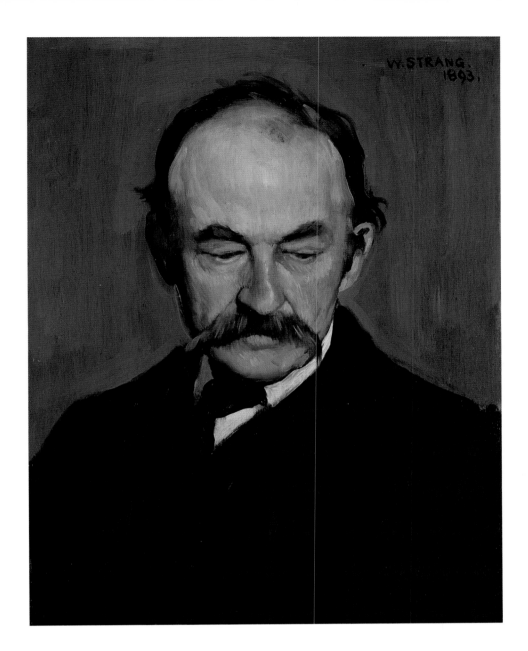

THOMAS HARDY
(1840–1928)
WILLIAM STRANG, SIGNED AND
DATED 1893
Oil on panel
432 x 381mm

Thomas Hardy was one of the last great novelists of the nineteenth century. His writing centred on tragic characters, such as Tess in *Tess of the d'Urbervilles* (1891), whose lives were played out in rural settings, most often his native Dorset. Other key works include *Far from the Madding Crowd* (1874) and *Jude the Obscure* (1896), in addition to volumes of poetry and an epic drama, *The Dynasts* (1904–8). The printmaker William Strang (1859–1921) only took up painting seriously in the 1890s under the influence of James McNeill Whistler.

This commission followed on from an earlier etched portrait of 1893. An inscription on the back of the painting notes that it was completed in the remarkably short time period of half an hour, a legacy of Strang's rigorous training at the Slade School of Fine Art under Alphonse Legros.

Strang captures the reserved writer in a moment of contemplation. The painter William Rothenstein described Hardy as having 'a small dark bilberry eye which he cocked at you unexpectedly. He was so quiet and unassuming, he somehow put me in mind of a dew-pond on the Downs.' Hardy himself said that he was often mistaken for a detective. NPG 2929

MRS PATRICK CAMPBELL
(1865–1940)

FREDERICK HOLLYER, 1893
Platinotype cabinet card
140 x 89mm

Beatrice Stella Campbell (née Tanner) was one of the leading British actresses of her time. Known by her first husband's name, Campbell made her stage debut in 1888, driven by the need to provide money for her family. She achieved fame the year this photograph was taken, in the title role of Arthur Wing Pinero's *The Second Mrs Tanqueray*, which premiered at the St James's Theatre, London. Campbell played Paula Tanqueray, an ex-prostitute whose sympathetic treatment challenged the attitudes of the day. Great success followed, including acclaimed performances opposite Johnston Forbes-Robertson and, in 1914, as Eliza Doolittle in the original production of George Bernard Shaw's *Pygmalion*.

Frederick Hollyer (1838–1933) specialised in the photographic reproduction of works of art but reserved Mondays for portraiture. This softly lit and intimate portrait of Campbell has a rare delicacy and beauty, and is presented on one of Hollyer's distinctive mounts.
NPG P229

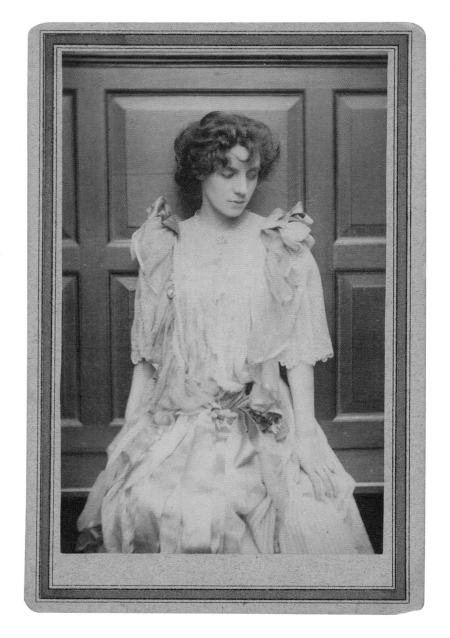

EDWARD CARPENTER
(1844–1929)

ROGER FRY, 1894
Oil on canvas
749 x 438mm

Socialist writer and campaigner
for homosexual equality, Edward
Carpenter was one of the great
dissenters from contemporary
orthodoxies. After a brief career at
the University of Cambridge, he
settled in Millthorpe, Derbyshire,
where he combined his literary
work with the simple life and, after
1893, lived openly with his lover,
George Merrill. His extensive
writings included *Towards
Democracy* (1883), *Civilisation:
Its Cause and Cure* (1889) and an
autobiography, *My Days and Dreams*
(1916).

 Roger Fry (1866–1934), the
future critic and champion of
avant-garde art, first met Carpenter
in 1886 when he was lecturing at
Cambridge; Fry was then in his
second year as an undergraduate.
He subsequently visited Carpenter
in Derbyshire. 'I knew him well
in my youth,' Fry wrote, when he
presented this painting to the
Gallery in 1930, 'and one of my
earliest and more or less complete
works was a portrait of him.'
On 14 January 1894, the year that
he painted this work, he described
it in a letter to his mother as
showing Carpenter 'standing up
and with a very anarchist overcoat
on'. Several months later he
reported to her that the portrait had
been requested for exhibition in
Liverpool, noting, 'that picture has
certainly done me a lot of good'.
NPG 2447

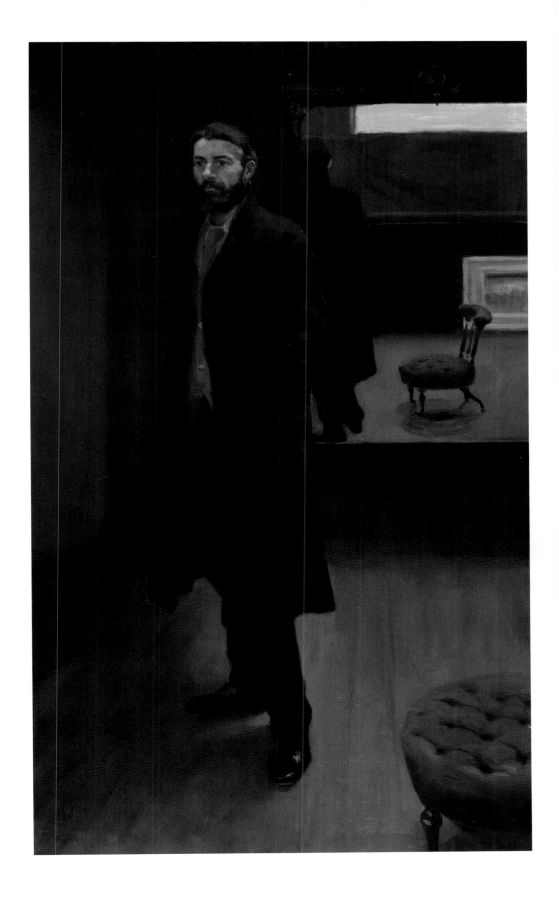

GERTRUDE, LADY COLIN CAMPBELL
(1857–1911)
GIOVANNI BOLDINI, *c.*1897
Oil on canvas
1843 x 1202mm

Gertrude Campbell was an Irish-born writer, sportswoman and dilettante. She and Lord Colin Campbell became engaged just days after meeting and, despite his father the Duke of Argyll opposing the match, they married in 1881. The marriage proved to be a disaster, with Gertrude filing for divorce on the grounds of her husband concealing his venereal disease, and Lord Colin countering his wife's claim by accusing her of adultery with four men. After a scandalous trial, her divorce was denied, prompting the suffragette Christabel Pankhurst to speak out against the double standards prevalent in Victorian England. Gertrude never quite recovered her reputation, but she built a successful career as a journalist and art critic for periodicals such as the *World* and the *Art Journal*, under pseudonyms including Véra Tsaritsyn. Her vivaciousness, wit and talents, ranging from fencing to singing and painting, led her to be welcomed into art circles, and she counted James McNeill Whistler and Oscar Wilde among her friends.

 With its exaggerated form and direct gaze, this portrait by the Italian society painter Giovanni Boldini (1842–1931) emphasises the statuesque beauty and engaging character of his sitter, who 'never [tries], by any means, to appear other than she really is' (*Etiquette*, 1893). NPG 1630

OCTAVIA HILL
(1838–1912)
JOHN SINGER SARGENT, 1898
Oil on canvas
1020 x 822mm

To mark the occasion of her sixtieth birthday, supporters of the social reformer Octavia Hill commissioned John Singer Sargent (1856–1925) to paint her portrait. By 1898 Hill's housing schemes, publications and role in the foundation of the National Trust had garnered her an international reputation, yet she remained averse to commemorations of any kind. Hill reluctantly agreed to the commission, but remained anxious that the memorial would become a 'real oppression and pain to the contributors'. Inevitably, the sittings in Sargent's Chelsea studio began awkwardly. However, he employed his considerable experience to break through Hill's initial reserve.

The artist was at this point at the height of his powers as a society portraitist. His reputation as the painter of a fashionable elite was such that, by the mid-1890s, he was painting up to three sitters a day. According to Hill's friend Mary Booth, 'he engaged her in conversation, and had the happy instinct to differ with her categorically on a point where she felt strongly … her face lit with all her characteristic force and fire'. The portrait was bequeathed to the National Portrait Gallery in 1915. NPG 1746

WILLIAM GILBERT ('W.G.') GRACE
(1848–1915)

ATTRIBUTED TO ARCHIBALD WORTLEY, 1890
Oil on canvas
902 x 699mm

One of the great celebrities of the later Victorian period, W.G. Grace earned a special place in national life thanks to his cricketing triumphs. He made his debut at Lord's and the Oval in the summer of 1864 and scored his first century in the same year. In an extraordinary career in first-class cricket between 1865 and 1908 he scored 54,896 runs, averaging 39.55, and took 2,876 wickets (average 17.92). He exemplifies the transformation of cricket into the modern sport with its structure of county championship and test matches, its technical development and its international reach. Portly and bearded, Grace was instantly recognisable and attracted spectators in vast numbers.

Authorship of this unfinished portrait remains uncertain, and there was much speculation as to who painted it at the time of its acquisition in 1926. But the existence of a drawing by Archibald Wortley (1849–1905) that is clearly related to the oil, and is monogrammed and dated 1890, strongly suggests that it is by him. NPG 2112

AUGUSTUS JOHN
(1878–1961)

SIR WILLIAM ORPEN, *c*.1900
Oil on canvas
991 x 940mm

Augustus John first met William Orpen (1878–1931) when they were both students at the Slade School of Fine Art and they became constant companions. In 1903 John founded the Chelsea Art School with Orpen as its co-principal. This was a period of great success for John, who became a leading figure of the avant-garde. He was elected to the New English Art Club and adopted a bohemian lifestyle, living between Paris and London. However, he never quite fulfilled his early artistic promise and from the 1920s his career went into decline.

John disparaged this portrait fifty years after it was made in *Finishing Touches* (the posthumous volume of his autobiography, 1964) for not conveying 'the shy, dreamy and reticent character of its model'. He told how, 'having selected Whistler's portrait of "Carlyle" for imitation, he [Orpen] posed me seated in profile against the wall, attired in a cast-off top-coat provided by Charles Conder. Unfortunately the result of his industry revealed no trace of the subtlety and distinction present in his exemplar.' Despite John's reservations, it is one of Orpen's greatest early works and captures the bohemian elegance of the sitter as a young artist at the height of his powers. NPG 4252

GWEN JOHN
(1876–1939)
SELF-PORTRAIT, *c.*1900
Oil on canvas
610 x 378mm

Gwen John's commanding gaze in this portrait, one of two early self-portraits, reflects the passionate determination with which she forged her artistic career. She studied at the Slade School of Fine Art, with her brother Augustus (page 177), and at James McNeill Whistler's Académie Carmen in Paris.

In London, she exhibited at the New English Art Club.

In 1904 she moved to France, where she stayed for the rest of her life. Initially, she earned a meagre living as an artists' model in Paris before becoming established as an artist herself. Most notably, she modelled for Auguste Rodin, with whom she began a passionate relationship. She stayed in France throughout the First World War and then began to exhibit in New York. In 1926 a large exhibition of her work at the Chenil Galleries, London, received considerable public attention. NPG 4439

ROBERT BADEN-POWELL, 1ST BARON BADEN-POWELL
(1857–1941)

SIR HUBERT VON HERKOMER, SIGNED IN MONOGRAM
AND DATED 1903
Oil on canvas
1419 x 1121mm

Baden-Powell is best remembered as the founder of the Boy Scout movement but he first came to public notice by virtue of his glittering military career. Selected for special duties in North Africa, he saw action in the Second Boer War (1899–1902), holding the town of Mafeking during a siege that lasted 219 days. This achievement depended on Baden-Powell's organisational and reconnaissance skills, and force of personality in sustaining morale – qualities that he was later to encourage in the Scouts. His success against the odds made him a hero in Britain and is alluded to in this portrait by the inscription 'Mafeking' on the box on which he sits. A keen supporter of voluntary organisations for young people, Baden-Powell published *Scouting for Boys* in fortnightly parts from January 1908 onwards, and founded the Boy Scout movement in the same year.

His uniform in this portrait is one he designed himself for the North African Constabulary and the hat was later adapted for the Scouts. This image is by the Bavarian-born artist Hubert von Herkomer (1849–1914), who forged a successful career in Britain. NPG 5991

SIR FRANK SWETTENHAM
(1850–1946)

JOHN SINGER SARGENT, SIGNED
AND DATED 1904
Oil on canvas
1708 x 1105mm

Frank Swettenham arrived in Singapore to join the Straits civil service in January 1871. From then until his early retirement in 1904 his career was entirely bound up in the colonial administration of the Malay states, and he was instrumental in their federation in 1895. He became resident-general in 1896 and governor of the Straits Settlements in 1901. Swettenham oversaw the construction of roads and railways and the founding of modern Kuala Lumpur, where he based his residency. Professionally competitive and socially ambitious, Swettenham led a difficult private life while also writing extensively on Malay affairs and culture and becoming an accomplished watercolour artist.

When the Straits Association decided in 1903 to commission a portrait of Swettenham for the Victoria Hall, Singapore, it was the sitter who suggested John Singer Sargent (1856–1925) as the artist. The original, still in Singapore, shows him full-length. A copy was to be made for Swettenham himself but in the end Sargent repainted and redesigned the portrait, taking additional sittings for the face. This portrait shows Swettenham in the full pomp of office, a globe above his head, his right hand clutching one of the rich Malay textiles that he collected. NPG 4837

HENRY JAMES
(1843–1916)
JOHN SINGER SARGENT, SIGNED AND DATED 1913
Oil on canvas
851 x 673mm

The American-born novelist Henry James is especially remembered for his novels that explore the conflict between American and European attitudes, such as *Washington Square* (1880), *The Portrait of a Lady* (1881) and *The Golden Bowl* (1904). Painter and playwright Walford Graham Robertson, who knew both men, described John Singer Sargent (1856–1925) and Henry James as true friends in his publication *Time Was: Reminiscences* (1931): 'They understood each other perfectly and their points of view were in many ways identical.' This closeness perhaps explains the difficulty that Sargent found in executing an effective likeness of the novelist. He had portrayed James three times previously, but remained dissatisfied with his efforts. The plan for the 1913 portrait was initiated by the American writer Edith Wharton, who petitioned James's friends in England to subscribe to the commission in celebration of his seventieth birthday. By this date Sargent was uncomfortable with portrait painting, having largely ceased the practice, and nervous about painting his friend. Both sitter and artist were, however, immensely pleased with the result. The portrait achieved notoriety whilst on display at the Royal Academy in 1914 because on 4 May it was attacked by Mrs Mary Wood, a militant suffragette who slashed the picture three times with a small hatchet before being restrained. Although it was fully restored by the artist, the tears in the canvas can still be discerned. NPG 1767

ROBERT FALCON SCOTT
(1868–1912)

HERBERT PONTING, 1911
Carbon print
356 x 457mm

Captain Scott is the most famous British explorer of the twentieth century. The failure of his final expedition has made him a controversial figure as well as an icon of heroism and courage. The travel photographer, Herbert Ponting (1870–1935), was invited by Scott to record his final, tragic expedition to the Antarctic of 1910. Working in extremely hazardous conditions, Ponting achieved photographs and motion pictures of exceptional technical and aesthetic quality. He left the expedition before its end because of ill health.

Scott had established his winter base at Cape Evans in January 1911, and this photograph shows him there, in his hut, working on his journal. It is dated 7 October 1911, just weeks before he set out on his fatal attempt to travel to the South Pole. He reached it on 17 January 1912, only to find that the Norwegian explorer Roald Amundsen had arrived a month earlier. Scott and his companions – Edward Wilson, Edgar Evans, Henry Bowers and Lawrence Oates – perished on the return journey. A search party found the bodies of Scott, Wilson and Bowers on 12 November 1912, together with the writings that recorded their fate. The last words in Scott's journal read: 'We shall stick it out to the end, but we are getting weaker, of course, and the end cannot be far. It seems a pity, but I do not think I can write any more.' NPG P23

Twentieth-Century Portraits

1914–1999

OPPOSITE
*MAN'S HEAD
(SELF-PORTRAIT III)*
LUCIAN FREUD, 1963
(DETAIL OF PAGE 225)

During the twentieth century, perhaps more than any other era in history, the idea of progress came to dominate Western civilisation. Whereas earlier generations nurtured tradition, those whose lives coincided with the Wright Brothers' first aeronautical flight in 1903 viewed the world with different eyes. Powered air travel signalled a new relationship with nature. Henceforward, man seemed capable of shaping a new, modern environment that reflected his needs and wishes. The past, therefore, was relevant only as far as it provided a point of departure. Not for nothing has the twentieth century been characterised as the age of modernism. With the principle of change elevated to the status of an ideology, a brave new world beckoned.

An atmosphere of confidence permeated the early years of the century. In 1903 the first radio communication was made between the United States and Britain. Less than twenty years later, John Alcock's first non-stop flight across the Atlantic in 1919 would make international travel a reality. Such advances were profoundly significant, for collectively they symbolised the vital role of communication in shaping the new era. While life was dramatically altered by an astonishing range of advances in almost every field of human activity – from science, medicine and engineering to the arts, architecture and technology – it was the hugely enhanced capacity for the exchange of information that most defines the last century and was most responsible for the pace and proliferation of change.

In Britain, the mood of progress gathered momentum in the period preceding the outbreak of the First World War. Having inherited the traditional values that evolved during Queen Victoria's long reign, the Edwardians began to rally around the idea of the new. In 1909, Winston Churchill (page 194) articulated this alternative outlook: 'We have arrived at a new time. Let us realise it. And with that time strange methods, huge forces, large combinations – a Titanic world – have sprung up around us.' Churchill saw that the potential for change was enormous, anticipating that, if embraced, renewal would spread to every corner of political, public and private life.

While such confidence was infectious, less well understood were the unpredictable consequences of embracing the unfamiliar. In the arts, there was a growing sense that modern life called for unconventional means of expression. As a result, painting and sculpture, literature, theatre and music all began to explore new ways of describing an ever-expanding range of experience. In London, exhibitions devoted to the work of European avant-garde artists, such as Cézanne, Matisse and Gauguin, caused bewilderment and derision, but they also spawned pockets of similar activity in Britain. The Camden Town Group, the artists and intellectuals associated with Bloomsbury and the emergence of Vorticism, all attested to the growth of artistic and cultural attitudes that broke with the past.

Coinciding with these assaults on old authorities, the role of women also began to undergo a fundamental transformation. Its most visible manifestation was the suffragette movement, driven by a profound dissatisfaction in certain sectors with the traditional place of women in society. The movement's activities took the form of marches, gatherings and occasional iconoclastic acts, such as the notorious slashing of Velázquez's painting the 'Rokeby Venus' in the National Gallery in 1914.

Confidence, now coupled with a volatile appetite for action, were the main ingredients in the atmosphere of celebration that greeted Britain's declaration of war on Germany in August 1914. For many, the coming conflict was seen as an opportunity to reassert British imperialism; for others, the war would provide a testing ground, a stage on which technological advances could be tried out. Either way, Britain's involvement was welcomed in the belief that it would provide a platform for change. The war's outcome, four years later, certainly yielded a radically altered human landscape, but one that bore no resemblance to earlier aspirations. Europe was decimated by appalling losses affecting all the participant countries; the toll of British soldiers killed was estimated at a million.

The position of women was strengthened by the important role they had played both in uniform and at home, and as a result their social and political standing now altered. In 1918 the Representation of the People Act enfranchised women over the age of thirty who met minimum property qualifications. In the visual arts, the effect of the war was to arrest the modernist trajectory. Now suspicious of unfamiliar forces, many artists sought reassurance in the steadying hand of tradition, provoking a return to more conventional means of expression. As a result, between the wars, avant-garde artistic activity in Britain remained largely the preserve of a minority.

After the Second World War, the privations endured by a nation once again stunned by war gave way to further far-reaching changes. Spurred on by the development of the mass media, from the 1960s there was, in effect, a social and artistic convulsion. Standards of behaviour, morality, belief, attitude and personal expression that had been in place at the turn of the century were progressively questioned and transformed. With the invention of the World Wide Web by Sir Tim Berners-Lee in 1989, the capacity of individuals to access and disseminate information was revolutionised, hugely extending the communication revolution that defines the era as a whole. Depicting some of the instigators of these enormous developments, as well as those who have responded in distinctive ways, twentieth-century portraiture reflects something of this wider context through a dizzying profusion of innovations, styles and media, each in thrall to a single idea: that of progress.

Paul Moorhouse

VIRGINIA WOOLF
(1882–1941)
VANESSA BELL, 1912
Oil on board
400 x 340mm

This compelling portrait of Virginia Woolf by her sister
Vanessa Bell (1879–1961) captures the sitter in a private
moment, leaning back in a chair, crocheting. The
informality of the image provides an intimate glimpse
of an individual who would later become recognised as
one of the greatest modernist writers of the twentieth
century. With its abstracted and summary treatment
of detail, the understated nature of the portrait also
contrasts somewhat with Woolf's significance as one

of the central figures in the Bloomsbury Group, the
circle of writers, artists and intellectuals that from
the first decade of the twentieth century challenged
convention. Woolf was in many ways a revolutionary.
In 1908 she declared, 'I shall reform the novel,' and the
essence of her literary achievement, which includes
the novels *Mrs Dalloway* (1925), *To the Lighthouse* (1927),
Orlando (1928) and *The Waves* (1931), is to have shifted
fiction away from its conventional reliance on character
and plot. In their place, Woolf focused instead on
interior experience, a flow of thoughts and impressions
conveyed as a 'stream of consciousness'. Subject
throughout her life to episodes of mental illness,
Woolf is revealed here as if inhabiting that secluded
world from which her art would grow. NPG 5933

RUPERT BROOKE
(1887–1915)

SHERRILL SCHELL, APRIL 1913
Vintage gelatin silver print
240 x 190mm

Cambridge-educated Rupert Brooke became celebrated for his striking good looks, charm and literary promise. His first volume of poetry appeared in 1911. He joined the Royal Navy at the outbreak of the First World War, later writing the five war sonnets that made him famous. The publication of these works coincided with his early death from septicaemia while on his way to join the campaign at Gallipoli. The most popular poet of the war, for some Brooke symbolised a pre-war golden age, destroyed by the conflict.

Brooke was photographed at the Pimlico home of American photographer Sherrill Schell (1877–1964) at the suggestion of the poet Francis Meynell. Several glass positives from this session, made by the firm of Emery Walker for use as photogravures, are held in the Gallery's Collection, together with a second vintage print. Schell's series of portraits from this sitting have become some of the most important images of the poet. A variant pose from this sitting was reproduced as the frontispiece to his book *1914 and other Poems* (1915). NPG P1698

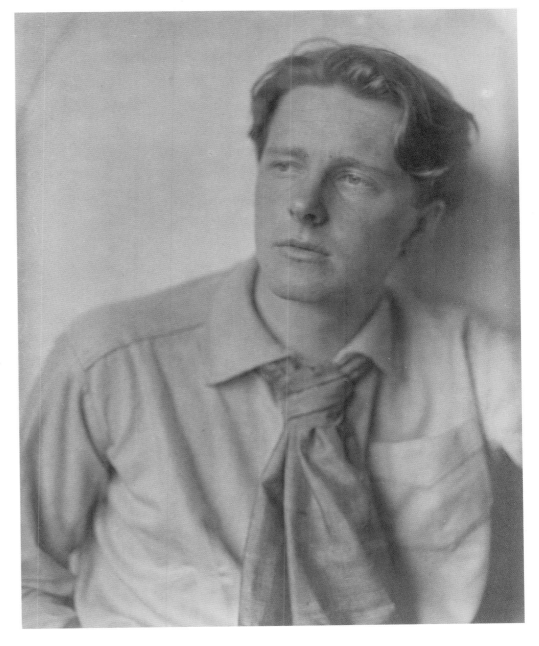

SELF PORTRAIT (DAME LAURA KNIGHT [1877–1970])

SELF-PORTRAIT, 1913
Oil on canvas
1524 x 1276mm

Nottingham-born Laura Knight was one of the most popular artists in Britain in the twentieth century. Resolutely representational and figurative at a time when this approach was being challenged by modernist movements, she was, nevertheless, committed to painting contemporary life. Her diverse subjects include the Cornish coast, the ballet and circus, Gypsy communities and, as a war artist during the Second World War, air crews and munitions workers. She was the first artist to be made a dame (1929) and the first woman to be elected a full member of the Royal Academy of Arts (1936).

This self-portrait, in which she presents herself as a professional painter with a mastery of the nude figure, is a defining work in Knight's career. As a student in Nottingham, Knight had been barred from attending the male-only life classes held at the art school, and she found this omission in her art training deeply frustrating. In 1907 Knight joined an artistic community in Cornwall, and this portrait, with its complex composition and vivid red tones, is an expression of the liberation and confidence she found there. The figure of the model was posed by fellow artist Ella Naper (1886–1972), a friend and neighbour in the Cornish village of Lamorna.
NPG 4839

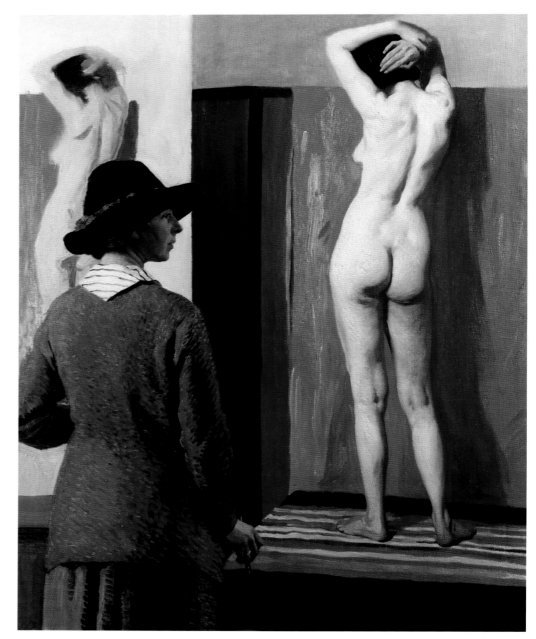

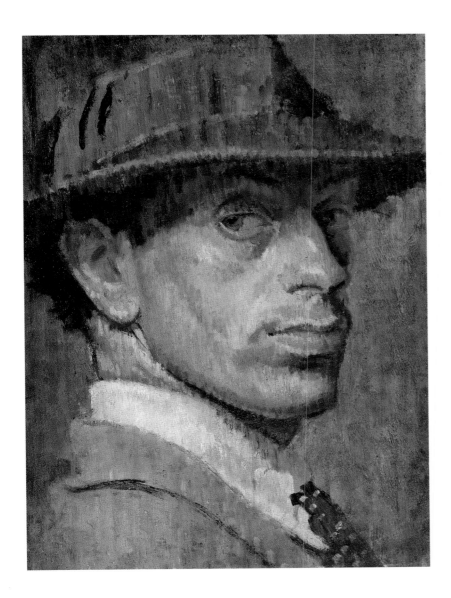

ISAAC ROSENBERG
(1890–1918)
SELF-PORTRAIT, 1915
Oil on panel
295 x 222mm

The artist and poet Isaac Rosenberg responded to the outbreak of war in 1914 with his poem 'On Receiving the News of the War', which was written in South Africa. Having studied painting at the Slade School of Fine Art in London, he had moved to Cape Town as an attempted cure for chronic bronchitis. He returned to England in October 1915, shortly before enlisting in the army.

He painted this self-portrait around that time. Rosenberg shows himself wearing a trilby hat, then fashionable among artists. Being shorter than the minimum height of 5ft 3in, he was assigned to the 12th Battalion of the Suffolk Regiment, a so-called bantam battalion. Declining the invitation to become a lance corporal, he was given the rank of private and later transferred to a different bantam battalion, the 11th (Service) Battalion of the King's Own Royal Lancaster Regiment. In June 1916 he was posted to the Western Front and, while serving in the trenches, he wrote the poems that have assured his reputation, notably 'Break of Day in the Trenches' and 'Dead Man's Dump'. He was killed on 1 April 1918, at dawn, while returning from a night patrol.
NPG 4129

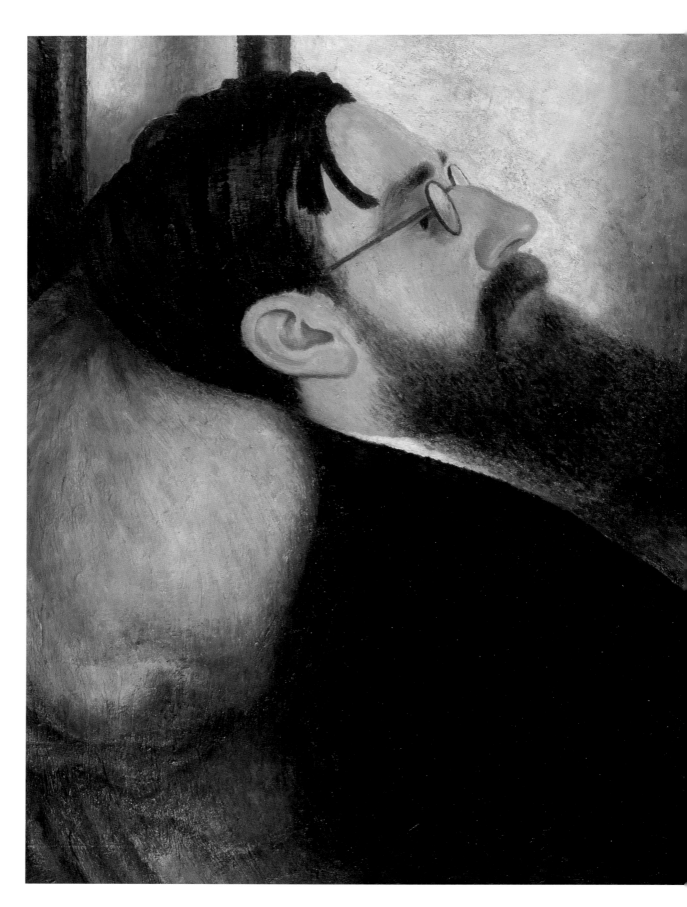

LYTTON STRACHEY
(1880–1932)
DORA CARRINGTON
Oil on panel, 1916
508 x 609mm

Dora Carrington (1893–1932) painted this portrait of
the writer and critic Lytton Strachey at the beginning
of what became a devoted, if unconventional,
relationship. The two met in 1916. Strachey had
studied at Trinity College, Cambridge, where he
met Clive Bell, Leonard Woolf and Saxon Sydney-
Turner. These individuals formed an important part
of the Bloomsbury Group to which Virginia Woolf and
Vanessa Bell also belonged. Although not a member
of Bloomsbury, Carrington met Strachey through
Bell, who was one of the Group's founders. Initially
they appeared incompatible. Strachey was learned,
literary, homosexual and older than Carrington, who
had studied at the Slade School of Fine Art and was
repulsed by his advances. Nevertheless, in November
1917 they began living together at Tidmarsh Mill in
Berkshire. The pair became a *ménage à trois* when they
were joined by Ralph Partridge, whom Carrington
married in 1922. By then, Strachey had achieved
considerable success with his book of biographical
essays *Eminent Victorians* (1918). When he died in 1932,
Carrington was distraught and committed suicide seven
weeks later, at the age of thirty-eight. NPG 6662

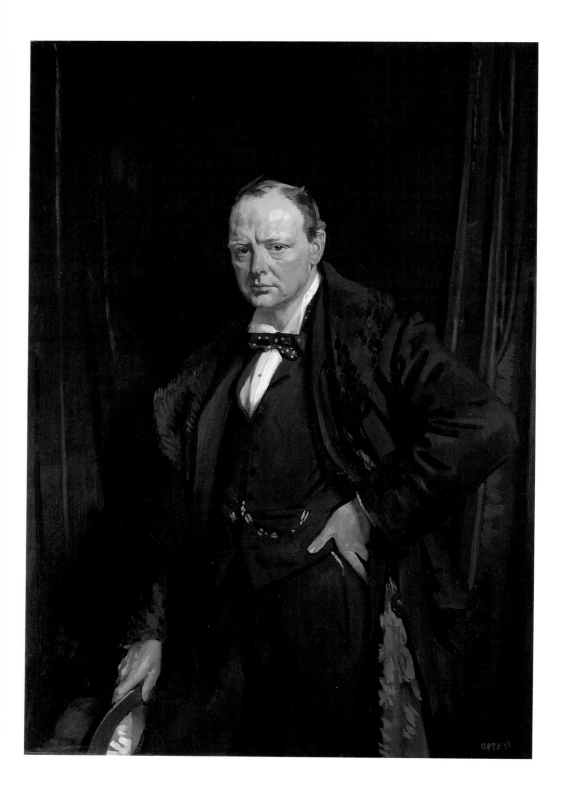

SIR WINSTON CHURCHILL
(1874–1965)

SIR WILLIAM ORPEN, SIGNED 1916
Oil on canvas
1480 x 1025mm
Lent by Trustees of the Churchill
Chattels Trust, 2012

This haunting portrait of
Winston Churchill, who would
become one of Britain's best-
known prime ministers, captures
him at a critical moment in
his career. It was painted over
eleven sittings in 1916 during
the Dardanelles Commission,
the official investigation into
one of the most disastrous naval
campaigns of the Great War.
As First Lord of the Admiralty,
Churchill was blamed for Britain's
catastrophic attempt to conquer
the Dardanelles Strait. He resigned
and prepared to defend himself
against accusations of incompetent
and reckless leadership. Having
lost his command, his position in
government and his reputation, he
feared he would never again take
public office.

This sombre, introspective
portrait by William Orpen (1878–
1931) captures this sense of bleak
uncertainty. It was described by the
artist as a depiction of 'the man of
misery'. When it was completed,
Churchill told Orpen, 'It is not the
picture of a man, it is the picture
of a man's soul.' Churchill's fears
were ultimately unfounded: the
Commission rehabilitated his
reputation and he went on to lead
Britain to victory in the Second
World War. He continued, however,
to regard this portrait as one of the
best paintings of himself, and it
hung in his dining room. NPG L250

VANESSA BELL
(1879–1961)

DUNCAN GRANT, *c*.1918
Oil on canvas
940 x 606mm

The Gallery's Collection contains two portraits of the painter Vanessa Bell made by Duncan Grant (1885–1978), of which this is the later work. During the years preceding and following the First World War, Bell, sister of the great modernist novelist Virginia Woolf, was a leading exponent of avant-garde painting in Britain. Vanessa and Virginia were the daughters of Sir Leslie Stephen, the first editor of *The Dictionary of National Biography*. After their father's death in 1904, they moved to Bloomsbury with their brothers Thoby and Adrian and began holding the gatherings that formed the nucleus of the Bloomsbury Group. These 'at homes', as they were known, attracted, among many others, the writers and art critics Lytton Strachey, Roger Fry and Vanessa's future husband Clive Bell, whom she married in 1907. Vanessa was greatly impressed by the two exhibitions of Post-Impressionist painting that Fry organised in 1910 and 1912, contributing work to the latter. In 1913 she established a relationship with Duncan Grant. The rich palette employed in Grant's portrait reflects both his and Vanessa's adoption of less literal, more expressive colour at this time. NPG 4331

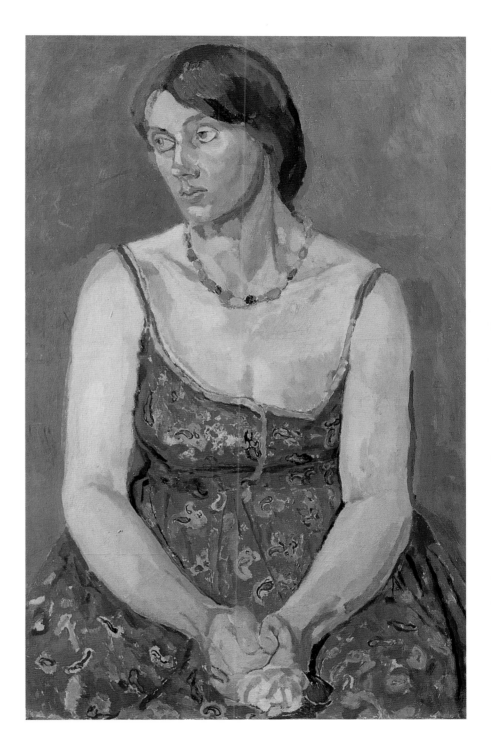

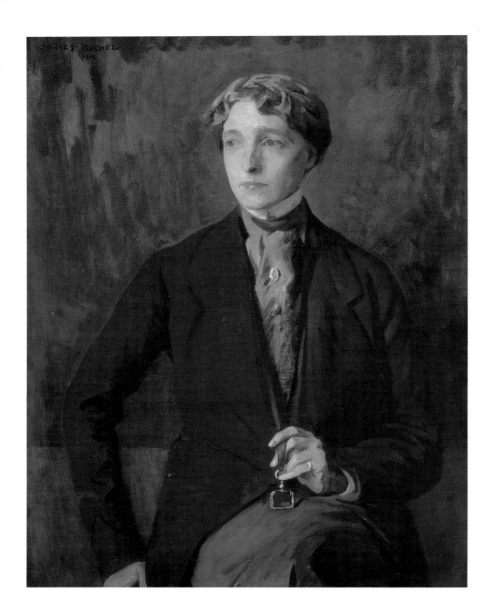

RADCLYFFE HALL
(1880–1943)
CHARLES BUCHEL, 1918
Oil on canvas
914 x 711mm

This portrait of the novelist Radclyffe Hall (born Marguerite Antonia Radclyffe-Hall) precedes the publication of her first book, *The Forge* (1924), by several years. It belongs to a period in her life when Hall, a lesbian and a professed 'congenital invert', had fallen in love with another woman, Una Troubridge, one of several affairs in which Hall became involved. From 1918 the two lived together, with Troubridge becoming 'wife' to Hall, to whom she gave the nickname John. Having inherited a generous legacy from her grandfather, Hall had a private income until her forties. Believing herself to be a man trapped in a woman's body, she cultivated the masculine appearance captured in this portrait by Charles Buchel (1872–1950), which was distinguished by short hair, bow tie, monocle and well-cut jacket and trousers. Hall and Troubridge remained together until the former's death and throughout the scandal that accompanied the publication of Hall's fifth novel, *The Well of Loneliness* (1928). Reflecting Hall's campaigning support for homosexuals, its treatment of lesbianism provoked controversy and, despite support from Virginia Woolf and John Buchan, the book was banned in England following a trial for obscenity. NPG 4347

THOMAS EDWARD ('T.E.') LAWRENCE
(1888–1935)
AUGUSTUS JOHN, 1919
Pencil
356 x 254mm

Intelligence officer and author
T.E. Lawrence – known as
'Lawrence of Arabia' – achieved
notoriety as a First World War hero
who, as a liaison officer to Emir
Feisal of the Hejaz, helped liberate
the Arabs from Turkish rule. His
exploits in the Middle East were
kept secret for security reasons
during the war, but were becoming
publicly known by 1919, making
him into something of a celebrity.
Lawrence began writing about his
experiences at the Colonial Office,
and the resultant book, a much
embellished account of his career
entitled *The Seven Pillars of Wisdom*,
was published in a private edition
in 1926 and in an abridged version
titled *Revolt in the Desert* in 1927,
both of which feature a reproduction
of this portrait.

The first of several drawings and
paintings made of Lawrence by
Augustus John (1878–1961), it was
apparently finished in two minutes
while Lawrence was looking out of
a window in the artist's apartment
in Paris, where he was attending
the Versailles Conference as Emir
Feisal's adviser and translator.
NPG 3187

EMMELINE PANKHURST
(1858–1928)
(MARY) OLIVE EDIS (MRS
GALSWORTHY), 1920S
Sepia-toned platinotype
153 x 99mm

Brought up in a large, politically active family on the outskirts of Manchester, Emmeline Pankhurst was acutely aware from an early age of the inequalities faced by women. Shortly after leaving school she began working for the suffrage movement, during which time she met and married the barrister and political activist Richard Pankhurst. After the death of her husband in 1898, she became convinced that socialist movements were ill equipped to fight for women's suffrage. She therefore founded the Women's Social and Political Union (WSPU) in 1903, joined by her daughters Christabel, Sylvia and Adela. The WSPU initially campaigned peacefully, but Pankhurst gradually implemented a more aggressive approach. With the outbreak of the First World War in 1914, militant activities were suspended whilst the movement focused on assisting the war effort. In 1918 women over twenty-one years were given the vote. Pankhurst later worked for the Canadian government and stood as a parliamentary candidate. She died in 1928, one month before the 1918 bill was extended to give women the vote, on equal terms with men.

Olive Edis (1897–1955) had studios in Farnham, Surrey and London, and was a pioneer of autochrome portraits. NPG x4332

ALBERT BALL
(1896–1917)

HENRY POOLE, 1920S
Bronze
603mm high

Albert Ball was born in Nottingham and was working as a trainee engineer when war was declared in 1914. He joined the Royal Flying Corps and in 1916 was posted to France, where he first distinguished himself as a fighter pilot in a single-seat biplane, the Nieuport 16. At his base at Savy Aubigny, Ball built a small wooden shed close to the hangar where he slept so as to attend more easily to his aircraft and be ready for take-off. As Flight Commander in an SE5 120-mph biplane, he flew bareheaded and without goggles, and often attacked multiple enemy formations single-handed. During his three years in the military, Ball shot down forty-three enemy planes and a Zeppelin. His bravery, no doubt foolhardy on occasion, was rewarded with successive promotions and, after he was killed in action over enemy territory on 7 May 1917, the Victoria Cross and the Légion d'honneur. Despite this, he was a reluctant hero during his lifetime and eschewed publicity.

Ball is commemorated by a public monument in Nottingham, for which this bronze by the Royal Academician Henry Poole (1873–1928) is the model. It was given to the Gallery by his father – Sir Albert Ball – in 1929. NPG 2277

ALAN ALEXANDER ('A.A.') MILNE (1882–1956) WITH CHRISTOPHER ROBIN MILNE (1920–96) AND POOH BEAR

HOWARD COSTER, 1926
Vintage bromide print
219 x 257mm

This classic photograph introduced one of the most famous characters in children's literature. Taken to coincide with the publication of *Winnie-the-Pooh* in October 1926, it also helped establish the reputation of the photographer Howard Coster (1885–1959), who opened his London studio that year. It shows A.A. Milne with his son Christopher and the teddy bear that was the inspiration for the story at the author's farmhouse home in Hartfield, Sussex.

Born in north London, Milne enjoyed a relatively liberal upbringing and received his early education at his father's private school. Although best known for his children's books, he wrote a number of successful plays and was a popular essayist and contributor to magazines. In 1920 the birth of his son, Christopher, inspired Milne to start writing children's poems. The first collection was published in 1924 as *When We Were Very Young*. The following year the *Evening News* asked Milne to write a piece for the newspaper; his response was an adaptation of a bedtime story he had created for Christopher, based around his teddy bear. Illustrated by Ernest H. Shepard, *Winnie-the-Pooh*, and its sequel *The House at Pooh Corner*, sold millions of copies and remains popular to this day. NPG P715

DAME EDITH SITWELL
(1887–1964)
MAURICE LAMBERT, 1985 (CAST FROM ORIGINAL
*c.*1926–7)
Aluminium
354mm high

This portrait head of Edith Sitwell was made three years after she had given a public reading of her poem 'Façade' (1922) at the Aeolian Hall, London, in June 1923. That event provoked controversy, but secured her reputation as Britain's leading modernist poet. Speculation about the work's literary merits arose in part from Sitwell's unconventional style of delivery. Sitting with her back to a bewildered audience, she intoned the poem's rhythmical lines through a Sengerphone. This instrument – a kind of megaphone made of papier-mâché, which fitted over the mouth and nose – preserved and accentuated the speaker's nasal tonalities. Some perceived this eccentricity as the hallmark of charlatanism. Others were beguiled by Sitwell's imagery, word play, and the music she conjured from the sounds she uttered. Indeed, 'Façade' was set to music by the composer William Walton.

This work was commissioned by Edith's brother Osbert, who approached Maurice Lambert (1901–64), brother of the composer Constant Lambert, after seeing his portrait head of Walton, exhibited in London in 1925. The unconventional choice of aluminium for the original cast (of which this is a later example) seems an appropriate response to 'Façade', an emphasis on surface being common to both. NPG 5801

SUPPER (NATALIE BEVAN [1909–2007])

MARK GERTLER, 1928
Oil on canvas
1075 x 718mm

This is the second of two portraits of Natalie Bevan by Mark Gertler (1891–1939). A celebrated beauty and a regular at the Gargoyle Club in Soho, during the 1920s she was the muse of many leading British artists, and numbered Christopher Wood, C.R.W. Nevinson, John Nash and John Armstrong among her admirers. She met Gertler at a party given by Augustus John in 1927, and both portraits were painted a year later. Whereas the other painting depicts her seated in an armchair, this work shows the nineteen-year-old surrounded by ripe fruit, fur and flowers. Calculated to convey an impression of sensuality, these props were actually less alluring than they appear, the 'fur' being in reality a blanket, the 'gown' a slip, and the 'linen tablecloth' a tea towel. But Gertler's transformation of these everyday items is eminently successful. Admitting the influence of Paul Cézanne and Pierre-Auguste Renoir, Gertler adopted a chromatically rich palette to underpin his overtly voluptuous image. In later life Bevan became a highly regarded hostess whose home, Boxted House in Essex, was a focal point for a later generation of artists. NPG 6877

PAULE VÉZELAY
(1892–1984)
SELF-PORTRAIT, 1927–8
Oil on canvas
651 x 543mm

This self-portrait was painted soon after Marjorie
Watson-Williams settled in Paris in 1926 and changed
her name to Paule Vézelay. Born in Bristol, she
had studied at the London School of Art but began
visiting Paris in 1920. Attracted by the avant-garde
artistic developments then unfolding there, and also
by contact with Henri Matisse, Joan Miró, Wassily
Kandinsky, Juan Gris and other leading artists, she
began exhibiting at the Salon des Surindépendants.

Vézelay's entry into this alternative artistic world was a
decisive influence, both personally and in terms of her
development as a painter.

The portrait marks a vital moment in that process.
It shows Vézelay at around the time that she met the
surrealist artist André Masson, with whom she had an
intimate relationship until 1932. Its bold, simplified forms
manifest a transition from her earlier, impressionistic
style towards more experimental work involving
surrealist imagery and abstract shapes. Encouraged
by her friendship with Hans Arp and his wife Sophie
Tauber-Arp, she eventually devoted herself completely
to abstract art and joined the Paris-based Abstraction-
Création group. Vézelay became one of the first British
artists to abandon figuration entirely. NPG 6003

ELISABETH WELCH
(1904–2003)

HUMPHREY SPENDER, JUNE 1933
Vintage bromide print
200 x 147mm

From her stage debut in 1922 to her final appearance in 1996, singer Elisabeth Welch was an important figure in the world of popular music. Born in New York, she helped to launch the Charleston on Broadway and popularised Cole Porter's scandalous 'Love for Sale'. In 1933 she introduced the song 'Stormy Weather' to British audiences. This photograph of Welch, taken by Humphrey Spender (1910–2005), marked the beginning of her sixty-year career in British musical theatre, as well as the start of Spender's career in photography.

In the 1930s the composer and actor Ivor Novello wrote songs for Welch, while the actor Paul Robeson was her leading man in films, and she enjoyed popularity as a cabaret star of London's café society. In the post-war years, Welch starred in stage plays, including *Tuppence Coloured* (1947) and *Penny Plain* (1951). Later, in 1979, her appearance in Derek Jarman's film of Shakespeare's *The Tempest* won her new fans. Welch defined her art quite simply as 'telling a story in song'.

Humphrey Spender, brother of the poet Stephen Spender, became well known in the 1930s working as a photojournalist for the *Daily Mirror* and *Picture Post*. NPG x14268

JOHN MAYNARD KEYNES (1883–1946) AND LYDIA LOPOKOVA (1892–1981)

WILLIAM ROBERTS, SIGNED 1932
Oil on canvas
740 x 810mm

This portrait depicts the economist John Maynard Keynes, Baron Keynes, with his wife, the Russian-born ballerina Lydia Lopokova. Keynes's works, notably *The Economic Consequences of the Peace* (1919) and *General Theory of Employment, Interest and Money* (1936), established what is known as 'Keynsian economics', a theory that became widely influential following the Second World War. He was instrumental in the foundation of the International Monetary Fund and the International Bank for Reconstruction and Development. A cultivated collector and patron of the arts, Keynes was a member of the literary and artistic Bloomsbury circle, and was first chairman of the Arts Council of Great Britain.

Keynes particularly admired the work of the painter William Roberts (1895–1980), and gave him financial support for many years. He commissioned this double portrait of himself with his wife. Lopokova had been one of Diaghilev's principal dancers at the Ballets Russes, and was portrayed by several artists, including Pablo Picasso and Laura Knight. She had made her London debut in 1919 in Massine's *La Boutique Fantastique* but abandoned the ballet to marry Keynes in 1925. NPG 5587

1933 (ST RÉMY-SELF-PORTRAIT WITH BARBARA HEPWORTH) (BEN NICHOLSON [1894–1982]; DAME BARBARA HEPWORTH [1903–75])

BEN NICHOLSON, 1933
Oil on canvas
273 x 168mm

This double portrait by Ben Nicholson of himself with the artist Barbara Hepworth celebrates their close relationship and also marks an important moment in his own artistic development. The two were among the leading British avant-garde artists of the 1930s. They met in 1931 and the following year they began to share a studio in Hampstead. In 1932 they had a joint exhibition in London, which demonstrated their progress towards abstraction. Around the same time, they took the first of several trips together to Paris, where they had contact with numerous artists, dealers and critics, including Pablo Picasso and Georges Braque, and later Piet Mondrian, Jean Arp and Alexander Calder. In 1933, the year that Nicholson painted this portrait, they joined the Abstraction-Création group, as well as Unit One, the British group of painters, sculptors and architects that included Henry Moore. These contacts, and the experience of working alongside Hepworth, led Nicholson's art towards a deeper engagement with pure abstract form. Shortly after painting this portrait he made his first abstract reliefs, which established his international reputation. Nicholson and Hepworth married in 1938.
NPG 5591

JAMES JOYCE
(1882–1941)

JACQUES-EMILE BLANCHE, 1935
Oil on canvas
1251 x 876mm

This portrait by Jacques-Emile Blanche (1861–1942) of James Joyce, one of the great modernist novelists of the twentieth century, was painted during a period of crisis in the sitter's life. By then, Joyce was established as a writer of great originality, his reputation founded on his first novel, *A Portrait of the Artist as a Young Man* (1916) and its successor *Ulysses* (1922). The latter book courted controversy and was banned in the United States until 1933, and in Britain until 1934. He had commenced his complex novel *Finnegans Wake* (1939), a project that preoccupied him for seventeen years. But from the 1930s, Joyce's health was precarious. In addition to attacks of colitis, the illness that would eventually kill him, he was beset with problems affecting his eyesight and worked with a magnifying glass. He was also gravely concerned about the mental state of his daughter, Lucia, who had been diagnosed with hebremia, a form of schizophrenia.

In 1935, when this portrait was painted, Lucia's increasingly violent behaviour led Joyce to recognise that she was in 'the abyss of insanity'. With his left eye afflicted, and self-conscious about his spectacles, Joyce was depicted with his face turned to the side.
NPG 3883

DYLAN THOMAS
(1914–53)

AUGUSTUS JOHN, *c.*1937–8
Oil on canvas
457 x 337mm
Lent by executors of Mrs Niel Gordon Clark, 1996

The poet Dylan Thomas was born in Swansea, South Wales, where he worked briefly as a journalist. By the age of nineteen, Thomas had filled four exercise books with 200 poems, many of which were published as *Eighteen Poems* (1934) and *Twenty-Five Poems* (1936), and are the foundation of his literary reputation. Much of his writing, including the short story collection *Portrait of the Artist as a Young Dog* (1940), evokes his early life in Wales. From 1940 Thomas wrote scripts for the BBC and worked as a broadcaster. He was affected by alcoholism but completed the radio play *Under Milk Wood* in May 1953, shortly before his death in New York.

As his literary reputation grew in the early 1930s, Thomas gravitated to London and was a distinctive figure in bohemian circles in Soho and Fitzrovia. Here he met the painter and fellow Welshman Augustus John (1878–1961), who introduced Thomas to his future wife, Caitlin Macnamara. Shortly after his marriage, Thomas sat for John twice when the newlyweds were staying in Hampshire, close to John's studio. Of his exuberant sitter, John wrote in his autobiography that when 'provided with a bottle of beer he sat very patiently'. NPG L213

WILLIAM MAXWELL AITKEN, 1st BARON BEAVERBROOK
(1879–1964)

WALTER SICKERT, SIGNED AND DATED 1935
Oil on canvas
1762 x 1073mm

This larger-than-life portrait of the newspaper proprietor and politician Baron Beaverbrook by Walter Sickert (1860–1942) was commissioned by Sir James Dunn, a Canadian financier and an energetic patron of the arts. Himself a Canadian, Beaverbrook had settled in England in 1910 and was elected a Unionist Member of Parliament the same year. Knighted in 1911, he received a peerage in 1917, becoming Minister of Information in 1918. Beaverbrook's passion was journalism, and he began acquiring shares in British newspapers from the moment of his arrival. By 1916 he had a controlling interest in the *Daily Express*, following this with the acquisition of the *Sunday Express* in 1918 and the *Evening Standard* in 1923. It is appropriate therefore that Sickert based the portrait on a photograph that he had spotted in the press. Taken in 1934, this informal snapshot showed Beaverbrook standing on the veranda of his country house near Leatherhead, Surrey. While Sickert felt that 'the expression was perfect', he nevertheless depicted Beaverbrook standing in front of Margate harbour, the location of the artist's studio but a place that Beaverbrook had never visited.
NPG 5173

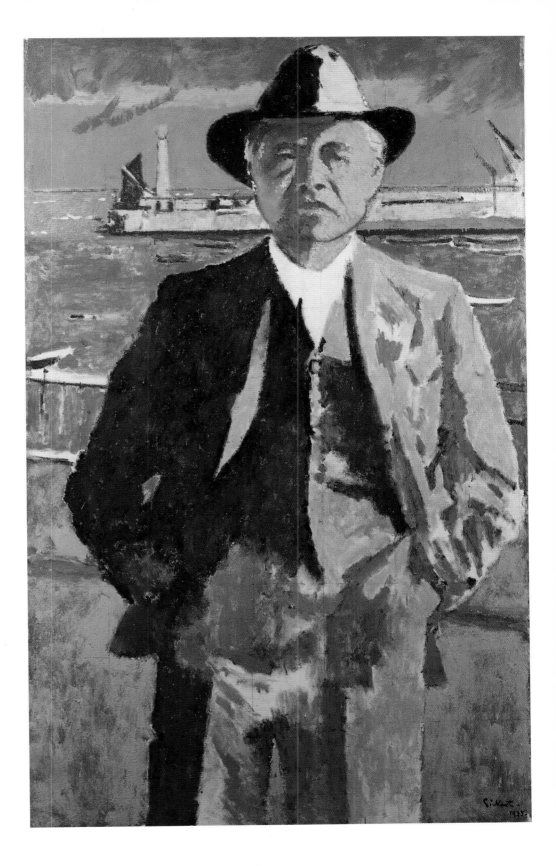

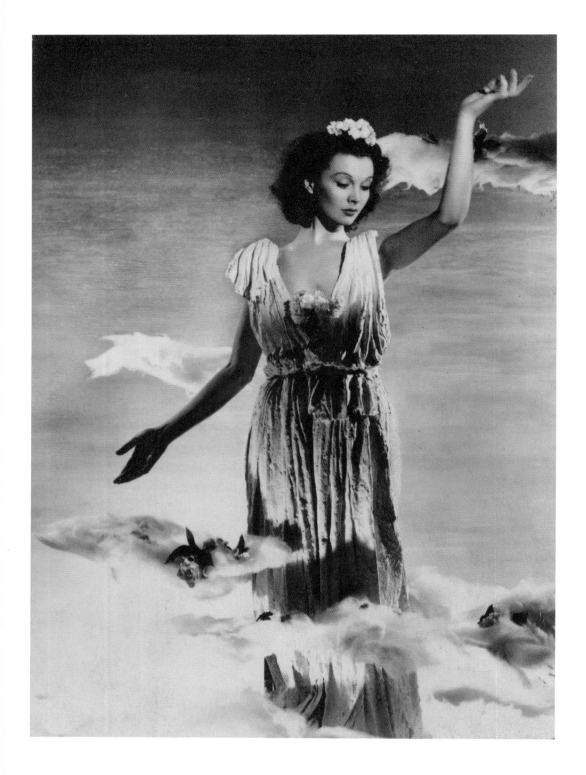

VIVIEN LEIGH (1913–67) AS AURORA, 'GODDESS OF DAWN'

ANGUS MCBEAN, 1938
Vintage bromide print
128 x 93mm

Vivian Hartley was born in Darjeeling, India, into a British military family. Following a convent school education in England and training at RADA, Vivien Leigh (her chosen stage name) became an overnight sensation in the play *The Mask of Virtue* (1935). Leigh's most famous performance, as Scarlett O'Hara in *Gone With the Wind* (1939) brought her worldwide recognition and the first of two Academy Awards. She and Laurence Olivier, whom she married in 1940, were one of the most celebrated couples of the era on stage and screen.

The surrealist portraits of Angus McBean (1904–90) appeared in the *Sketch* throughout 1938 with the painter Roy Hobdell closely collaborating to create trompe-l'oeil and other effects.

McBean's first portraits of Leigh were taken to publicise her early stage role starring opposite Ivor Novello in *The Happy Hypocrite* (1936). These images established him as a photographer and initiated an association with Leigh that lasted for thirty years. His photographs of Leigh a decade later as Blanche DuBois in the stage production of Tennessee Williams's *A Streetcar Named Desire* were considered some of his finest theatrical portraits. When she died from tuberculosis on 7 July 1967, aged just fifty-three, the press lamented the loss of the 'greatest beauty of all time'.

NPG AX183861

CHRISTOPHER ISHERWOOD (1904–86)
AND WYSTAN HUGH ('W.H.') AUDEN
(1907–73)
LOUISE DAHL-WOLFE, JULY 1938
Vintage bromide print
250 x 206mm

Christopher Isherwood and W.H. Auden first met at St Edmund's preparatory school in Surrey and, after being reintroduced in London in late 1925, became lifelong friends, literary collaborators and, intermittently, lovers. This portrait was taken for *Harper's Bazaar* in New York's Central Park by American fashion and portrait photographer Louise Dahl-Wolfe (1895–1989), who worked for the magazine from 1936 to 1958. Auden

and Isherwood spent two weeks in the city in July 1938 on their return from a visit to China and Japan, which resulted in their travel book about the Sino-Japanese War, *Journey to a War* (1939). Exhilarated by America, Auden and Isherwood returned in January 1939, and became American citizens in 1946.

This print belonged to the composer Benjamin Britten, with whom Auden had become close friends in 1935 when they were both working for the General Post Office Film Unit, producing documentary films on social themes, such as *Coal Face* (1935) and *Night Mail* (1936). Britten also collaborated with Auden and Isherwood in Rupert Doone's experimental Group Theatre, writing the music for their dramas *The Ascent of F6* (1936) and *On the Frontier* (1938). NPG x15194

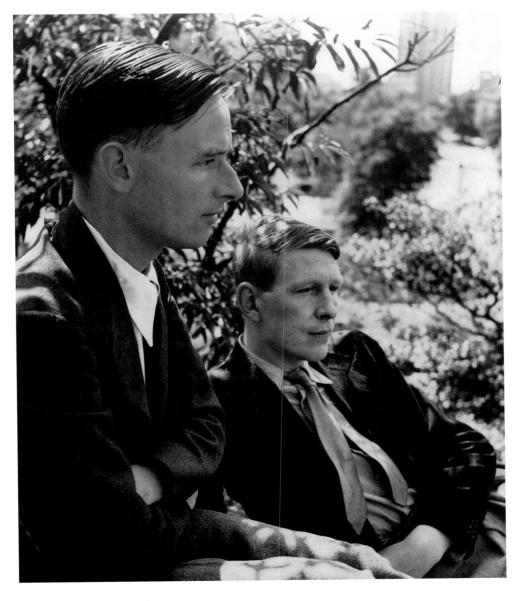

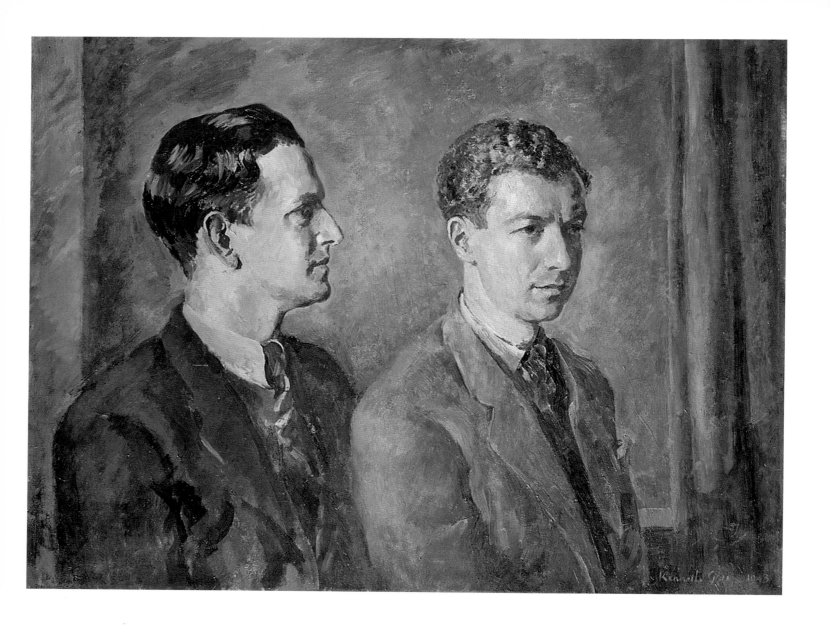

SIR PETER PEARS (1910–86) AND BENJAMIN BRITTEN, BARON BRITTEN (1913–76)

KENNETH GREEN, SIGNED AND DATED 1943
Oil on canvas
715 x 969mm

One of the greatest British composers of the twentieth century, Benjamin Britten is depicted in this double-portrait with the singer Peter Pears, with whom he had a close personal and musical relationship that lasted from 1939 until Britten's death. They became a celebrated voice and piano duo, with Britten writing a stream of works for Pears's voice. At the time of this portrait by Kenneth Green (1905–86), they had returned from the United States, having made the Atlantic crossing in wartime conditions that were far from safe. During the voyage, Britten composed his setting to W.H. Auden's *Hymn to St Cecilia* and *A Ceremony of Carols*. He was also by then forming ideas for one of his greatest works, the opera *Peter Grimes*, with a libretto based on George Crabbe's poem of the same title. On their return to England, both registered as conscientious objectors. In his written submission, Britten stated that 'The whole of my life has been devoted to a life of creation ... and I cannot take part in acts of destruction.' NPG 5136

ANNA ZINKEISEN
(1901–76)
SELF-PORTRAIT, SIGNED *c.*1944
Oil on canvas
752 x 625mm

Having studied painting at the
Royal Academy Schools, during
the inter-war period Anna
Zinkeisen produced designs for
advertisements, magazine covers
and book jackets, painted portraits,
and in 1934 was commissioned to
paint a mural, *The Four Seasons*,
for the ocean liner *Queen Mary*.
Throughout this period she
exhibited at the Royal Academy.
Following the outbreak of the
Second World War in 1939, she
volunteered for work in the first-
aid post at St Mary's Hospital,
Paddington. During the mornings
she provided nursing support in
the casualty ward, while her spare
time in the afternoons was devoted
to painting in a disused operating
theatre. As an officer in the St
John's Ambulance Brigade, her
experiences enabled her to develop
a specialism in pathological and
clinical drawing, and she produced
numerous meticulous drawings
of injuries sustained by victims
of bombing raids. This assured
self-portrait was painted at that
time. The St John's Ambulance
Brigade insignia on her bracelet,
an enamelled Maltese Cross, is an
allusion to her double life in art and
nursing. NPG 5884

Self-portraits

ROSIE BROADLEY

The National Portrait Gallery's Collection contains numerous portraits of artists, from the sixteenth century to the present day. A large proportion of these are self-portraits – a depiction of the artist by his or her own hand – which, as an expression of identity, can be startlingly direct. There are many reasons why artists choose themselves as subjects; at the most practical level, in the absence of a willing model, a self-study is both simply arranged and cheap. It can be a place to explore style and technique beyond the constraints of a commission, or the exacting eyes of a sitter. Some of the most impressive examples of self-portraits in the Gallery's Collection were made for the purpose of self-promotion, intended to assert the skill and status of their makers.

The earliest example of self-portraiture in the Collection is one of its most intriguing, made by the German artist Gerlach Flicke in 1554 (page 42). The inscription reveals that it was painted when he was in prison, and was conceived as a token of friendship and as a memento of its maker. By contrast, the origin of Sir Nathaniel Bacon's polished self-portrait (right), made around 1625, is more elevated. A wealthy landowner, Bacon was also a keen amateur painter and presents himself as a distinguished gentleman, richly attired, and offers no clue that he is the author of his own likeness.

The self-portraits in the Gallery's Collection attest to the rising status of professional artists across the centuries. In the late seventeenth century, Michael Dahl, a Swedish painter at the court of Queen Anne, pictures himself not just as an artist, but also as a man of learning and refinement (left). Draped in luxurious silk, he gestures elegantly to an antique bust on which rests a palette and brushes. From the eighteenth century, this growing professional confidence is reflected in self-portraits that show artists at work. The Gallery's Collection includes important examples by William Hogarth (page 106), Sir Joshua Reynolds (page 103) and Angelica Kauffmann (page 109), one of the few professional woman artists at this time. Kauffmann rests her 'porte-crayon' on the portfolio she holds, as though she has paused while drawing.

George Romney (below) was one of the most successful portrait painters of the eighteenth century, and although he does not show himself painting, the unfinished state of the canvas in his self-portrait draws attention to the process itself. The artist has concentrated on finishing his head and face, which, according to his friend the poet William Hayley, as recorded in *The Life of George Romney esquire* (1809), is expressive of his 'pensive vivacity and profusion of ideas'.

ABOVE

Michael Dahl (1659–1743), self-portrait. Oil on canvas, 1691, 1258 x 1013mm, NPG 3822 • Born in Stockholm, Dahl came to London in 1682. A fashionable painter, he was patronised by aristocracy and royalty.

RIGHT

George Romney (1734–1802), self-portrait. Oil on canvas, 1784, 1257 x 991mm, NPG 959 • Born in Lancashire, Romney was known for his history paintings and portraiture, particularly his series of portraits of Emma, Lady Hamilton (page 111).

A comparable intensity is evident in Dante Gabriel Rossetti's intimate self-portrait drawing (below), known amongst his family as the 'long-haired' portrait. The soulful appearance of the budding eighteen-year-old artist was influenced by his teenage passion for the Romantic poets.

Moving into the twentieth century, Laura Knight's self-portrait (page 190) overturns many of the conventions of professional self-portraiture, which were by now well established. In this multi-layered composition, created using several mirrors, the artist turns her back to the viewer and works on a canvas that appears to be the self-portrait itself. As the century progressed, artists became less reliant on the mirror as a tool in self-representation. R.B. Kitaj depicts himself in bed (right), but the tortured features and red eyes that emerge from the bright floral bedclothes are

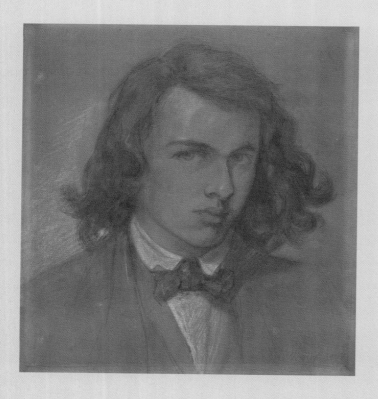

LEFT

Dante Gabriel Rossetti (1828–82), self-portrait. Pencil and white chalk on paper, 1847, 207 x 168mm, NPG 857 • The year after he made this drawing, Rossetti became a founding member of the Pre-Raphaelite Brotherhood of artists.

ABOVE

Self Portrait: Hockney Pillow (R.B. Kitaj, 1932–2007), self-portrait. Oil on canvas, 1993–4, 1016 x 508mm, NPG 6791 • The title is a reference to Kitaj's close friend, the artist David Hockney. The pillow was designed by Hockney's friend and sitter Celia Birtwell.

unrecognisable and describe the artist's psychological condition rather than his physical appearance. Marc Quinn's sculptural work entitled *Self* (above) comprises the artist's head cast in several pints of his own frozen blood and housed in a reflective refrigeration unit. As an object, it is the most physically direct representation of any artist in the Gallery, but one that also asks viewers to contemplate their own mortality, and the nature of existence itself.

LAURIE LEE
(1914–97)
ANTHONY DEVAS, 1944
Oil on canvas
508 x 410mm

Laurie Lee's literary reputation was secured by his acclaimed memoir of childhood, *Cider with Rosie* (1959). This portrait was painted while the poet, novelist and screenwriter was lodging with the painter Anthony Devas (1911–58) in Markham Square, Chelsea. Devas's wife Nicolette recalled that Lee's face was 'like water … never the same, mastered by the weather with a change of colour and texture; glass smooth, ripples, dead sulky. His weather was his moods.' At this time,

Lee's literary circle included Cecil Day-Lewis, Cyril Connolly and Stephen Spender. His affair with Lorna Wishart, wife of the publisher Ernest Wishart, had just ended with the start of her new relationship with the painter Lucian Freud, which brought Lee to the edge of a breakdown. Shortly afterwards, his first book of poetry, *The Sun My Monument* (1944), was published and Lee noted in his diary, 'I am a bit depressed about my book – it seems so slight. At the party [held by the writer Rosamond Lehmann] people were picking it up and putting it down as if it were a month old *Evening Standard*.' In addition to a radio play, *The Voyage of Magellan* (1948), Lee wrote journalism and followed *Cider with Rosie* with *As I Walked Out One Midsummer Morning* (1969) and *A Moment of War* (1991). NPG 6726

THOMAS STEARNS ('T.S.') ELIOT
(1888–1965)

PATRICK HERON, SIGNED AND
DATED 1949
Oil on canvas
762 x 629mm

The genesis of this painting of T.S. Eliot by Patrick Heron (1920–99) was a drawing made from life on 4 March 1947. Two months earlier, the young, relatively unknown painter had written to Eliot, one of the twentieth century's greatest poets, asking whether he would be willing to sit for a portrait. Encouraged by a positive response, Heron visited Eliot in his office at the publishers Faber & Faber, where he was a director. An electricity crisis meant that there was no heating, so Eliot awaited his visitor wearing a blue overcoat, references to which can be seen in the completed painting. Observing the writer of *The Waste Land* (1922) and *Four Quartet*s (1943), both landmarks in modern literature, Heron recalled 'finding myself looking into the grey eye of this greatest of living writers, and feeling that I was looking into the most conscious eye in the universe'. At that time, Heron's art was influenced by Pierre Bonnard, Henri Matisse, Pablo Picasso and Georges Braque, and their example is evident. Subsequent drawings from life, and related experimental studies, underpinned a progressively abstracted image incorporating a double profile. This drew on observation but eventually was made, over a period of nearly three years, from memory. NPG 4467

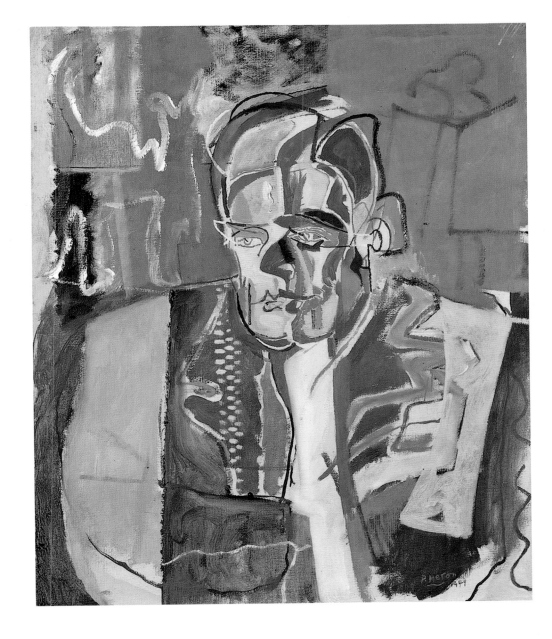

AUDREY HEPBURN
(1929–93)
CECIL BEATON, MARCH 1954
Vintage bromide print
256 x 246mm

Born in Belgium to an Anglo-Irish father and a Dutch baroness, Audrey Hepburn entered an English boarding school aged six, returning to Holland at the outbreak of the Second World War. She trained in ballet in Amsterdam, and then in London with Marie Rambert, before making her London stage debut in 1948. The French novelist Colette, who first saw Hepburn while she was filming in Monte Carlo, recommended she star in the adaptation of her novella *Gigi* on Broadway in 1951. Her grace, charm and pencil-slim figure made her famous in films such as *Roman Holiday* (1953), *Funny Face* (1957) and *Breakfast at Tiffany's* (1961). In her later years Hepburn acted as a goodwill ambassador for UNICEF; she made her final film appearance in *Always* (1989).

This portrait by Cecil Beaton (1904–80), which was taken for *Vogue* magazine also appears in his book *Face of the World* (1957), where he describes the essence of Hepburn's impact: 'It took the rubble of Belgium, an English accent and an American success to launch the striking personality that best exemplified our post-war Zeitgeist.' Beaton photographed Hepburn on a number of occasions, particularly during the filming of *My Fair Lady* (1964). NPG x40181

TED HUGHES
(1930–98)
SYLVIA PLATH, DATED *c*.1957
Pen and ink
213 x 130mm

Poet Laureate from 1984, Ted
Hughes grew up in rural Yorkshire,
and many of his best-known works,
notably *Crow* (1970), reveal the
violence inherent in the natural
world. At the University of
Cambridge, Hughes studied
anthropology, immersing himself
in the folklore of primitive
societies, which contributed to
his originality as a poet. He was
awarded the Whitbread Award for
Birthday Letters (1998), a collection
of poems, composed over a quarter
of a century, addressed to the
American poet Sylvia Plath
(1932–63), his first wife.

 Plath's intimate portrait of
Hughes, probably sketched on a
page of her journal, was made
a year into their marriage. Her
husband's career had been recently
launched when he received the
Galbraith Prize, Plath having typed,
arranged and submitted Hughes'
collection *Hawk in the Rain* for
the award, which it won to great
acclaim. As a poet, Plath's reputation
is commensurate with Hughes',
and her work includes *The Bell
Jar* (1963) and *Ariel*, published
posthumously in 1965, following
her suicide. Plath enjoyed drawing,
commenting in 1956, during their
honeymoon in Spain, 'Every
drawing has in my mind and heart
a beautiful association of our sitting
together in the hot sun, Ted
reading, writing poems, or just
talking with me.' NPG 6739

FRANCIS BACON
(1909–92)
IRVING PENN, 1962
Platinum palladium print
321 × 324mm

Born in Dublin, Francis Bacon left Ireland aged sixteen and settled permanently in England in 1928. After working as an interior designer, he began painting in about 1930, making his first major impact with *Three Studies for Figures at the Base of a Crucifixion* (1944, Tate). This photograph was taken in Bacon's London studio for *American Vogue* (published 1 November 1963), and the worn reproduction of a fake Rembrandt portrait in the background is typical of the diverse sources of imagery that he preserved for inspiration. Bacon's international reputation was confirmed by retrospectives at the Institute of Contemporary Arts, London (1955), Guggenheim Museum, New York (1963) and Grand Palais, Paris (1971). He remains one of the most acclaimed British painters of the twentieth century.

Irving Penn (1917–2009) was one of the twentieth century's most distinguished photographers, and his portraiture spanned seven decades. His long affiliation with *Vogue* magazine began in 1943. This portrait of Bacon is representative of a change in style that Penn adopted during the 1950s and 1960s, in which he produced much closer, more confronting studies of the face, which filled the photographic frame. NPG P587

SIR MICHAEL CAINE
(b.1933)
DAVID BAILEY, MAY 1965
Vintage bromide print
409 x 407mm

Born Maurice Micklewhite in
London, Michael Caine served
in the Korean War before acting
in repertory theatre and small
television roles under his adopted
stage name. He came to prominence
in 1964 as a young army officer,
Lieutenant Bromhead, in the film
Zulu. Caine was photographed by
David Bailey (b.1938) in the year
that he played the spy Harry
Palmer in *The Ipcress File* (1965),
adapted from Len Deighton's 1962
novel. An alternative pose from this
sitting was published in *David
Bailey's Box of Pin-ups* (1965), a
portfolio of thirty-six portraits of
key cultural figures who defined
Sixties' London. Caine's memorable
film parts during the 1960s also
included the title role in *Alfie* (1966)
and Charlie Croker in *The Italian
Job* (1969). Caine received two
Academy Awards – for *Hannah and
Her Sisters* (1986) and *The Cider
House Rules* (1999) – and was
knighted for services to drama
in 2000. NPG P951

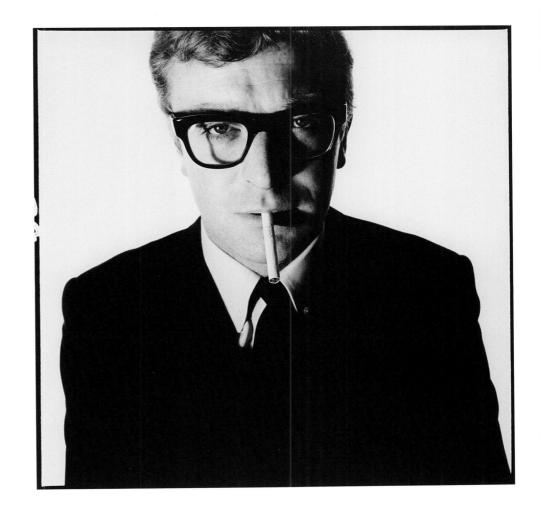

BRIDGET RILEY
(b.1931)

IDA KAR, SEPTEMBER 1963
Original film negative

Born in London, Bridget Riley studied at Goldsmiths College and the Royal College of Art. The leading exponent of op art in Britain, Riley worked initially in black and white, only introducing colour in 1967. Her first solo exhibition was held at Gallery One in 1962, and in 1964 she became the only woman to be included in *The New Generation* (1965) at the Whitechapel Art Gallery. A series of overseas shows that year further boosted her reputation and she won the International Prize for Painting at the 1968 Venice Biennale, the first British painter and female artist to achieve this distinction. Her meticulously executed paintings engage with visual sensation and until 1980 were mainly concerned with generating perceptual experiences, the basis of which is what Riley has termed 'the pleasures of sight'. Recent British exhibitions have been held at the Serpentine Gallery (1999), Tate Britain (2003) and the National Gallery (2010). A display of her mid-1950's portraits, exploring her early indebtedness to life-drawing, was held for the first time at the National Portrait Gallery in 2010.

Of Armenian origin, Ida Kar (1908–74) established her photographic practice in 1933 in Cairo, and moved to London in 1945 with her second husband, the poet and art dealer Victor Musgrave. Kar photographed Riley at her second exhibition at Gallery One, in September 1963. NPG x127158

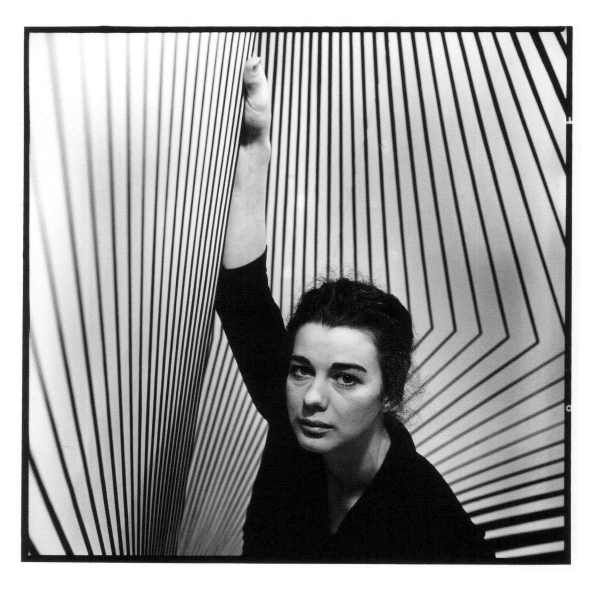

MAN'S HEAD (SELF-PORTRAIT III) (LUCIAN FREUD [1922–2011])
SELF-PORTRAIT, 1963
Oil on canvas
305 x 251mm

Artist Lucian Freud, the grandson of Sigmund Freud, was born in Berlin and emigrated to England with his family in 1933. He briefly attended the Central School of Arts and Crafts in London and was also taught for a period by Cedric Morris, who influenced Freud's early precise style of painting. In the late 1950s Freud began to adopt a looser, more expressive style, using hog's hair brushes to build a heavily impastoed surface. The result of many hours spent with sitters, his closely observed figurative works have been described as 'excessively' realist. The subjects are often naked, and the scrutiny with which Freud consistently portrayed the human body distinguished him amongst fellow artists in the twentieth century. In this painting, one of several self-portraits, Freud turned his uncompromising gaze upon himself. Yet, the presence of the artist is implicit throughout his oeuvre, which includes portraits of lovers, children and friends. As Freud himself has stated, 'my work is purely autobiographical ... it is about myself and my surroundings ... I work from people that interest me and that I care about.' NPG 5205

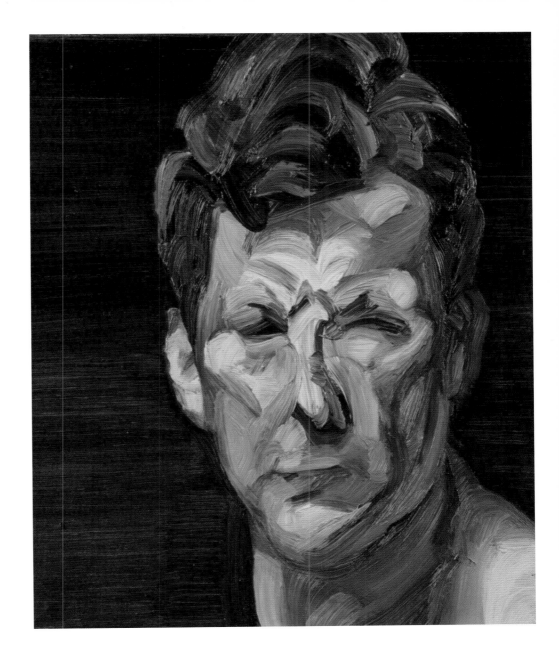

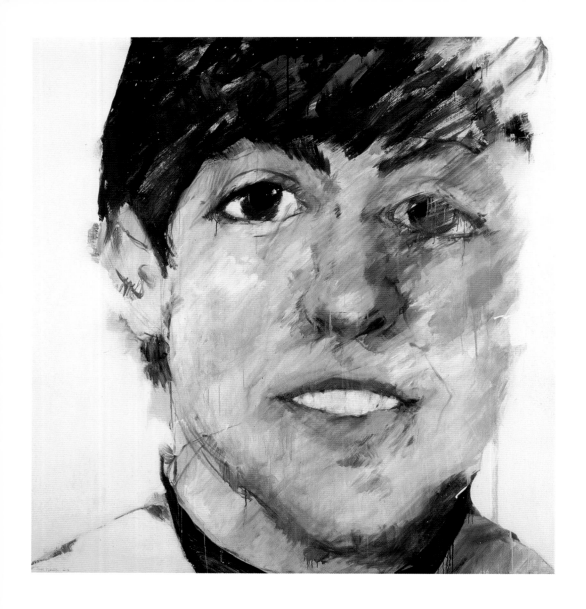

MIKE'S BROTHER
(SIR PAUL MCCARTNEY
[b.1942])
SAM WALSH, 1964
Oil on masonite
1825 x 1550mm

As a member of The Beatles, Paul McCartney was an international star by 1964 and one of the most recognisable faces in popular culture. Following the group's formation in Liverpool in 1960, the success of their debut single 'Love Me Do' attracted a mass following in Britain. Spurred on by the media fascination that ensued, 'Beatlemania' spread to the United States, where the phenomenon secured further adulation. With his song-writing partner John Lennon, bass guitarist McCartney was a major contributor to the group's success and, collectively, the musical style evolved by The Beatles transformed popular music, supplanting earlier trends such as jazz.

The Liverpool-based painter Sam Walsh (1934–89) made this portrait of McCartney at the height of the group's fame. The title refers ironically to McCartney's less well-known brother, Mike McGear, who also achieved success in the 1960s as part of the satirical trio The Scaffold and was a friend of the artist. Based on photographs, the portrait demonstrates Walsh's distinctive painterly brushwork, deriving from American Abstract Expressionism combined with imagery based on published photographs, a figurative approach associated with pop art, which was then also at its height.
NPG 6172

NELSON MANDELA
(1918–2013)

MICHAEL PETO, JUNE 1962
Bromide print from original negative
326 x 328mm

Former leader of the African National Congress, Nelson Mandela was the first president of South Africa to be elected in fully representative democratic elections, serving from 1994 to 1999. A member of the ANC from 1944, in January 1962 Mandela secretly left South Africa, using the adopted name David Motsamayi. After travelling around Africa, he visited England in June that year to gain support for the ANC's struggle against the apartheid policies of the ruling National Party. During this trip, Michael Peto (1908–70) photographed Mandela for the *Observer* at the Haringey home of Oliver Tambo, with whom Mandela had established South Africa's first black legal practice. On his return to South Africa, Mandela was arrested on 5 August 1962. He served a continuous term of imprisonment for his involvement in the struggle against apartheid until 1990. During this time Mandela became an international symbol for freedom, human rights and racial equality. He was later awarded the Nobel Peace Prize (with F.W. de Klerk) in 1993 and, in recognition of his influence in the UK, his portrait was acquired for the Collection. NPG x137674

Portrait Photography in the Twentieth Century

TERENCE PEPPER

The early years of the century saw the enduring influence of the art-photographer or 'pictorialist', who had emerged in response to claims that photography was purely representational, without the filter of artistic interpretation. For more than three decades painters, photographers and art critics debated opposing artistic philosophies, culminating in the view that photography was indeed an art form. The Gallery's collection of photographs includes outstanding examples of the work of many of the major photographers of the twentieth century.

At the outset, the studio portrait dominated; self-styled 'camera artists', such as Cavendish Morton, Baron De Meyer, H. Walter Barnett, E.O. Hoppé and G.C. Beresford, captured key figures of the day, from the dancers of Diaghilev's Ballets Russes to members of the literary Stephen family (right). The portrait photograph – like a painting, drawing or engraving – engaged on an emotional level with the viewer.

Colour portraiture gathered momentum, pioneered by such photographers as Olive Edis, who enthusiastically took up the autochrome process, patented in France by the Lumière Brothers in 1903. Her most significant portraits were taken from 1912 to the 1930s, and included images of writers such as Thomas Hardy, members of the royal family, including the Princess Royal, Princess Mary, and politicians including Arthur Balfour, 1st Earl of Balfour and Sir Eric Geddes (opposite, top).

Pictorialism gradually declined in popularity after 1920 with the arrival of the Jazz Age. The angular, streamlined design aesthetic of art deco influenced portrait styles, evident in the work of Dorothy Wilding

ABOVE

Virginia Woolf (née Stephen, 1882–1941), by G.C. Beresford. Platinum print, 1902, 152 x 108mm, NPG P221 • This iconic image was for many years the Gallery's best-selling postcard. Between 1902 and 1932 G.C. Beresford made portraits of leading literary, artistic and political figures. Having made half-plate glass plate exposures, he then contact printed them as platinum prints, or 'platinotypes', a popular photographic process that continued until the First World War.

(below). Wilding, who employed over twenty-five female staff at her studio, was just one of many women photographers who seized the artistic opportunities that photography offered. Backgrounds and set designs became a crucial element of portraiture during this era, as also exemplified by Cecil Beaton, one of the most imaginative photographers of his generation. Beaton took early advice from Paul Tanqueray, who was one of the youngest photographers in London in the 1920s. Tanqueray opened his first studio in 1925, aged twenty, so was perfectly placed to document an era obsessed with youth and modernism. His portraits appeared alongside those of contemporaries such as Bertram Park, whose work was marked by dramatic lighting and simple backgrounds, and Hugh Cecil, whose portraits radiated elegant simplicity.

The 1930s were the golden age of the studio portrait, creatively lit formal images in the then-fashionable Hollywood style. But the same decade saw the publication of Man Ray's first monograph (1934), which included the celebrated solarised image of the model, muse and fellow photographer Lee Miller (overleaf). The first London surrealist exhibition (1936) made its mark, influencing photographers such as Madame Yevonde, whose reputation grew from 1914, with the opening of her first studio, and who from 1932 would develop the Vivex colour process for portraiture.

ABOVE

Katharine Legat (1880–1963) and Sir Eric Geddes (1875–1937), by Olive Edis. Half-plate autochrome, 1920s, NPG X132476 • The politician Sir Eric Geddes is portrayed playing chess with Olive Edis's sister, Katharine Legat. Edis opened a studio in Sheringham, Norfolk, where she specialised in portraits of fishermen as well as other well-known figures in the area.

RIGHT

The Duke (1894–1972) and Duchess of Windsor (1896–1986), by Dorothy Wilding. Vintage bromide print, 1943, 221 x 282mm, NPG X35662 • After taking the accession portraits of King George VI and Queen Elizabeth in 1937, Dorothy Wilding set up a second studio in New York, where this portrait was made.

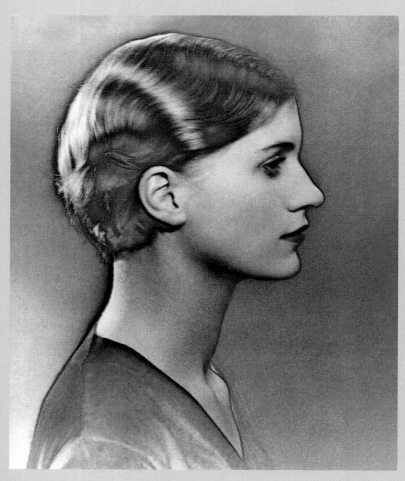

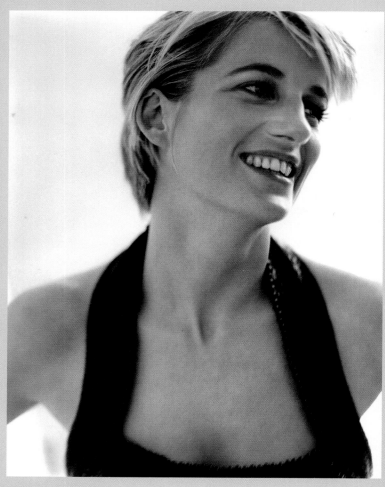

Diana, Princess of Wales (1961–97), by Mario Testino. Durst and Lambda bromide print, 1997, 1243 x 1001mm, NPG P1016 • With their relaxed informality, the photographs of Princess Diana by Mario Testino created a sensation when they appeared in *Vanity Fair* magazine in July 1997 shortly before her death in a car accident. The photoshoot was commissioned to promote the sale of her dresses at a charity auction, which included the black velvet beaded evening dress by Catherine Walker worn by Princess Diana here. Testino's fresh approach to these portraits gives the impression, as he put it in an interview with Patrick Kinmouth, 'as if you were alone in private with her'.

ABOVE

Lee Miller (1907–77), by Man Ray. Photogravure, 1929, 280 x 211mm (image size), NPG X137153 • This solarised image of Lee Miller was published as a photogravure in Man Ray's monograph *Man Ray Photographs 1920–1934, Paris* (1934). Miller, an American-born fashion model with an interest in photography, became Man Ray's assistant in 1929. Together they discovered solarisation, an effect achieved when exposing a semi-developed print to light.

With the emergence of photojournalism, the studio portrait was gradually replaced by the photo-essay, pictures that told a story. Publications such as *Weekly Illustrated*, *Picture Post* and *Lilliput* became particularly popular. The magazine was the messenger, and photography was its dominant medium, a showcase for what would become the most accessible art form in the twentieth century. While Dorothy Wilding spent much of the 1940s in New York, producing studio portraits of American personalities and her acclaimed double portrait of the Duke and Duchess of Windsor, Felix H. Man, Kurt Hutton, Dan Farson and Bill Brandt all moved out of the studio and into the world at large, a development made possible by the arrival of the small-format hand-held camera. In the 1950s grainy enlargements formed the 'kitchen sink' school of naturalism spearheaded by Antony Armstrong-Jones and Lewis Morley.

The bold graphics and fashion of the 1960s and the fledgling Sunday newspaper colour supplements paved the way for a young generation of photographers, including David Bailey, Terence Donovan and Brian Duffy, best known for their graphic black-and-white portraits. Leading fashion and society magazines, such as *Town*, *Queen*, *Tatler*, *Harper's Bazaar* and *Vogue*, also commissioned what would become era-defining photographs. The work of the German-born photographer Helmut Newton, known for his confrontational tableaux and heightened sense of drama, first emerged in the pages of Australian and British *Vogue*.

Mario Testino's work from the last decade of the century introduced a sense of collaboration between photographer and sitter in the making of a portrait. Best known for his fashion photography, he became internationally recognised almost overnight through the publication of his portfolio of images of Princess Diana in *Vanity Fair*. Of all the photographs taken of her, these are thought to be the most iconic.

Through its many facets – studio portraits, art photography, photojournalism and fashion – the photographic portrait has defined the twentieth century, recording the faces who shaped it, and who are now represented in the Gallery's Collection.

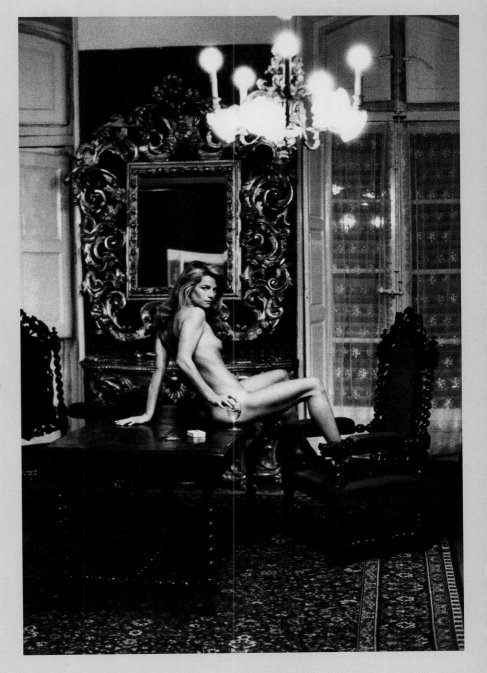

ABOVE

Charlotte Rampling (b.1946), by Helmut Newton. Vintage bromide print, 1973, 462 x 313mm, NPG X32395 • This portrait, taken for *Vogue* at the Hotel Nord Pinus, Arles, is one of Helmut Newton's earliest portraits, but characteristic in its use of an elaborate *mise-en-scène* and tone of sexual audacity. The point of view is voyeuristic, suggesting an unspoken drama between photographer and subject.

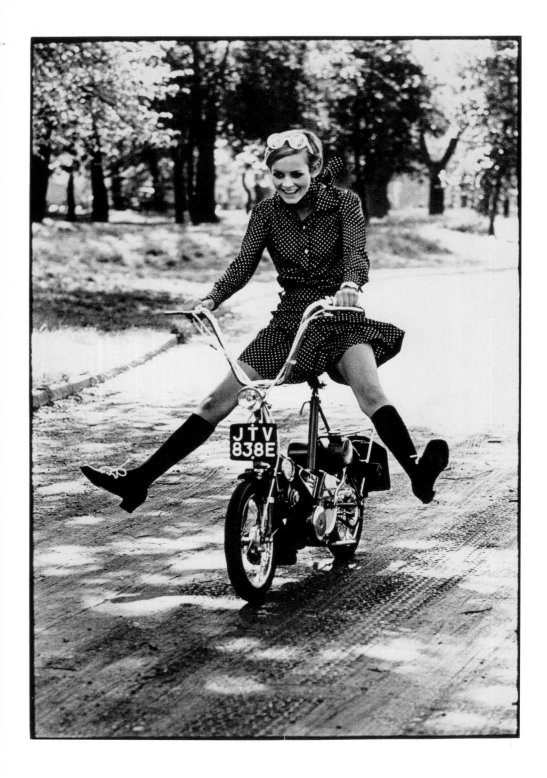

TWIGGY LAWSON
(b.1949)
RONALD TRAEGER, 1967
Archival Hahnemuehle print
388 x 260mm

Born Lesley Hornby, Twiggy
was so named for her twig-like
appearance when she first started
modelling. Standing 5ft 6in tall
and weighing just 6½ stone, she
created a new type of image with
her freckled face and distinctive
eye make-up. Her career as a
fashion model was launched when
Barry Lategan's photographs of
her, with a distinctive haircut
created by Leonard, were
published in the *Daily Express*,
which declared Twiggy 'the Face
of 1966'. Arguably the world's first
supermodel, Twiggy's characteristic
Sixties look was celebrated in
studies by photographers such
as Richard Avedon, Cecil Beaton,
Lewis Morley, Norman Parkinson,
Melvin Sokolsky and Bert Stern.

Ronald Traeger (1936–68)
photographed her on a number
of occasions. This 'action realism'
image, taken of her riding a moped
in Battersea Park and wearing
designs by Foale and Tuffin, was
part of a portfolio of six studies for
British *Vogue* published in July 1967.
Twiggy later developed a career as
an actress, dancer and television
personality, which included playing
the lead in Ken Russell's film *The
Boyfriend* (1971) and in the Broadway
musical *My One and Only* (1983–4).
NPG x134359

THE ROLLING STONES

(CLOCKWISE FROM LEFT: CHARLIE WATTS [b.1941];
SIR MICK JAGGER [b.1943]; BILL WYMAN [b.1936];
BRIAN JONES [1942–69]; KEITH RICHARDS [b.1943])

MICHAEL JOSEPH, JUNE 1968
Iris Kodalith print
531 x 483mm

The release of The Rolling Stones' album *Beggar's Banquet* was delayed by several months following Mick Jagger's request to use an image of a graffiti-covered lavatory wall as part of the cover artwork, which the group's record company refused. The cover under which it was finally released carried only text, while the inside gatefold depicted a scene of decadence.

Michael Joseph's photographic session with The Rolling Stones lasted for two days. The band – with three dogs, a cat, a goat and a sheep – recreated a medieval banquet in and around two stately homes: Sarum Chase in Hampstead, former home and studio of the artist Frank O. Salisbury, and Swarkestone in Derbyshire. Considered one of the greatest rock 'n' roll albums of the 1960s, *Beggar's Banquet* reached No.3 in the UK charts. It includes the singles 'Sympathy for the Devil' (the title of the Jean-Luc Godard film in which the band appeared) and 'Street Fighting Man'.

Michael Joseph (b.1941) was born in Kimberley, South Africa. He worked extensively for magazines such as *Town* and *Queen*. NPG P877

SIR HENRY COOPER
(1934–2011)
WILLIAM REDGRAVE, 1969
Bronze bust
415mm high

The defining moment in the career of heavyweight boxer Henry Cooper was his fight against Muhammad Ali, then known as Cassius Clay, in 1963, considered to be one of the greatest events in British boxing history. Although Cooper was defeated, the match was close and ended only when a cut opened up on Cooper's forehead. As a teenager, Cooper had competed in the 1952 Helsinki Olympics, and by 1970 was British, European and Commonwealth heavyweight champion, a record unmatched by any other British boxer. Cooper was renowned not only for his powerful left-hook, known as ''Enry's 'Ammer' that had famously floored Ali, but also his good humour.

Sculpted from life, initially in clay, the bronze bust by William Redgrave (1903–86) embodies Cooper's physical strength, whilst the bust format, traditionally associated with classical virtues, dignifies Cooper's distinctive 'boxer's nose'. This portrait was made at the height of Cooper's career, and his popularity twice won him BBC Sports Personality of the Year, in 1967 and again in 1970. NPG 6925

DAVID BOWIE
(b.1947)
BRIAN DUFFY, 1973
K3 Ultrachrome print
197 x 197mm

Born David Robert Jones in Brixton, south London, singer-songwriter David Bowie gained recognition with his single *Space Oddity* (1969), the release of which coincided with the first moon landing, and achieved international fame with his rock albums *The Rise and Fall of Ziggy Stardust and the Spiders from Mars* (1972) and *Aladdin Sane* (1973). Bowie's music career has spanned more than four decades, characterised by continual reinvention and experimentation, alongside further achievements as an actor, and he has become one of the most influential figures in modern British popular culture.

Renowned for his distinctive make-up, futuristic costumes and theatrical performances, Bowie appeared as one of his flamboyant stage alter-egos for the cover of his sixth album, *Aladdin Sane*. Taken in Brian Duffy's north London studio, a similar pose to this one, showing Bowie with his eyes closed, was finally used for the cover. It has become one of the most recognisable and celebrated of pop images.

Brian Duffy (1936–2010), a fashion, music and advertising photographer who came to prominence during the 1960s, is considered to have defined the era, along with David Bailey and Terence Donovan. He also photographed Bowie for the covers of his albums *Lodger* (1979) and *Scary Monsters (and Super Creeps)* (1980). NPG x137463

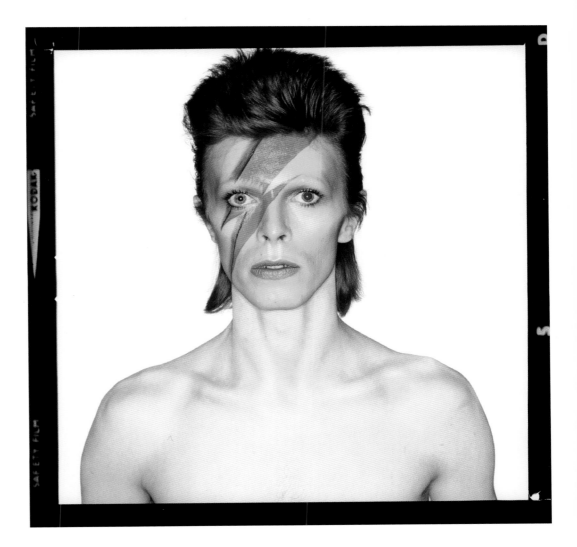

HAROLD WILSON, BARON WILSON OF RIEVAULX (1916–95)

RUSKIN SPEAR, *c.*1974
Oil on canvas
511 x 381mm

Depicted with his trademark pipe, and wreathed in tobacco smoke, the twice-elected British Prime Minister Harold Wilson is depicted in this portrait by Ruskin Spear (1911–90) as many of his detractors saw him: a populist politician with a down-to-earth style yet with an elusive, even evasive personality. Spear portrayed Wilson on several occasions. This portrait, the sittings for which took place in Downing Street, was exhibited in the year that Wilson returned to the premiership following his general election victory in October 1974. Spear saw him as 'a great actor', noting the way he used his pipe 'as an extension of himself, stabbing with its stem to emphasize points'. He added, 'We talked, mainly about tobacco as I also smoke a pipe.' Wilson was the only Labour leader to have led more than one government (a distinction later equalled by Tony Blair), but his second election was achieved by a narrow margin and the campaign was lacklustre. Wilson now confronted 25 per cent inflation. In April 1976 he retired from office voluntarily, the first prime minister since Asquith to take that step. NPG 5047

GRAHAM SUTHERLAND
(1903–80)

SELF-PORTRAIT, 1977
Oil on canvas
527 x 502mm

Graham Sutherland painted this self-portrait for an exhibition of his portraits held at the Gallery in 1977. By then he had been painting portraits for almost forty years, but this important aspect of his work was less known than his paintings of landscapes. Sutherland began as a printmaker, and his pastoral studies in this medium, which continued from the early 1920s to the mid-1930s, were influenced by Samuel Palmer. In 1934 he visited Pembrokeshire for the first time, and this area became an important inspiration for the paintings he began to make following the collapse of the print market in the 1930s. In 1948 his acquaintance with Somerset Maugham prompted him to attempt a portrait of the writer and this involved a somewhat different approach. In contrast to the process of metamorphosis that characterised his paintings of natural forms, portraiture called for accuracy, and he observed that 'in falsifying physical truth you falsify psychological truth'. In common with his later portraits, the Somerset Maugham portrait was based on drawings made in front of the sitter. Later he employed a system of squaring-up drawings made from life on to the canvas, as would have been the case with this penetrating portrait.
NPG 5338

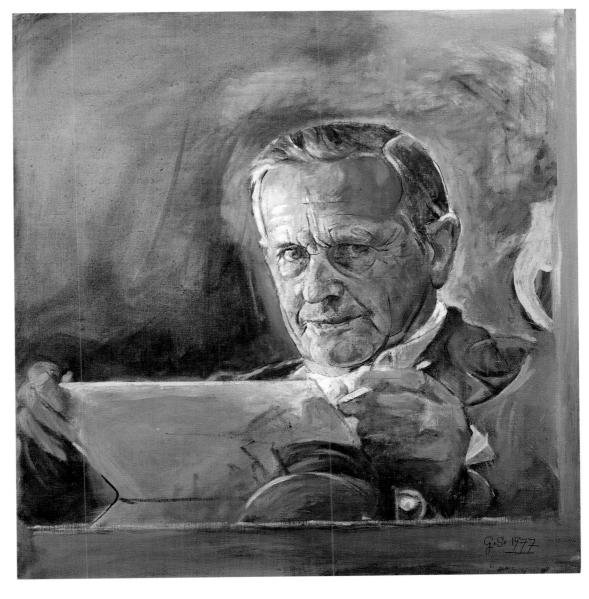

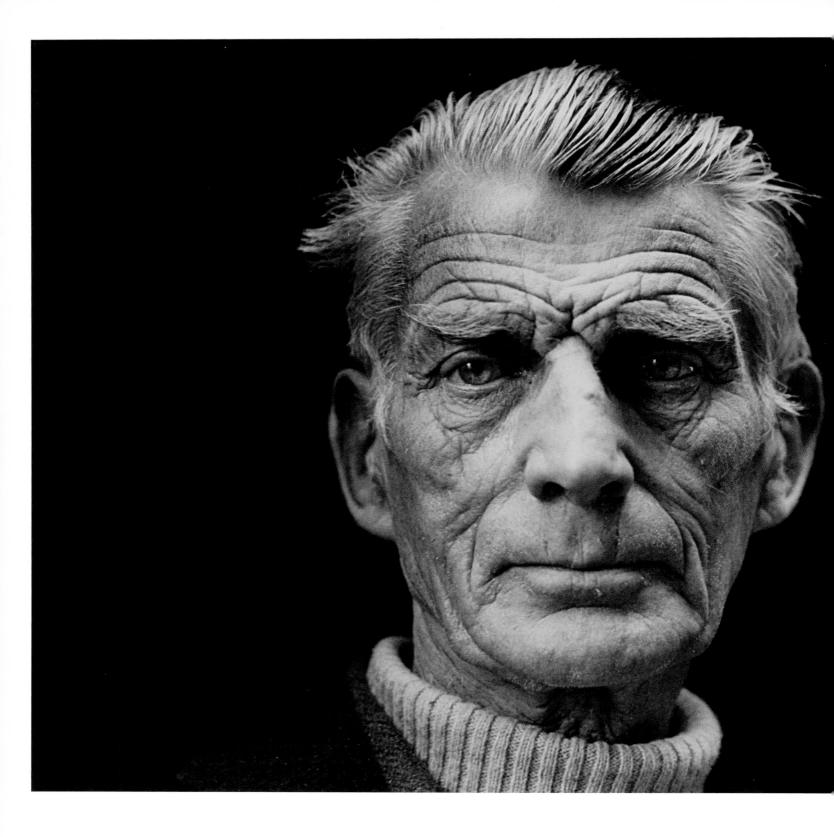

SAMUEL BECKETT
(1906–89)
JANE BOWN, 1976
Bromide print
335 x 493mm

Born in Dublin, Samuel Beckett studied at Trinity College (1923–7) in his hometown. He became associated with the writer James Joyce while working as an English assistant at the École Normale Supérieure in Paris, where he settled in 1932. Early published work included the poem 'Whoroscope' (1930), the collection of short stories *More Pricks than Kicks* (1934) and *Murphy* (1938). Most subsequent works were written in French, including the play *En attendant Godot (Waiting for Godot)* on which much of his reputation as an innovator lies. *Godot* premiered in Paris in 1953 and in London two years later, bringing Beckett's tragicomic outlook on the human predicament international renown. His later works, including *Breath* (1970), became increasingly minimal. Beckett was awarded the 1969 Nobel Prize for literature and he became a highly influential figure within his own lifetime.

Jane Bown (b.1925) began her photographic career, and her long association with the *Observer*, when the newspaper published her portrait of Bertrand Russell in 1949. She is admired for her naturally posed, black and white portraits, usually taken with available light. Her published books include *The Gentle Eye* (1980), which was accompanied by an exhibition at the Gallery, and *Exposures* (2009). NPG P373

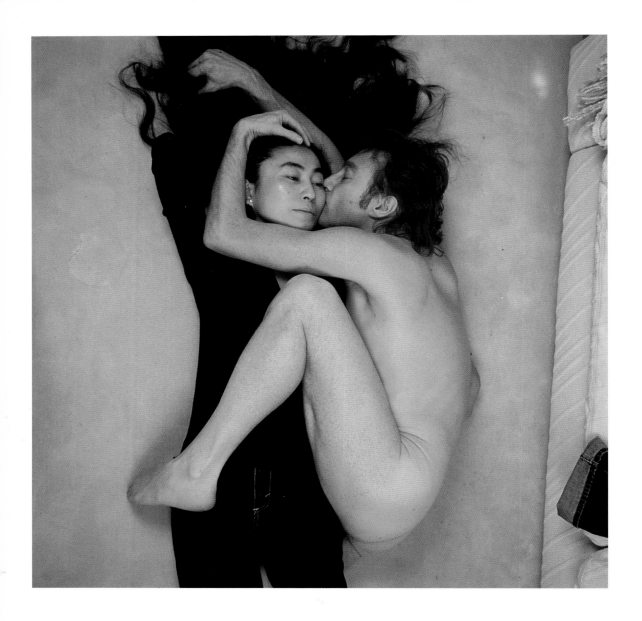

YOKO ONO (b.1933) AND JOHN LENNON (1940–80)

ANNIE LEIBOVITZ, 8 DECEMBER 1980
C-type print
327 x 327mm

John Lennon first met Yoko Ono after The Beatles' final tour in 1966, at her exhibition at the Indica Gallery, London. They married in Gibraltar in 1969. As a couple, they promoted peace, feminism and racial harmony, and their activism against prejudice included staging a 'Bed-In' for peace in Amsterdam, and later Montreal, where they recorded the single 'Give Peace a Chance'. Their son, Sean Ono Lennon, was born in 1975.

The last of her Lennon pictures made over thirteen years, this image was taken by Annie Leibovitz (b.1949) at the couple's New York flat, a few hours before Lennon was murdered. In her publication *Annie Leibovitz Photographs* (1983), Leibovitz recalled, in conversation with her interviewer David Felton: 'I really felt that what was so phenomenal of their time together was that they were still together … I thought of the embrace, them lying naked together, and the embrace is based on something from my life, the way I used to sleep with someone, a very relaxed position. So I had sketches made of them lying exactly like that and I tried it on them.' This iconic image was later published on the cover of the magazine *Rolling Stone* (22 January 1981). NPG P628

DIANA, PRINCESS OF WALES
(1961–97)
BRYAN ORGAN, 1981
Acrylic on canvas
1778 x 1270mm

One of the Gallery's most celebrated works, this portrait by Bryan Organ (b.1935) of Lady Diana Spencer (as she was at the point of commission) was marked by controversy almost from the beginning. The painting was commissioned by the Gallery as a companion piece to Organ's earlier portrait of Prince Charles (1980). The artist was known to be a relatively fast worker and, following the engagement of Lady Diana to Prince Charles in February 1981, it was proposed that the painting should be ready in time for the royal wedding later that year on 29 July. Organ requested a couple of sittings and, based on photographs and studies, the finished portrait – which shows Lady Diana in the Yellow Drawing Room of Buckingham Palace – was ready in time, being inaugurated at the Gallery on 23 July. It immediately attracted widespread interest. The press responded in particular to the unusual depiction of a member of the Royal Family wearing trousers, an idea proposed by the artist. However, on 29 August the portrait was slashed by a protestor. Despite initial concerns, a successful restoration was quickly expedited and the painting was returned to public display in November 1981. The Prince and Princess of Wales were later to divorce, and Princess Diana was killed in a car accident in 1997. NPG 5408

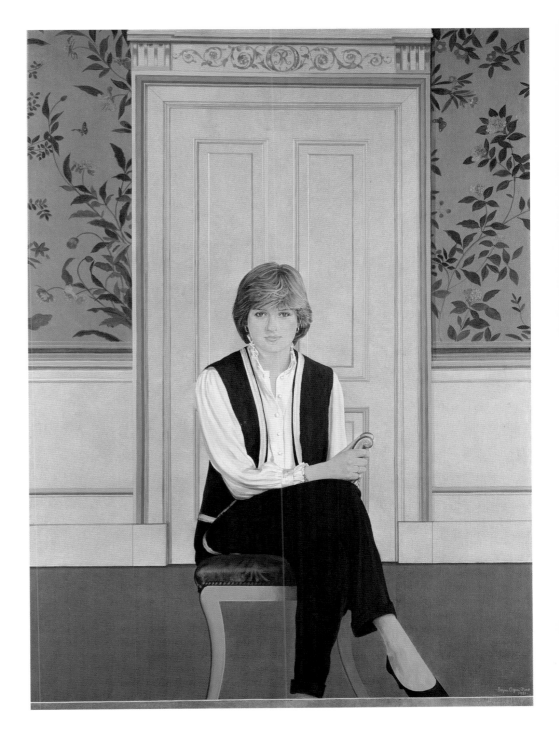

QUEEN ELIZABETH II
(b.1926)
ANDY WARHOL, 1985
Silkscreen prints
1000 x 800mm each

These portraits of the British monarch consist of four colour variants of the same image, the set forming part of a larger series of sixteen screen prints by Andy Warhol (1928–87) titled *Reigning Queens*. In addition to Queen Elizabeth II, the series features Queen Margrethe of Denmark, Queen Beatrix of the Netherlands and Queen Ntombi of Swaziland, each depicted by four prints. An initiator of pop art in the 1950s and 1960s, Warhol used photography to create secondary images, which had an innovatory and rejuvenating impact on portraiture. The abstracted nature of this portrait reflects Warhol's obsession with fame and the mechanisms by which celebrity is created and represented. Based on the official 1977 photograph taken by Peter Grudgeon to mark Queen Elizabeth's Silver Jubilee, this image resembles an enlarged postage stamp, a traditional means by which the monarch's portrait is disseminated. By repeating the same motif four times, Warhol creates a sense of artifice, heightened by the way the portrait has been manipulated, the introduction of decorative colour producing a mask-like appearance. Having once said, 'I want to be as famous as the Queen of England,' Warhol's portrait dissects the nature of fame and its ambiguous connection with the real person within.

NPG 5882 (1–4)

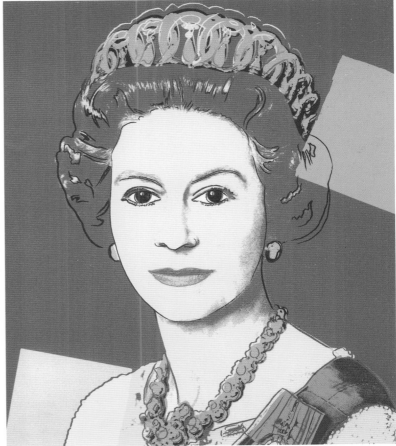

MARGARET THATCHER, BARONESS THATCHER

(1925–2013)

RODRIGO MOYNIHAN, SIGNED AND
DATED 1983–5
Oil on canvas
1265 x 1015mm

Prime minister between 1979 and
1990, Margaret Thatcher was the
first woman to hold the office in
Britain and was re-elected twice, in
1983 and 1987. Born in Grantham,
Lincolnshire, Thatcher first worked
as a research chemist and then as a
barrister specialising in tax law. Her
House of Commons career began
when she was elected Member of
Parliament for Finchley in 1959, and
she entered the Cabinet as education
secretary in 1970. Thatcher became
leader of the Conservative Party
in 1975. During her first term in
office she led the country into war
against Argentina in the Falkland
Islands. In her second term the
government pursued a controversial
programme of privatisation and
deregulation that would introduce
market mechanisms into areas
such as health and education, with
wide-ranging impacts upon public
services in Britain.

 Commissioned whilst Thatcher
was in office, the artist Rodrigo
Moynihan (1910–90) had eight
sittings with the Prime Minister,
which took place at 10 Downing
Street. Thatcher expressed concern
with the finished painting, however,
so the artist continued to work on
the portrait, making alterations
to the eyes, previously judged
to suggest a squint, and the
background colour, which was
softened from a bright blue to
a grey tone. NPG 5728

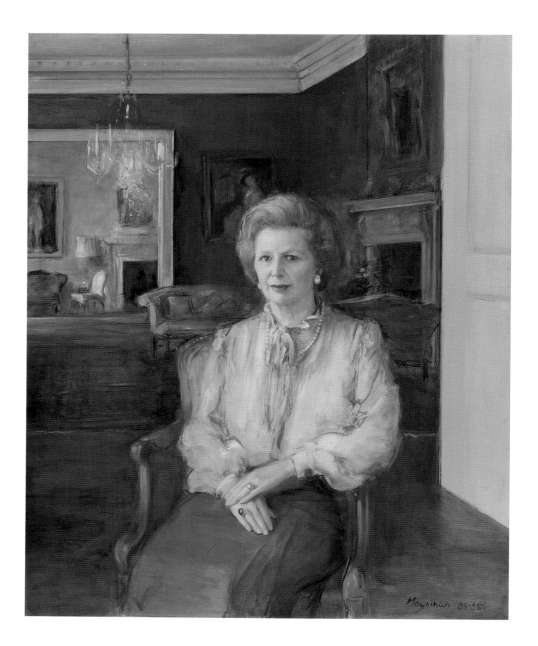

DOROTHY HODGKIN
(1910–94)
MAGGI HAMBLING, 1985
Oil on canvas
932 x 760mm

In 1964 crystallographer Dorothy
Hodgkin became the first British
woman to win the Nobel Prize for
Chemistry. Fascinated with crystals
from childhood, Hodgkin was an
outstanding student at Somerville
College, Oxford, and spent most
of her career working in Oxford
University laboratories. She was the
first scientist to define the structure
of penicillin (1942–9), vitamin
B12 (1964) and insulin (1969) using
X-ray diffraction photography.
Her results made it possible
for others to develop improved
therapies for a range of diseases.
The Royal Society gave her their
most prestigious award, the Copley
Medal, in 1976, the first woman
to receive this honour. Politically
active, Hodgkin was, in later life,
Director of the Pugwash campaign
against nuclear weapons.

Hodgkin sat for Maggi Hambling
(b.1945) in the study at her
Warwickshire home, where she
is shown immersed in her work.
A structural model of the four
molecules of insulin is on the
table in the foreground. Despite
Hodgkin's acute arthritis, contracted
when she was twenty-eight,
Hambling noted that her hands
were 'like busy animals, always on
the go', and included two pairs of
arms to evoke this energy, rather
than fixing a pose. NPG 5797

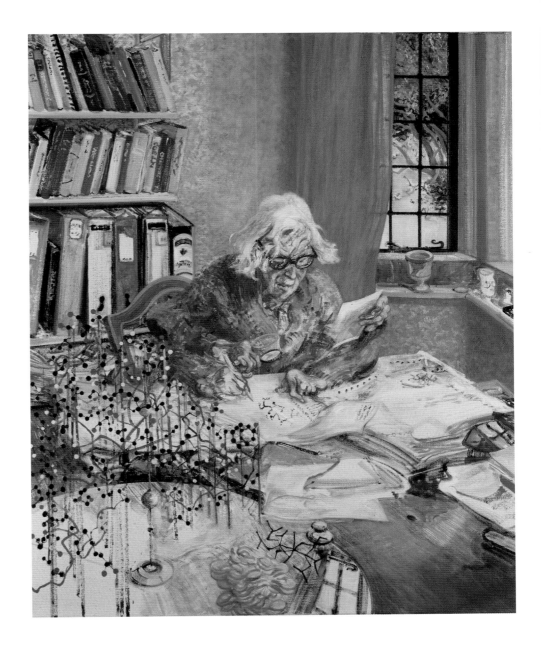

RICHARD ROGERS, BARON ROGERS OF RIVERSIDE
(b.1933)
SIR EDUARDO PAOLOZZI, 1988
Bronze
514mm high

Widely acknowledged as one of the founders of pop art in Britain, Eduardo Paolozzi (1924–2005) was commissioned by the Gallery to create a portrait of Richard Rogers, one of the leading architects of the late twentieth century. Beyond their shared stature as significant figures in the visual arts and architecture respectively, both men had Italian parents and, in a wider creative sense, the work of both was rooted in collage. Whether employing two or three dimensions, Paolozzi used from the outset disparate, found images and materials that he combined to form new visual entities. Similarly, Rogers' celebrated buildings, notably the Centre Georges Pompidou, Paris, and the Lloyd's Building, London, exposed functional and structural elements on the exterior.

In creating this bust, Paolozzi began by creating a naturalistic likeness, which was then deconstructed by cutting up the whole into smaller parts. The resulting fragments were then recombined, creating a new, constructed image. Accompanying this process, Paolozzi's working notes contained the injunction: 'Juggle with proportions a little and recast the plasters to keep making minute changes which finally describe that bizarre harmony that suggests the sitter.'
NPG 6021

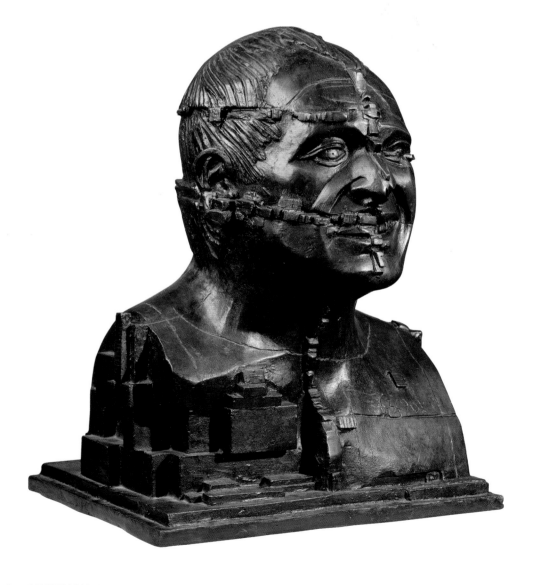

ALAN BENNETT
(b.1934)

DERRY MOORE, 12TH EARL OF
DROGHEDA, 1992
Fujichrome print
347 x 297mm

Born in Leeds, Alan Bennett
studied at the University of
Oxford, where he performed
with the Oxford Revue. His
collaboration with Dudley Moore,
Jonathan Miller and Peter Cook
in the satirical revue *Beyond the
Fringe* (Edinburgh, 1960) brought
him instant acclaim. Notable
successes on stage, screen and radio
include the stage play *A Question of
Attribution* (1988) and the television
monologues *Talking Heads* (1988).
The Lady in the Van (first broadcast
on radio in 2009) was based on Mrs
Shepherd, who lived on Bennett's
driveway; his autobiographical
works include *Telling Tales* (2000)
and *Untold Stories* (2005). Bennett's
droll humour and compassion
have made his readings widely
popular. *The History Boys* won three
Laurence Olivier awards in 2005,
and a film adaptation was released
the following year. More recently
his plays *The Habit of Art* (2009) and
People (2012) have been staged at
the National Theatre, London.

Derry Moore (b.1937), best
known as a photographer of people
in architectural interiors, became a
professional photographer in 1971,
after studying with Bill Brandt.
His photograph of Bennett includes
the sitter's mantelpiece replete
with postcards, one of which shows
Howard Coster's 1937 photograph
of W.H. Auden from the Gallery's
Collection. NPG P525

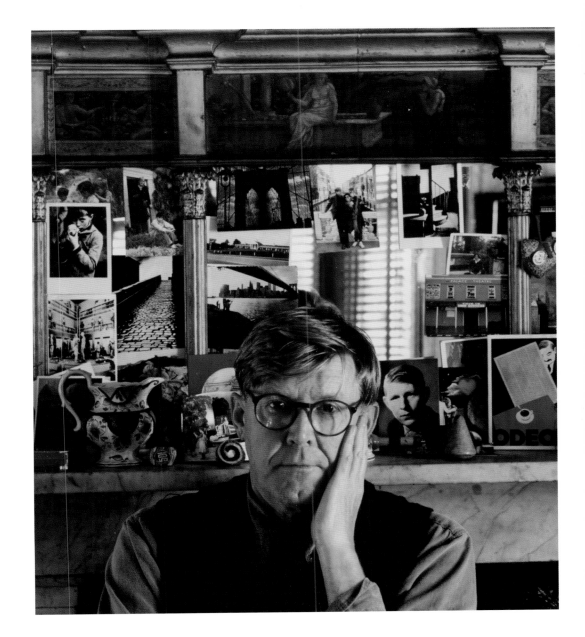

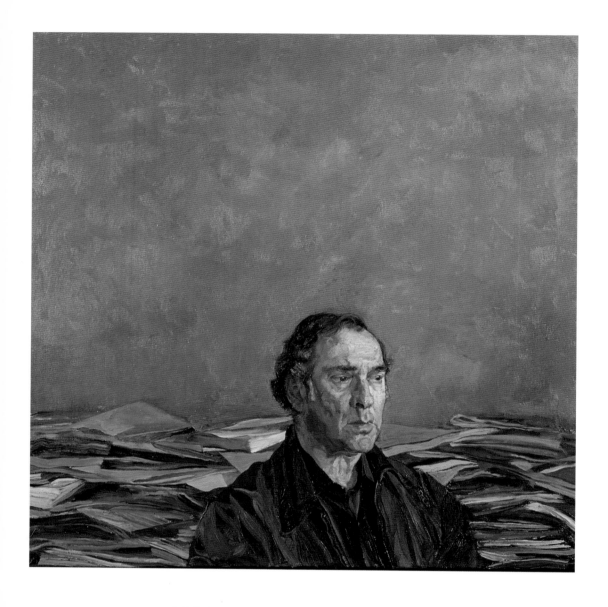

HAROLD PINTER
(1930–2008)
JUSTIN MORTIMER, 1992
Oil on canvas
910 x 910mm

Harold Pinter was one of the most distinguished playwrights of his generation, and a respected director and actor. Born in Hackney, east London, his reputation was secured with *The Caretaker* (1960). *The Homecoming* (1965) and *No Man's Land* (1975) followed, evoking uncertainty and menace whilst revealing the poetry and comedy of everyday language. His screenwriting credits include *The Servant* (1962), *The Go-Between* (1970) and *Betrayal* (1978). In 2003 Pinter memorably expressed his political convictions at an anti-war demonstration in Hyde Park, London. He was awarded the Nobel Prize for Literature in 2005.

The Gallery commissioned Justin Mortimer (b.1970), winner of the Gallery's annual portrait award in 1991, to undertake this portrait. Completed over a number of sittings at the writer's home, it is in effect a modern version of the 'man-of-letters' portrait type and shows Pinter's head before a massive pile of books and scripts against a vivid red background. Interviewed for the *Independent on Sunday* in 1999, Pinter recalled the painter begging him to keep absolutely still: '"You don't understand," he said, "my whole career is at stake here" – he was only half joking but it was very important to him.' Meanwhile, Pinter 'just sat back and thought about life, death, everything'. NPG 6185

DARCEY BUSSELL
(b.1969)

ALLEN JONES, 1994
Oil on canvas
1829 x 1521mm

In 1989 Darcey Bussell became the youngest-ever principal dancer at the Royal Ballet and went on to become one of the most highly acclaimed British ballerinas of her generation. She performed in *The Prince of the Pagodas* as Princess Rose, a role she created as the last muse of choreographer Sir Kenneth MacMillan. Bussell established herself as a dancer of artistic significance in MacMillan's *Manon* in 1992. During her ballet career she performed all the major roles in the classical repertoire, including Aurora in *The Sleeping Beauty* and Odette/Odile in *Swan Lake*, with companies including the Kirov and New York City Ballet. Since retiring in 2002, she has appeared as a judge on the BBC competitive series *Strictly Come Dancing*.

The portrait was commissioned from the artist Allen Jones (b.1937) in 1994, at a time when Bussell's popularity was helping to revive the fortunes of the Royal Ballet at Covent Garden. Jones had risen to prominence in the 1960s, and his highly sexualised depictions of women often proved controversial. Bussell posed over seven evenings at the artist's studio, following a day's rehearsal at the Royal Ballet. She admired the physicality of Jones's depiction, and the sense that she was 'going somewhere'.

NPG 6252

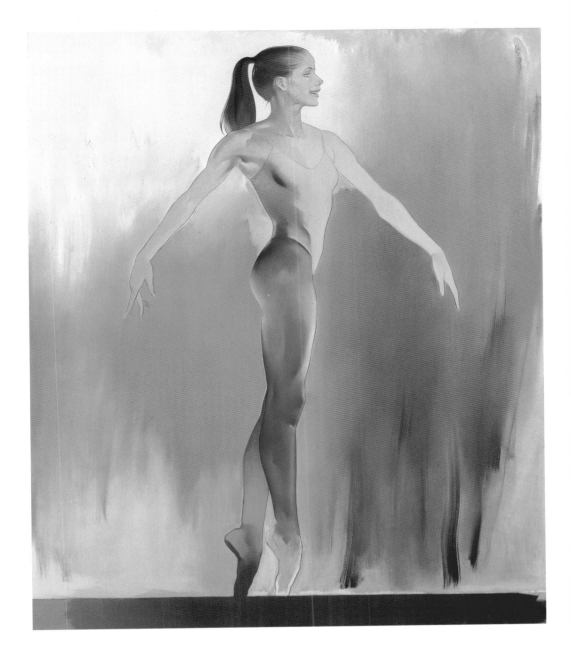

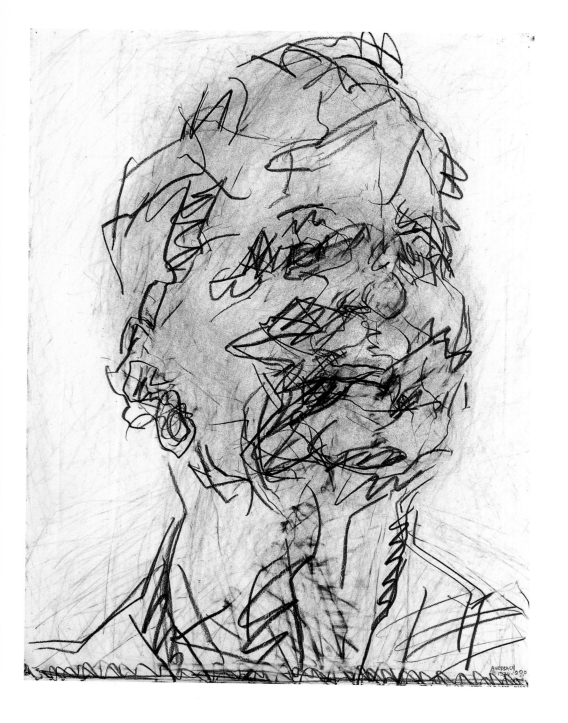

FRANK AUERBACH
(b.1931)
SELF-PORTRAIT, 1994–2001
Pencil and graphite
764 x 577mm

Frank Auerbach is one of Britain's
pre-eminent post-war artists, who
contributed to a radical new realism
in British figurative painting. Born
in Berlin, he arrived in England as
a child refugee from Nazi Germany.
His subjects are cityscapes around
Camden Town, and a small group
of close friends and family whom
he portrays repeatedly.

This drawing is a self-portrait,
a rare aspect of the artist's work. At
the time of acquisition, he likened
this evasive process to 'chasing
one's own shadow'. He returned to
this image, on which he had been
working sporadically since 1994, in
2001, when he was preparing for
his Royal Academy retrospective.
Following the Gallery's acquisition
of the work, Auerbach provided a
statement describing how he would
usually encircle his sitters in order
to understand them 'as a solid mass
displacing space'. However, when
working on the self-portrait, he
had recourse only to a mirror and
a photograph of himself, cut out
from a newspaper, to gain 'a certain
objectivity'. This unique and
powerful image comprises layers
of animated lines in pencil and
graphite, the silver tones the
result of countless rubbings out,
which the artist describes as
'transformations'. NPG 6611

GERMAINE GREER
(b.1939)

PAULA REGO, 1995
Pastel on paper laid on aluminium
1200 X 1111mm

Germaine Greer rose to prominence in 1970 with the publication of *The Female Eunuch* (1970), a key feminist text that addressed the role of women in Western society. Australian-born, Greer came to Britain in the 1960s to undertake a doctorate at the University of Cambridge whilst contributing to *Private Eye* and *Oz* satirical magazines. Subsequent publications have included *The Obstacle Race: The Fortune of Women Painters and Their Work* (1979), *Slip-Shod Sibyls: Recognition,* *Rejection and the Female Poet* (1995), *The Whole Woman* (1999), a sequel to *The Female Eunuch*, and *The Beautiful Boy* (2003).

Paula Rego (b.1935), one of Britain's leading figurative artists, chose Greer as her subject for this Gallery commission. Wearing a Jean Muir dress and some favourite old shoes, Greer posed in Rego's London studio over a number of days, during which they listened to Wagner's *Ring* cycle in its entirety. Writing in the *Independent on Sunday* in 1999, Greer described the work as a portrait of the artist as much as herself: 'It's got this incredible flicker about it, or energy, which is her energy more than mine, but my image is invested with her power and her concentration.' NPG 6351

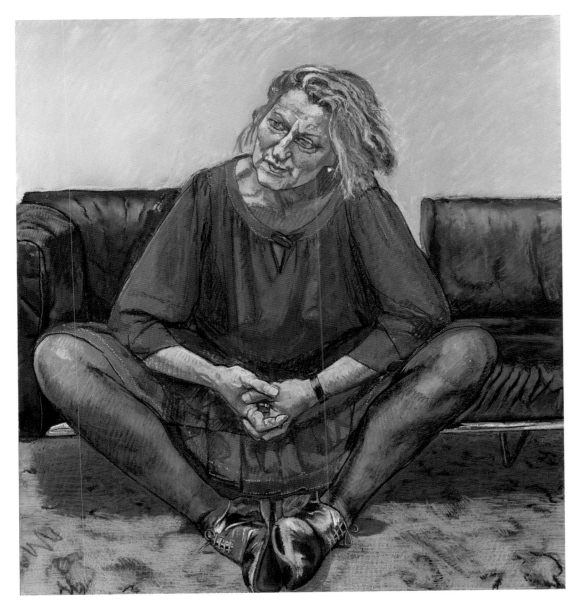

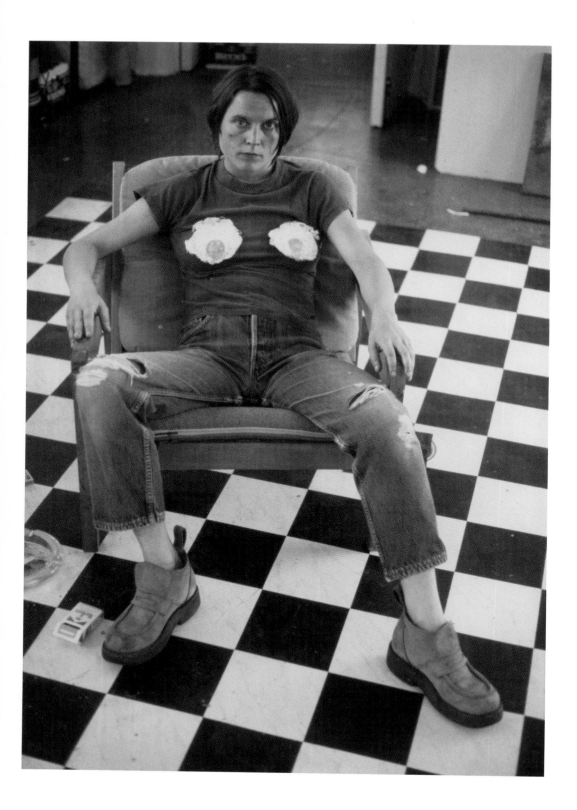

SELF-PORTRAIT WITH FRIED EGGS (SARAH LUCAS; b.1962)

SELF-PORTRAIT, 1996
Iris print
746 x 515mm

Using a pair of fried eggs to suggest breasts, this self-portrait by Sarah Lucas exemplifies the strategy of provocation and 'attitude' that defines her work in general. One of the original Young British Artists, or 'YBAs', a stylistically disparate group of artists that attracted attention from the late 1980s, Lucas's work has focused on issues related to sex, gender and her own identity. These themes are brought together in this portrait in which Lucas's posture and demeanour, though clothed, are reminiscent of the portrayal of women in pornography. Using her own image as a vehicle for the exploration of these ideas is also overtly connected with the culture of self-obsession – an extension of the so-called 'me generation' first identified in the 1970s – that is said to dominate the younger age group in contemporary society. The creation of imagery involving narcissism, sexual allusion and the portrayal of women characterises other self-portraits by Lucas in which, for example, she depicts herself eating a banana or sitting on a toilet. The use of deliberate banality, shock tactics and throwaway materials are also part of a calculated affront to conventional aesthetic values in an age of relativism and shifting standards.
NPG P884(5)

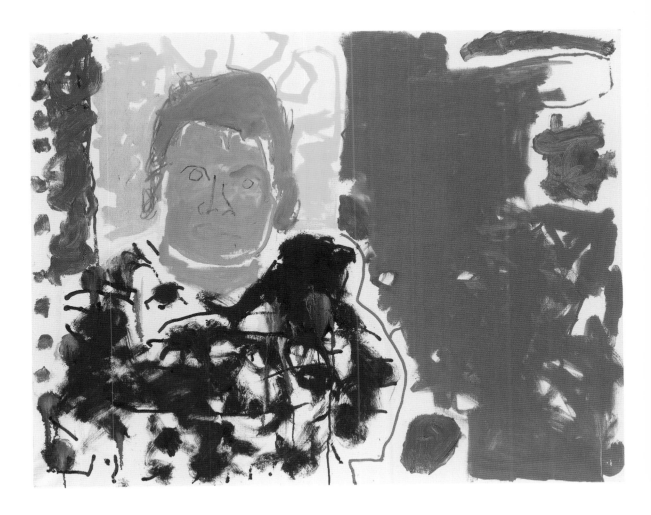

PORTRAIT OF A S BYATT: RED, YELLOW, GREEN AND BLUE: 24 SEPTEMBER 1997 (DAME ANTONIA SUSAN ('A.S.') BYATT; b.1936)
PATRICK HERON, 1997
Oil on canvas
968 x 1216mm

The novels of acclaimed writer A.S. Byatt include *The Virgin in the Garden* (1978), the first in the Frederica quartet, the Booker Prize-winning *Possession* (1990) and *The Biographer's Tale* (2000). She is also a critic and essayist, writing on art history, literary history and philosophy. When the National Portrait Gallery began discussions with the writer about a possible portrait, she expressed her admiration for the semi-cubist portrait of the poet T.S. Eliot (1949) by Patrick Heron (1920–99), now in the Gallery's Collection (page 219). Still active at his studio in Zennor, Cornwall, Heron accepted the Gallery's invitation to paint Byatt, and she wrote a compelling account of the process for the Gallery's records. During her first sitting, she noted that artist and writer share an apprehension of the blank page, 'only in the case of a portrait, this anxiety is doubled, both sitter and artist are anxious'. The final portrait emerged from drawings and paintings made over several months. It evokes the sitter's creative intellect and is, according to Byatt when interviewed for the *Guardian* newspaper in 2006, 'a picture of what I really feel like when I am working at full speed. It is a picture of somebody who might conceivably write a book.' NPG 6414

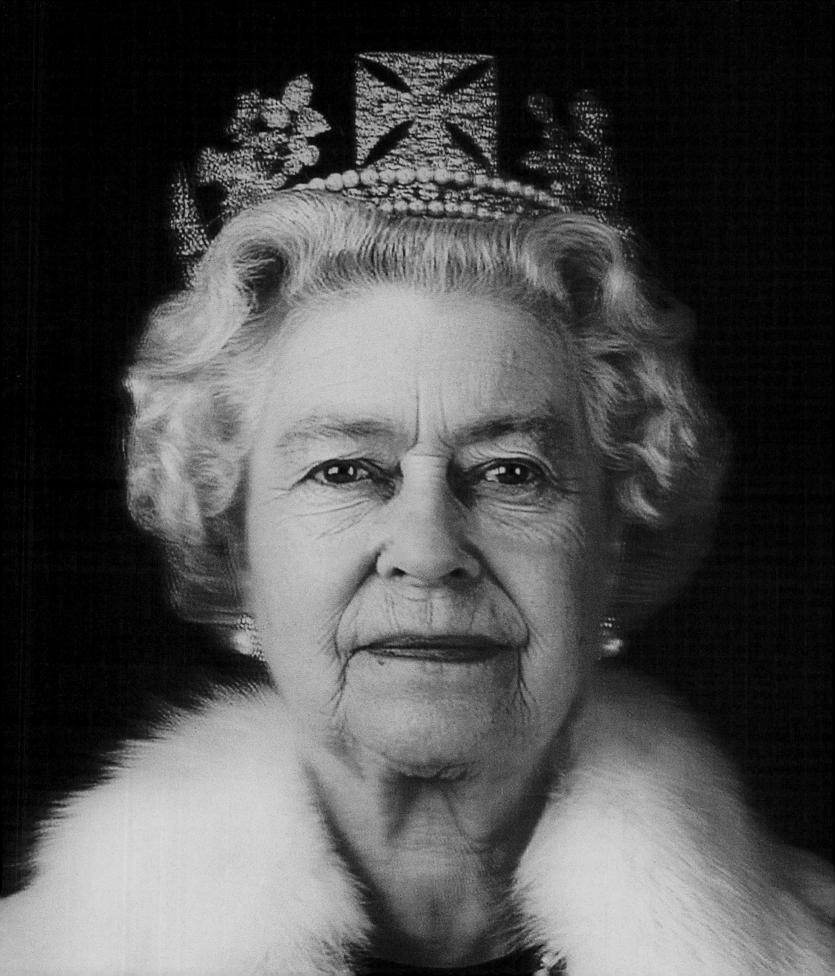

CHAPTER 6

Contemporary Portraits

(2000–PRESENT)

It was only in 1969, under the directorship of Sir Roy Strong, that the National Portrait Gallery began to collect contemporary portraits of living people. Since then the contemporary collection has grown considerably through both acquisition and commission. A large number of photographs and a smaller quantity of paintings, sculptures and digital works are added every year.

The contemporary collection currently encompasses works produced from 2000 to the present day and includes portraits of people who have made a significant contribution to modern British society. While the Gallery's founding principle, which emphasises the primacy of the sitter remains, the commissioning programme has enabled the Gallery to collaborate with a range of artists – some established, others at the beginning of their careers – whose work embraces different media. The Collection includes portraits of subjects who are involved in the arts and sciences, public service, media, sport, business and technology. In recent years the Gallery has addressed under-represented areas of the Collection. A series of portraits of influential women, including the actress Dame Judi Dench and the barrister, broadcaster and writer Helena Kennedy, Baroness Kennedy of the Shaws, has been funded by the bank J.P. Morgan. Portraits have also been commissioned of military figures, such as General Sir Mike Jackson, who served in Bosnia, and Johnson Beharry (page 271), recipient of the Victoria Cross for his bravery in Iraq.

Leading international artists of the day are represented, many of whom do not consider themselves to be portraitists, but are fascinated by portraiture and twenty-first-century preoccupations with selfhood, identity, geopolitics and celebrity. Acquisitions by artists such as Marlene Dumas and Marc Quinn illustrate the exploratory leanings of contemporary practice and challenge the very nature of portraiture. Dumas's memorial to Amy Winehouse was not painted from the life but, after the singer's tragically early death, using images found on the Internet. Quinn's abstract portrait of Sir John Sulston was not produced using traditional materials but created from the geneticist's own DNA and is regarded by the artist as both a realistic portrait of Sulston and a portrait of everyman.

In an age of celebrity culture, in which some faces have become all too familiar, the Gallery aims to represent subjects in surprising and challenging ways. Zaha Hadid is portrayed fittingly by means of a vibrant computerised line drawing that changes colour in infinite combinations (page 283). The graphic portrait of the four members of the band Blur by Julian Opie (pages 258–9) was already a familiar image when acquired by the Gallery, having been widely seen as an album cover and as posters on London buses. Some sitters whose faces may be unfamiliar to visitors have, nonetheless, had a huge impact on our lives. The scientist James Lovelock is represented in a Holbeinesque manner by Michael

Gaskell, and Sir Paul Nurse (pages 272–3), the Nobel Prize-winning oncologist, is presented in appropriately forensic detail by Jason Brooks.

Other contemporary artists in the Collection reference earlier artists or traditional portrait themes in their work. Dean Marsh's finely painted portrait of Camilla Batmanghelidjh (page 274) owes much to Ingres in the pose and treatment of her sumptuous robes. Gillian Wearing is known mainly for her self-portraits incorporating masks, the use of which can be seen as a recurring theme in our historical Collection. For her portrait of Shami Chakrabarti (page 278), Wearing created a mask for her sitter to hold, which intimates the subtle difference between her public and private persona.

The age-old tradition of royal portraiture thrives in the twenty-first century. Paul Emsley's portrait of the Gallery's patron, the Duchess of Cambridge (page 279), attracted much interest, particularly as it was the first portrait she had ever sat for. A painted portrait rather than a photograph, it focused attention on how a woman in her early thirties might be portrayed. By contrast, Queen Elizabeth II is the most represented royal in history. Rather than sit for a traditional painted portrait to mark her Diamond Jubilee in 2012, the Queen agreed to a holographic portrait, *Equanimity*, by Chris Levine and Rob Munday (page 281). The resulting image, which required her to sit for hundreds of photographs, is at once regal and contemporary.

The tradition of political portraiture also continues, often presenting artists with particular challenges. In the case of the late Mo Mowlam, the former Secretary of State for Northern Ireland, John Keane had intended to portray all the members of the Good Friday Agreement, but in the end only Mowlam was able to sit (page 260). The Gallery aims to commission a portrait of every prime minister, but because of political schedules, sittings often take place after the prime minister has left office; for example the portrait of Tony Blair by Alastair Adams took many years to complete.

While some artists, like Keane, work with the aid of photography, which is useful given the busy lives of their sitters, others continue to work in a traditional manner from the life. Tai-Shan Schierenberg, who has painted several portraits in the Collection, including that of the late poet Seamus Heaney, continues the British expressionist tradition, taking a delight in representing flesh in paint (page 268).

The Gallery remains committed to collecting and commissioning for posterity portraits of those who shape our world. While the challenges of contemporary life often dictate the way in which certain portraits are made, for some subjects sitting for a 'slow' portrait is a way of stepping out of their daily lives. Every portrait is as unique as its subject and there is no doubt that people will continue to be fascinated by the human face well into this new millennium.

Sarah Howgate

ALEX, BASSIST.
DAMON, SINGER.
DAVE, DRUMMER.
GRAHAM, GUITARIST.
JULIAN OPIE, 2000
C-type colour prints on paper
laid on panel
868 x 758mm each

Alex James (b.1968), Damon Albarn (b.1968), Dave Rowntree (b.1964) and Graham Coxon (b.1969, shown below, left to right) formed the band *Blur* in 1989, when Albarn, Coxon and James were students at Goldsmiths College. Their chart-topping album *Parklife* (1994) announced the band's leading position in the era of Brit Pop. Further albums included *The Great Escape* (1995), *Blur* (1997) and *13* (1999). The band members have also pursued individual projects in musical theatre, politics, journalism, broadcasting and cheese-making. After a period of hiatus, a reinvigorated band headlined the Glastonbury Festival in 2009 and performed to large crowds in Hyde Park, London, in 2009 and 2012.

With the exception of photographs, opportunities for the Gallery to acquire portraits of pop bands by leading artists are rare. This work was originally commissioned by the band for the cover of their album *Blur: The Best Of* (2000). Created by British artist Julian Opie (b.1958), whose graphic language is derived from signage and advertising, the image was, appropriately, reproduced on billboards and merchandise to promote the album. Opie made 'digital drawings' by sketching on to photographs of the band and reducing their features to the minimum. Befitting their celebrity, the image presents the individual band members as instantly recognisable and yet completely unknowable. NPG 6593 (1–4)

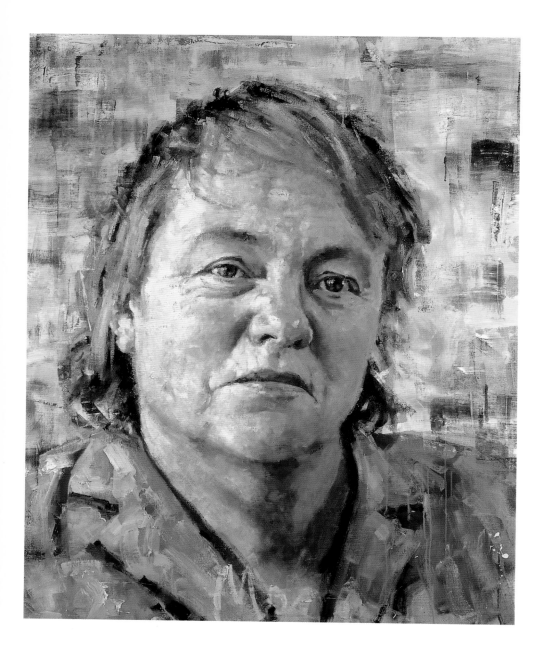

MO MOWLAM
(1949–2005)
JOHN KEANE, 2001
Oil on canvas
1528 x 1224mm

Following an academic career, Mowlam became a
Labour Member of Parliament in 1987, and the first
female Secretary of State for Northern Ireland in 1997.
She played a key role in orchestrating the Good Friday
Agreement and reviving the peace process.

This portrait began as an ambitious proposal by John
Keane (b.1954) to paint all the participants in the Irish
Peace Talks. When the talks went into crisis, the idea
was abandoned in favour of a commission to paint just
Mowlam, in recognition of her personal contribution.

Keane's work is often concerned with issues of
conflict; he had been the official artist of the Gulf
War in 1990, but this portrait offered a refreshing
opportunity to celebrate a resolution. Preferring to
work alone in his studio, he used photographs, an
approach that suited his busy sitter. Keane has recorded
that the paint itself is as important as the subject on
the canvas: 'It's where the substance of paint dissolves
into image and vice versa that sets up a kind of tension
in the surface.' NPG 6468

THOMAS ADÈS
(b.1971)

PHIL HALE, 2002
Oil on canvas
2138 x 1073mm

Thomas Adès has achieved acclaim as a composer, conductor and pianist. His work with the Hallé Orchestra includes *These Premises Are Alarmed*, performed for the opening of the Bridgewater Hall (1996). The orchestral piece *Asyla* (1997) was toured by the City of Birmingham Symphony Orchestra under Sir Simon Rattle's direction. *Powder Her Face* (1995), his first opera, was followed by *The Tempest* (2004), a commission from the Royal Opera House, London. A collaboration with video artist Tal Rosner resulted in a piano concerto and moving image piece titled *In Seven Days*, which premiered at the Royal Festival Hall (2008). Artistic Director of the Aldeburgh Festival (1999–2008), Adès has recorded works by composers including György Kurtág, Igor Stravinsky and Leoš Janáček.

Canadian-born artist Phil Hale (b.1963), who had won second prize in the Gallery's BP Portrait Award in 2001, made numerous photographs, drawings and oil sketches over a seven-month period. Adès was clear that he did not want to be depicted in a concert hall for his portrait. The decision was finally made to set the portrait in an anonymous corner of the composer's London home, a contrast to the dramatised pose of the sitter. NPG 6619

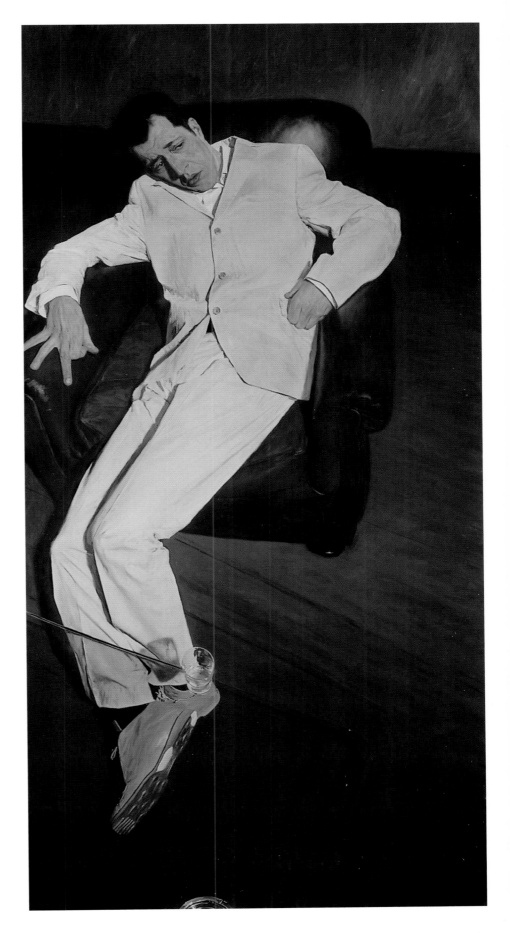

Celebrity

SARAH HOWGATE

Fuelled by the Internet, the paparazzi and the culture of the gossip magazine, we undoubtedly live in an age of celebrity, but the concept is not a reflection solely of modern times. When the National Portrait Gallery was founded in 1856, one of the first resolutions that Earl Stanhope put to the Trustees stated: 'the rule which the Trustees desire to lay down to themselves in either making purchases or receiving payments is to look to the celebrity of the person represented rather than to the merit of the artist'.

The historian Thomas Carlyle wrote extensively about hero-worship in the 1840s, when celebrity had a different meaning; the words 'eminence' or 'lasting fame' were more commonly used. There are many portraits of celebrity figures in the Gallery's historical collections. For example, in sixteenth-century Europe Francis Drake (page 53) was a figure to be feared, his enemies as well as his friends desiring to see his image. In the eighteenth century Emma Hamilton, whose notorious affair with Horatio Nelson, one of the greatest heroes of the age, shocked society, astutely managed her public image through countless painted portraits (page 111).

In 1969 the abandoning of the Gallery's 'ten year rule', which stated that sitters (with the exception of royalty) had to be deceased for ten years before they qualified for inclusion, opened up the Collection. Although it is still only people that have contributed to British history and culture who are eligible, in some cases, in addition to their achievement, they may have celebrity status. Anna Wintour (below), British editor of American *Vogue*, who was painted by Alex Katz, is one example. With her geometric haircut and large sunglasses Wintour is instantly recognisable at international runway shows. Katz's portrait plays on and distils her distinctive look.

The portrayal of celebrity culture today has its roots in the 1960s. The medium of television, together with

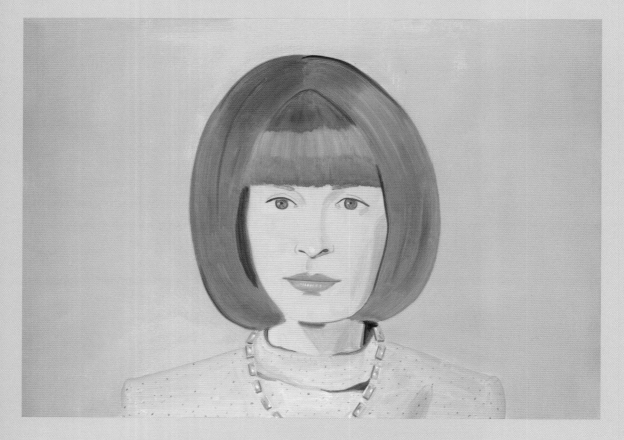

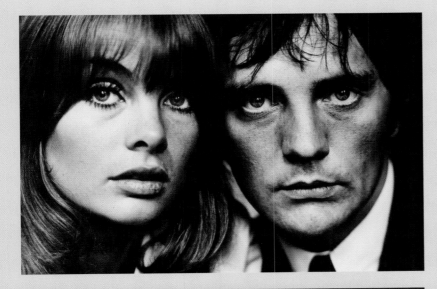

the electric effect of popular music, created new icons, and the policy of the Gallery changed accordingly under Roy Strong's directorship. Popular themes, previously ignored, were embraced. Models and actors, football players and convicts have since joined royalty in the Gallery's Collection. In 1968 Strong also staged the Gallery's first photographic exhibition – the hugely successful *Beaton Portraits 1928–68*, with its emphasis on living sitters – which championed the importance of photography as an art form and led to a photographic acquisitions policy.

The Gallery's Collection traces the multi-faceted nature of celebrity. Reflecting the dominant youth culture of the 1960s, Terry O'Neill's double image of model Jean Shrimpton and actor Terence Stamp epitomises the style and attitude of the decade, the faces of his young, confident subjects shown almost full frame. As The Beatles rose to fame, becoming one of the most influential groups of all time, their stylistic reinventions, in both music and appearance, were recorded by photographers such as Norman Parkinson. Where some celebrity photographs literally invaded the private arena, made possible by technical developments in flash, fast film and lenses, the informality of Parkinson's portrait

TOP LEFT

Jean Shrimpton (b.1942) and Terence Stamp (b.1940), by Terry O'Neill. Bromide print, 1964, 270 x 405mm, NPG x125463 • Terry O'Neill is one of the world's most published photographers, who has worked for *Vogue*, *Paris Match* and *Rolling Stone*. This double portrait of model Jean Shrimpton and actor Terence Stamp was taken during their three-year relationship.

BOTTOM LEFT

Christine Keeler (b.1942), by Lewis Morley. Bromide print, 1963, 508 x 413mm, NPG P512(13) • One of Lewis Morley's best-known photographs, this portrait of Christine Keeler has become a defining image of the 1960s. It was taken in Morley's studio over the Establishment Club in London's Greek Street.

(below) invites us to think we are present at some happy, private moment. Pop artist Andy Warhol's sleeping portraits of iconic figures of the 1960s would, in turn, influence Sam Taylor-Johnson's intimate portrayal of footballer David Beckham in 2004 (pages 266–7).

Other acquisitions from the 1960s onwards depict subjects whose fame was based on notoriety rather than achievement. Christine Keeler, photographed by Lewis Morley, is an example. The seductive pose of the former call girl, naked astride a copy of an Arne Jacobsen chair (page 263), will be forever associated with political scandal and the Profumo Affair.

Royalty were once regarded as celebrities – in the 1940s, the Duke and Duchess of Windsor personified glamour – but in the classless society of the 1960s, youth, beauty and talent were the only credentials necessary. Three decades later, Princess Diana would bridge the gap to become the first modern celebrity royal, very aware of her public image. Photographer Mario Testino captured her transition and a new-found informality (page 230).

But it is not always the prerogative of the sitter to be the celebrity; nor is it always the remit of the photographer to control a portrait. A generation of photographers in the 1960s became as famous as the celebrities who posed for them, David Bailey, Terence Donovan and Terry O'Neill among them. More recently the model Corrine Day became an important chronicler of the world around her. In her multiple portrait of model Kate Moss (opposite), commissioned in 2006, a naturalistic Moss appears to lead the photo session in a way that models do not usually do: the celebrity is directing her own image.

From the fictional celebrity of contemporary tableaux, created in the photographer's imagination, to the 'selfie' that captures the literal 'I was here at this time in this place' moment, digital technology and social networking sites have enabled everyone to become world-famous. To paraphrase Warhol, everyone can be a celebrity now, if only for fifteen minutes …

OPPOSITE

The Beatles (left to right:
George Harrison [1943–2001],
Sir Paul McCartney [b.1942],
Ringo Starr [b.1940], John
Lennon [1940–80]), by
Norman Parkinson. Bromide
print, 1963, 250 x 378mm,
NPG X27128 • This photograph
of The Beatles, arguably the
most famous British celebrities
of the 1960s, was taken in a
hotel suite in Russell Square,
London.

RIGHT

Kate Moss (b.1974), by
Corinne Day. Bromide print,
2006, 1510 x 1305mm, NPG
P1274 • Corinne Day, a friend
of Moss and former model,
said on the making of this
photograph: 'I suggested
to Kate that we have a
conversation about a serious
subject. The subject she chose
to talk about revealed her true
feelings and in turn defined
her character.'

DAVID (DAVID BECKHAM; b.1975)
SAM TAYLOR-JOHNSON (SAM TAYLOR-WOOD)
2004
Digital film displayed on plasma screen

Footballer David Beckham was born in Leytonstone
in east London and attended one of Bobby Charlton's
football schools in Manchester. He signed to play for
Manchester United in 1991 and the team won the
Premier League title six times, the FA cup twice and
the UEFA Champions League in 1999. Beckham
captained the England team for six years and, since
leaving Manchester United in 2003, has played for Real
Madrid, Los Angeles Galaxy and Paris Saint-Germain.
He received an OBE in 2003, and in 2010 he was
presented with the BBC Sports Personality of the Year
Lifetime Achievement Award.

 Although he is an internationally recognisable figure,
this portrait of Beckham by Sam Taylor-Johnson
(b.1967) gives us a view with which we are unfamiliar.
The potential dynamism both of the moving image
and of the subject is quietened and Beckham is
depicted in a moment of repose. It is a private-seeming
portrayal and this sense is enhanced by the perceived
documentary or real-time quality of the film. Eliciting
the viewer's voyeuristic tendency, Taylor-Johnson's
work also speaks of the nature and power of celebrity
status in contemporary culture. NPG 6661

SEAMUS HEANEY
(1939–2013)

TAI-SHAN SCHIERENBERG, 2004
Oil on canvas
967 x 915mm

Irish poet Seamus Heaney was one of the most renowned voices in poetry in the twentieth century, both critically praised and popular. Awarded the Nobel Prize for Literature in 1995, he was praised for 'works of lyrical beauty and ethical depth, which exalt everyday miracles and the living past'. His first collection of poems, *Death of a Naturalist* (1966), was published to immediate critical acclaim. Other books of verse include *Door into the Dark* (1969), *The Spirit Level* (1996) and a much-praised modern translation of the Anglo-Saxon poem *Beowulf* (1999). In the early 1990s he was Professor of Poetry at the University of Oxford, and had a long relationship with Harvard University, which contributed to his significant international reputation.

Painted by Tai-Shan Schierenberg (b.1962), this portrait arose from a commission by Queen's University Belfast, where Heaney had been Chancellor. A formal portrait had been selected for that setting, while this more introspective version was acquired by the Gallery. In a letter to the Gallery after its acquisition of the portrait in 2005, Heaney – echoing the rural imagery of his own early poems – wrote that he admired the work for its 'blocked-in, blocked-out presence, the field 'n' farm pigments, and the general honest-to-earth quality.' NPG 6703

ALFRED BRENDEL
(b.1931)
TONY BEVAN, 2005
Acrylic on canvas
756 x 670mm

Alfred Brendel is one of the world's great pianists. Based in London, he was born in northern Moravia, now part of the Czech Republic, and his early years were spent in Croatia and Austria. Largely self-taught, Brendel's musical training consisted of childhood piano lessons. A precocious talent, he made his first professional recording aged twenty-one and his career spans over six decades. In the 1960s he became the first artist to record Beethoven's complete works for solo piano, and is a renowned interpreter of Mozart, Schubert, Brahms and Liszt.

Brendel is also an admired poet and essayist and, as a young man, briefly contemplated a career as a painter, exhibiting watercolours in Graz, Austria.

The British painter Tony Bevan (b.1951) was commissioned to paint Brendel after the pianist expressed admiration for the artist's work. Bevan is one of Britain's leading figurative painters, whose approach is rooted in the European expressionist tradition. Although much of Bevan's work is based around the self-portrait, he is not a conventional portrait artist and had never previously undertaken a commission. This powerful portrait emerged from a large group of paintings and sketches of his sitter, which Bevan made over twelve months following a single sitting. NPG 6720

JOANNE KATHLEEN ('J.K.') ROWLING
(b.1965)

STUART PEARSON WRIGHT, 2005
Oil on board construction with coloured pencil
on paper
972 x 720mm

J.K. Rowling is the author of the successful Harry
Potter series of books, now translated into sixty-one
languages with over a quarter of a billion copies sold
worldwide. Rowling said that the characters and plot
of the first novel, *Harry Potter and the Philosopher's
Stone* (1997) came to her 'fully formed' during a train
journey in 1990, and she completed the book with the
assistance of an award from the Scottish Arts Council.

Both *Harry Potter and the Goblet of Fire* (2000) and *Harry
Potter and the Order of the Phoenix* (2003) in turn held the
record for the fastest-selling book in history.

Stuart Pearson Wright (b.1975) trained at the Slade
School of Fine Art, London, and in 2001 won First
Prize in the Gallery's BP Portrait Award. This work was
commissioned as a result, and Pearson Wright travelled
to Edinburgh to meet the author, where he made
several preliminary sketches. Cutting out sections
of the painting and positioning them within a three-
dimensional space concealed behind a false wall,
Pearson Wright has created a *trompe-l'oeil* portrait that
approaches the fictional worlds in Rowling's own work
and references the café where Rowling wrote the first
Harry Potter book. NPG 6723

JOHNSON BEHARRY
(b.1979)
EMMA WESLEY, 2006
Acrylic on panel
804 x 336mm

Lance Corporal Beharry is the first living British person to be awarded the Victoria Cross, Britain's highest award for gallantry, since 1965. Born in Grenada, the fourth of eight children, Beharry came to Britain to stay with his grandparents at the age of twenty. He worked as a handyman and decorator in Hounslow before joining the British Army in 2001 as part of the Princess of Wales's Royal Regiment. After training, in April 2004 he was posted to Iraq. There, under intense enemy fire, Beharry saved the lives of thirty of his fellow soldiers, sustaining considerable injuries in the process that have prevented him from returning to active service. The sittings for this portrait took place in Beharry's London flat in late summer, with Beharry wearing full military dress.

Artist Emma Wesley (b.1979) has exhibited widely and shown regularly with the Royal Society of Portrait Painters and in the BP Portrait Award annual exhibition. Her intention was to convey her subject's 'modesty, generosity, humility and humour', and she achieved this by adding an element of informality, portraying Beharry with his cap resting on his lap, thus revealing his facial battle scars, and his crossed hands echoing the shape of the medal he wears. NPG 6803

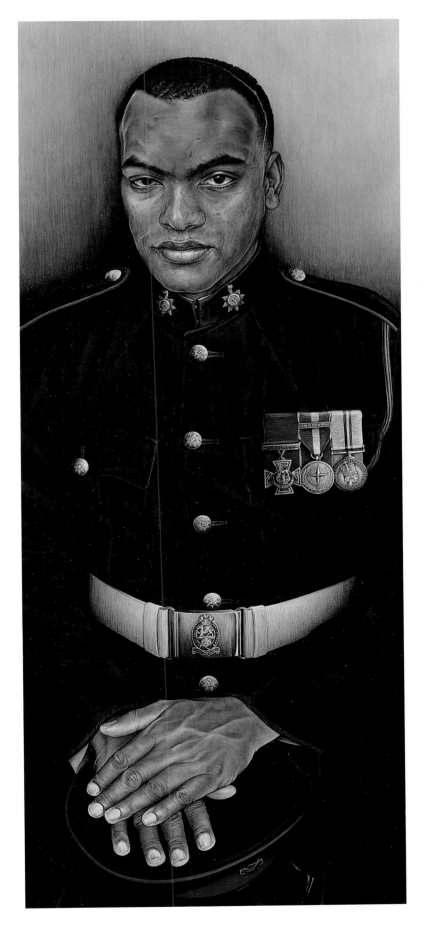

PAUL (SIR PAUL NURSE; b.1949)
JASON BROOKS, 2008
Acrylic on linen
1710 x 2710mm

Geneticist and cell biologist Paul Nurse was awarded the 2001 Nobel Prize in Physiology or Medicine jointly with Dr Tim Hunt and Dr Leland Hartwell for his work on the genes that regulate the cell division cycle. His important discoveries have improved our understanding of how cancer cells divide. Nurse was formerly Chief Executive of Cancer Research UK, the largest cancer charity in the United Kingdom. He has been President of Rockefeller University in New York since 2003, where he continues his research, and in 2010 became President of the Royal Society. In 2011 he was appointed Director and Chief Executive of The Francis Crick Institute.

Using photographic source material, Jason Brooks (b.1968) uses an airbrush to create his large paintings, which he refines with a scalpel and dentist's drill, erasing the painterly qualities on the surface. Viewed closeup, as in this monochromatic portrait of Nurse, the large scale of his work emphasises the uniformity of the faces. This painting is an attempt to reveal what he calls his subjects' 'essential make up', which seems a particularly fitting way of depicting this eminent scientist. NPG 6837

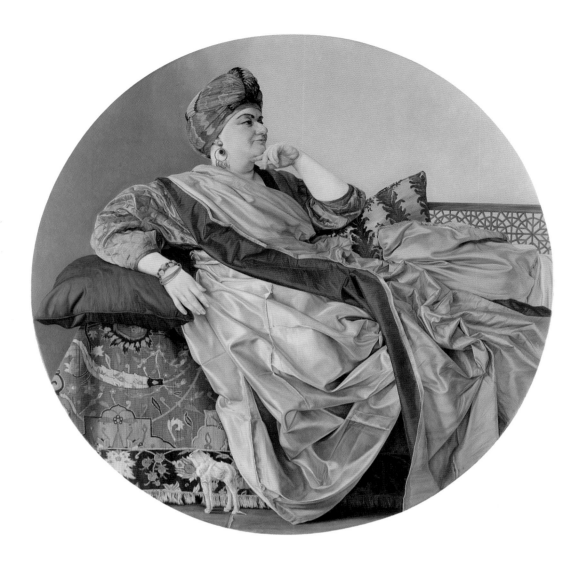

CAMILA BATMANGHELIDJH
(b.1963)
DEAN MARSH, 2008
Oil on panel
763mm diameter

Camila Batmanghelidjh is an Iranian-born psychotherapist and founder of Kids Company, a charity that provides support to thousands of vulnerable inner-city children. She is a passionate advocate for young people and, while in her twenties, she founded her first charity, The Place to Be, now a national organisation providing school-based mental health support for children.

Commissioned by the Gallery, the artist Dean Marsh (b.1968) had won the Gallery's annual BP Portrait Award in 2005. Inspired by Batmanghelidjh's distinctive clothes, he based this portrait on *Madame Rivière* by Jean-Auguste-Dominique Ingres (1806, Musée du Louvre, Paris), in which the subject is almost enveloped by gorgeous fabrics. In the making of this portrait, Marsh rejected lengthy sittings, deciding that his sitter's time 'was better spent doing what she does', so initial studies were made in the Kids Company office. In his studio Marsh fabricated and worked from a life-sized dummy, dressed in his sitter's turban, earrings and bangles, a proxy solution pioneered by artists in preceding centuries. Following the portrait's unveiling in 2008, Batmanghelidjh commented that the inclusion of this portrait in the Collection 'serves to recognise the extraordinary courage and dignity of the children I work for'.
NPG 6845

SELF-PORTRAIT WITH CHARLIE (DAVID HOCKNEY; b.1937)
SELF-PORTRAIT, 2005
Oil on canvas
1829 x 914mm

David Hockney was a leading figure in the pop art movement, before moving in late 1963 to California, where he found fresh inspiration, the swimming pool becoming a motif. In the 1970s Hockney also designed for the stage, his productions including *The Rake's Progress* (1975) and *The Magic Flute* (1978) being performed at Glyndebourne and the New York Metropolitan Opera House. In the late 1990s he began researching artists' use of mirrors and lenses through the centuries, publishing his discoveries in *Secret Knowledge* (2001). A series of portraits made with the aid of the camera lucida followed.

In recent years, Hockney has divided his time between California, London and East Yorkshire, and his projects have included *A Bigger Picture* (2012), a Royal Academy exhibition incorporating work executed using the Brushes iPad application.

This self-portrait is one of a series of almost life-size figure paintings made in Hockney's Hollywood Hills studio in 2005, all completed from life in just a few sittings and shown at the Gallery in 2006. Hockney worked directly on to the canvas in oils, without photographic reference or preparatory drawings. The work sets up a triangular exchange of gazes between the viewer, the artist and the seated figure – New York-based curator Charlie Scheips. NPG 6819

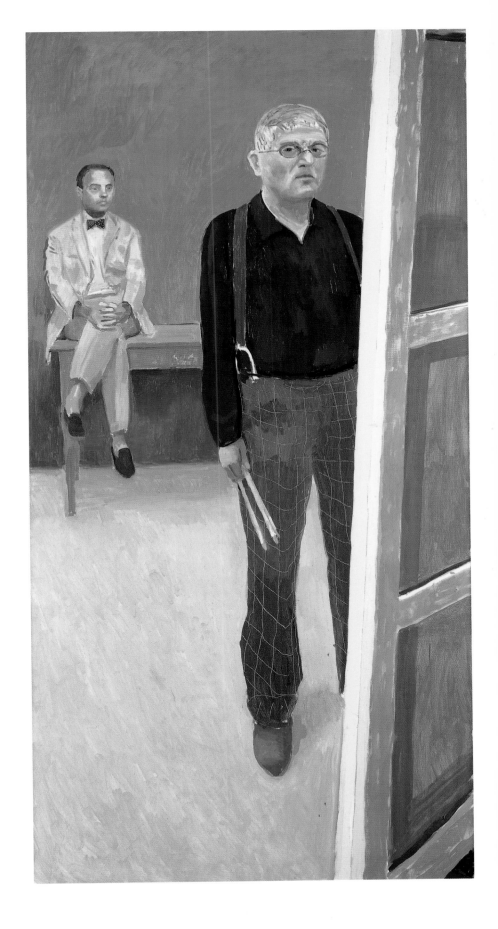

SIR WILLARD WHITE
(b.1946)
ISHBEL MYERSCOUGH, 2009
Oil on canvas
762 x 562mm

Willard White is an internationally acclaimed opera singer. Born in Jamaica, he made his debut at the New York City Opera and is now based in London. He has sung all the major bass-baritone roles in the repertoire, including Duke Bluebeard in *Bluebeard's Castle* by Bartók, Wotan in Wagner's *Ring Cycle*, and Porgy in Gershwin's *Porgy and Bess*. He has performed with the world's leading conductors and orchestras, including the Berlin Philharmonic under Sir Simon Rattle. In Britain, White has performed at the Royal Opera House in Covent Garden and the English National Opera, and has appeared as a soloist at numerous BBC Proms.

The artist Ishbel Myerscough (b.1968) had several sittings with the singer at his London home, where she was privileged to hear her sitter in the incongruity of a domestic setting. Recording her experience for the Gallery in 2009, she wrote that White 'would warm up his voice by exercising it as he walked around the house doing jobs, such as going to make a cup of coffee or adjusting the heating. He never sang to me or indeed in the same room as me, but I could hear him wherever he was in the house.' NPG 6886

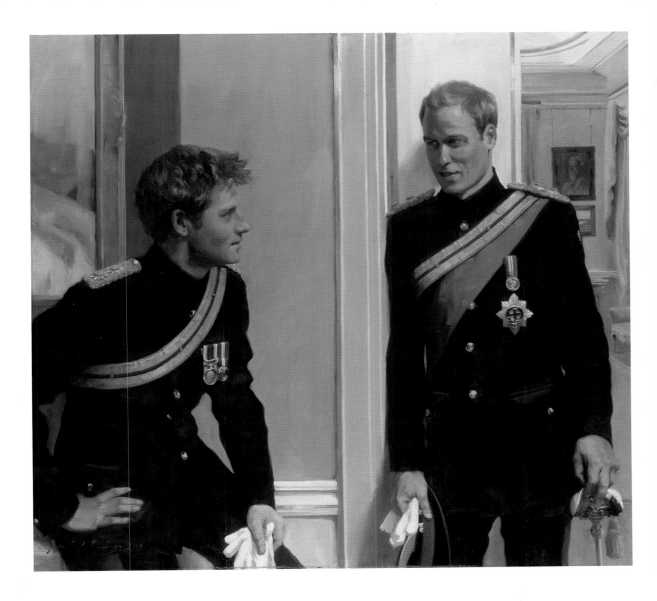

PRINCE WILLIAM, DUKE OF CAMBRIDGE (b.1982) AND PRINCE HENRY ('HARRY') (b.1984)

NICOLA JANE ('NICKY') PHILIPPS, 2009

Oil on canvas

1374 × 1475mm

This is the first official portrait of Prince William and Prince Harry. Commissioned by the National Portrait Gallery, the portrait represents a unique moment in the lives of the royal brothers; they were both serving officers in the Household Cavalry (Blues and Royals) and are depicted, mid-conversation, wearing the regiment's dress uniform. The Duke of Cambridge wears the star and sash of the Order of the Garter, to which he was appointed by the Queen

shortly before sittings for this portrait commenced in 2008.

Whilst the painting sits comfortably within the tradition of historic royal portraiture, the artist Nicky Philipps (b.1964) subtly refreshed the format to convey what she describes as an 'informal moment within a formal context'. The young men are shown in the library of Clarence House, the official residence of their father, the Prince of Wales, and adopt relaxed poses that emphasise their companionable relationship. After the portrait was completed, the Duke of Cambridge married Catherine Middleton (page 279) and retired from the army to concentrate on royal duties. Their son, Prince George, was born in 2013. That same year Prince Harry qualified as an Apache helicopter pilot with the Army Air Corps. NPG 6876

SHAMI CHAKRABARTI

(b.1969)

GILLIAN WEARING, 2011
Gelatin silver print
929 x 800mm

Since 2003, Shami Chakrabarti has been the director of the influential human rights pressure group Liberty, becoming a spokesperson for issues relating to civil liberties. Born in London of Indian heritage, Chakrabarti studied law at the London School of Economics. She was called to the Bar in 1994, before joining the Home Office as a lawyer, where she contributed to the implementation of the Human Rights Act. Chakrabarti is portrayed holding a wax mask of her own face hanging from a ribbon.

Exploring the disparity between public and private identities, the mask is a feature of the work of Turner Prize-winning artist Gillian Wearing (b.1963). In the case of this portrait, however, the idea was prompted by the sitter, who commented upon first meeting the artist that her public persona is mask-like, often interpreted as 'grim', 'worthy' and 'strident'. The mask was sculpted from a digital scan of the sitter's head and included glass eyes. Chakrabarti was photographed in black and white using a large format camera, an approach that replicates the static sobriety of Victorian portrait photography. NPG 6923

CATHERINE, DUCHESS OF CAMBRIDGE
(b.1982)

PAUL EMSLEY, 2012
Oil on canvas
1152 x 965mm

Catherine Elizabeth Middleton, now Her Royal Highness The Duchess of Cambridge, was born in Berkshire and attended Marlborough College. She studied at the British Institute in Florence before enrolling at the University of St Andrews in Fife to study history of art. She married His Royal Highness Prince William at Westminster Abbey on 29 April 2011. In February 2012, St James's Palace announced her patronage of five charities, one of which is the National Portrait Gallery.

Glasgow-born artist Paul Emsley (b.1947) grew up in South Africa and won First Prize in the 2007 BP Portrait Award. The Duchess sat for Emsley twice, at Kensington Palace and in the artist's studio. Emsley's subjects are frequently located against a dark background and are imbued with an imaginative, almost ethereal quality. This portrait depicts the Duchess at an important time: the beginning of her public life in Britain. NPG 6956

DAME KELLY HOLMES
(b.1970)
CRAIG WYLIE, 2012
Oil on canvas
1728 x 1152mm

Athlete Kelly Holmes joined the army at the age of eighteen, at the same time continuing the athletics training she had begun at school. In 1994 she won the 1500m in the Commonwealth Games. Holmes became a professional athlete in 1997 and, despite suffering injury, won a bronze medal in the 800m at the 2000 Olympics in Sydney. A string of wins culminated in a British record-breaking performance at the 2004 Olympics in Athens, during which Holmes took two gold medals: in the 800m and the 1500m events. Holmes was awarded BBC Sports Personality of the Year in 2004 and is Founder and Chair of the Dame Kelly Holmes Legacy Trust, a charity that seeks to create life chances for young people through sport.

The unveiling of this portrait in 2012 was timed to coincide with the London Olympic and Paralympic Games. Sittings took place in late 2011, and artist Craig Wylie (b.1973) took a number of photographs of Holmes from which to work during these sessions. The large scale of this portrait is important to the artist, who has said that the act of painting creates 'a kind of hyperreality through amplification', reflecting the sitter's extraordinary sporting achievements. NPG 6944

EQUANIMITY
(QUEEN ELIZABETH II;
b.1926)
CHRIS LEVINE (ARTIST) AND
ROB MUNDAY (HOLOGRAPHER),
2012
Lenticular print on lightbox
795 x 595mm

Queen Elizabeth II, the ruling
monarch of the United Kingdom
and head of the Commonwealth,
succeeded her father George VI
in 1952, aged twenty-five. Her
coronation in 1953, the first ever
to be televised, was broadcast
internationally. Her Silver and
Golden Jubilees were celebrated
in 1977 and 2002, and 2012 was
her Diamond Jubilee marking
sixty years on the throne, the
second longest reign of a British
monarch. She is the most portrayed
individual in history.

Ontario-born Chris Levine
(b.1972) studied graphic design
at Chelsea School of Art and
computer graphics at Central Saint
Martins School of Art. His practice
incorporates photography, lasers,
holography and stage design.
Made by Levine with holographer
Rob Munday, *Equanimity* was
commissioned by the Island of
Jersey in 2004 to commemorate
the island's 800-year allegiance
to the Crown. Two sittings took
place and, to create the three-
dimensional portrait, over 10,000
images were made. *Equanimity* is
the first holographic portrait of the
Queen. NPG 6936

Innovation in Portraiture

INGA FRASER

The advent of new image-making technologies and the proliferation of techniques and materials used by the avant-garde in art in the twentieth and twenty-first centuries have transformed our understanding of what a portrait might consist of. Before this time the use of more unusual materials in portraiture was a matter of decorative effect, personal intent or sometimes economy. For example, *memento mori* portraits might be framed with personal items, such as a lock of hair. In the twentieth century, however, the move towards abstract and conceptual art meant that the particular media used for a portrait acquired greater significance, reflecting the theoretical concerns of the artist or the life of the subject. Yet the use of non-traditional media within portraiture – a genre in which realism, or likeness to life has been prized – is limited, and these works are proportionately in the minority within the Collection.

Collage and printing techniques used by pop artists in the 1960s revisited those of the Surrealists and Dadaists in the first quarter of the century. This appropriation of contemporary visual culture was intended as a critique of its aesthetic and also of the method of its production, as in Andy Warhol's 1967 silkscreen prints of Elizabeth II (pages 242–3). A later work, Stephen Willats's 1984 portrait of the performance artist Leigh Bowery (below), comprises two panels, separated by a tower of ten painted breeze blocks, which incorporate objects such as a Daz washing-powder box and a beaded necklace, taken from the sitter's London flat. The range of media with which artists experiment continues to expand in line with scientific or technological developments. Marc Quinn, for example, has consistently worked with biological matter, such as DNA or blood (page 217).

LEFT

Leigh Bowery (1961–94) (*What is he trying to get at? Where does he want to go?*), by Stephen Willats. Two-panel work with tower of ten breeze blocks, 1984, NPG 6660. Panel one: 1520 x 980mm; panel two: 1520 x 980mm; tower: 2000 x 440mm • The breeze-block tower was Leigh Bowery's innovation and represents the block of flats in east London in which he lived.

ABOVE

Heads, by Peter Gidal
(composite image). 16mm
black-and-white film, 1969,
NPG 6827 • Peter Gidal filmed
Heads with a clinical scrutiny,
using a close-up zoom that
is met by his subjects' head-
on stare.

TOP RIGHT

Dame Zaha Hadid (b.1950),
by Michael Craig-Martin.
LCD monitor with integrated
software, 2008, 1257 x 749mm
overall, NPG 6840 • Michael
Craig-Martin's use of computer-
aided graphics in this portrait
mirrors that of Zaha Hadid in
her architectural designs.

Over the last century, artists have also produced
evocative and intriguing portraits using a range of
moving-image technologies, of which the earliest
example in the Gallery's Collection dates from 1969.
Peter Gidal's *Heads* (left) is a 16mm film that features
Marianne Faithful and David Hockney, among others.
It references Warhol's famous *Screen Tests* series, and
subjects are shown close up, enabling the viewer to
scrutinise the subject's features in detail. The portraits
are in many ways the artist's response to his discovery
of the technology and, as a 16mm projection, the film
represents Gidal's particular way of seeing at the time
of production. More recently, artists have experimented
with the possibilities afforded by computer software.
In Michael Craig-Martin's 2008 portrait of the award-
winning architect Zaha Hadid (above), the subject's
linear features appear as a fixed image on an LCD
screen, but the colours within change over time in
infinite combinations, frustrating any fixed view of
the subject.

Non-traditional media present particular challenges
in terms of both preservation and display within the
National Portrait Gallery. Nevertheless, these works
are uniquely evocative of their time and reflect the
ingenuity, and often irreverence, of the artistic
imagination.

Acquisition supporters

Key to abbreviations: National Portrait Gallery, London (NPG); National Heritage Memorial Fund (NHMF); t: top; b: bottom; l: left; r: right.

p.10tl Bequeathed by Sir George Scharf, 1895; p.30 Given by James Thomson Gibson-Craig, 1862; p.37 Purchased with help from the Gulbenkian Foundation, 1965; p.43 Purchased with help from the Art Fund, the Pilgrim Trust, Elizabeth Taylor and Richard Burton, 1972; p.44 Purchased with help from the NHMF, the Art Fund, the Portrait Fund, L.L. Brownrigg, John Morton Morris, Paul Dacre, and many other donations, 2008; p.45 and p.46r Given by Harold Lee-Dillon, 17th Viscount Dillon, 1925 and 1932; p.46l Purchased with help from the Art Fund and NHMF, 2004; p.52 Purchased with help from the Art Fund, the Pilgrim Trust, and an anonymous donor, 1961; p.53 Purchased with help from the Wolfson Foundation, 1971; p.58 Purchased with help from the NHMF, the Art Fund, Lord Harris of Peckham, L.L. Brownrigg, the Portrait Fund, Sir Harry Djanogly, the Headley Trust, the Eva & Hans K. Rausing Trust, The Pidem Fund, Mr O. Damgaard-Nielsen, Sir David and Lady Scholey and numerous Gallery visitors and supporters, 2006; p.61 Given by Francis Egerton, 1st Earl of Ellesmere, 1856; p.69 Purchased with help from the Art Fund, 1957; p.71 Given by Benjamin Seymour Guinness, 1952; p.79 Purchased with help from the Heritage Lottery Fund, 1997; p.80 Given by Henry Louis Bischoffsheim, 1899; p.81 Purchased with help from the Pilgrim Trust, 1984; pp.82–3 Purchased with help from the Art Fund, 1970; p.84 Purchased with help from the Art Fund, the NHMF and the Dame Helen Gardner Bequest, 1992; p.85 Acquired with the support of the Heritage Lottery Fund, the Art Fund in honour of David Verey CBE (Chairman of the Art Fund 2004–2014), the Portrait Fund, The Monument Trust, the Garfield Weston Foundation, the Aldama Foundation, the Deborah Loeb Brice Foundation, Sir Harry Djanogly CBE, Mr and Mrs Michael Farmer, Matthew Freud, Catherine Green, Dr Bendor Grosvenor, Alexander Kahane, the Catherine Lewis Foundation, the Material World Foundation, the Sir Denis Mahon Charitable Trust, Cynthia Lovelace Sears, two major supporters who wish to remain anonymous, and many contributions from the public following a joint appeal by the NPG and the Art Fund; p.87 Purchased with help from the NHMF, through the Art Fund (with a contribution from the Wolfson Foundation), Camelot Group plc, David and Catharine Alexander, David Wilson, E.A. Whitehead, Glyn Hopkin and numerous other supporters of a public appeal including members of the Chelsea Arts Club, 2005; p.92 Bequeathed by John Neale, 1931; p.94 Purchased with help from Private Treaty and the Worshipful Company of Musicians, 1974; p.95 Purchased with help from the Art Fund, 1936; p.104 Given by an anonymous donor, 1911; p.105 Purchased with help from the Handel Appeal Fund, 1968; p.108 Purchased with help from the NHMF, the Art Fund (with a contribution from the Wolfson Foundation) and the Portrait Fund, 2012; p.110 Purchased with help from the NHMF, the Art Fund and the Pilgrim Trust, 1986; p.112 Purchased with help from the Art Fund, 1933; p.115 Given by Dr D.M. McDonald, 1977; p.116 Bequeathed by Jane, Lady Shelley, 1899; p.117 Given by the Art Fund, 1917; p.118 Purchased with help from the NHMF, 1985; p.120 Given by W.P.G. Collet, 1956; p.121l Purchased through the NHMF, 1986; p.121r Given by Rupert Gunnis, 1965; p.122l Given by Mrs Anna Henley, 1913; p.123 Given by Estate of Isabella Blow and Tim Noble and Sue Webster, 2009; p.125 Purchased with help from the Friends of the National Libraries, 1948; p.127 Bequeathed by Jane, Lady Shelley, 1899; p.128 Given by S. Smith Travers, 1859; p.129 Bequeathed by John Fisher Wordsworth, 1920; p.130 Given by executors of Sir Robert Harry Inglis, 2nd Bt, 1857; pp.140–1 Purchased with help from the NHMF and the Art Fund, 1993; p.142 Given by Sir Mayson Beeton, 1932; p.143 Given by Mr and Mrs A.J.W. Vaughan, 1972; p.144 and p.145 Given by Florence Barclay, 1921; p.146 Given by Queen Victoria, 1867; p.147 Given by Helen Macgregor, 1978; pp.150–1 Given by Sir William Agnew, 1st Bt, 1890; p.153 Given by the Misses Palgrave, 1924; p.154 Purchased with help from the National Lottery through the Heritage Lottery Fund and Gallery supporters, 2008; p.155 Given by George Frederic Watts, 1897; p.157 Bequeathed by Sir Charles Wentworth Dilke, 2nd Bt, 1911; p.158 Purchased with help from the Art Fund and the Heritage Lottery Fund, 2002; p.159 Given by Dame Ellen Terry, 1910; p.161 Given by William Henry Smith, 3rd Viscount Hambleden, 1945; p.162 Purchased with help from the Art Fund, 1996; p.163r Given by an anonymous donor, 1973; p.164t Purchased with help from Kodak Ltd, 1973; p.164b Purchased jointly with the National Media Museum, Bradford, through the Art Fund and the NHMF, 2002; p.165r Given by Robert R. Steele, 1939; p.166 Given by William Erasmus Darwin, 1896; p.169 Bequeathed by Sir William Schwenck Gilbert, 1937; p.170 Given by Sir William Blake Richmond, 1896; p.171 Bequeathed by Florence Emily Hardy,1938; p.173 Given by Roger Fry, 1930; p.174 Given by Winifred Brooke Alder by wish of the sitter, 1911; p.175 Bequeathed by Octavia Hill, 1915; p.176 Given by Marylebone Cricket Club and other cricket clubs, 1926; p.177 Given by the Art Fund, 1962; p.178 Given by the Art Fund to mark Sir Alec Martin's 40 years service to the Fund, 1965; p.180 Bequeathed by Sir Frank Swettenham, 1971; p.181 Bequeathed by Henry James, 1916; p.188 Purchased with help from the Art Fund, 1987; p.191 Given by Mrs Wynick, 1959; pp.192–3 Bequeathed by Frances Partridge 2004; p.194 Lent by Trustees of the Churchill Chattels Trust, 2012; p.196 Bequeathed by Una Elena Vincenzo, Lady Troubridge, 1963; p.197 Given by George Bernard Shaw, 1944; p.198 Given by (Mary) Olive Edis (Mrs Galsworthy), 1948; p.199 Given by Sir Albert Ball, 1929; p.200 Given by Estate of Howard Coster, 1959; p.205 Given by King's College: Cambridge: UK, 1983; p.209 Given by Beaverbrook Foundation, 1977; p.211 Given by The Britten Estate, 1981; p.212 Given by Mrs Behrend, 1973; p.216r Purchased with help from The Art Fund, 2006; p.217 Purchased with help from the Art Fund, the Henry Moore Foundation, Terry and Jean de Gunzburg and ProjectB Contemporary Art, 2009; p.219 Purchased with help from the Contemporary Art Society, 1965; p.221 Purchased with help from Mrs T.S. Eliot, AF, and Roy Davids, 2005; p.227 Given by University of Dundee – Michael Peto Collection, 2013; p.299r Given by Susan Morton, 1976; p.230l Given by Terence Pepper, 2012; p.230r Given by Mario Testino, 2003; p.232 Given by Tessa Traeger, 237 Given by Mrs Graham Sutherland, 1980; pp.238–9 Given by Jane Bown and The Observer, 1981; p.240 Given by Annie Leibovitz, 1995; p.248 Commissioned as part of the first prize, BP Portrait Award 1991, 1992; p.250 Given by the Art Fund, 2002; p.252 Given by Sadie Coles HQ, 2001; pp.258–9 Given by The Art Fund, 2001; p.261 Commissioned with help from the Jerwood Charitable Foundation through the Jerwood Portrait Commission, 2002; p.262 purchased with help from the Art Fund, 2010; p.263t Given by Terry O'Neill, 2002; p.263b Given by Lewis Morley, 1992; p.264 Given by Norman Parkinson, 1981; pp.266–7 commission made possible by J.P. Morgan through the Fund for New Commissions, 2004; p.270 commissioned as part of the first prize, BP Portrait Award 2001, 2005; pp.272–3 Commission made possible by J.P. Morgan through the Fund for New Commissions, 2008; p.274 commissioned as part of the first prize, BP Portrait Award 2005, 2008; p.275 purchased with help from the proceeds of the 150th anniversary gala and Gift Aid visitor ticket donations, 2007; p.276 Commission made possible by J.P. Morgan through the Fund for New Commissions, 2009; p.278 Commission made possible by J.P. Morgan through the Fund for New Commissions, 2011; p.279 An NPG commission given by Sir Hugh Leggatt in memory of Sir Denis Mahon through the Art Fund, 2012; p.280 Commissioned as part of the first prize, BP Portrait Award 2008, 2012; p.281 Given by The People of Jersey, 2012; p.283r Commission made possible by J.P. Morgan through the Fund for New Commissions, 2008.

Picture credits

Unless otherwise stated, all illustrations are © National Portrait Gallery, London. Every effort has been made to contact the holders of copyright material, and any omissions will be corrected in future editions if the publisher is notified in writing. The publisher would like to thank the following for permission to reproduce works for which they hold the copyright: p.33 By permission of the Archbishop of Canterbury and the Church Commissioners; on loan to the NPG; p.122r Photograph © NPG; p.123 Sculpture © Tim Noble and Sue Webster/DACS, London 2014; Photograph by Andy Keate, © NPG; p.190 © Reproduced with permission of The Estate of Dame Laura Knight DBE RA 2014. All Rights Reserved; p.194 Lent by the Churchill Chattels Trust; Photograph © NPG; p.201 Photograph © NPG; p.205 © William Roberts Society; p.206 © Angela Verren Taunt 2014. All rights reserved, DACS, 2014; p.208 © estate of Augustus John/Bridgeman Images; p.210 Angus McBean Photograph © Harvard Theatre Collection, Houghton Library, Harvard University; p.211 Louise Dahl-Wolfe/courtesy Staley-Wise Gallery New York; p.216r © estate of R.B. Kitaj/NPG; p.217 © Marc Quinn. Photography by Todd-White Art Photography, courtesy White Cube, London; p.218 © Prosper Devas & Associates; p.219 © The Estate of Patrick Heron. All rights reserved, DACS, 2014; p.220 Courtesy of the Cecil Beaton Studio Archive at Sotheby's; p.221 © estate of Sylvia Plath/ Faber & Faber Ltd; p.222 © 1963 Condé Nast Publications Inc.; p.223 © David Bailey; p.225 © The Lucian Freud Archive/Bridgeman Images p.226 © estate of Sam Walsh; p.227 © University of Dundee The Peto Collection; p.230l © Man Ray Trust/ADAGP, Paris and DACS, London 2014; p.230r © Mario Testino; p.231 © The Helmut Newton Estate; p.232 © estate of Ronald Traeger; p.233 © Michael Joseph; p.234 Photograph © NPG; p.235 Photo Duffy © Duffy Archive & The David Bowie Archive™; pp.238–9 © Jane Bown; p.240 © Annie Leibovitz/Contact Press Images; pp.242–3 © 2014 The Andy Warhol Foundation for the Visual Arts, Inc./Artists Rights Society (ARS), New York and DACS, London; p.246 Photograph © NPG; p.247 © Derry Moore; p.250 © Frank Auerbach/Marlborough Fine Art (London) Ltd/NPG; p.252 © Sarah Lucas; p.253 © The Estate of Patrick Heron. All rights reserved, DACS, 2014; pp.258–9 © Julian Opie/DACS; p.262 © Alex Katz, DACS, London/ VAGA, New York 2014; p.263t © Terry O'Neill; p.263b © Lewis Morley Archive/NPG; p.264 © Norman Parkinson Ltd./courtesy Norman Parkinson Archive; p.265 © Estate of Corinne Day/Commissioned by the NPG/trunkarchive. com; pp.266–7 © Sam Taylor-Johnson; p.268 © Tai-Shan Schierenberg/NPG; p.275 David Hockney, *Self Portrait with Charlie*, 2005, 72 x 36in © David Hockney, Collection NPG; p.281 © Chris Levine; p.282 © Stephen Willats; p.283l © Peter Gidal.

Index

Page numbers in **bold** refer to captions.